PHOTOGRAPHY CALLING!

Inka Schube, Thomas Weski
Sprengel Museum Hannover in Kooperation mit der Niedersächsischen Sparkassenstiftung

STEIDL

IMPRESSUM KATALOG/IMPRINT CATALOGUE

Herausgeber/Editors: Inka Schube, Sprengel Museum Hannover, Thomas Weski, Berlin, im Auftrag der/on behalf of Niedersächsische/n Sparkassenstiftung
Lektorat/Copy-editing: Miriam Wiesel, Berlin
Mitarbeit/Assistance: Gesa Lehrmann, Stefanie Loh, Katja Roßocha, Johanna Saxen, Martin Smolka
Übersetzungen/Translations: John Brogden (Weski), Tim Chafer, Christopher Cordy/Carolyn Kelly (Schube)
Reproduktionen/Reproductions: Robert Adams, Diane Arbus, Lee Friedlander: Michael Herling/Uwe Voigt, Sprengel Museum Hannover; John Gossage, Nicholas Nixon, Lee Friedlander: Aline Gwose/Michael Herling, Sprengel Museum Hannover; Lewis Baltz, Bernd und Hilla Becher: Raimund Zakowski, Hannover; William Eggleston: Photo-Team Jürgen Brinkmann, Hannover
Konzept und Gestaltung/Concept and Design: Müller & Wesse, Berlin
Separationen/Separations: Steidl's digital darkroom/Reiner Motz
Herstellung/Production: Bernard Fischer, Gerhard Steidl
Druck/Print: Steidl, Göttingen

Bibliografische Information der Deutschen Nationalbibliothek: Die Deutsche Nationalbibliothek verzeichnet diese Publikation in der Deutschen National-bibliografie; detaillierte bibliografische Daten sind im Internet über http://dnb.ddb.de abrufbar./Bibliographic information published by the Deutsche National-bibliothek: The Deutsche Nationalbibliothek lists this publication in the Deutsche Nationalbibliografie; detailed bibliographic data are available in the Internet at http://dnb.d-nb.de.

Erste Auflage/First edition 2011

Steidl
Düstere Str. 4
37073 Göttingen
Tel. +49 551 49 60 60/Fax +49 551 49 60 649
mail@steidl.de/www.steidl.de/www.steidlville.com

ISBN 978-3-86930-379-6
Printed in Germany

INHALT/CONTENTS

Mehr als jedes andere visuelle Medium hat die Fotografie unsere Wahrnehmung beeinflusst. Fotografien bebildern historische Momente und sind die Ikonen unserer Zeit.

Weil die Herstellung einer Fotografie in den Anfängen ein aufwändiger technischer Prozess war und ein Foto zunächst vor allem abbildete, was sich vor dem Apparat befand, galt die Fotografie lange Zeit als ein rein dokumentarisches Medium und nicht als Kunst.

Dies hat sich zum Glück geändert, und die Fotografie ist heute eine anerkannte, eigenständige Kunstgattung. Mit den fotografischen Experimenten der Surrealisten in den 1920er-Jahren und amerikanischen Fotografen wie Walker Evans beginnt sich auch die Kunstwelt für das Medium Fotografie zu interessieren. Die erste Einzelausstellung eines Fotografen in einem Kunstmuseum – und damit die Anerkennung des Mediums Fotografie als Kunstform – fand 1938 in Amerika statt. In Deutschland bot 1977 die documenta 6 die erste große Überblicksschau über Fotografie als Kunst.

In den 1970er-Jahren entwickelt sich Hannover als Zentrum der Fotografie in Norddeutschland. 1972 gründeten hier die Fotografen Heinrich Riebesehl, Peter Gauditz und Joachim Giesel die inzwischen legendäre Spectrum Photogalerie, die 1979 in das neu errichtete Sprengel Museum Hannover integriert wurde. Das Museum zeigte damit von Beginn an Ausstellungen namhafter Fotografen wie William Eggleston, Andreas Feininger, Raoul Hausmann, Martin Parr, Umbo und vielen weiteren. Als eines der ersten Kunstmuseen in Deutschland richtete das Sprengel Museum Hannover im Jahr 1993 eine eigene Fotografieabteilung ein und widmet sich seitdem kontinuierlich der Sammlung und Präsentation zeitgenössischer Fotografie.

Das Land Niedersachsen unterstützte das Sprengel Museum Hannover bei dem Erwerb fotografischer Sammlungen maßgeblich. So hat das Land Niedersachsen im Jahr 2000 das umfangreiche Archiv Heinrich Riebesehls erworben. Es umfasst über 3.300 Bromsilbergelatineabzüge, mehr als 19.000 Negative und über 12.600 Kontaktabzüge bzw. Kontaktbögen. Das Konvolut wurde im Jahr 2001 dem Sprengel Museum Hannover als Dauerleihgabe übergeben und wird dort wissenschaftlich bearbeitet und ausgestellt. Im vergangenen Jahr konnte das Museum ebenfalls mit beachtlicher Unterstützung des Landes Niedersachsen ein umfangreiches Konvolut von Arbeiten des Bauhaus-Schülers und Fotografen Umbo (Otto Umbehr) erwerben, der in der Nachkriegszeit vor allem in Hannover tätig war.

Während der EXPO im Jahr 2000 zeigte das Sprengel Museum Hannover mit Unterstützung der Niedersächsischen Sparkassenstiftung die große Fotografieausstellung *How you look at it. Fotografien des 20. Jahrhunderts*.

Die Ausstellung PHOTOGRAPHY CALLING! setzt diese erfolgreiche Zusammenarbeit nun fort und präsentiert Werkgruppen von amerikanischen und europäischen Foto-grafen, die in ihren Fotoarbeiten vom Leben erzählen. Viele Ausstellungsstücke sind Leihgaben der Sammlung der Niedersächsischen Sparkassenstiftung.

Mit dem geplanten Erweiterungsbau des Sprengel Museum Hannover wird das Museum zusätzliche Ausstellungsfläche – insbesondere für die Präsentation seines Schwerpunktes „Fotografie" – erhalten, darüber hinaus zusätzliche Depotflächen, um die in den letzten Jahren stark vergrößerte Sammlung des Museums unterzubringen. Dazu gehören auch Depots, die den speziellen Anforderungen der Lagerung von Fotografien genügen. Damit verfügt das Sprengel Museum Hannover über die besten Voraussetzungen, um auch zukünftig einen Spitzenplatz als Museum für die Kunst des 20. und 21. Jahrhunderts und als herausragendes Zentrum für zeitgenössische Fotografie in Norddeutschland einzunehmen.

An alle bei der Planung, Vorbereitung und Durchführung Beteiligten dieser so umfangreichen Schau geht ein ganz besonderer Dank.

Der Ausstellung PHOTOGRAPHY CALLING! wünsche ich einen großen Erfolg.

Prof. Dr. Johanna Wanka
Niedersächsische Ministerin für Wissenschaft und Kultur

Photography has influenced our perception more than any other visual medium. Photographs stand for the historic moments of our century and are the icons of our time.

Because, more than anything else, the production of a photograph was originally a complex technical process and, more than anything else, a photograph initially illustrated what was in front of the lens, photography was long considered a purely documentary medium and not art.

This, thankfully, has changed and photography today is a recognized art genre in its own right. With the photographic experiments of the surrealists in the 1920s and American photographers like Walker Evans, the art world started to take note of photography as a medium. The first solo exhibition of a photographer in a museum of art—and hence the acknowledgement of photography as an art form—took place in America in 1938. In Germany, documenta 6 presented the first major overview exhibition of photography as art in 1977.

In the 1970s, Hanover developed into a center of photography in northern Germany. In 1972, the photographers Heinrich Riebesehl, Peter Gauditz and Joachim Giesel founded the now legendary Spectrum Photogalerie, which was integrated in 1979 into the newly built Sprengel Museum Hannover. From the outset, the museum thus staged exhibitions of such notable photographers as William Eggleston, Andreas Feininger, Raoul Hausmann, Martin Parr, Umbo and many others. In 1993, the Sprengel Museum Hannover became one of the first art museums in Germany to establish its own photography department and has since continuously devoted itself to the collection and presentation of contemporary photography.

The Land of Lower Saxony has had a large hand in supporting the Sprengel Museum Hannover in the purchase of photographic collections. In the year 2000, for instance, the Land of Lower Saxony purchased Heinrich Riebesehl's extensive archive. It comprises over 3,300 silver gelatin prints, over 19,000 negatives and over 12,600 contact prints and sheets. The collection was presented to the Sprengel Museum Hannover on permanent loan in 2001 and is being expertly processed and exhibited there. Last year, again with considerable support from the Land government, the museum succeeded in purchasing an extensive collection of works of Bauhaus student and photographer Umbo (Otto Umbehr), who worked mainly in Hanover in the post-war period.

During EXPO 2000, the Sprengel Museum Hannover, with the support of the Niedersächsische Sparkassenstiftung, showed the major exhibition of photography entitled *How you look at it. Photographs of the 20th Century*.

The exhibition PHOTOGRAPHY CALLING! continues this successful cooperation and is presenting groups of works of American and European photographers who report on life in their photographic works. Many exhibits are loans from the collection of the Niedersächsische Sparkassenstiftung.

With the planned extension of the Sprengel Museum Hannover, the museum will gain extra exhibition space, particu-larly for the presentation of its important photographic works, as well as additional storage space for the accommodation of the museum's collection, which has grown enormously in the last few years. This also includes rooms that create ideal conditions for the storage of photography. This means that the Sprengel Museum Hannover will have all the means at its disposal for maintaining its leading position as a museum of art of the 20th and 21st centuries and as an outstanding center for contemporary photography in northern Germany.

Special thanks go to those involved in the planning, preparation and staging of such an extensive exhibition.

I wish the exhibition PHOTOGRAPHY CALLING! much success.

Prof. Dr. Johanna Wanka
Minister of Science and Culture of Lower Saxony

Der Kunstcharakter der Fotografie war lange Zeit umstritten. Große internationale Museen haben früh die Fotografie in ihren Arbeitsrahmen gehoben; auch in Deutschland gibt es heute bedeutende Sammlungen und Häuser, die sich in ihren Ausstellungen der Geschichte und Gegenwart künstlerischer und dokumentarischer Fotografie widmen. Dass das Sprengel Museum Hannover zu diesen Häusern gehört, ist inzwischen unbestritten.

Mit der frühen Hinwendung zur Fotografie durch die Aufnahme der Spectrum Photogalerie 1979 hat das Museum wesentlich zur Anerkennung der Fotografie als Kunstform beigetragen und eine breitere Beschäftigung mit der europäischen fotografischen Moderne initiiert. Nur so konnten hier über Jahre große Sammlungen und Konvolute verwahrt und bearbeitet werden.

Bereits seit einiger Zeit ist deutlich, dass die Auseinandersetzung mit der Fotografie im Sprengel Museum Hannover auf eine neue Stufe gehoben werden soll. Mit dem Erweiterungsbau des Museums, dessen Baubeginn für Ende 2012 geplant ist, wird der Arbeitsschwerpunkt Fotografie gestärkt. Neben der Erweiterung der Ausstellungsmöglichkeiten durch eine Folge wunderbarer, tanzender Räume steht gleichberechtigt die Errichtung eines professionellen fotografischen Depots, in dem die unterschiedlichen Werke aus der Geschichte der Fotografie ihren jeweiligen Erhaltungsnotwendigkeiten nach professionell aufbewahrt werden können. Die Planungen für diesen Bereich sind auf die Zukunft angelegt; sie sind so dimensioniert, dass sich hier ein Ausbau der Sammlung durch profunde Dauerleihgaben und Zustiftungen ohne Probleme realisieren lässt. Auch die personelle Erweiterung der Abteilung Fotografie im wissenschaftlichen und konservatorischen Bereich ist angedacht.

So erschallt der Ruf PHOTOGRAPHY CALLING! just zu einer Zeit, in der ein Aufbruch in Hannovers Kultur wieder einmal spürbar ist. Mit dem Erweiterungsbau des Museums und der Realisierung professioneller Depots für die Fotografie wird der Arbeit des Sprengel Museum Hannover in Zukunft eine noch wesentlichere Rolle zukommen. Ein so verstärkter Schwerpunkt für die Fotografie im Norden Deutschlands wird weiterhin die Unterstützung aller Beteiligten benötigen. Die Fotografinnen und Fotografen, das macht allein die Künstlerliste der Ausstellung deutlich, unterstützen dabei diesen Impuls.

Eine solche Entwicklung über die Jahre mit vorbereitet und unterstützt zu haben, ist das große Verdienst von vielen. Dank gilt der Stiftung Niedersachsen mit dem „SPECTRUM" Internationaler Preis für Fotografie, der Sparkasse Hannover und der Niedersächsischen Sparkassenstiftung, die schon im Jahr 2000 parallel zur EXPO mit der Ausstellung *How you look at it. Fotografien des 20. Jahrhunderts* eine erste große Positionierung und Befragung zeitgenössischer Fotografie und Kunst unterstützt haben. Es ist zu hoffen, dass Kooperationen wie diese in Zukunft in organisierter und enger Form weitergeführt werden können, um so die Betreuung und Zusammenführung von großen Sammlungen zur internationalen Fotografie in Niedersachsen zu ermöglichen.

Inzwischen sind seit der Ausstellung im Jahr 2000 die Sammlungen weiter gewachsen, die – wie die der Niedersächsischen Sparkassenstiftung in herausragender Weise kuratorisch betreut – Schwerpunkte der europäischen und internationalen Fotografie zusammengetragen haben. Die Sammlung der Niedersächsischen Sparkassenstiftung ist heute eine der großen Quellen internationaler Ausstellungen. Sie hat den Stellenwert Hannovers bei dem an Fotografie interessierten Publikum deutlich erhöht.

Den Initiatoren, Kuratoren und Kooperationspartnern der Ausstellung gilt unser Dank für einen so professionellen Beitrag zur Situation der Fotografie in unserer Zeit. Wir wünschen PHOTOGRAPHY CALLING! einen herausragenden Erfolg.

Stephan Weil
Oberbürgermeister der Stadt Hannover

For a long time, photography's quality as art was disputed. However, major international museums were quick to include photography within their compass. And in Germany today, important collections and institutions stage exhibitions devoted to documentary and art photography past and present. There can be no doubt that the Sprengel Museum Hannover ranks among these institutions.

With its early commitment to photography by accommodating the Spectrum Photogalerie in 1979, the museum has had a large hand in photography's recognition as an art form and initiated a broader preoccupation with modern European photography. This is how the museum has been able to preserve and process large collections over the years.

It has been clear for some time now that the museum's involvement with photography is to be elevated to a new level. The extension of the Sprengel Museum Hannover, with construction due to start at the end of 2012, will lend greater weight to photography as a focus of its work. In addition to the increase in exhibition space made possible by a series of wonderful, dancing rooms, equal status is being accorded to the establishment of professional photographic storage space in which various works from the history of photography can be professionally safeguarded in accordance with their specific preservation needs. The planning for this area looks far ahead; its scale is such that the collection can be effortlessly extended to include notable permanent loans and donations. There are also plans to recruit additional staff in the photography department in the aesthetic and preservation fields.

The call of photography in PHOTOGRAPHY CALLING! has thus sounded at a time when a spirit of new beginnings can be sensed in Hanover's art scene. The extension of the Sprengel Museum Hannover and the creation of professional storage for photography will add to the importance of the museum's future activities. Nonetheless, this reinforced base for photography in the North of Germany will still require the support of everyone concerned. From the list of artists for the exhibition, the undertaking obviously enjoys the support of photographers.

The development, preparation and support for such a project over the years have been made possible by many. Our thanks go to the Stiftung Niedersachsen with its "SPECTRUM" International Award for Photography, and to the Sparkasse Hannover and the Niedersächsische Sparkassenstiftung that supported the first major positioning and analysis of contemporary photography and art with the exhibition *How you look at it. Photographs of the 20th Century*, held concurrently with the EXPO in 2000. It is to be hoped that close cooperative ventures like these will be continued to be organized in the future so that large international photography collections can be brought together and managed in Lower Saxony.

Since the exhibition in 2000, the collections have continued to grow and—like that of the Niedersächsische Sparkassenstiftung with its outstanding curatorship—have built up key focuses of European and international photography. One of the major sources for international exhibitions today, the collection of the Niedersächsische Sparkassenstiftung has undoubtedly enhanced Hanover's standing in the world of photography.

To the exhibition's initiators, curators and cooperation partners, we wish to express our gratitude for such a professional contribution to contemporary photography. And we wish PHOTOGRAPHY CALLING! much success.

Stephan Weil
Lord Mayor of Hanover

PHOTOGRAPHY CALLING! Mit der von der Niedersächsischen Sparkassenstiftung und der Sparkasse Hannover initiierten Ausstellung, deren Titel ganz bewusst appellativen Charakter besitzt, setzen wir ein deutliches Zeichen für die künstlerische Fotografie in Niedersachsen und wollen dazu beitragen, dass Hannover als lebendiges Zentrum der Fotografie im Norden wahrgenommen wird.

Wir begrüßen in diesem Zusammenhang ausdrücklich den von der Stadt Hannover und dem Land Niedersachsen geplanten Erweiterungsbau des Sprengel Museum Hannover und die Errichtung von dringend benötigten zusätzlichen Ausstellungsflächen und großzügigen Depots für den Sammlungsbereich Fotografie. Durch die geplante Einrichtung eines Kühllagers für sensible Farbfotografien, das höchsten konservatorischen Ansprüchen genügt, werden zukünftig optimale Voraussetzungen geschaffen, um die in den vergangenen drei Jahrzehnten aufgebaute Sammlung für künstlerische Fotografie des Museums adäquat zu lagern. Darüber hinaus bietet der Bau von zusätzlichen Ausstellungs- und Depoträumen sowie die geplante Einrichtung einer zusätzlichen Stelle für das Museum zugleich die einmalige Chance, als erstes Kunstmuseum in Norddeutschland zukünftig auch weitere herausragende fotografische Nachlässe und Sammlungen professionell lagern, wissenschaftlich bearbeiten und der Öffentlichkeit in umfangreichen Ausstellungen präsentieren zu können.

Bevor dieses hochgesteckte Ziel in den nächsten Monaten in die Tat umgesetzt wird, möchten wir unserem langjährigen Engagement für die Förderung der künstlerischen Fotografie in Niedersachsen schon heute durch die Ausstellung PHOTOGRAPHY CALLING! Ausdruck verleihen. Eine Ausstellung, die fotografische Serien von 31 national und inter-national bekannten Fotografen präsentiert, die seit den 1960er-Jahren bis heute in der Tradition einer direkten, wirklichkeitsbeschreibenden Fotografie arbeiten, und die einen Diskurs über die Wandlung und Bedeutung des Dokumentarischen in der Fotografie anregen will. Das groß angelegte Ausstellungsprojekt wird von Inka Schube und Thomas Weski kuratiert und auf über 2.000 Quadratmetern im Sprengel Museum Hannover präsentiert. Die Niedersächsische Sparkassenstiftung und die Sparkasse Hannover fördern das ambitionierte Vorhaben – wie viele innovative kulturelle Projekte in der Region – nicht nur finanziell in bedeutendem Umfang, sondern kooperieren in diesem Fall auch eng mit dem Museum und unterstützen das Vorhaben durch die Bereitstellung von mehr als 200 Leihgaben aus der stiftungseigenen Sammlung.

Die Sammlung Niedersächsische Sparkassenstiftung zur Kunst nach 1945 wird seit mehr als zwei Jahrzehnten aufgebaut und umfasst neben Gemälden, Arbeiten auf Papier, Skulpturen, Installationen, Filmen und Videoarbeiten seit dem Jahr 1998 auch künstlerische Fotografien. Dieser Sammlungsschwerpunkt geht auf die Ausstellung *How you look at it. Fotografien des 20. Jahrhunderts* zurück, die das Sprengel Museum Hannover anlässlich der EXPO 2000 in Kooperation mit der Niedersächsischen Sparkassenstiftung realisiert hat. Seitdem ist die Sammlung konsequent erweitert worden und umfasst heute weit über tausend Fotografien von 24 einflussreichen Vertretern einer künstlerischen Fotografie im dokumentarischen Stil, von denen ausgewählte Positionen in der Ausstellung PHOTOGRAPHY CALLING! präsentiert werden. Bei dem Aufbau der fotografischen Sammlung hat sich die Stiftung von Prof. Thomas Weski beraten lassen, einem herausragenden Experten für zeitgenössische künstlerische Fotografie, sowie von Dr. Heinz Liesbrock und weiteren Mitgliedern des Kunstbeirats der Niedersächsischen Sparkassenstiftung, dem derzeit Prof. Dr. Stephan Berg, Prof. Dr. Ulrich Bischoff, Dr. Ulrike Groos, Prof. Dr. Sabine Schulze und Dr. Dieter Schwarz angehören.

Schon die ersten Ankäufe, die die Stiftung im Vorfeld der Ausstellung *How you look at it* getätigt hat, belegen, dass das Sammeln für die Stiftung nicht Selbstzweck ist, sondern dass wir es von Anfang an als wichtigste Aufgabe angesehen haben, unsere Kunstsammlung Museen und Ausstellungshäusern als Leihgabe zur Verfügung zu stellen und die Werke somit einer breiten Öffentlichkeit zugänglich zu machen. Zu den Institutionen, in denen seit 1998 große Teile der fotografischen Sammlung der Niedersächsischen Sparkassenstiftung präsentiert wurden, zählen neben Einrichtungen aus Niedersachsen, wie die Städtische Galerie Delmenhorst oder die Große Kunstschau Worpswede, auch zahlreiche überregionale Häuser. So zum Beispiel das Kunstmuseum Kloster Unser Lieben Frauen Magdeburg, das Kunstmuseum Dieselkraftwerk Cottbus oder das Haus der Kunst München, die Tate Modern in London, das Whitney Museum of Modern Art in New York oder das Hamburger Museum für Kunst und Gewerbe, das im Frühjahr 2011 über 200 Arbeiten aus der fotografischen Sammlung der Stiftung in der Ausstellung *Portraits in Serie* präsentiert hat.

Nach der erfolgreichen Kooperation bei der Ausstellung *How you look at it* im Jahr 2000 lag es für uns nahe, erneut eine Partnerschaft mit dem Sprengel Museum Hannover einzugehen, dem einzigen Museum der Kunst des 20. und 21. Jahrhunderts in Niedersachsen, das seit seiner Gründung im Jahr 1979 kontinuierlich Ausstellungen zur künstlerischen Fotografie präsentiert und parallel eine fotografische Sammlung aufbaut. Ein Haus, das Pionierarbeit leistete und die Fotografie schon früh als gleichberechtigtes künstlerisches Medium im Dialog mit anderen Werken der Bildenden Kunst präsentierte, lange bevor andere Museen und Ausstellungshäuser die Fotografie für sich entdeckten.

Unser Dank gilt zunächst Inka Schube und Thomas Weski für ihre kompetente Konzeption der Ausstellung und ihr großes Engagement. Danken möchten wir außerdem dem Direktor des Sprengel Museum Hannover, Prof. Dr. Ulrich Krempel, allen Mitarbeiterinnen und Mitarbeitern des Museums, die an der Realisierung der Ausstellung und Publikation beteiligt waren, den Mitgliedern des Kunstbeirats der Stiftung sowie allen Fotografinnen und Fotografen, die ihre Arbeiten als Leihgaben für die Ausstellung zur Verfügung gestellt haben,

von denen viele in Hannover erstmals zu sehen sind. In diesem Zusammenhang möchten wir vor allem auch den Fotografen aus der Sammlung der Stiftung danken, die die Realisierung der Ausstellung unterstützt haben: Robert Adams, Lewis Baltz, Hilla Becher, William Eggleston, Lee Friedlander, Stephen Gill, John Gossage, Paul Graham, Nicholas Nixon und Stephen Shore sowie John Pelosi, der den Nachlass von Diane Arbus betreut.

Wir erwarten, dass wir mit der Unterstützung der Ausstellung dazu beitragen, die langjährige engagierte Arbeit der Abteilung für Fotografie und Medien am Sprengel Museum Hannover zu stärken, und dass dieses Projekt den Auftakt für weitere Kooperationsvorhaben darstellt.

Wir wünschen der Ausstellung den verdienten Erfolg und dem Museum, dass viele Menschen dem Aufruf PHOTOGRAPHY CALLING! folgen.

Thomas Mang
Präsident der Niedersächsischen Sparkassenstiftung

Dr. Sabine Schormann
Direktorin der Niedersächsischen Sparkassenstiftung

Walter Kleine
Vorstandsvorsitzender der Sparkasse Hannover

As a deliberate appeal and the title of the exhibition initiated by the Niedersächsische Sparkassenstiftung and Sparkasse Hannover, PHOTOGRAPHY CALLING! lends expression to our firm commitment to art photography in Lower Saxony and to our aim to amplify the perception of Hanover as a vibrant center of photography in northern Germany.

In this connection, we explicitly welcome the extension of the Sprengel Museum Hannover planned by the City of Hanover and the Land of Lower Saxony and the creation of the urgently needed, extra exhibition space and extensive storage facilities for the photographic collections. With the planned erection of a refrigerated store for sensitive color photographs that meets the highest standards of preservation, ideal conditions will be created for the effective safekeeping of the museum's collection of art photography built up over the last three decades. In addition, the creation of additional exhibition and storage space and the planned creation of an extra post also gives the museum the unique opportunity to become the first museum of art in northern Germany capable of professionally storing further outstanding photographic estates and collections and having them processed by experts and publicly presented in large-scale exhibitions.

Before this ambitious goal comes to fruition over the coming months, we wish to underline our many years of commitment to the funding of art photography in Lower Saxony by holding the exhibition PHOTOGRAPHY CALLING! This is an exhibition that presents series of photographs of 31 nationally and internationally well-known photographers who have been working from the 1960s to the present in the tradition of a direct, reality-depictive photography. Stimulating discussion on changes in and the importance of the documentary in photography, this large-scale exhibition project occupying over 2,000 square meters of space at the Sprengel Museum Hannover is being curated by Inka Schube and Thomas Weski. The Niedersächsische Sparkassenstiftung and Sparkasse Hannover are sponsoring the ambitious venture—like many other innovative cultural projects in the region—not only financially on a major scale, but are also cooperating in this case closely with the museum and supporting the project by providing more than 200 loans from the foundation's own collection.

The Niedersächsische Sparkassenstiftung's collection of post-1945 art has been built up over a period of more than two decades. Along with paintings, works on paper, sculptures, installations, films and video work, it has also included art photography since 1998. This focus of the collection goes back to the exhibition *How you look at it. Photographs of the 20th Century* that the Sprengel Museum Hannover put on in cooperation with the Niedersächsische Sparkassenstiftung on the occasion of EXPO 2000. Since then the collection has been steadily expanded, and today encompasses well over 1,000 photographs from 24 influential exponents of art photography in the documentary style. Selected works are being shown in the exhibition PHOTOGRAPHY CALLING! In the process of building up the photographic collection, the foundation has been advised by Prof. Thomas Weski, an outstanding expert in contemporary art photography, and by Dr. Heinz Liesbrock and other members of the art advisory board of the Niedersächsische Sparkassenstiftung, to which Prof. Dr. Stephan Berg, Prof. Dr. Ulrich Bischoff, Dr. Ulrike Groos, Prof. Dr. Sabine Schulze and Dr. Dieter Schwarz currently belong.

The very first purchases made by the foundation in the run-up to the exhibition *How you look at it* demonstrate that the foundation is engaging in collecting not for its own sake. In fact, from the very outset we considered it our foremost task to make our art collection available on loan to museums and exhibition venues and thus make the works accessible to a broad public. The institutions at which large portions of the photographic collection of the Niedersächsische Sparkassenstiftung have been exhibited since 1998 include venues not only in Lower Saxony such as the Städtische Galerie Delmenhorst and the Grosse Kunstschau Worpswede, but also numerous establishments beyond the immediate region. These include the Kunstmuseum Kloster Unser Lieben Frauen Magdeburg, Kunstmuseum Dieselkraftwerk Cottbus, Haus der Kunst München, the Tate Modern in London, the Whitney Museum of Modern Art in New York and the Hamburg Museum für Kunst und Gewerbe that displayed over 200 works from the foundation's photographic collection in the *Portraits in Series* exhibition in spring 2011.

After successful cooperation on the exhibition *How you look at it* in 2000, it was a logical step for us to enter into renewed partnership with the Sprengel Museum Hannover. For the latter is the only museum of 20th and 21st century art in Lower Saxony that, since its inception in 1979, has continually staged exhibitions of art photography and built up a photographic collection at the same time. It is an institution that has blazed a trail for photography, treating it with equal status as an art medium in dialog with other works of fine art, long before other museums and exhibition venues had discovered photography for themselves.

We owe our thanks firstly to Inka Schube and Thomas Weski for their skilled planning of the exhibition and their huge enthusiasm. We also wish to thank the Director of the Sprengel Museum Hannover, Prof. Dr. Ulrich Krempel, all the employees of the museum involved in the realization of the exhibition and the publication, the members of the foundation's art advisory board, and all photographers who have made their works available on loan to the exhibition, many of which will be on show for the first time in Hanover. In this connection, we also wish to thank, above all, the photographers of the foundation's collection who have supported the holding of the exhibition: Robert Adams, Lewis Baltz, Hilla Becher, William Eggleston, Lee Friedlander, Stephen Gill, John Gossage, Paul Graham, Nicholas Nixon and Stephen Shore as well as John Pelosi, executor of Diane Arbus's estate.

It is our expectation that, by supporting the exhibition, we can help to strengthen the many years of devoted work of the

Department of Photography and Media at the Sprengel Museum Hannover and that this project will be the prelude to further cooperation projects.

We wish the exhibition the success it deserves and, for the museum, a big public turnout in response to PHOTOGRAPHY CALLING!

Thomas Mang
President of the Niedersächsische Sparkassenstiftung

Dr. Sabine Schormann
Director of the Niedersächsische Sparkassenstiftung

Walter Kleine
Executive Board Chairman of Sparkasse Hannover

„Was ist Photographie? Genaueste Wiedergabe der Wirklich-keit, nicht Nachahmung der Natur. [...] Die Photographie hat sich gelöst von ihrem bisherigen Stoffgebiet, das nur uns geläufige Vorwürfe des Malers umfaßte, und kann plötzlich alles. [...] Diese neue Art der Photographie läßt uns einen herrlichen Reinigungsprozeß erleben."

Walter Dexels Sätze aus seinem Text „Neue Wege der Photographie" von 1928 skizzieren nur eine Sicht auf die Schritte in ein „Neues Sehen", wie sie im Deutschland in der Weimarer Zeit unübersehbar getan wurden. Die Fotografie als mechanisches, scheinbar objektives Medium erlangte jetzt neben dem Medium Film ungeahnte Bedeutung in der öffent-lichen Wahrnehmung; im wissenschaftlichen wie journalistischen Gebrauch, in Werbung, Typografie und Buchgestaltung wurde sie das neue Mittel zum Einstieg in eine betont zeitgenössische Bildsprache. Aber auch im künstlerischen Diskurs begann sie nun, eine dezidierte Rolle einzunehmen; die Professionalisie-rung der Fotokunst tritt an die Stelle einer eher anonymen Kunstfotografie. Große, heute legendäre Ausstellungen wie die *Pressa* (1928 in Köln) oder, im gleichen Jahr in Jena, *Neue Wege der Photographie*, in der Dexel unter anderem Werke von Hugo Erfurth, Albert Renger-Patzsch, László Moholy-Nagy, Lucia Moholy und Umbo präsentierte, belegen dies. Im Frühjahr 1929 folgte in Essen die Ausstellung *Fotografie der Gegenwart*, die später auch in Hannover gezeigt wurde. Die Internationale Ausstellung des Deutschen Werkbunds in Stuttgart, 1929, mit einer von Moholy-Nagy gestalteten Einführung, fokussierte ganz auf Fotografie und Film. Und auch wichtige Publikationen dieser Jahre sprechen von einer intensiven künstlerischen Zuwendung zum Medium, darunter László Moholy-Nagys *Malerei, Fotografie, Film* (1927), Jan Tschicholds *Die Neue Typographie* (1928) oder Franz Rohs und Tschicholds gemein-sames Werk *foto-auge* (1929).

Auf einen solchen Diskurs und die nachfolgende breite Entwicklung in der internationalen Fotografie haben die Museen erst mit Verspätung reagiert. Es brauchte lange, bis deren ästhetischer Diskurs auf die Erkenntnisse der Künstler zurück-griff. Dabei gab ein Satz von Renger-Patzsch schon 1927 die mögliche Denkrichtung vor: „Das Geheimnis einer Photo-graphie, die künstlerischen Qualitäten, die ein Werk der bildenden Kunst besitzen kann, beruht auf ihrem Realismus. [...] Überlassen wir daher die Kunst den Künstlern und versuchen wir mit den Mitteln der Photographie Photographien zu schaffen, die durch ihre *photographischen* Qualitäten bestehen können – ohne daß wir von der Kunst borgen."

Dass das Sprengel Museum Hannover heute längst zu den Museen gehört, die die Fotografie in ihre Sammlungen und Ausstellungen aufgenommen haben, ist auch aus künstleri-schen und organisatorischen Traditionslinien am Ort geboren. Da ist das Werk von Otto Umbehr (1902–1980), besser bekannt als Umbo, der nach dem Zweiten Weltkrieg in Hannover lebte und fachfremd arbeitete und heute als eine der großen Positionen deutscher Fotografie der 1920er- und 1930er-Jahre gilt. Da ist

das Werk von Walter Ballhause (1911–1991), dessen sozial-dokumentarische Fotografie der Weimarer Jahre das demokra-tische Hannover einer verflossenen Epoche beleuchtet. Da ist schließlich das Werk von Heinrich Riebesehl, der in seinen lako-nischen, magisch aufgeladenen Bildern die Landschaft Nieder-sachsens gegen Ende des 20. Jahrhunderts vermessen hat.

Heute sind – dank der Unterstützung des Landes Niedersachsen und der Stadt Hannover, dank Schenkungen privater Sammler – Werkgruppen und Nachlässe aller genann-ten Fotografen in unserer Sammlung vertreten. Die Geschichte der Fotografie in Hannover führte zielgerichtet auf solche Präsenz hin. Gründeten doch schon 1972 die hiesigen Foto-grafen Peter Gauditz, Joachim Giesel und Heinrich Riebesehl die Spectrum Photogalerie, eine der ersten Fotogalerien Europas, und begannen eine lange und erfolgreiche Ausstel-lungstätigkeit. Seit 1979 war die Galerie in das Sprengel Museum Hannover integriert, 1993 wurde hier schließlich eine eigene Abteilung für Fotografie und Medien eingerichtet. Ihr erster Leiter war Thomas Weski. Seit dem Jahre 2001 hat Inka Schube die Abteilung erfolgreich weiterentwickelt.

Viele Kooperationen haben dabei über die Jahre unsere Abteilung an Umfang und Bedeutung wachsen lassen. Sei es die Kooperation mit dem Sammlerpaar Ann und Jürgen Wilde von 1992 bis 2011, die in Hannover zu einer ganzen Reihe von Premierenausstellungen aus der Sammlung führten, seien es die jahrelange Kooperation mit der fotografischen Sammlung des ehemaligen Siemens artsprogram oder mit der Stiftung Niedersachsen, die seit 1995 regelmäßig den „SPECTRUM" Internationaler Preis für Fotografie vergibt.

Besondere Bedeutung kommt über die Jahre der Zusammenarbeit mit der Niedersächsischen Sparkassen-stiftung und der Sparkasse Hannover zu. So vergibt die Stiftung in Kooperation mit dem Museum den Kurt-Schwitters-Preis, den Sprengel-Preis und hat viele engagierte Ausstellungs-projekte unterstützt. Im Bereich der künstlerischen Fotografie besteht schon seit dem Jahr 2000 eine enge Kooperation. Damals wurde mit der Ausstellung *How you look at it. Foto-grafien des 20. Jahrhunderts* zur EXPO in Hannover ein Maß-stab für die Auseinandersetzung mit der künstlerischen Foto-grafie in Vergangenheit und Gegenwart gesetzt. Die großartige Sammlung, die nunmehr seit ca. 15 Jahren von der Niedersäch-sischen Sparkassenstiftung zusammengetragen wurde, ist mit über eintausend Werken längst eine der herausragenden Sammlungen der Fotografie im dokumentarischen Stil, die veritable Maßstäbe setzt. Die enge Kooperation mit den hier vertretenen Fotografinnen und Fotografen lässt die Sammlung der Stiftung höchst lebendig weiterwachsen.

Lange war es unser Traum, im Sprengel Museum Hannover die Depotsituation für die Fotografie auf höchstem professionellen Standard zu lösen. Mit dem Erweiterungsbau, der 2014 abgeschlossen sein soll, ist es nun so weit, dass auch die delikaten Werke der Farbfotografie eine neuesten Erkennt-nissen folgende Aufbewahrung und Pflege in zukunftsweisenden Depots finden werden. Auch personell soll die Abteilung Fotografie und Medien wachsen. Mehr als bereits heute werden

dann die Künste auch in den neuen Sammlungsräumen des Museums interagieren und ihre vielfältigen Beziehungen zeigen können, dabei die Fotografie immer einschließend, als wichtiges bildschaffendes Medium des 20. und 21. Jahrhunderts. Mit solcher Grundlage hoffen wir, wichtige Sammlungen dauerhaft als Partner für unser Haus gewinnen zu können. Dabei steht die fulminante Sammlung der Niedersächsischen Sparkassenstiftung zuvörderst auf unserer Wunschliste.

Mit PHOTOGRAPHY CALLING! setzen wir die Kooperation mit der Niedersächsischen Sparkassenstiftung und der Sparkasse Hannover fort. Inka Schube und Thomas Weski haben in ihrer gemeinsamen Ausstellung zwei unterschiedliche Kuratorenstimmen zu einer einheitlichen Auswahl zusammengeführt; für den Mut zu einer solchen Zusammenarbeit kann ich beiden nicht genug danken. Die Initiative und Unterstützung unserer Partner, vertreten durch Thomas Mang, Präsident der Niedersächsischen Sparkassenstiftung, und Walter Kleine, Vorstandsvorsitzender der Sparkasse Hannover, sowie Dr. Sabine Schormann, Direktorin der Niedersächsischen Sparkassenstiftung, haben dabei das Projekt überhaupt erst ermöglicht und zur heutigen Form gebracht. Ich darf mich im Namen des Museums in aller Form für eine solche kulturschaffende wie kulturpolitische Initiative bedanken, die uns die Projektierung einer so großen und komplexen Ausstellung überhaupt erst möglich macht. Ulrike Schneider soll hier zudem stellvertretend für die MitarbeiterInnen der Sparkassenstiftung gedankt werden.

Zuletzt, und eigentlich doch ganz zuallererst, geht mein Gruß an die Künstlerinnen und Künstler. Ohne ihre vielfältigen Stimmen wäre PHOTOGRAPHY CALLING! kein so überzeugendes, die Sinne ergreifendes Unternehmen. Ihnen allen sei für ihre Arbeit und für diese Ausstellung herzlich gedankt.

Prof. Dr. Ulrich Krempel
Direktor des Sprengel Museum Hannover

"What is photography? The highly precise rendition of reality and not the imitation of nature. [...] Photography has released itself from its previous subject-matter that solely comprised the familiar concepts of the painter and is now capable of anything [...] This new type of photography allows us to experience a wonderful process of purification."

Walter Dexel's lines from his text "Neue Wege der Photographie" (New ways in photography) of 1928 outlines just one view of the steps towards a "new seeing" as unmistakably taken during the Weimar period. Photography as a mechanical, seemingly objective medium now rose to unexpected importance in the public eye alongside the medium of film. In academia and journalism, in advertising, typography and book design, it became the new means of access to an emphatically contemporary visual language. However, in artistic discourse, it also started to play a very definite role; the professionalization of photographic art took the place of somewhat anonymous art photography. This is demonstrated by large, now legendary exhibitions like *Pressa* (in Cologne in 1928) and, in Jena in the same year, *Neue Wege der Photographie*, in which Dexel presented, among other things, works by Hugo Erfurth, Albert Renger-Patzsch, László Moholy-Nagy, Lucia Moholy and Umbo. In the spring of 1929, these were followed by the exhibition *Fotografie der Gegenwart* (Photography of the present) in Essen, which was later also shown in Hanover. The International Exhibition of the Deutscher Werkbund in Stuttgart in 1929, with an introduction by Moholy-Nagy, was devoted entirely to photography and film. And important publications of these years point to an intensive artistic preoccupation with the medium: László Moholy-Nagy's *Malerei, Fotografie, Film* (Painting, photography, film; 1927), Jan Tschichold's *Die Neue Typographie* (The new typography; 1928) and Franz Roh's and Tschichold's work *foto-auge* (Photo-eye; 1929).

The museums were slow to respond to such a discourse and subsequent broad developments in international photography. It took a long time for their discourse on aesthetics to draw on artists' findings. A possible line of thinking is expressed in a quote from Renger-Patzsch in as early as 1927: "The secret of a photography that can have artistic qualities like a work of the fine arts lies in its realism [...] Let us therefore leave art to the artists and attempt with the means of photography to create photographs that can exist by virtue of their *photographic* qualities—without borrowing them from art."

The fact that the Sprengel Museum Hannover has long joined the ranks of museums that have included photography in their collections and exhibitions is also due to local artistic and organizational lines of tradition. There's the work of Otto Umbehr (1902–1980), better known as Umbo, who after the Second World War lived and worked in other fields in Hanover and is today regarded as one of the great exponents of German photography of the 1920s and 1930s. There's the work of Walter Ballhause (1911–1991), whose social-documentary photography of the Weimar period illuminates the democratic

Hanover of a bygone age. And, finally, there's the work of Heinrich Riebesehl, who in his laconic, magically charged pictures surveyed the landscape of Lower Saxony toward the end of the 20th century.

Today, thanks to the support of the Land of Lower Saxony and the City of Hanover and thanks to donations from private collectors, groups of works and estates of all the mentioned photographers are represented in our collection. The history of photography in Hanover led directly to such an outcome, with local photographers Peter Gauditz, Joachim Giesel and Heinrich Riebesehl founding the Spectrum Photogalerie, one of the first galleries of photography in Europe, in 1972 and initiating a long and successful series of exhibitions. The gallery has been integrated in the Sprengel Museum Hannover since 1979, and the museum's own department for Photography and Media was founded here finally in 1993. Its first head was Thomas Weski. The department has been successfully continued under Inka Schube's management since 2001.

Our department has grown in scope and importance due to the many cooperative ventures over the years. Be it the cooperation with collectors Ann and Jürgen Wilde from 1992 to 2011, which led to a whole series of exhibition premieres from the collection, many years of cooperation with the photographic collection of the Siemens Stiftung, or the decades of successful cooperation with the Stiftung Niedersachsen, which has been regularly conferring the „SPECTRUM" International Award for Photography since 1995.

Of special importance has been the cooperation over the years with the Niedersächsische Sparkassenstiftung and Sparkasse Hannover. In cooperation with the museum, the foundation awards the Kurt-Schwitters-Prize and the Sprengel-Prize and has supported many enthusiastic exhibition projects. In the field of art photography, there has been close cooperation since 2000. This was when, in the exhibition *How you look at it. Photographs of the 20th Century* coinciding with the EXPO in Hanover, a benchmark was set for the treatment of art photography past and present. Encompassing over a thousand works, this splendid collection, brought together over a period of 20 years by the Niedersächsische Sparkassenstiftung, has long become one of the outstanding collections of documentary photography that truly sets standards. The foundation's collection continues to grow in a very lively fashion thanks to close cooperation with the photographers represented.

It has long been our dream to create genuinely professional storage facilities for photography at the Sprengel Museum Hannover. Thanks to the extension due for completion by 2014, we will be able to provide state-of-the-art storage and care in modern store rooms even for the delicate works of color photography. We also intend to recruit new staff for the Photography and Media department. In the museum's new collection rooms, the arts will then have greater scope for interaction than they already have today and reveal their manifold relations, and always including photography as an important visual medium of the 20th and 21st centuries. On this basis, we hope to be able to attract important collections to our institution. Top of our wish

list is the magnificent collection of the Niedersächsische Sparkassenstiftung.

PHOTOGRAPHY CALLING! is a continuation of cooperation with the Niedersächsische Sparkassenstiftung and Sparkasse Hannover. In their joint exhibition, Inka Schube and Thomas Weski have combined their different styles of curatorship in bringing together a uniform selection. I cannot thank the two of them enough for their courage to work together in this way. The very fact that the project has been possible and taken its present form we owe to the initiative and support of our partners, represented by Thomas Mang, President of the Niedersächsische Sparkassenstiftung, Walter Kleine, Chairman of the Board of Management of Sparkasse Hannover, and Dr. Sabine Schormann, Director of the Niedersächsische Sparkassenstiftung. On behalf of the museum, I wish to express my gratitude in all due form for a project that supports the arts in exemplary fashion and has made the planning of such a large and complex exhibition possible. I should also like to thank the employees of the Sparkassenstiftung in the person of Ulrike Schneider.

Finally, though in fact first and foremost, I should like to extend my greetings to the artists. Without their varied voices, PHOTOGRAPHY CALLING! wouldn't be such a convincing and moving undertaking. Thank you all very much for your work and for this exhibition.

Prof. Dr. Ulrich Krempel
Director of the Sprengel Museum Hannover

A Box of Ten Photographs, 1971, Portfolio

DIANE ARBUS

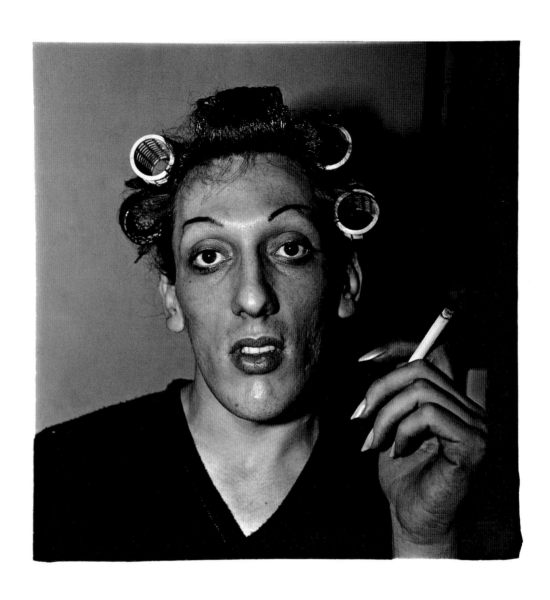

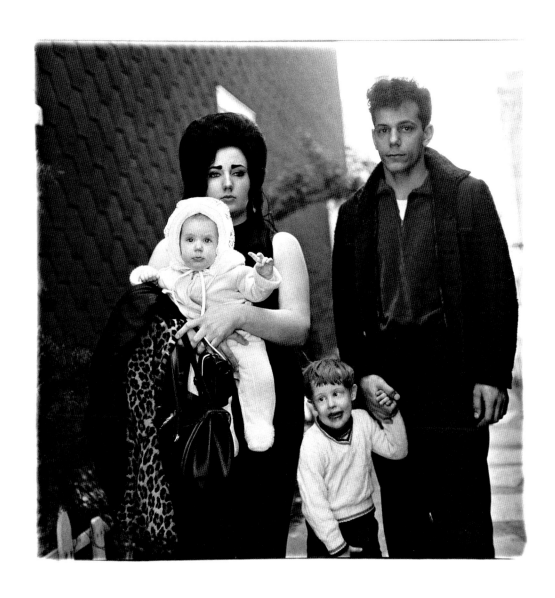

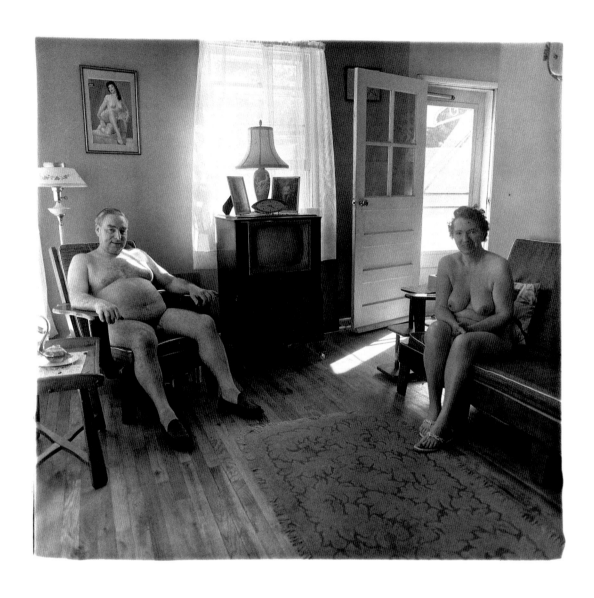

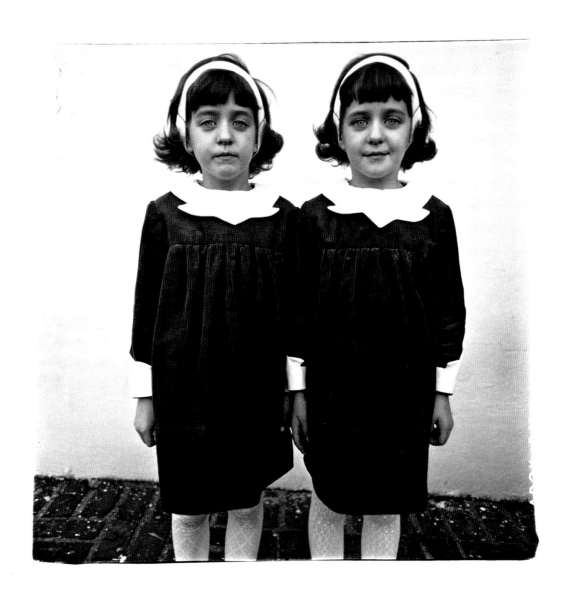

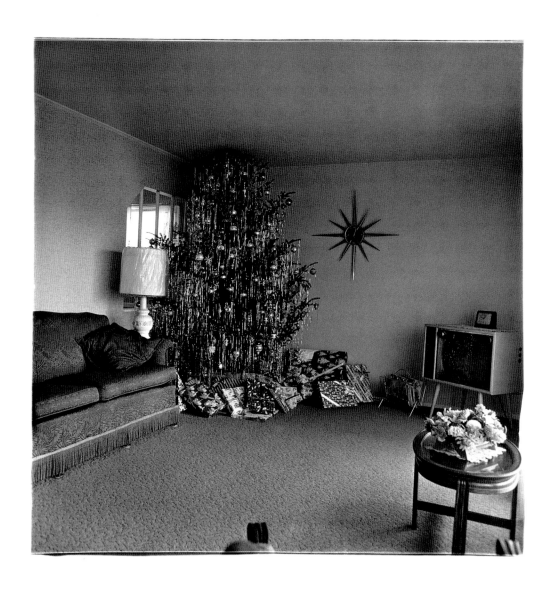

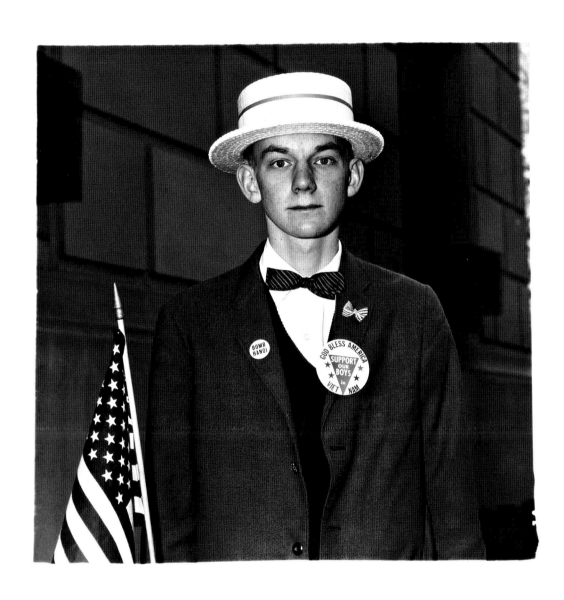

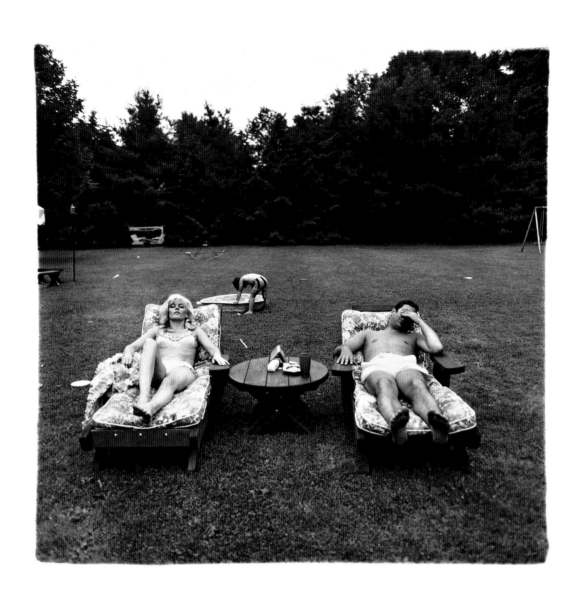

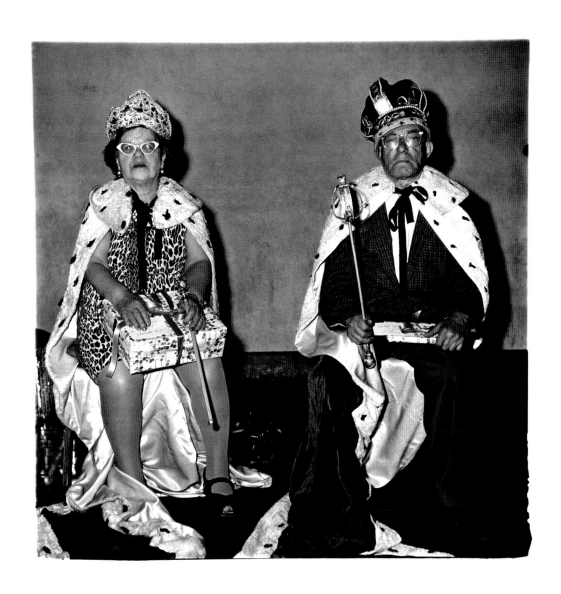

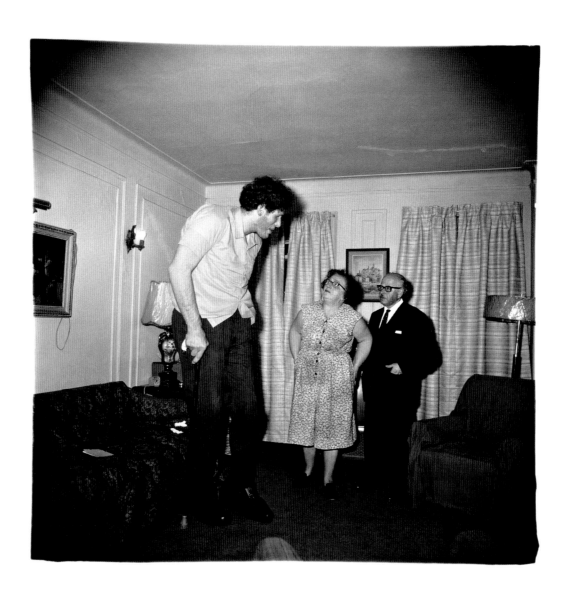

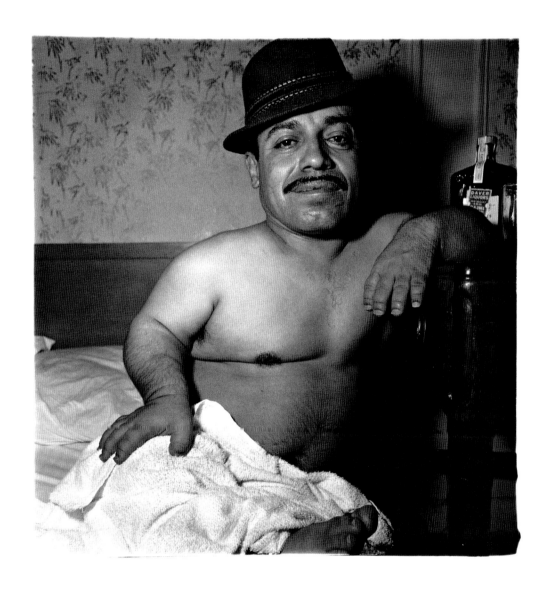

Aus dem Portfolio/from the portfolio *Coming up for Air,* 2008/09

32–41 Alle Arbeiten ohne Titel/all works untitled

STEPHEN GILL

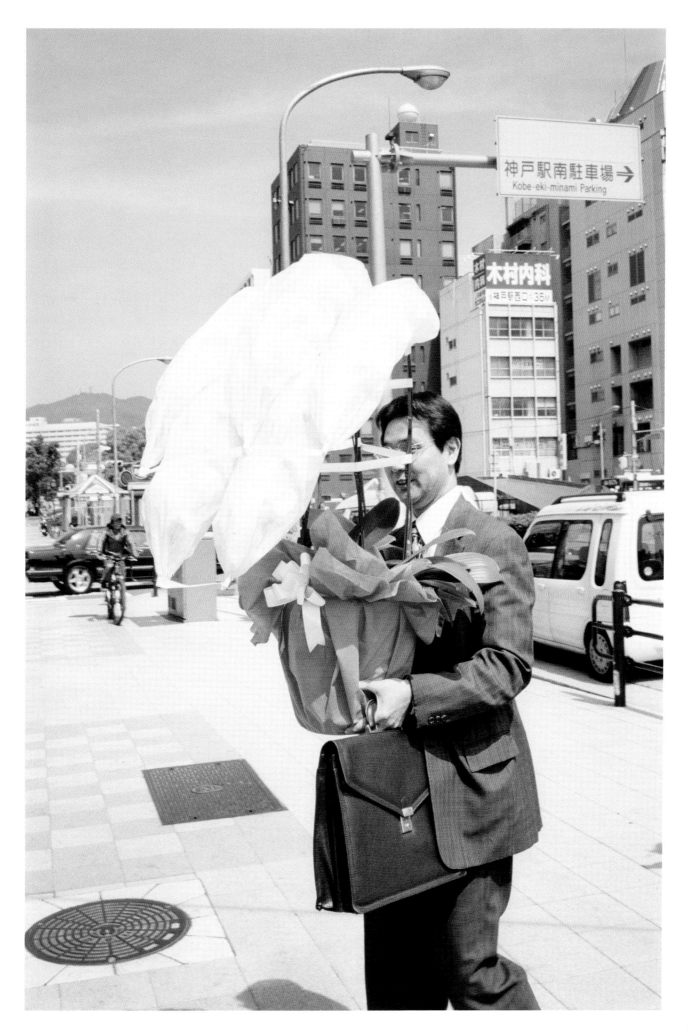

Fabrikhallen/Factory Buildings, 1963–1994 (1996) , 21-teilige Typologie/typology, set of 21

44–47 obere Reihe/top row *Grube Anna, Alsdorf/Aachen, D*, 1992
Zeche Friedrich der Große, Herne, Ruhrgebiet, D, 1978
Zeche Werne, Werne, Ruhrgebiet, D, 1976
Zeche Pluto, Wanne-Eickel, Ruhrgebiet, D, 1981
Dortmund-Hörde, D, 1989
Rombas, Lorraine, F, 1992
Mines de Roton, Charleroi, B, 1976

 mittlere Reihe/middle row *Grube Anna, Alsdorf/Aachen, D*, 1992
Schafstädt/Merseburg, Sachsen-Anhalt, D, 1994
Zeche Lothringen, Bochum, Ruhrgebiet, D, 1980
Zeche Concordia, Oberhausen, Ruhrgebiet, D, 1967
Zeche Zollern II, Dortmund, D, 1971
Siège Simon, Forbach, Lorraine, F, 1989
Werdohl, Sauerland, D, 1985

 untere Reihe/bottom row *Zeche Werne, Werne, Ruhrgebiet, D*, 1976
Calais, F, 1985
Harlingen, NL, 1963
Charleroi-Montigny, B, 1984
Rodange, Luxembourg, 1979
Calais, F, 1995
Werdohl, Sauerland, D, 1985

BERND UND HILLA BECHER

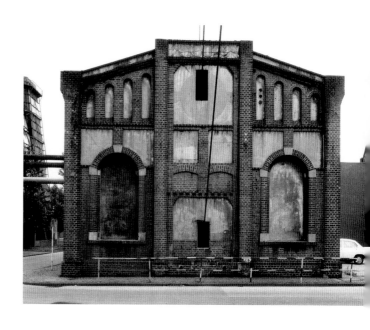
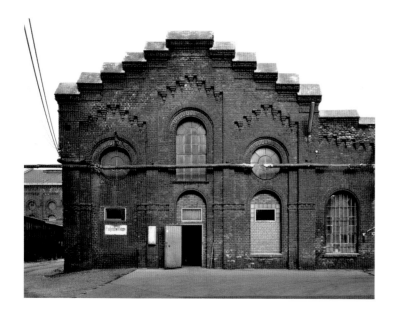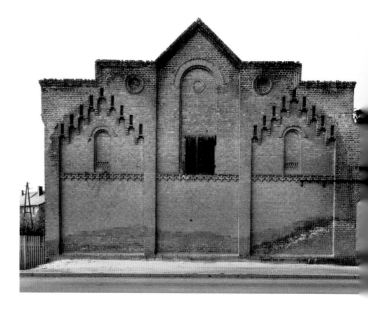
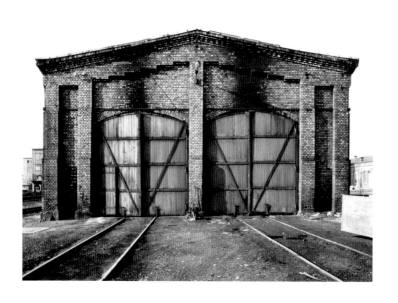

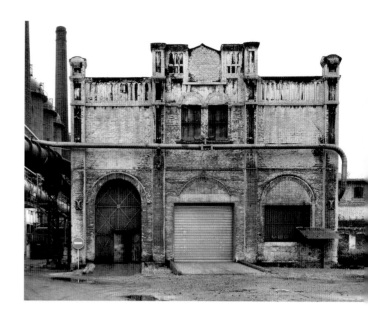

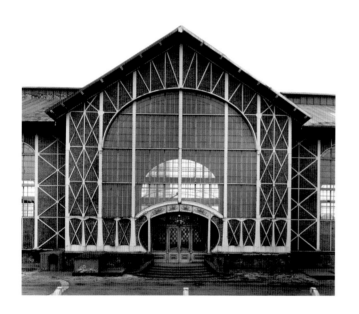

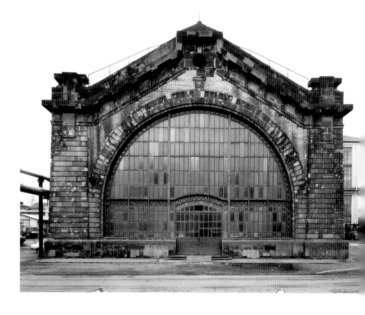

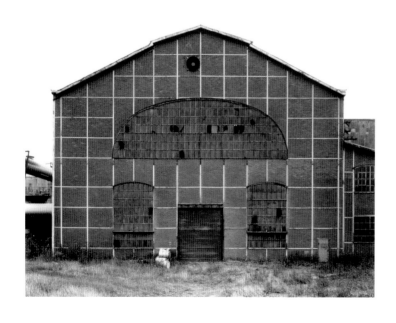

THOMAS RUFF

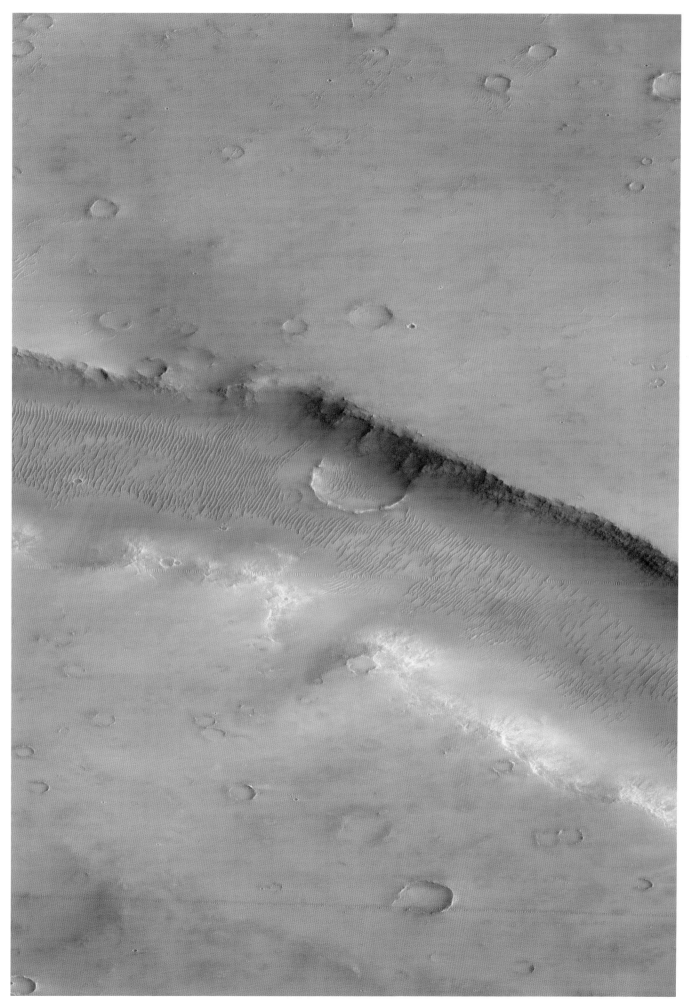

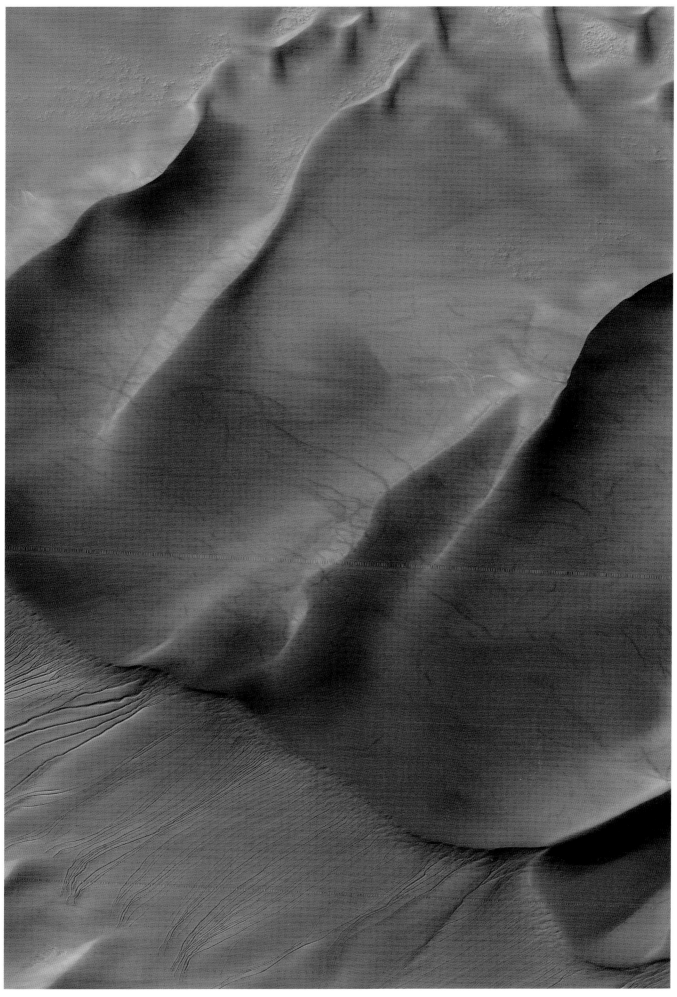

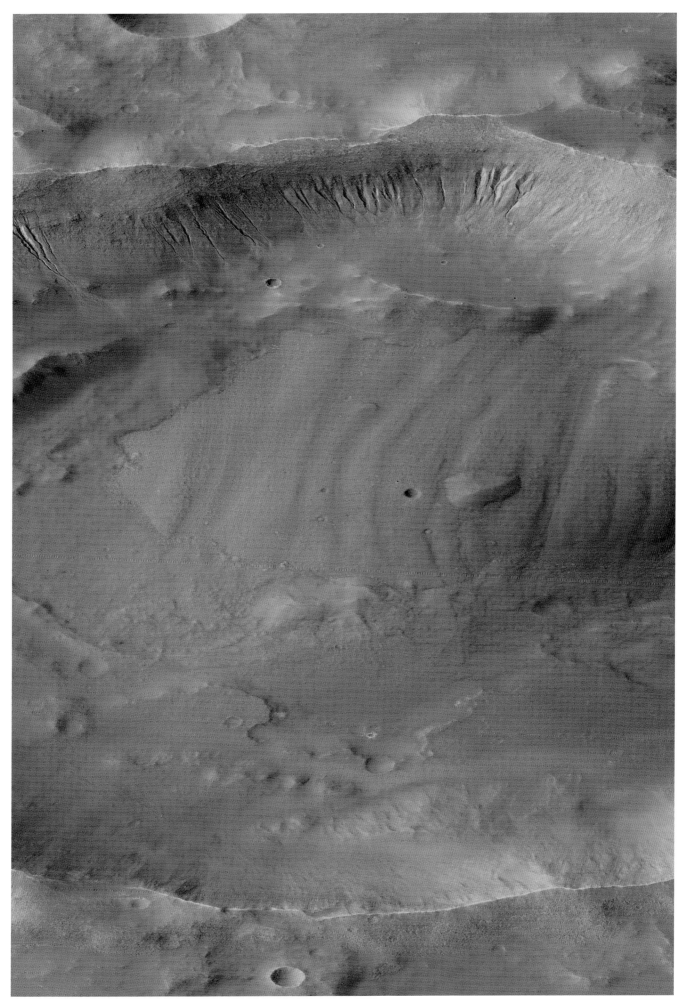

Aus/from *The New West*, 1968–1971

ROBERT ADAMS

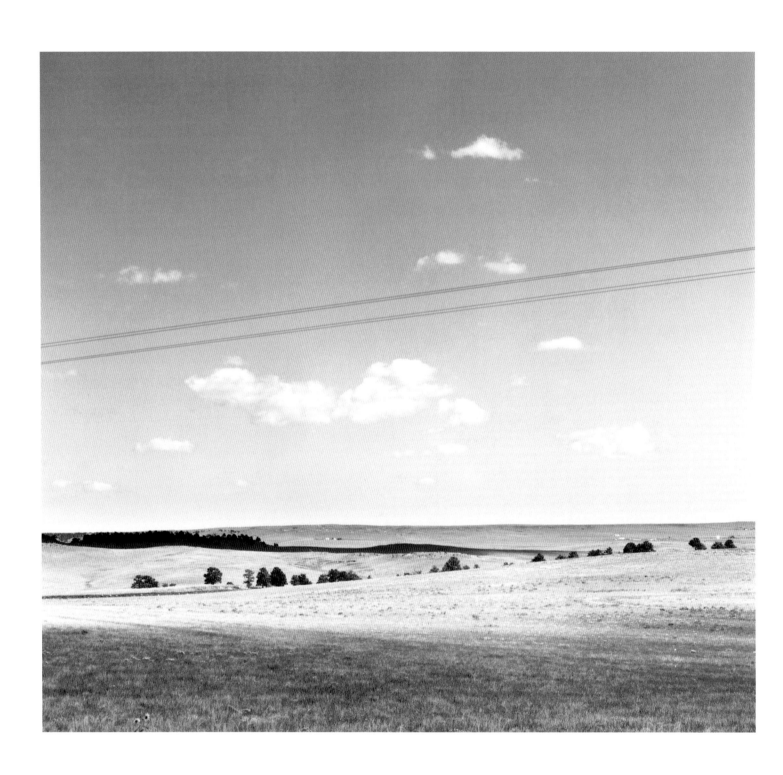

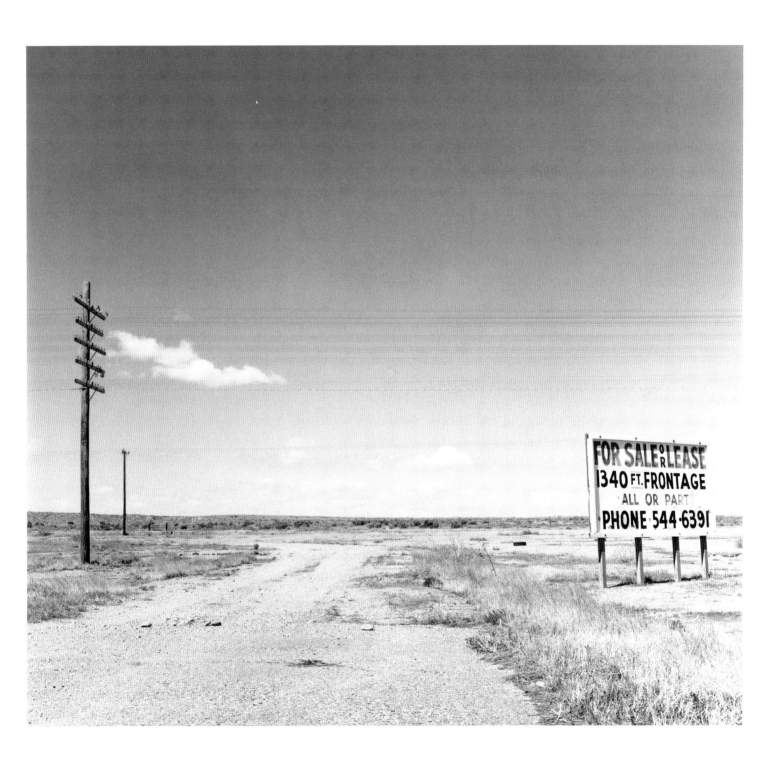

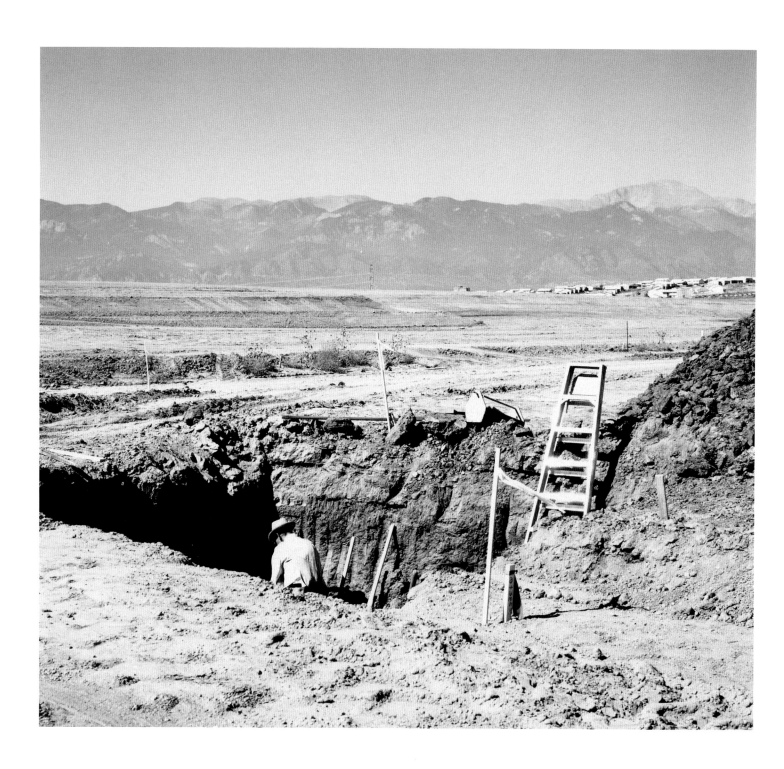

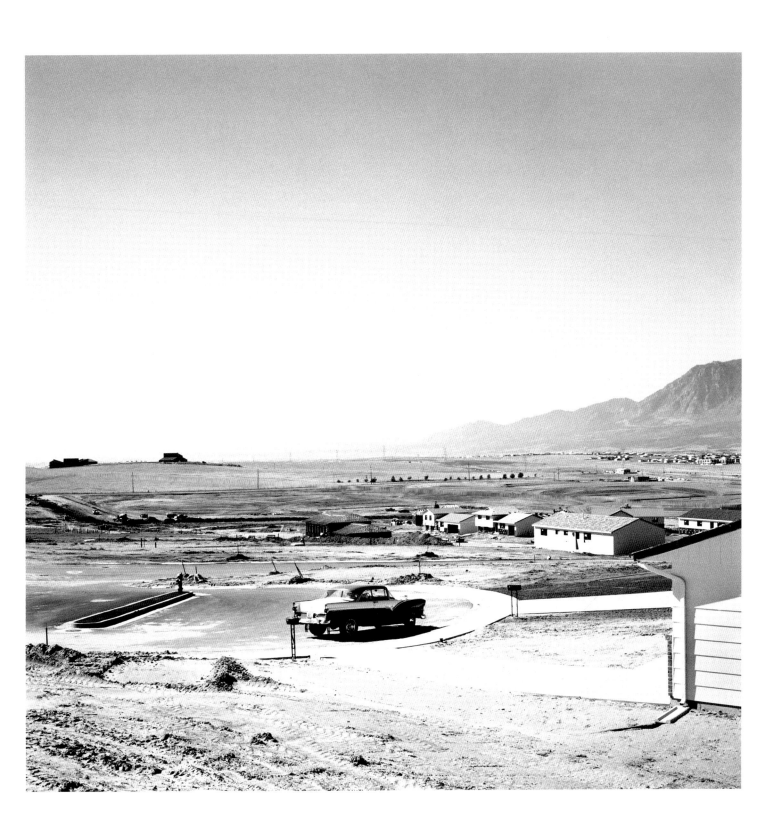

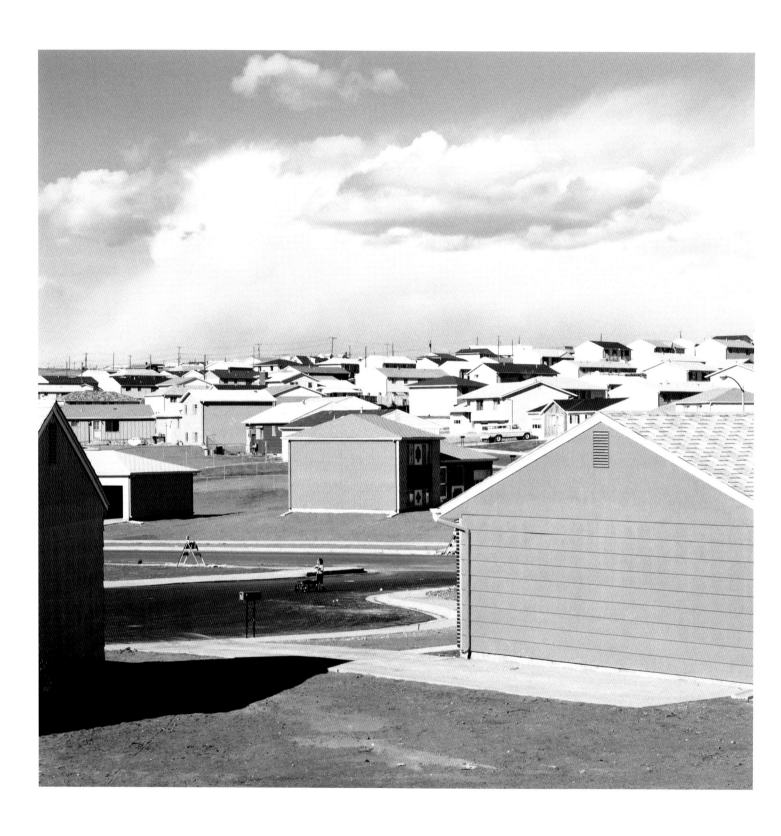

Aus/from *Termini*, 2010/11

HEIDI SPECKER

Aus dem Portfolio/from the portfolio *14 Pictures*, 1974

WILLIAM EGGLESTON

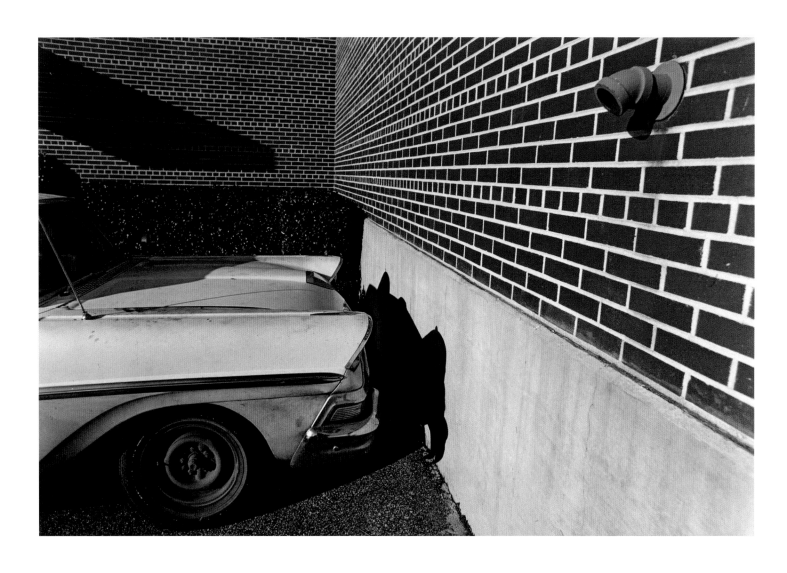

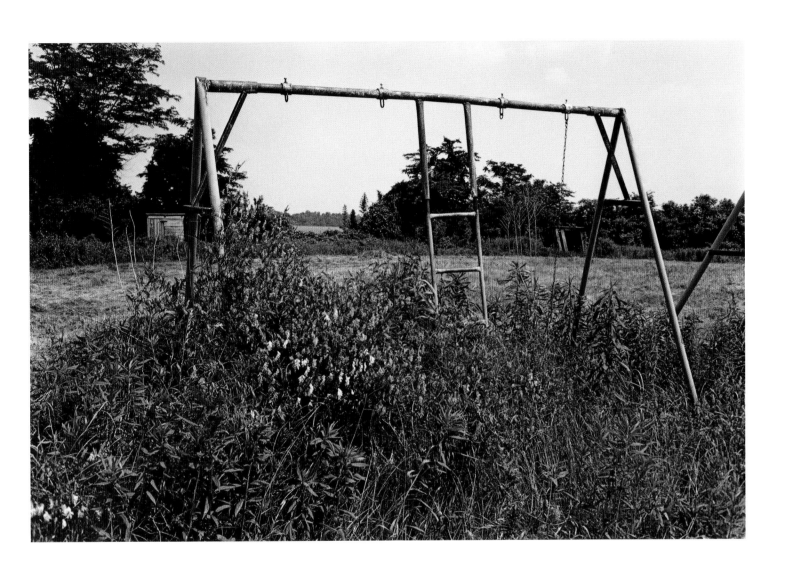

Aus/from *Photographs from One Year*, 1981/82

NICHOLAS NIXON

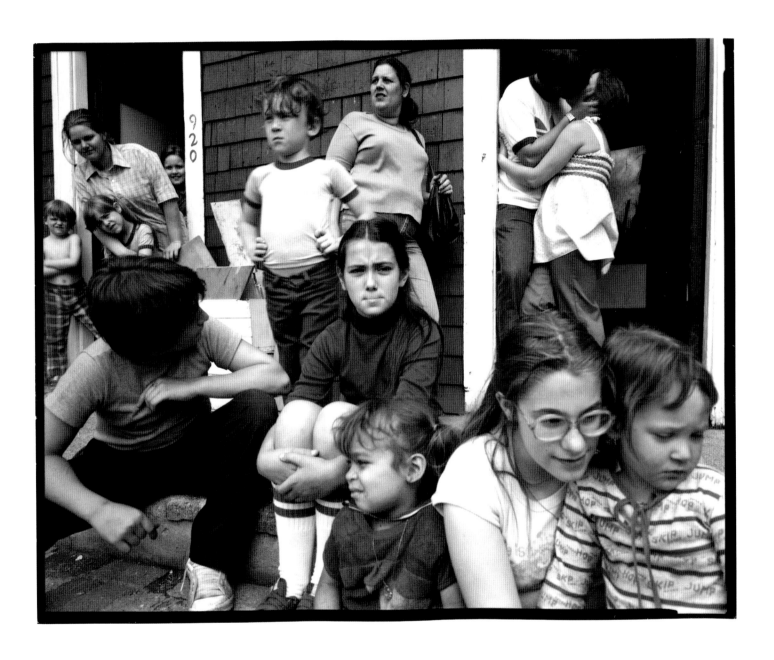

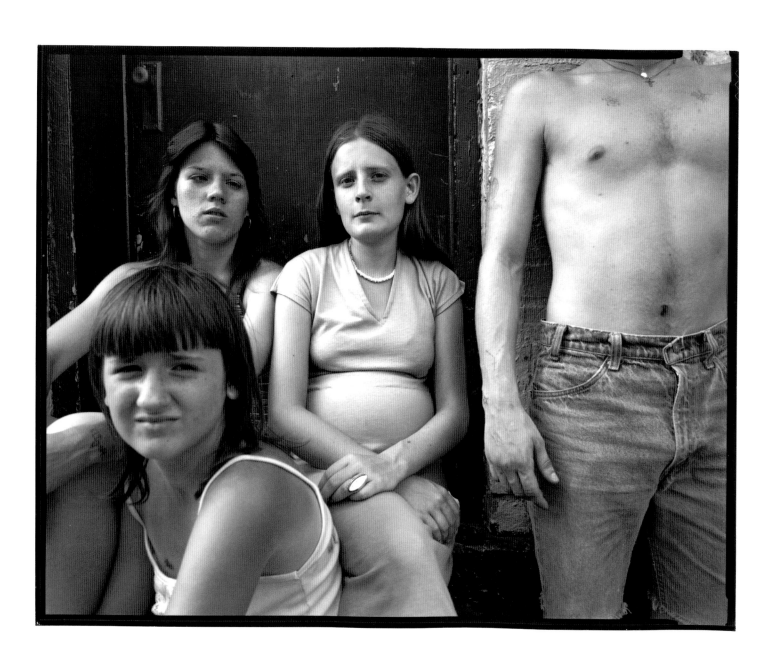

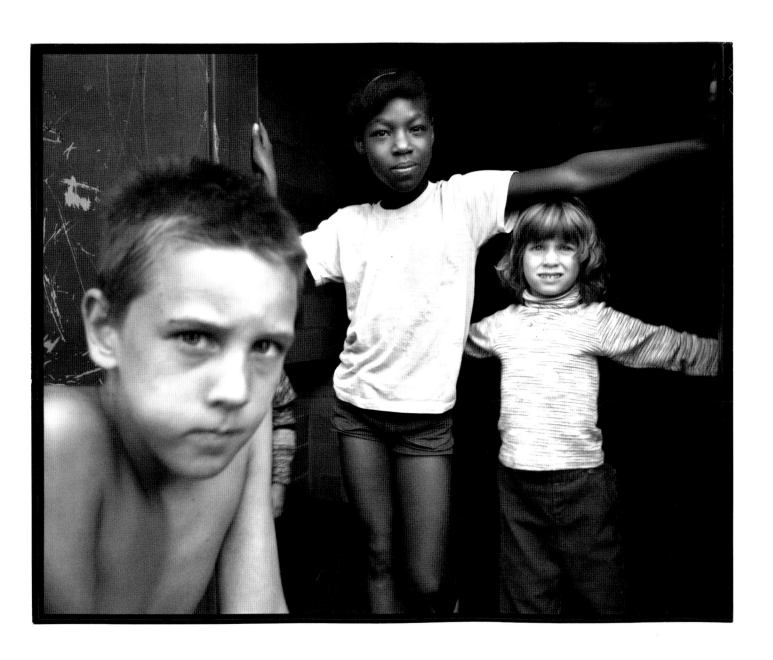

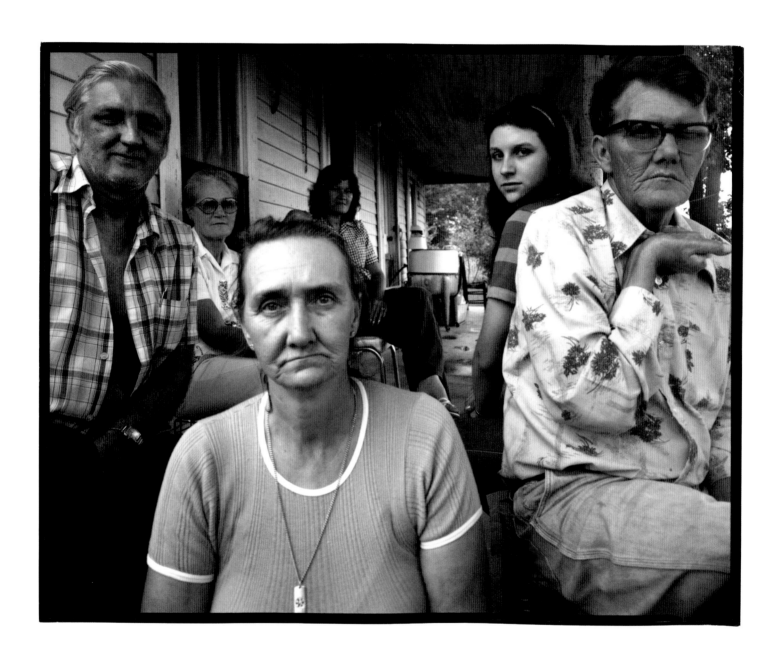

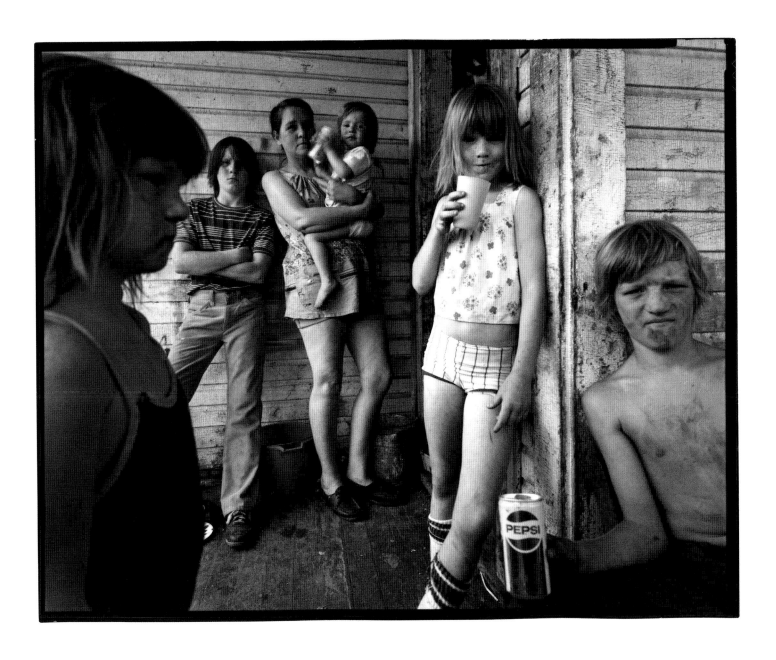

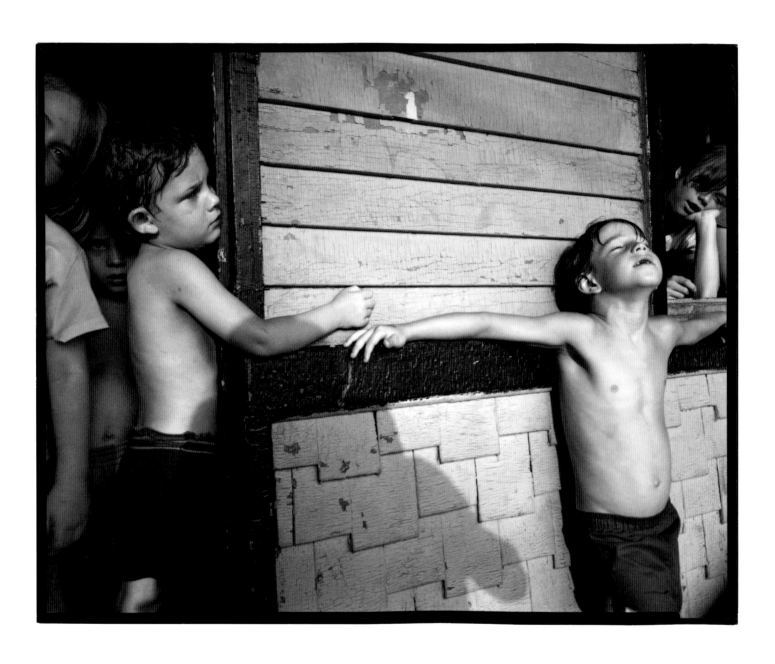

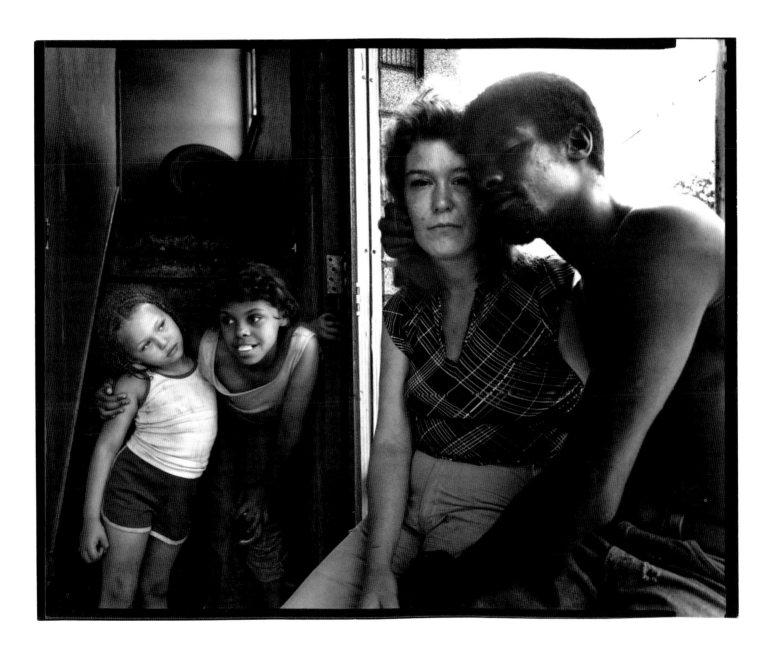

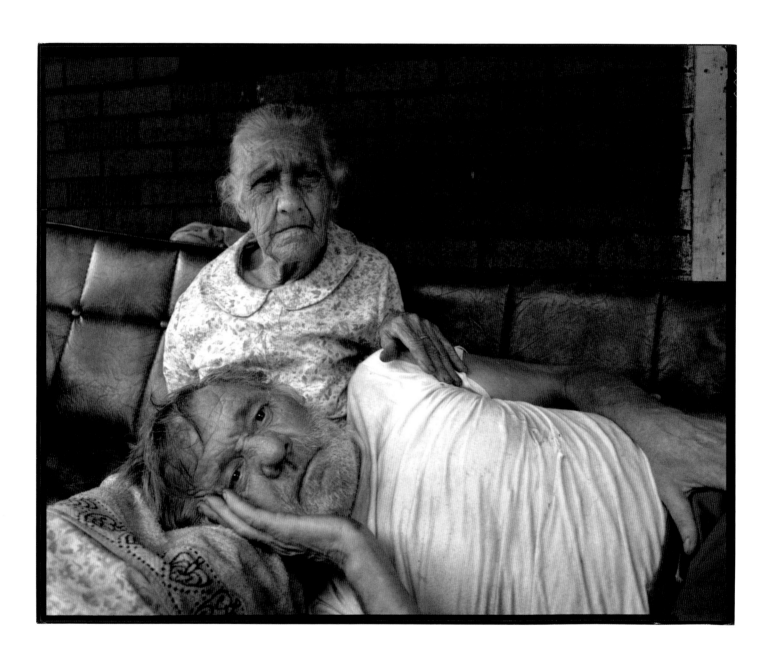

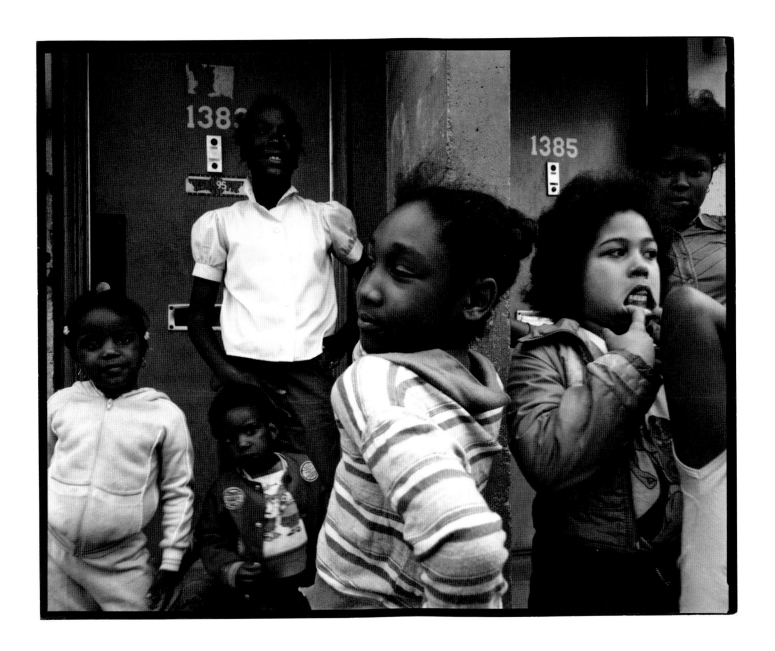

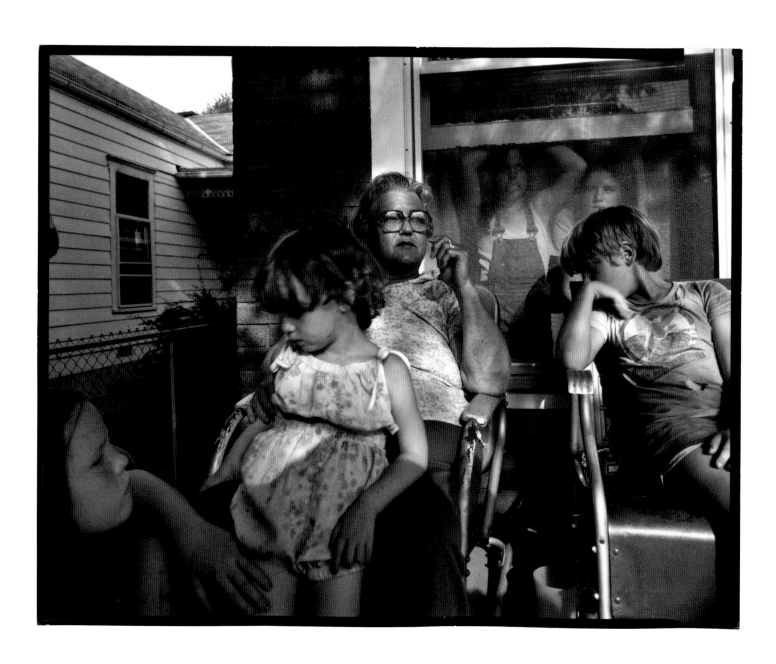

Aus/from *Trona – Armpit of America*, 2008

TOBIAS ZIELONY

Trona/ Oh Trona/ put me in a coma/ give me a stoma/ let me die/ Oh Trona so fair/ I do not care/ Let the tweekers run free/ on an arson spree/ Oh Trona/ Alkiline flats and all/ Crumbling shit/ for a town hall/ Oh Trona/ Please let me die/ not that I seen it/ I have to ask why/ Oh Trona/ tear it all down/ I want to drive up north/ to the motel called Clown/ I want to drink sour milk/ and forget what I saw/ Trona, oh Trona/ Armpit of it all

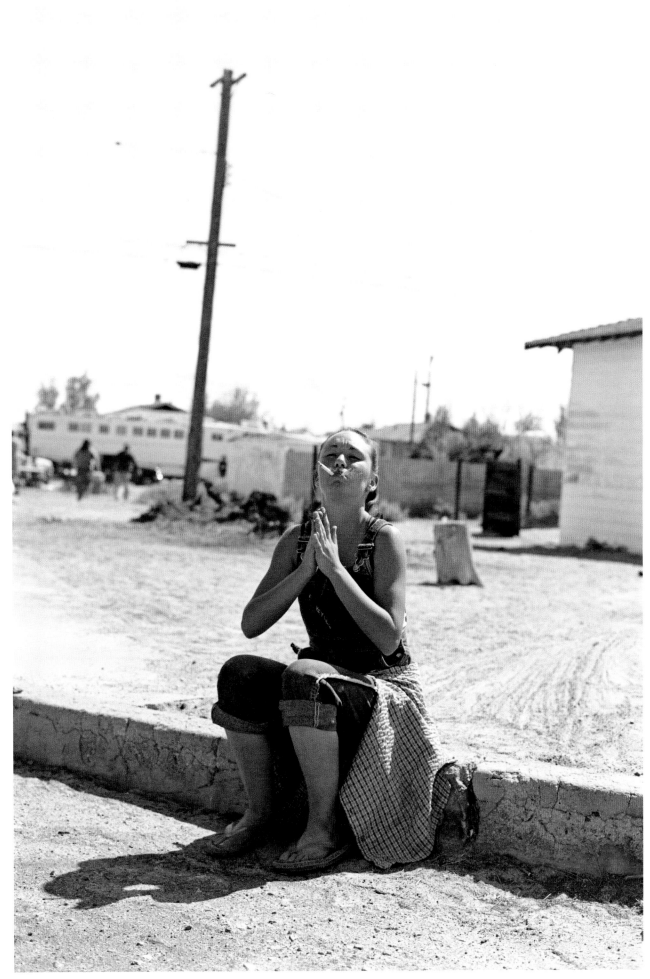

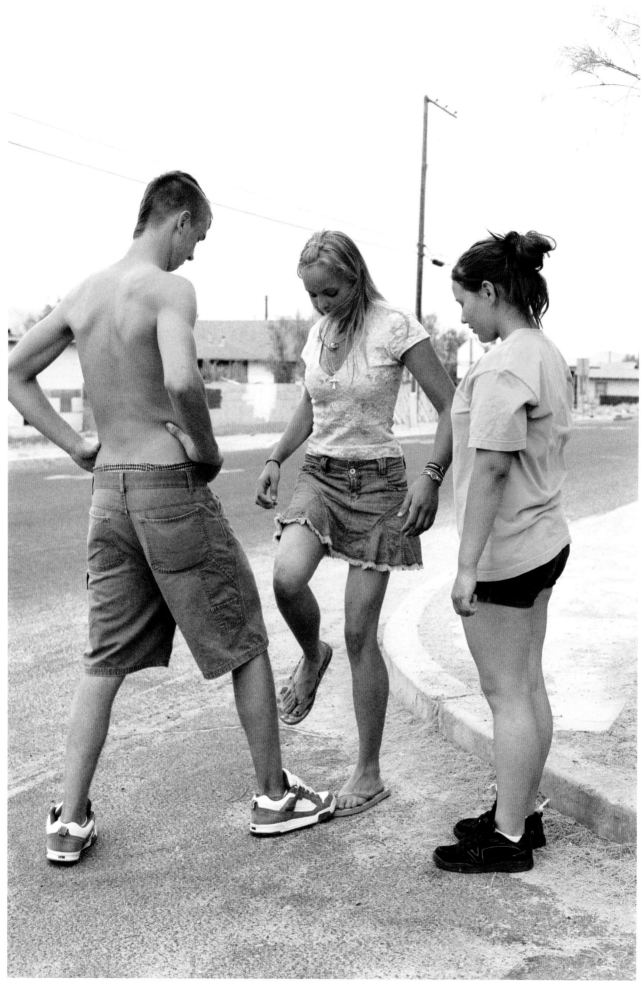

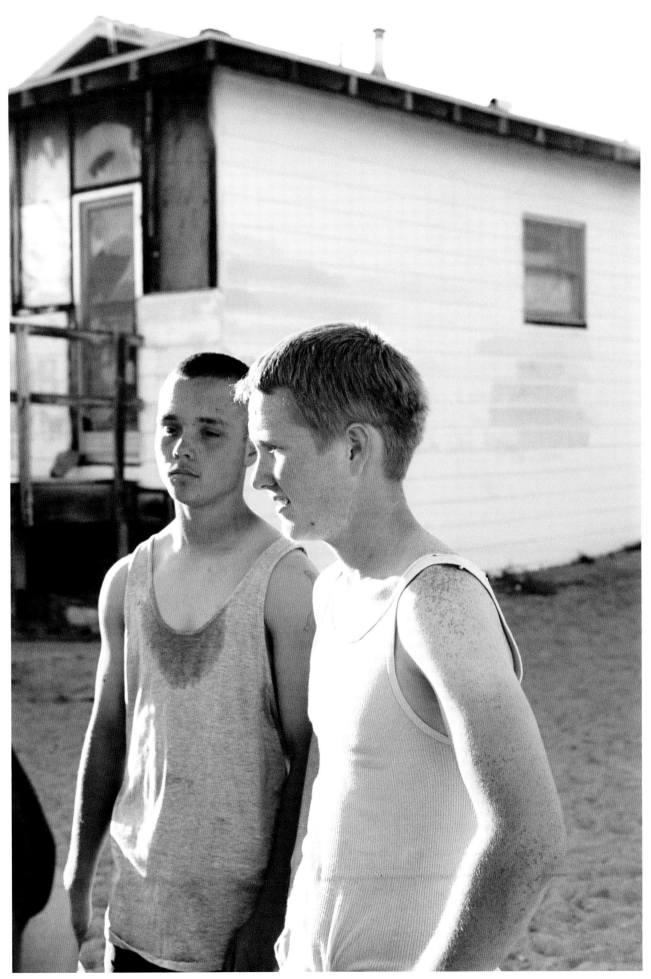

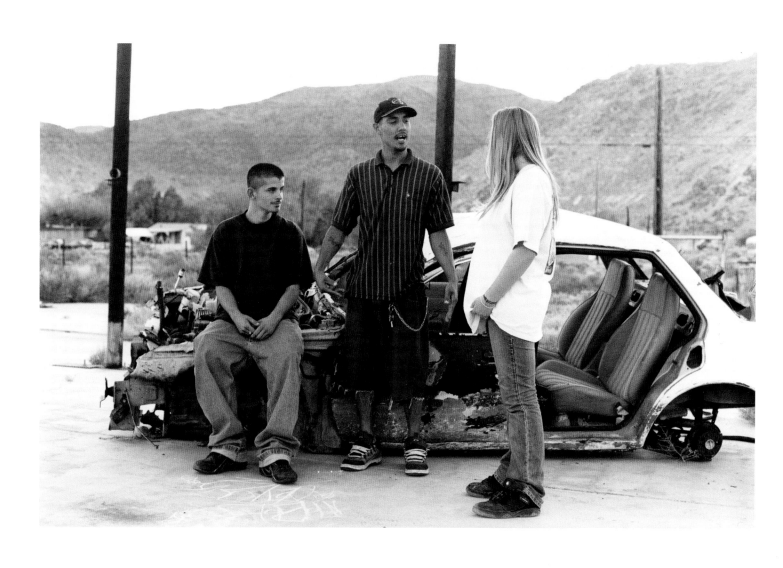

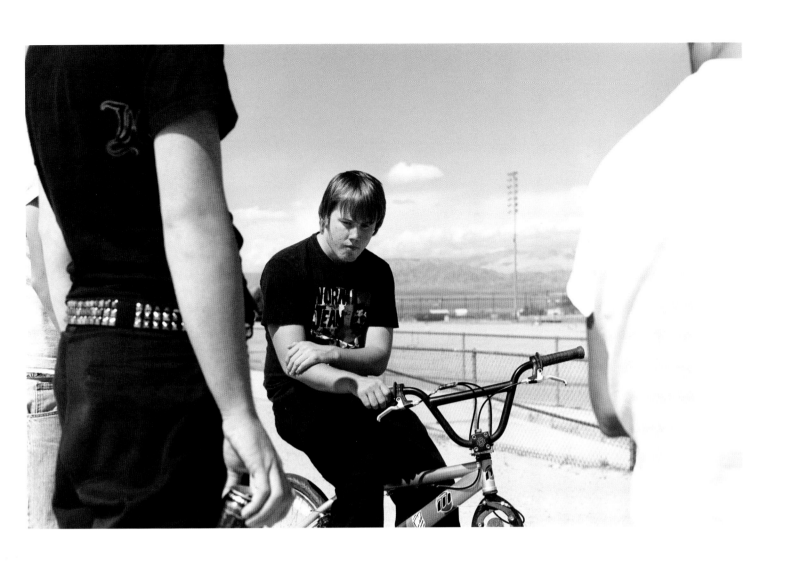

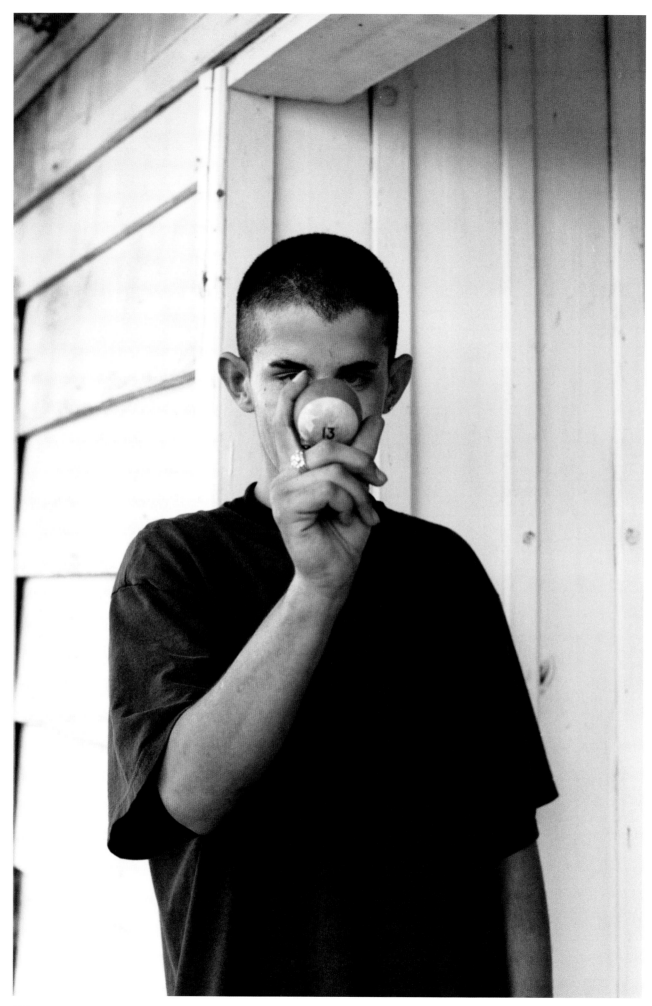

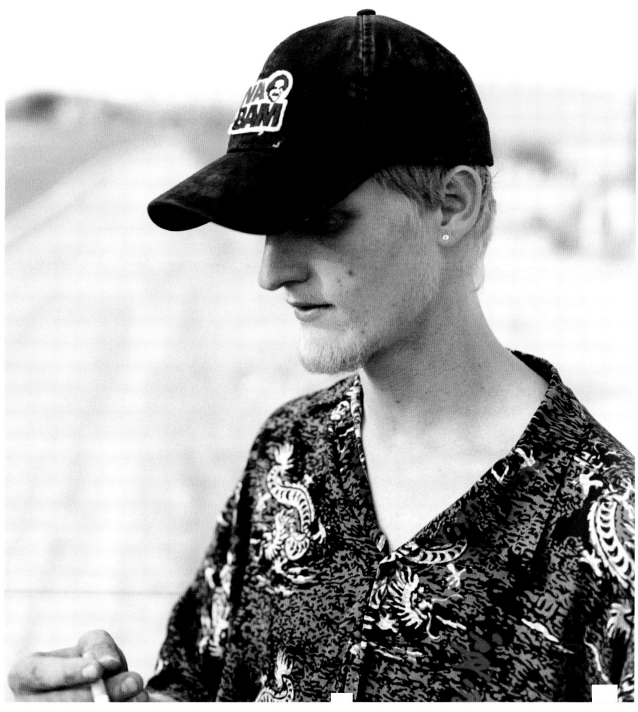

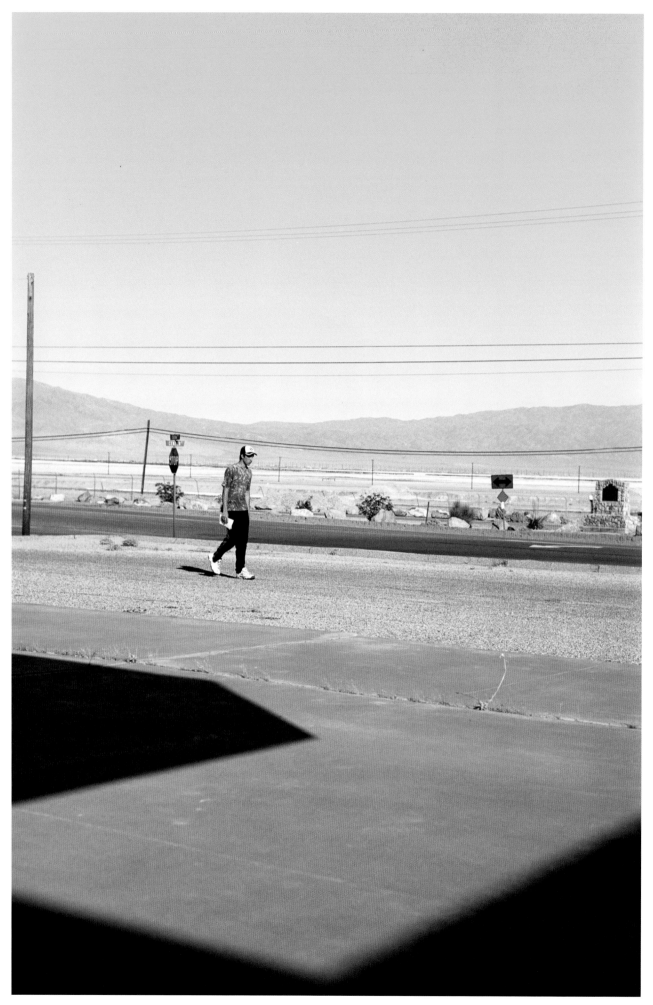

How to Make Methamphetamine the Nazi Way
==
by Speed Rebel

Here's the REAL Nazi way to make methamphetamine. (The Nazis used meth during WWII to make their troops super-hyper and CRAZY as FUCK. Hitler loved the stuff, which may be why he came up with so many amazingly BAD IDEAS.)

WARNING: You will be using dangerous chemicals while producing this shit. This is not a fucking game, this is not something you do for fun, you MUST know what you're doing.

I have used this formula and made 1/4 pound of some high quality shit.

Materials you need:

3 Gallons of Anhydrous Ammonia
40 lithium batteries (although I've never tried it, I've heard you can replace the batteries with lithium pills)
4 gal of starter fluid
5000 Ephedrine pills
2 liter GLASS bottle
long rubber hose
bottle of sufuric acid
5 gallon bucket
ball of alluminium foil

Remove the casing from the batteries and get the strips.
Put the Ani, pills, starter fluid, and lithium strips in the 5 gallon bucket.
Make a hole in the bottle that is big enough to fit your hose. Put the hose on the bottle.
Put the sufuric acid in the bottle, but be carefull cause that shit will eat you to the bone.
Put a ball of alluminium foil in the bottle.
Take the free end of the hose and put it in the bottom the bucket.
When all the bubbling is done, give it a stir and let it sit for 4 hours.
After 4 hours CAREFULLY pour out the nasty liquid. You will see a lot of gunk at the bottom, that's all meth. Get it all out and let it dry.

WHAT?! It's that easy. Not exactly, take EVERY precaution you can.

After it's done, it will be one big chunk of rock. You can either crush it up into a powder and sell it as crank (which seems to go farther), or you can break off small chunks and sell it as ice (goes shorter but people LOVE ice). After you're done, you will have a 1/4 pound of meth, which is 4 ounces. I sold 3 and kept one for myself.

Precautions
===========

Wear a mask and gloves if you can.

Do it someplace remote.

NEVER let the sufuric acid touch the ani, as it will poison your batch. Make sure there's no moisture in or around the bucket or, as totse says,

KA-FUCKING-BOOM!

Don't be a dumbass. KNOW WHAT YOU'RE FUCKING WITH!!!

ANDREAS GURSKY

Aus/from *Forest*, 2000–2005

JITKA HANZLOVÁ

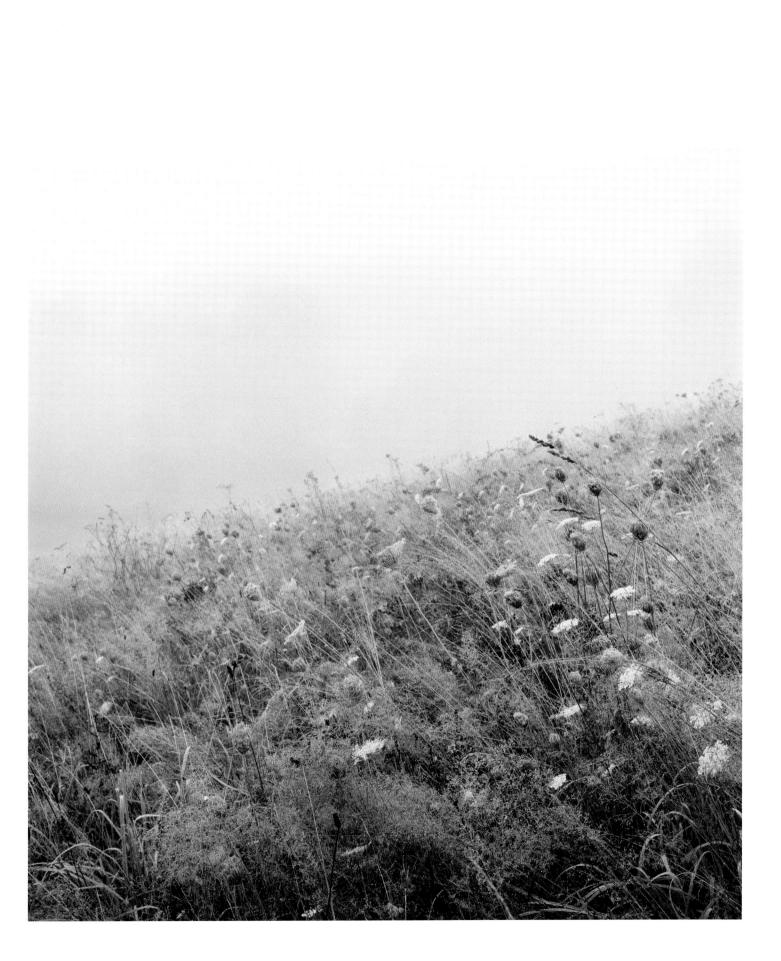

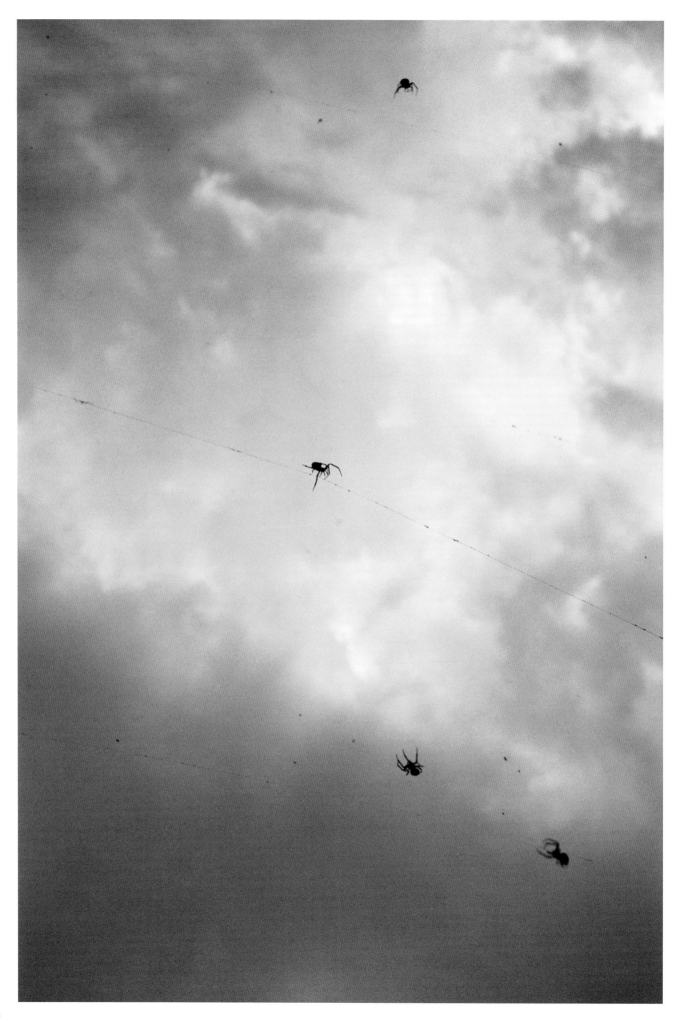

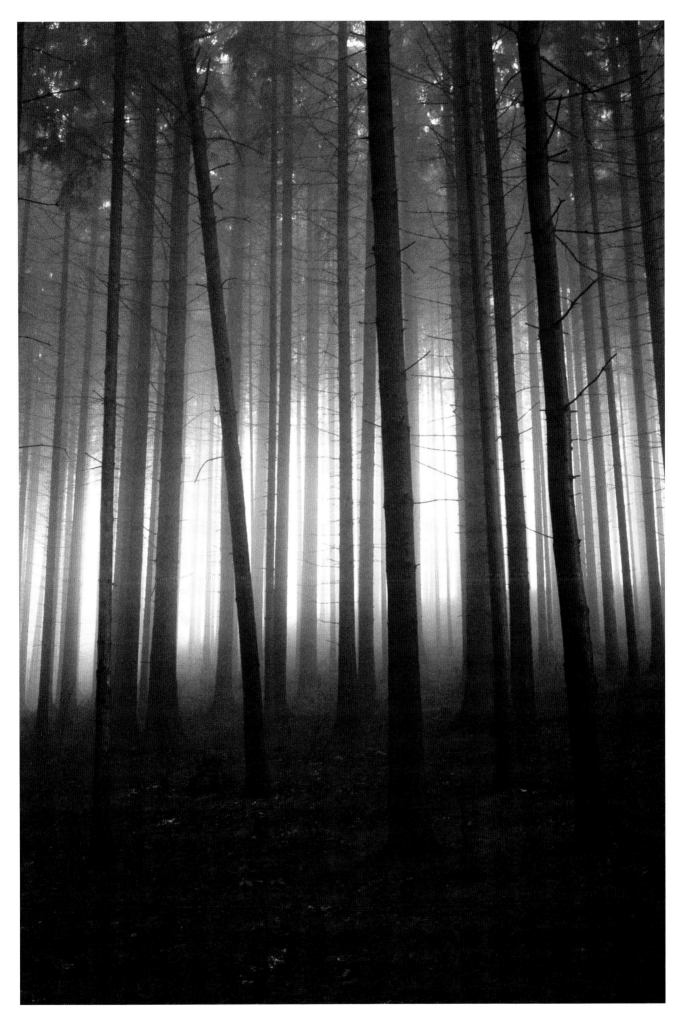

Nevada, 1977

LEWIS BALTZ

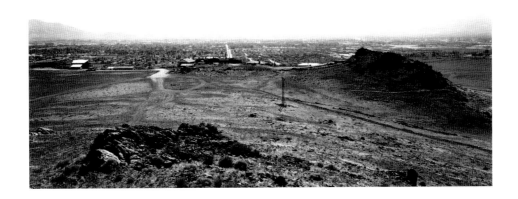

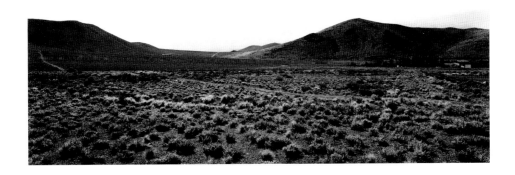

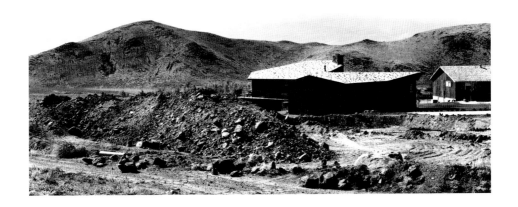

Aus/from *Ökoton*, 2011

148–157 Alle Arbeiten ohne Titel/all works untitled

ELISABETH NEUDÖRFL

161–169 *Blumenbilder/Flowerpictures,* 2006

HANS-PETER FELDMANN

Aus/from *Ihme-Zentrum 1997/98*, geprintet/printed in 2009

MICHAEL SCHMIDT

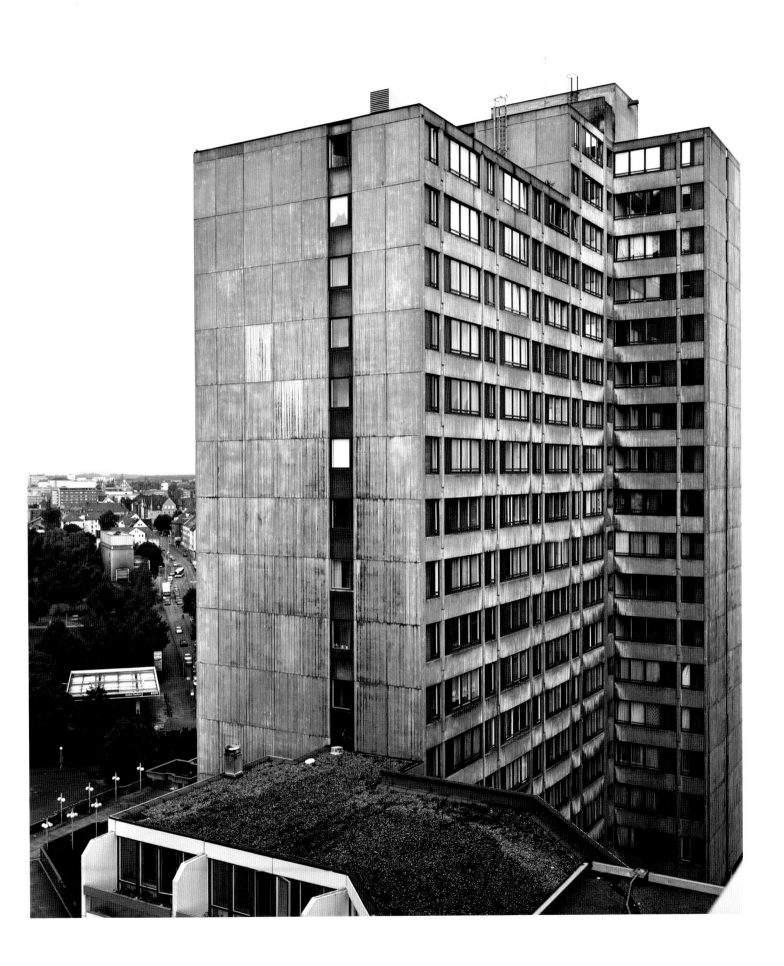

THOMAS DEMAND

JOCHEN LEMPERT

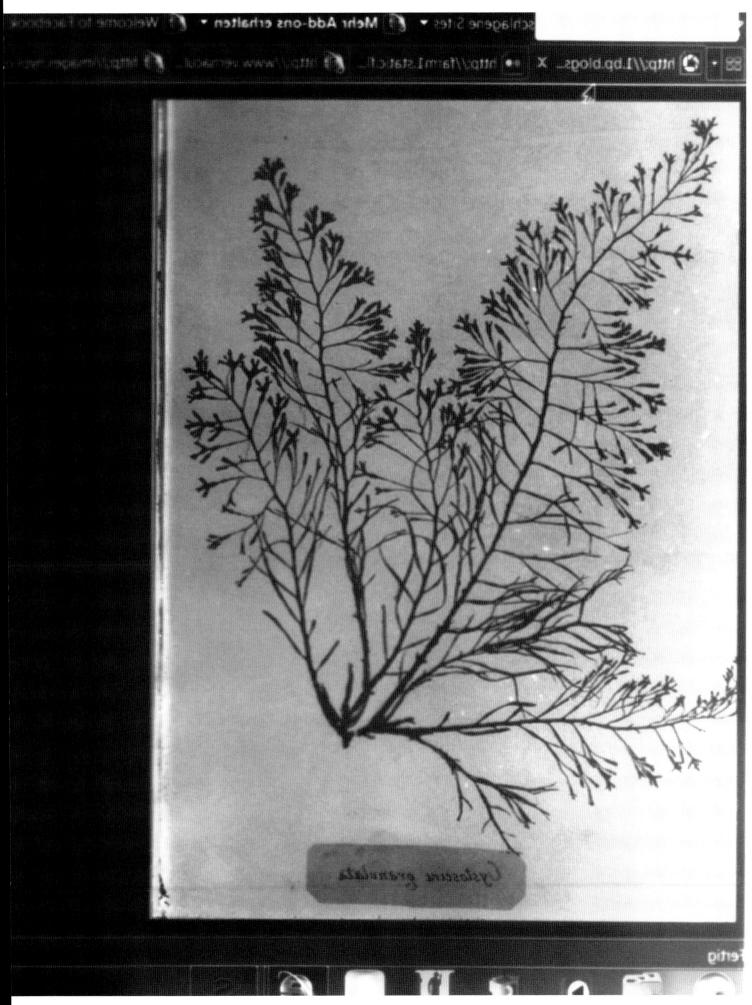

Cystosira granulata

WOLFGANG TILLMANS

Aus/from *blindlings/blindly*, 2011, 2 Gruppen à 8 Bilder/2 sets of 8 pictures each

MAX BAUMANN

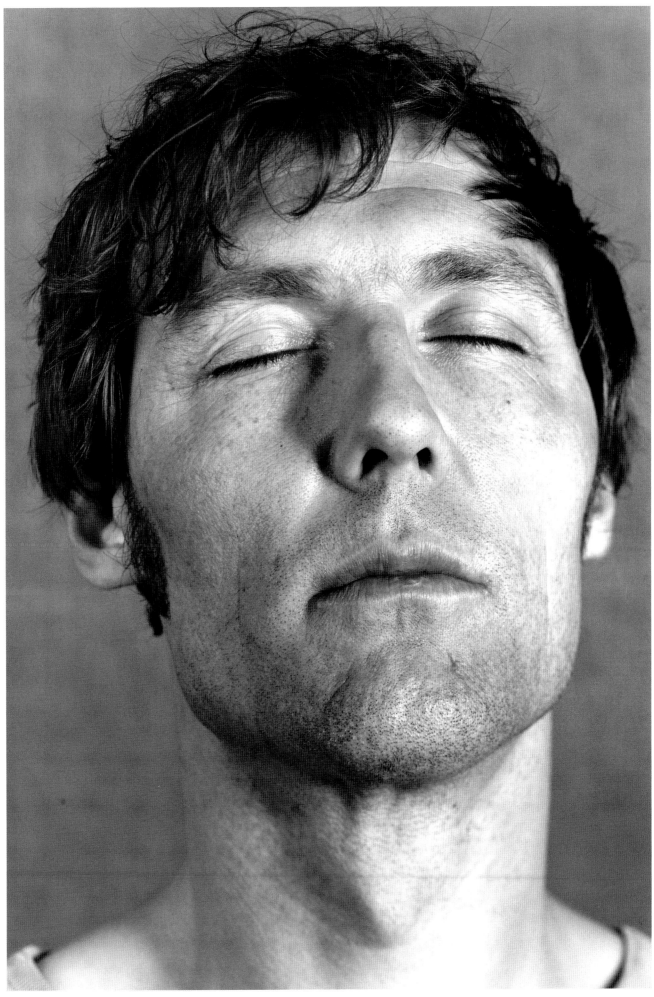

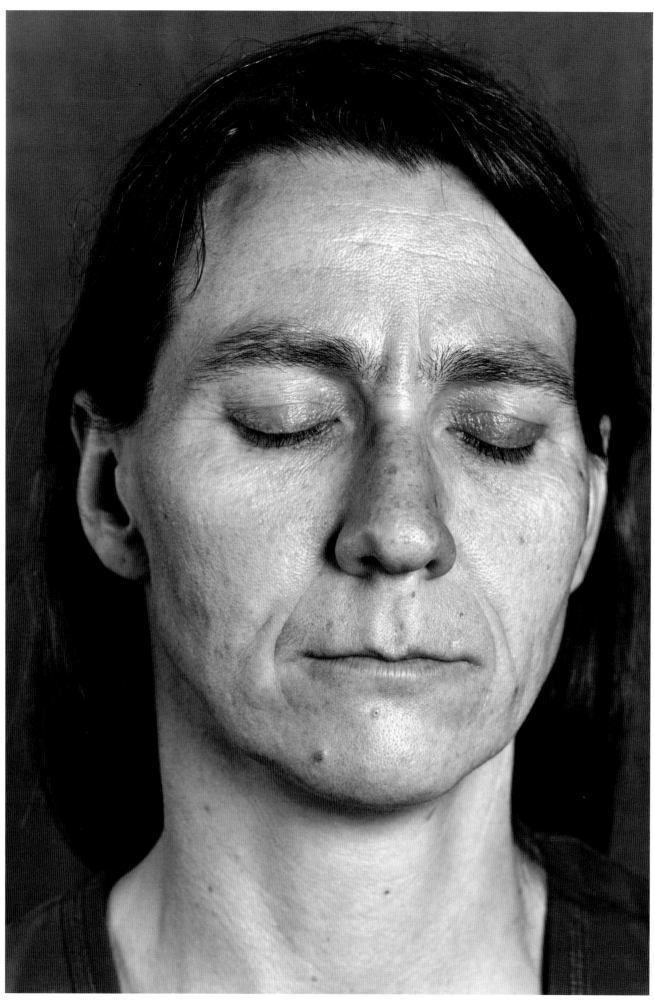

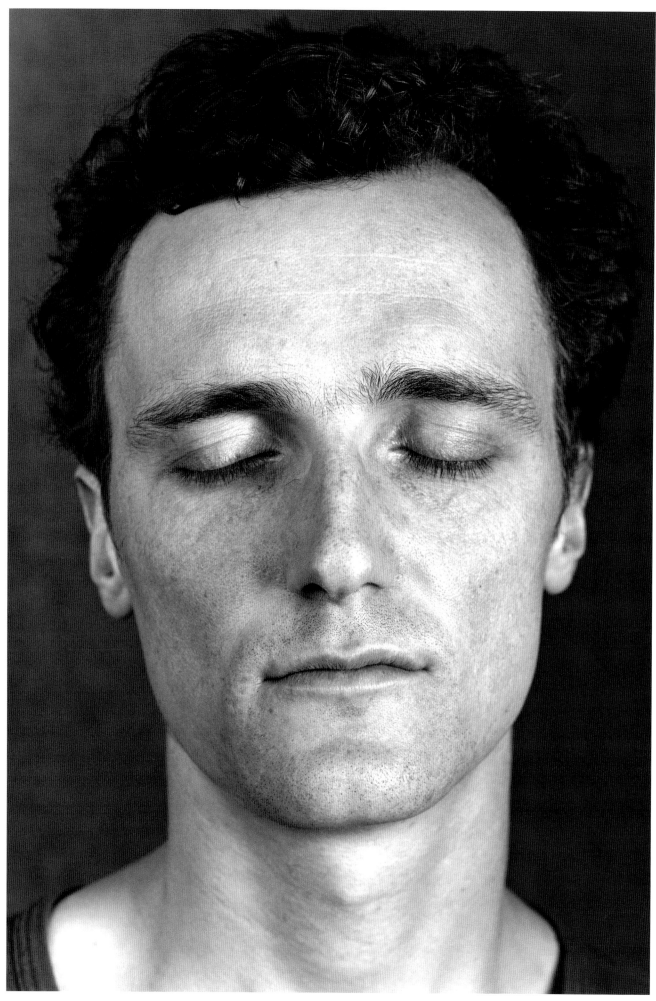

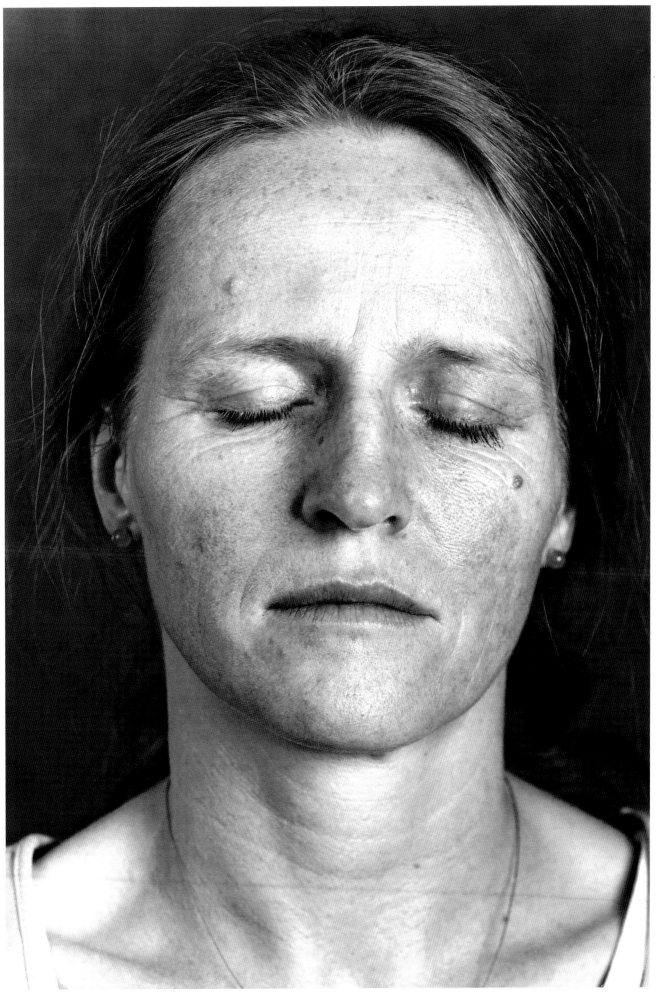

221

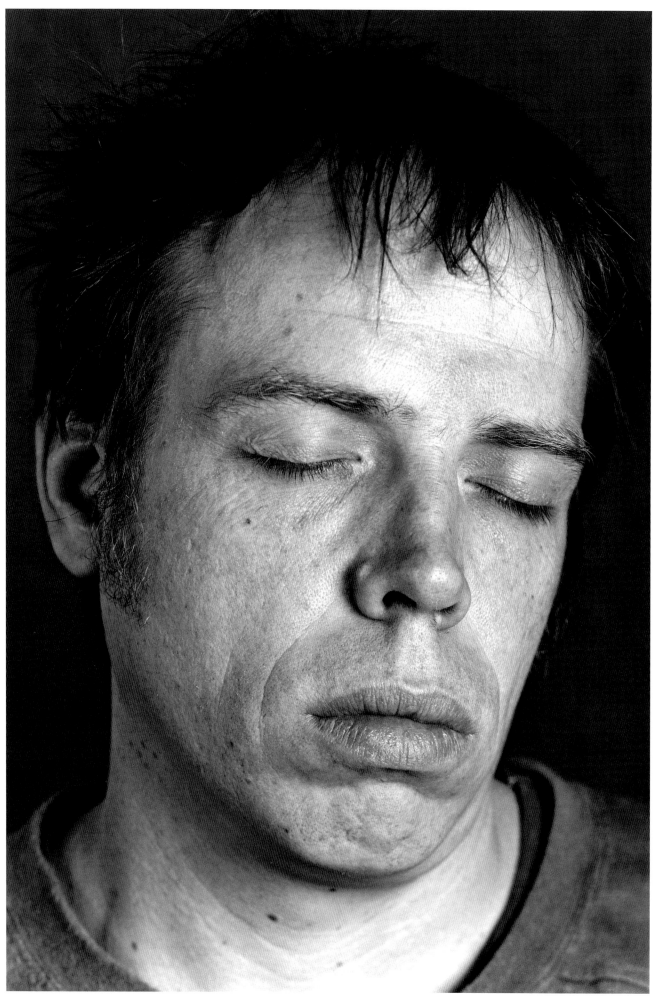

JEFF WALL

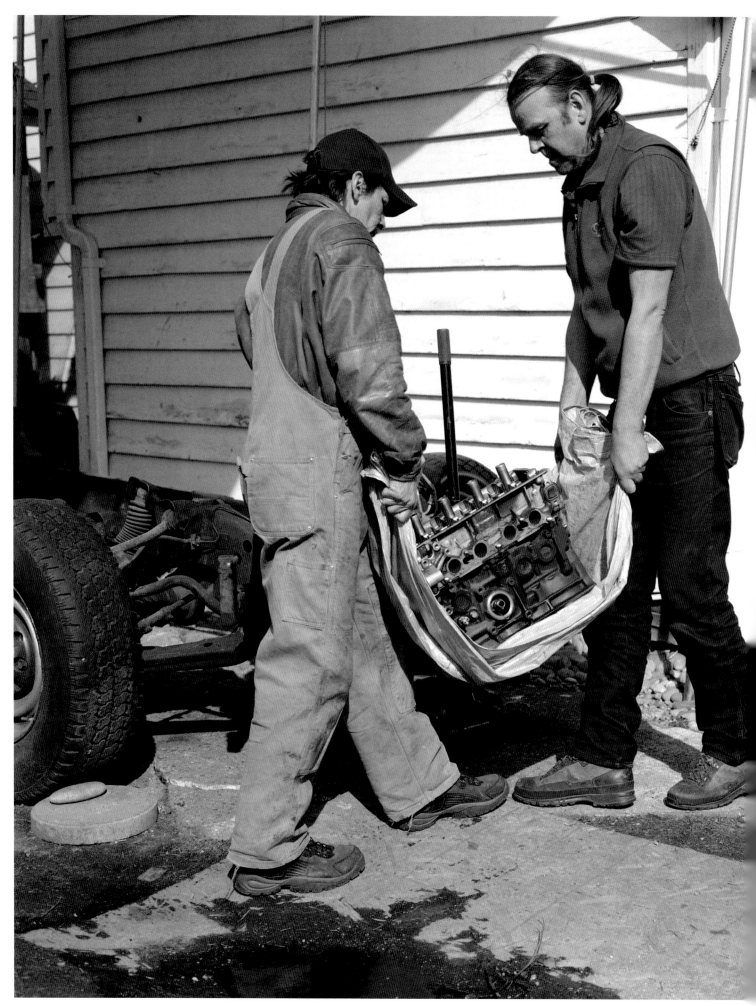

Aus/from *The Pond*, 1985

237-247 Alle Arbeiten ohne Titel/all works untitled

JOHN GOSSAGE

Aus/from *Color Lab Club*, 2007/08

250/251 *Niépce*, 2007
252 *Labgirl*, 2008
253 *Fototaube/pigeon photographer*, 2007
254/255 *Man Ray*, 2007
256/257 *Labor*, 2007
258/259 *Carte de visite – Lab Girls* (1–16), 2008

LAURA BIELAU

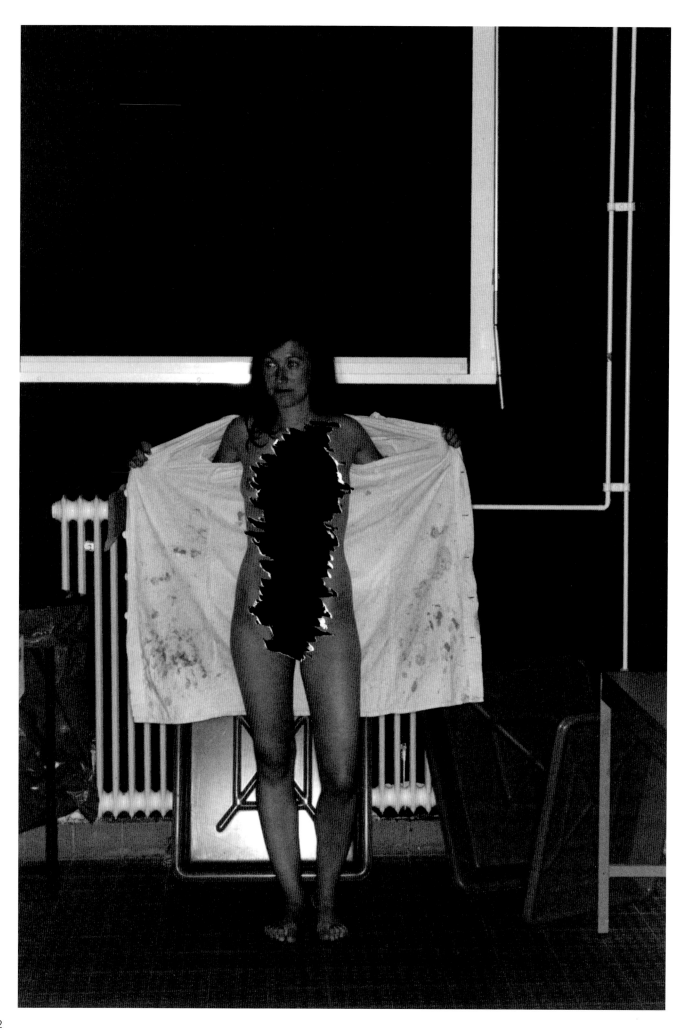

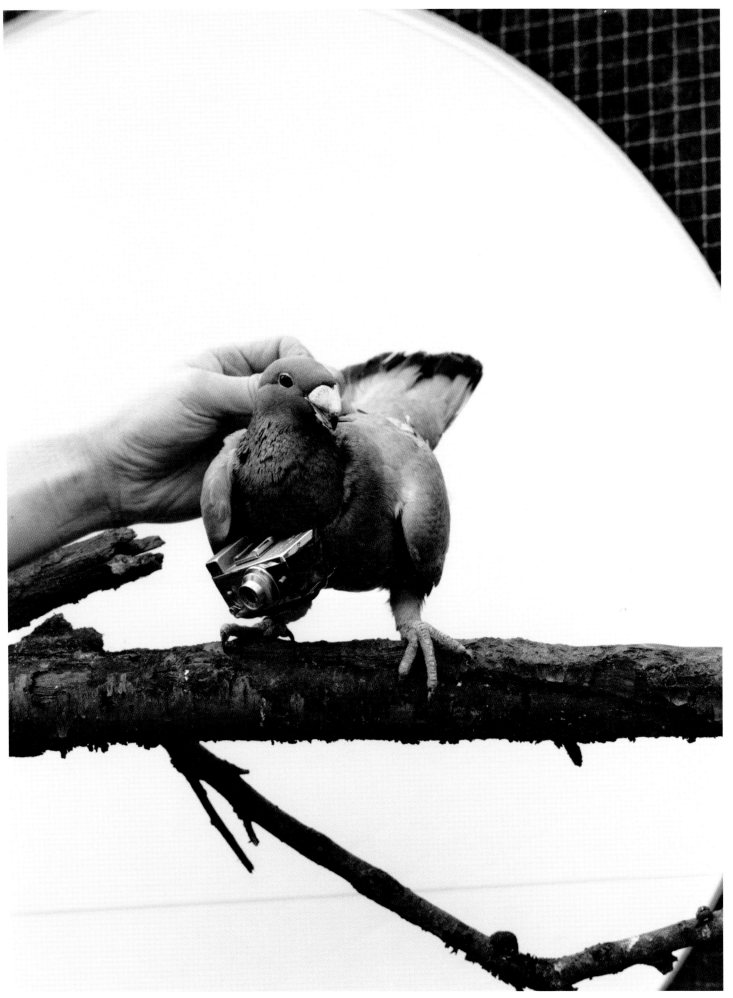

Atelier Laura Bielau
COLOR LAB CLUB

Atelier Laura Bielau
COLOR LAB CLUB

Atelier Laura Bielau
COLOR LAB CLUB

Atelier Laura Bielau
COLOR LAB CLUB

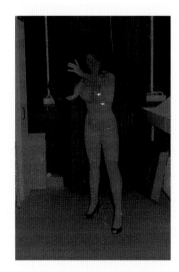

Atelier Laura Bielau
COLOR LAB CLUB

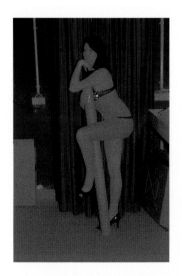

Atelier Laura Bielau
COLOR LAB CLUB

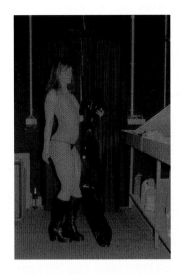

Atelier Laura Bielau
COLOR LAB CLUB

Atelier Laura Bielau
COLOR LAB CLUB

Atelier Laura Bielau
COLOR LAB CLUB

Atelier Laura Bielau
COLOR LAB CLUB

Atelier Laura Bielau
COLOR LAB CLUB

Atelier Laura Bielau
COLOR LAB CLUB

Atelier Laura Bielau
COLOR LAB CLUB

Atelier Laura Bielau
COLOR LAB CLUB

Atelier Laura Bielau
COLOR LAB CLUB

THOMAS STRUTH

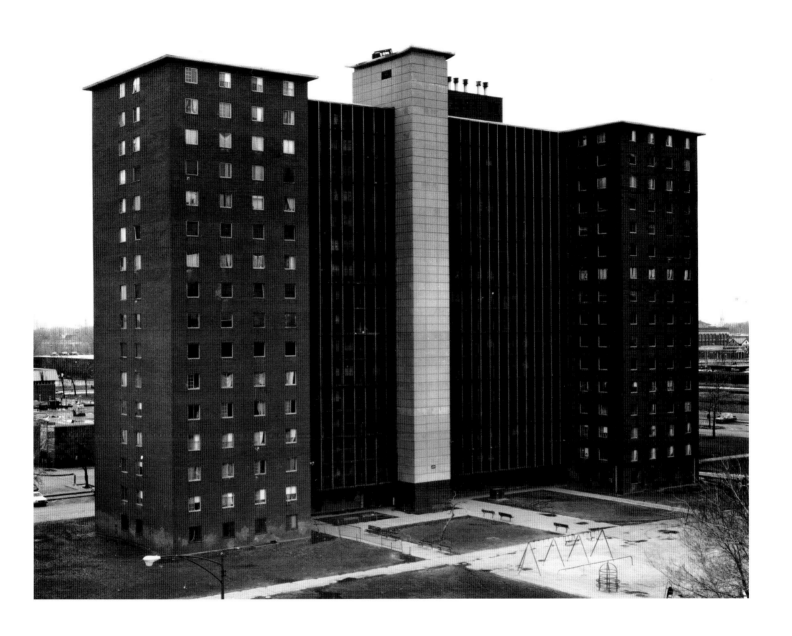

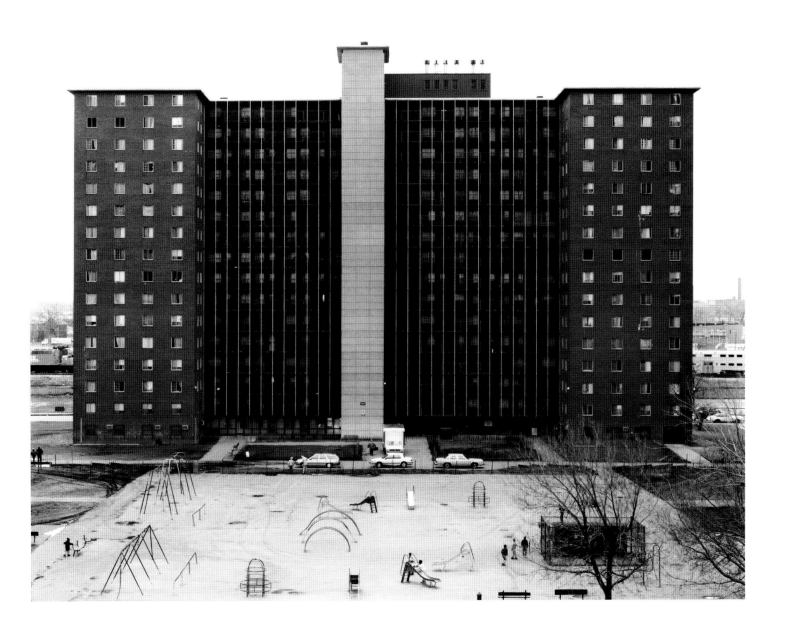

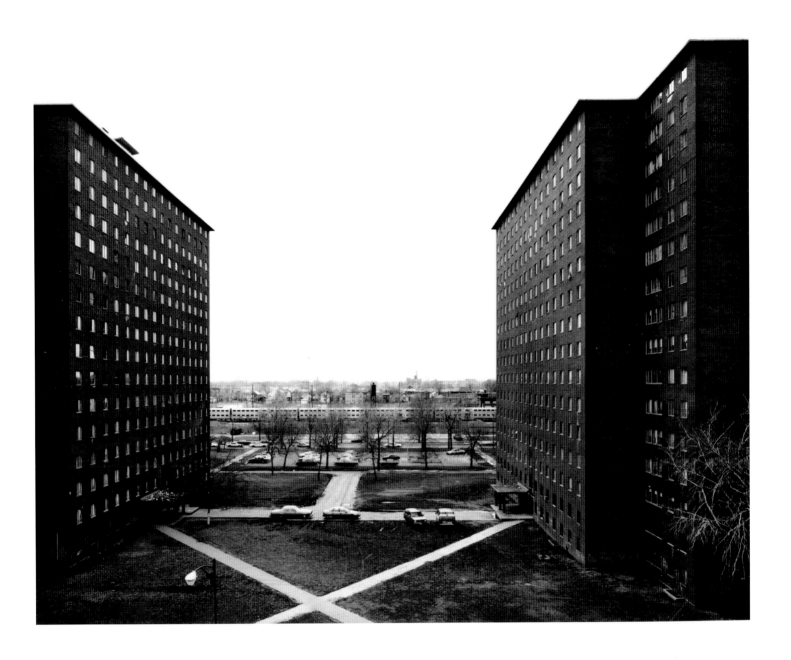

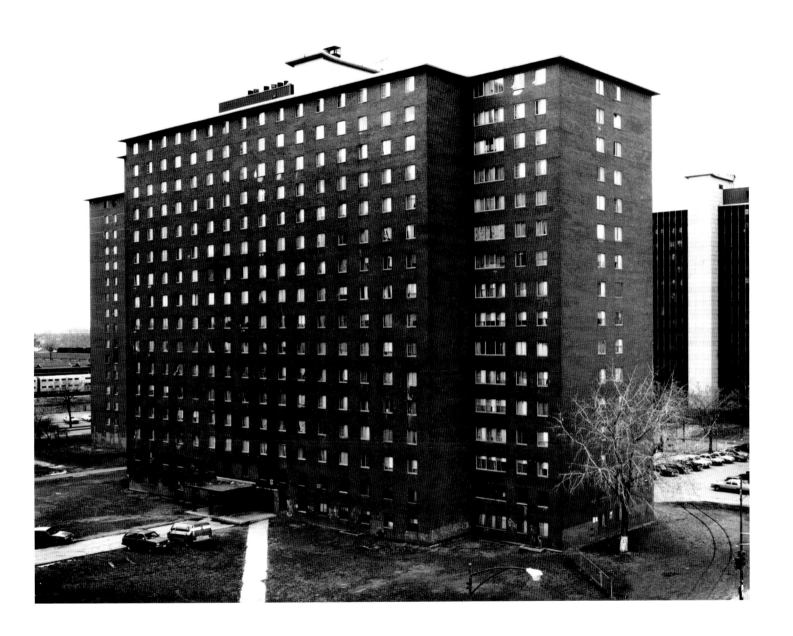

LEE FRIEDLANDER

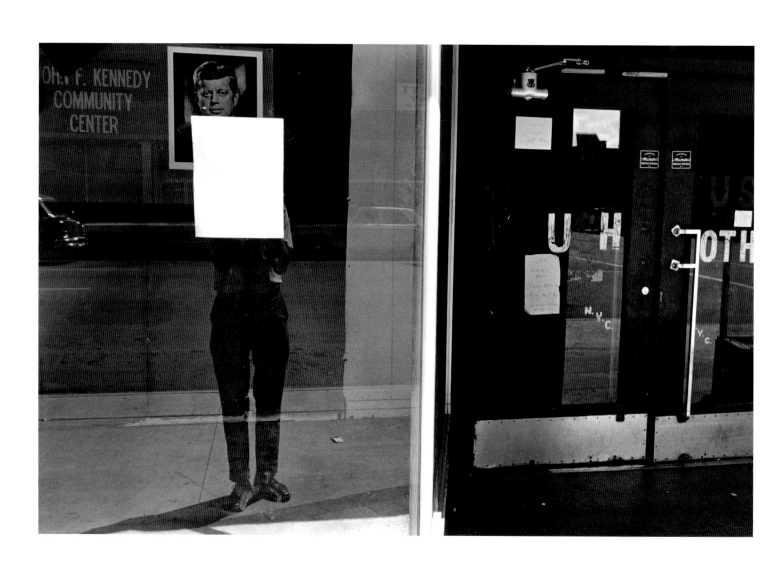

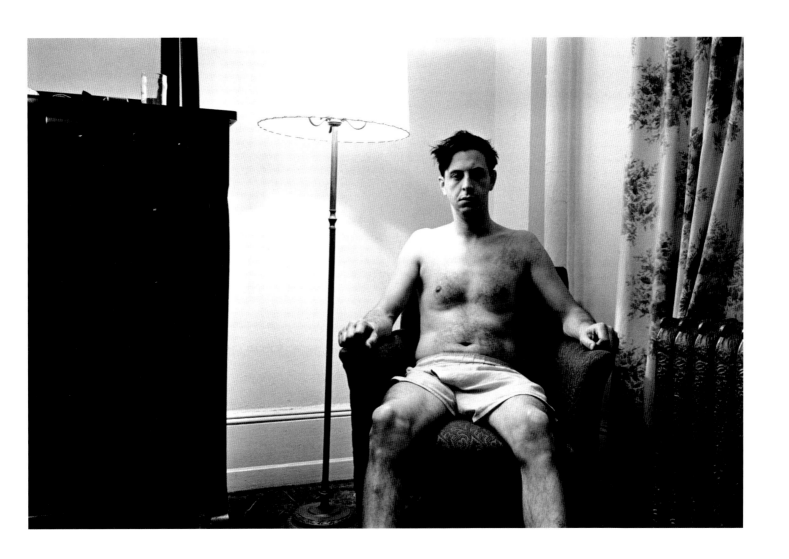

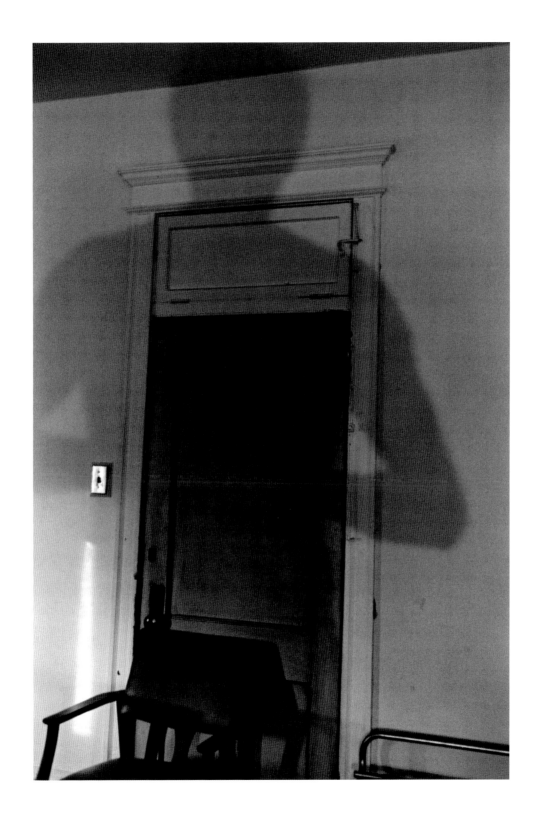

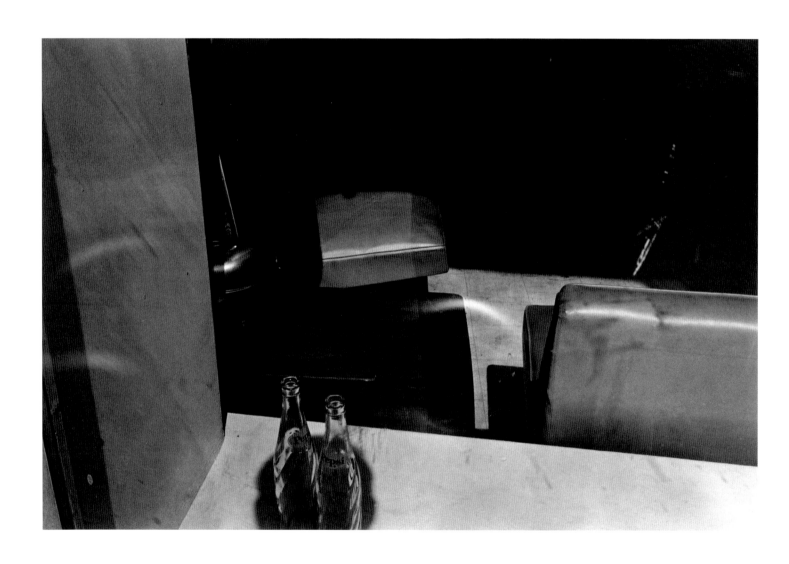

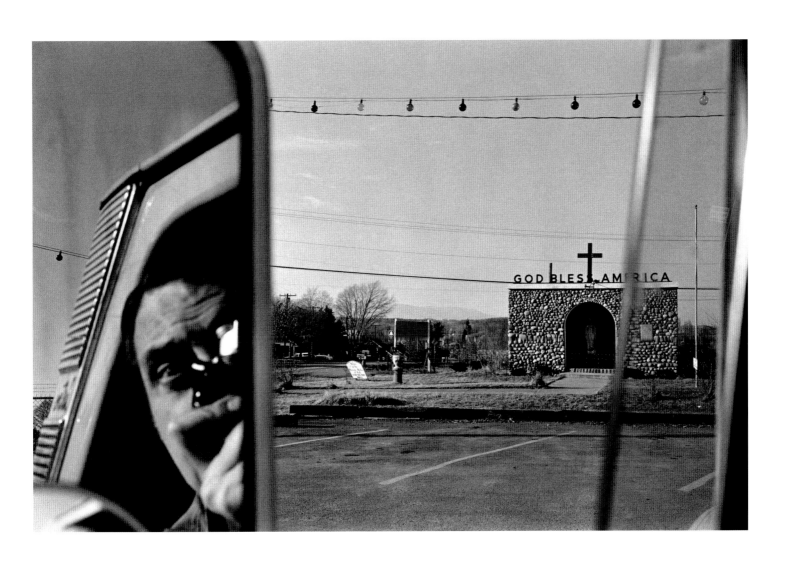

Aus/from *Anwesenheit/Presence*, 1996–2005

RITA OSTROWSKAJA

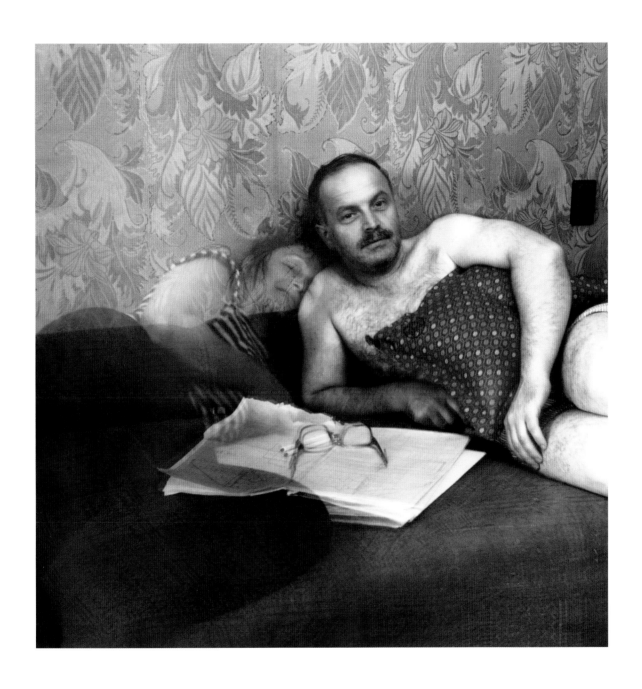

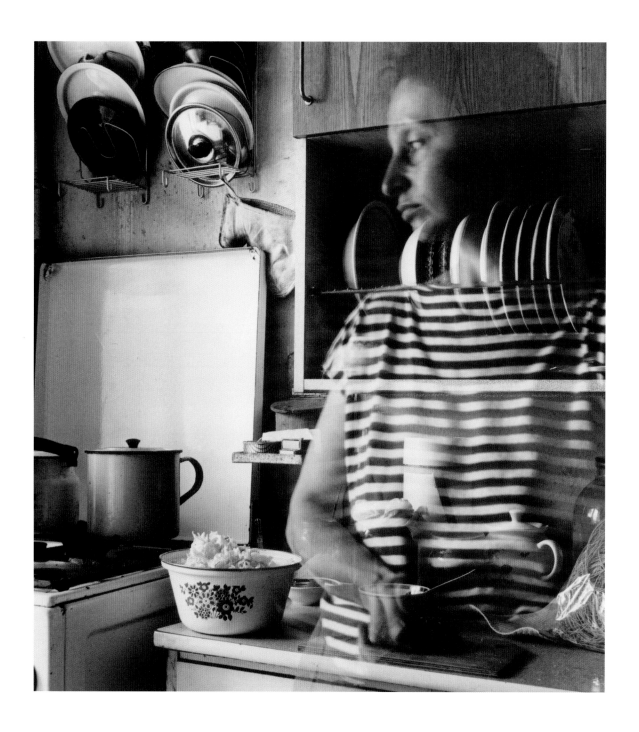

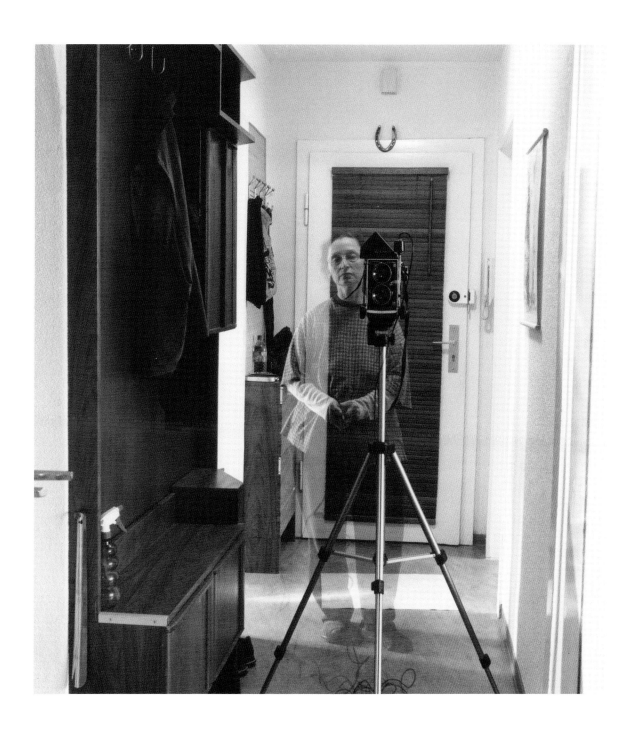

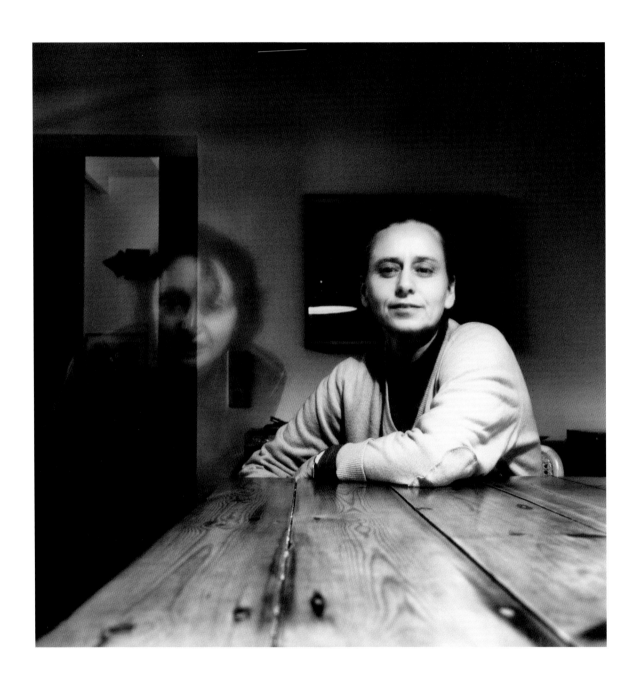

Aus/from *Selbstporträts/Self-portraits*, 1981–1989

296-305 Alle Arbeiten ohne Titel/all works untitled

HELGA PARIS

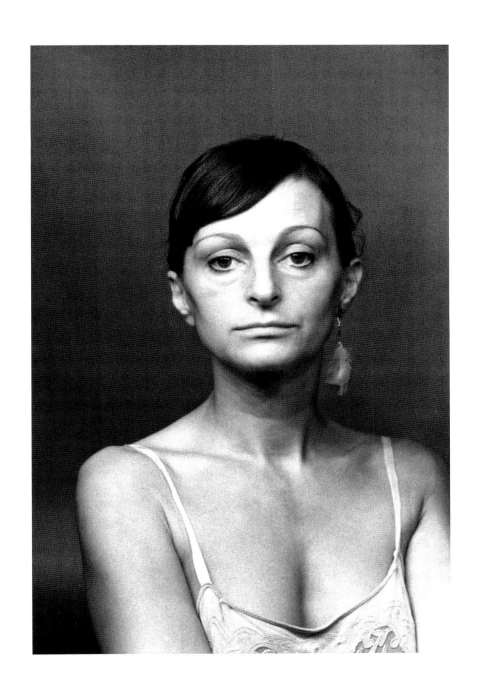

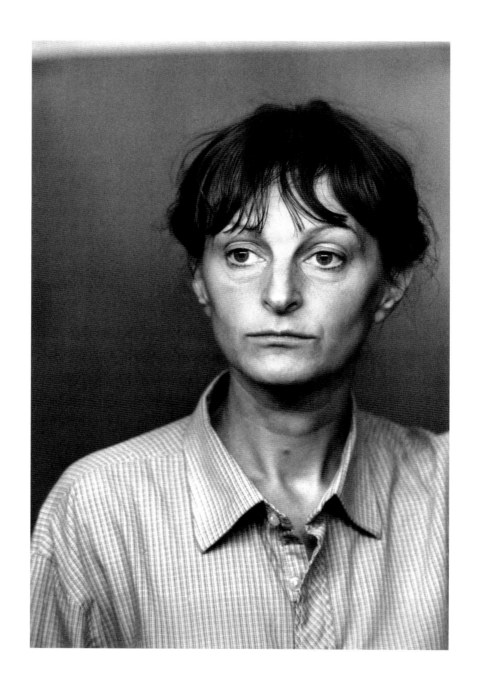

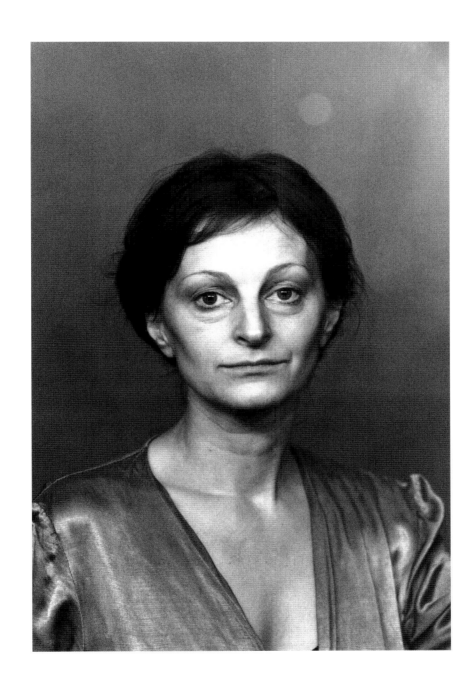

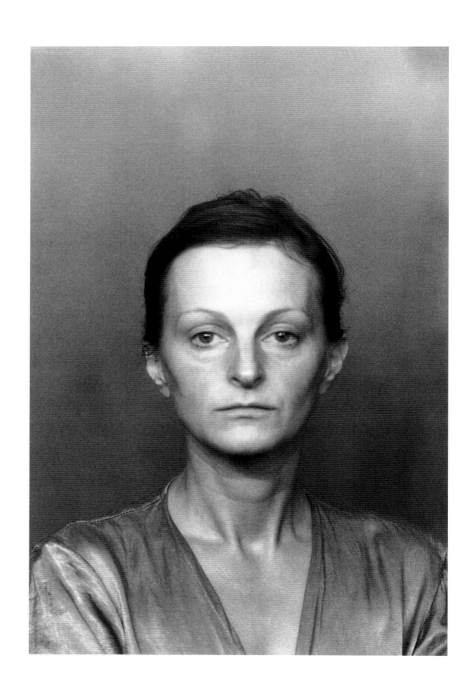

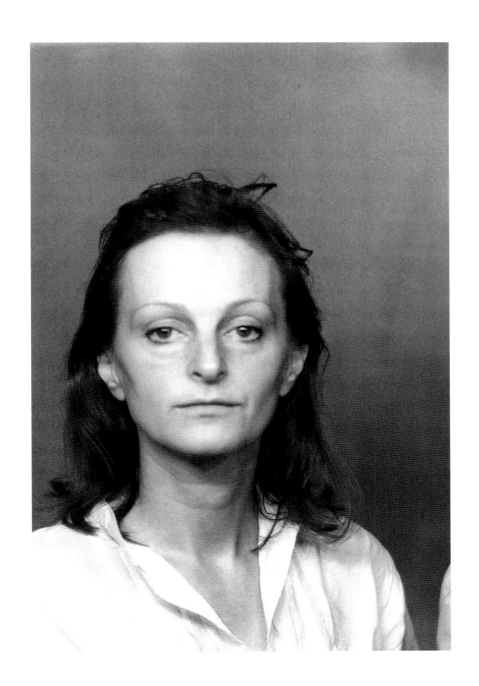

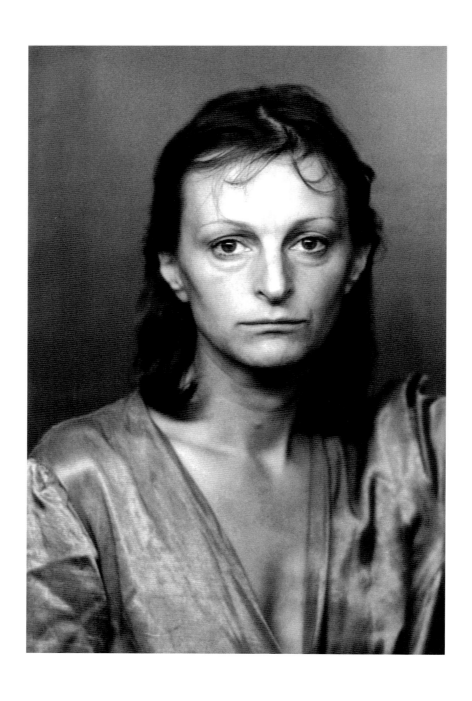

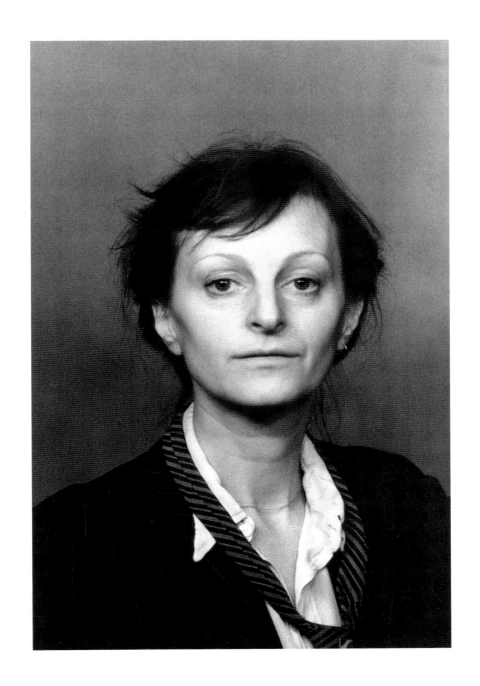

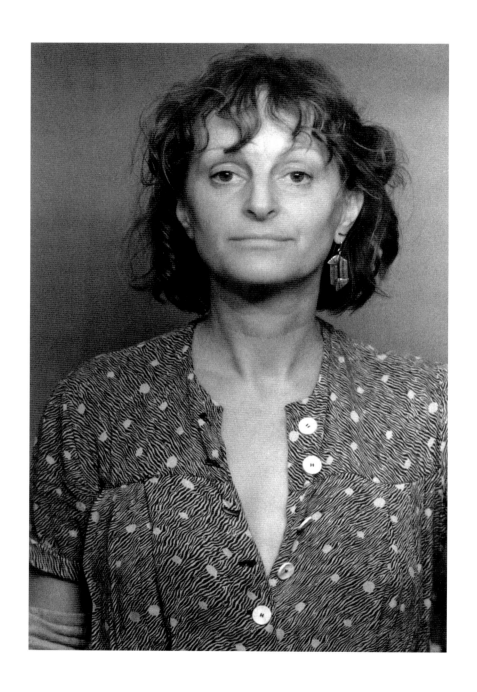

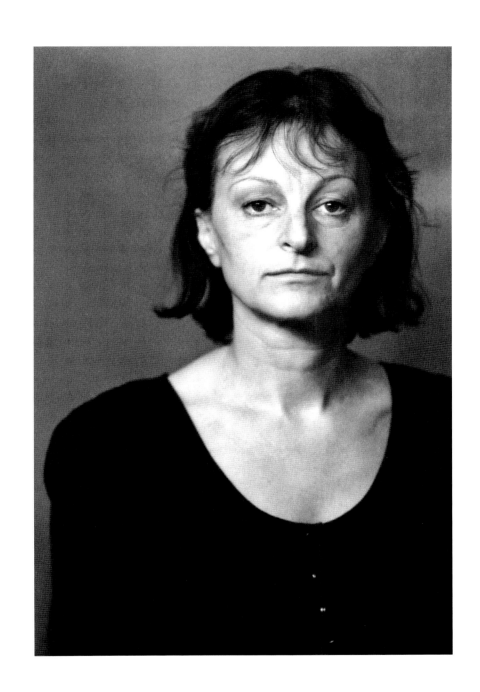

RINEKE DIJKSTRA

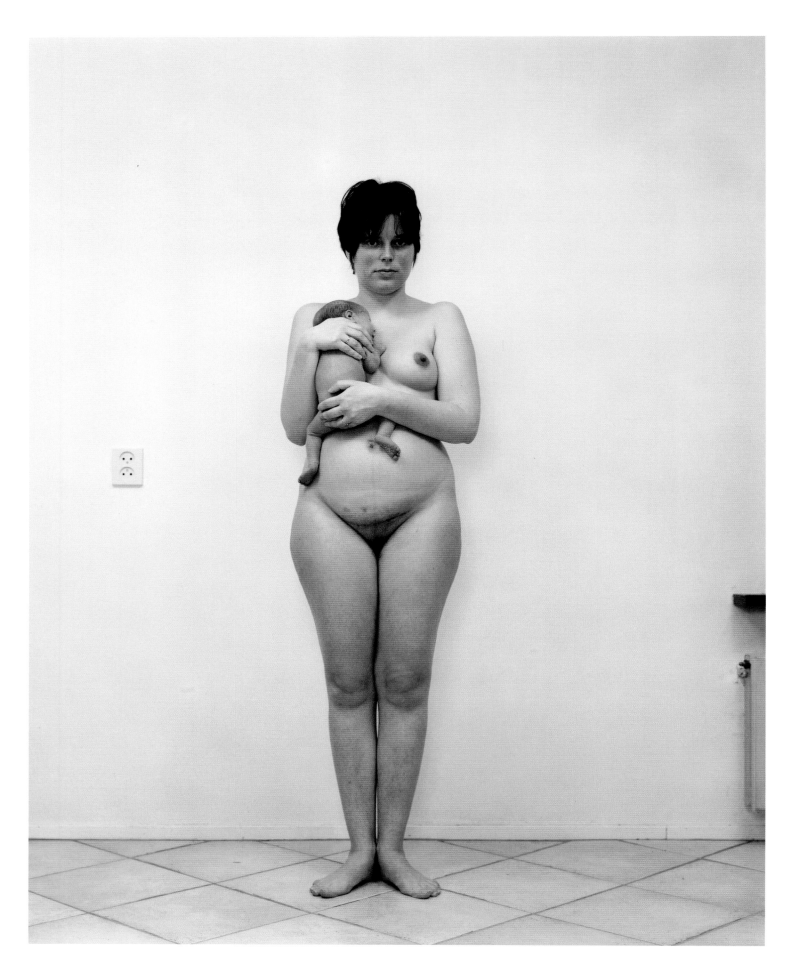

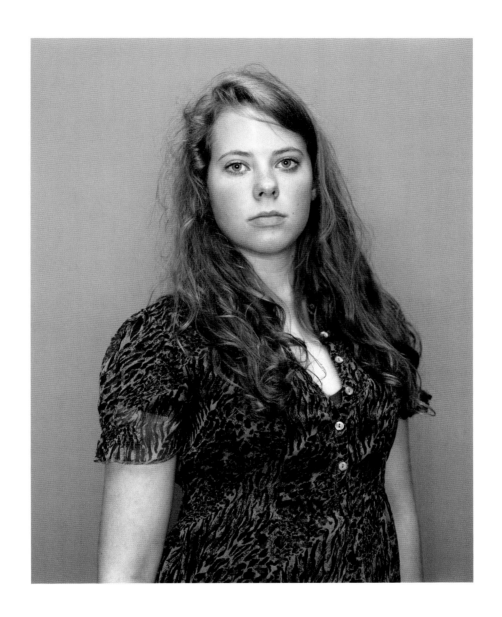

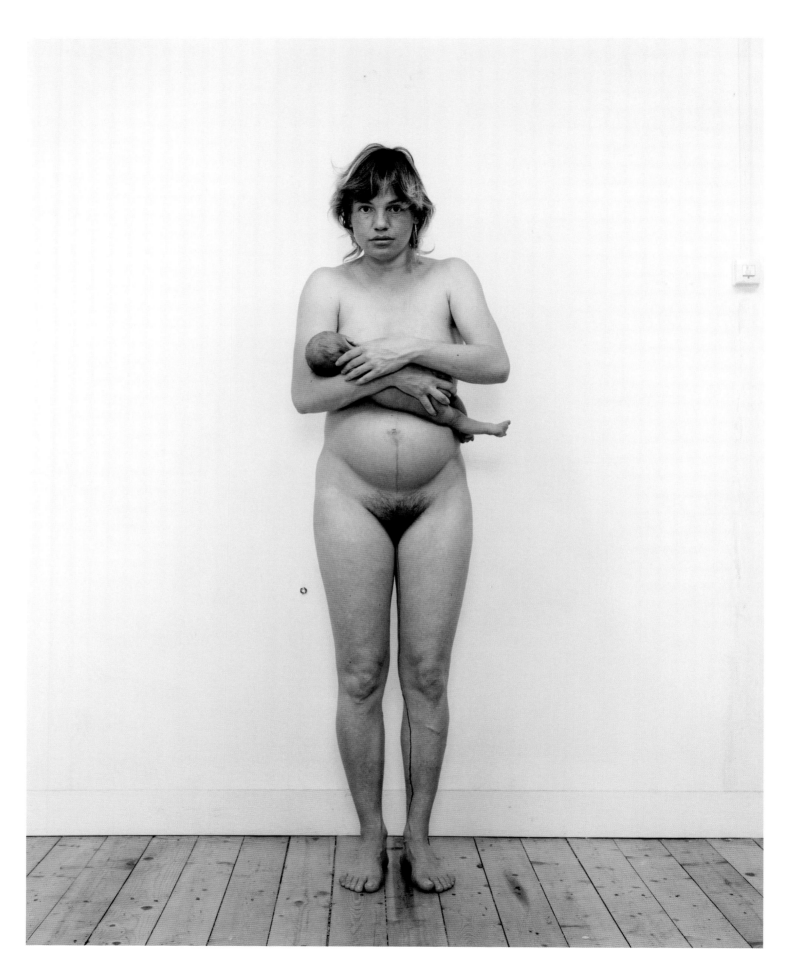

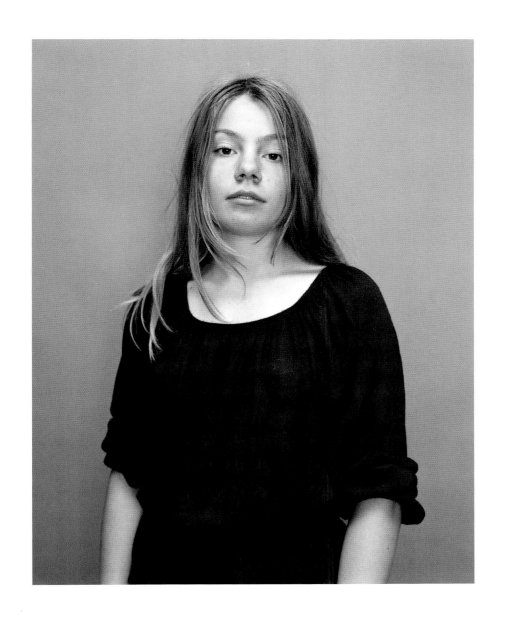

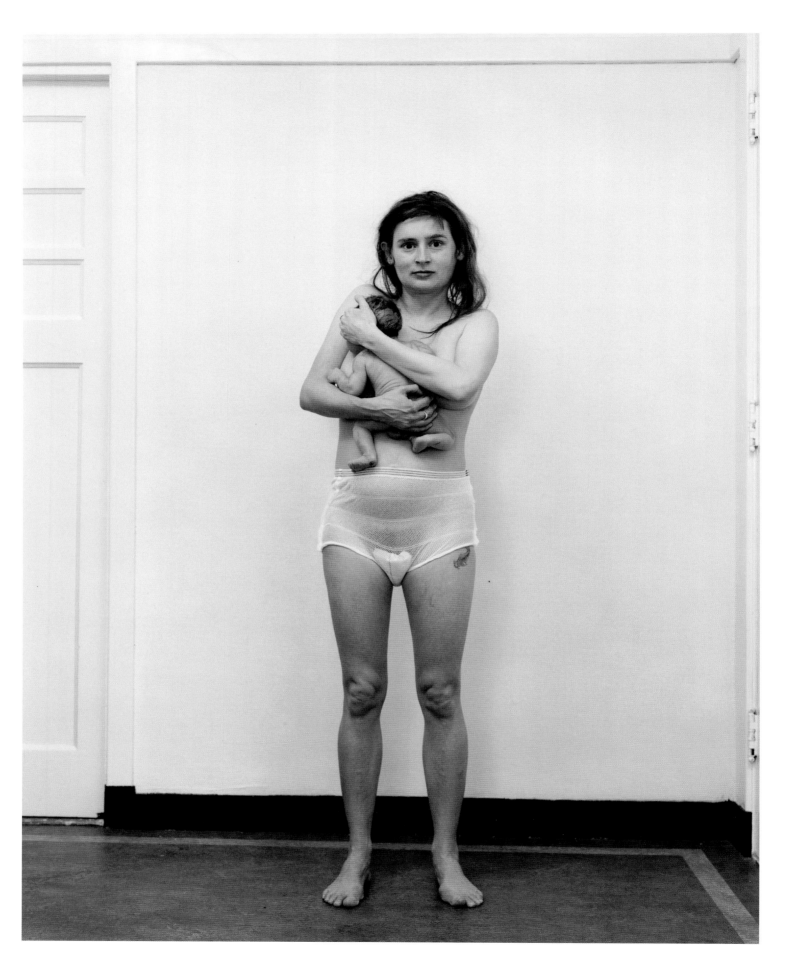

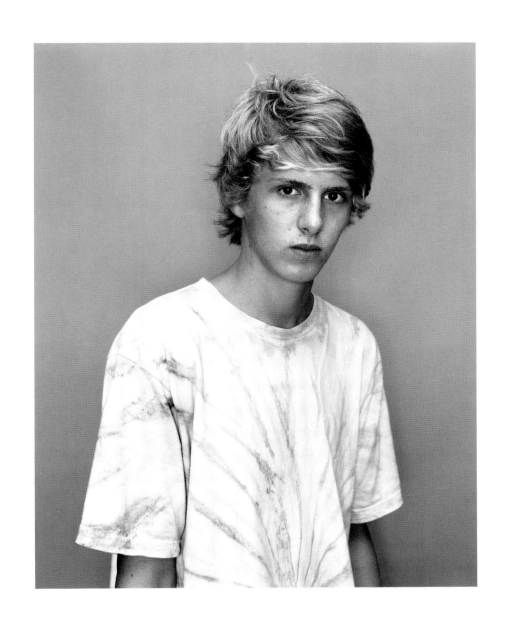

Aus/from *A Shimmer of Possibility*, 2005/06

316/317 Ohne Titel/untitled (Louisiana), 2005/06, 5-teilig/5-parts
318–325 Ohne Titel/untitled (New York/North Dakota), 2005, 15-teilig/15-parts

PAUL GRAHAM

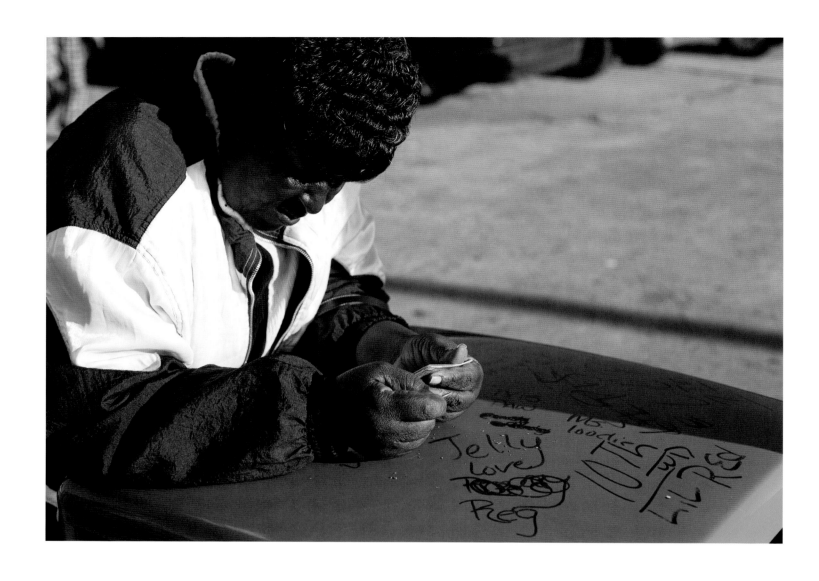

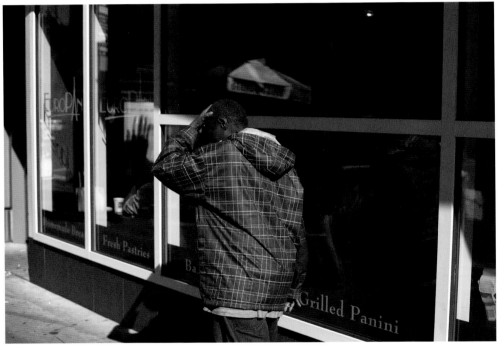

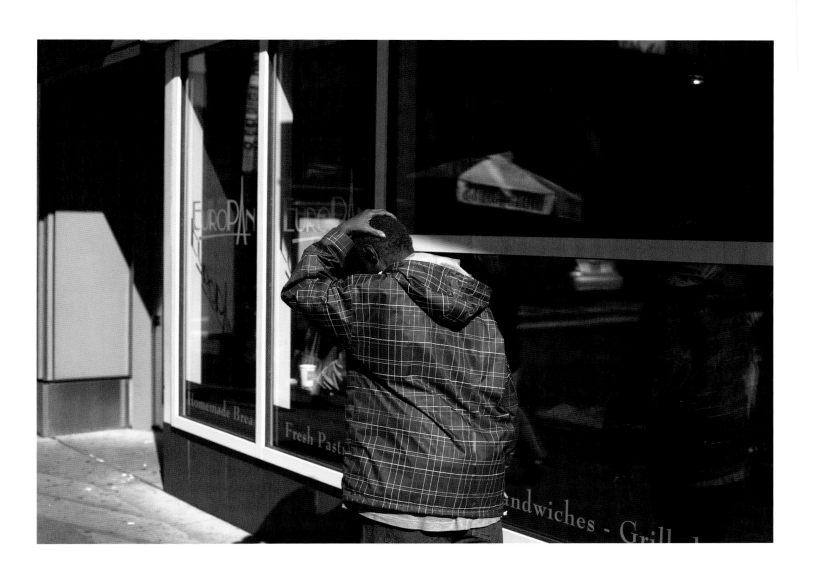

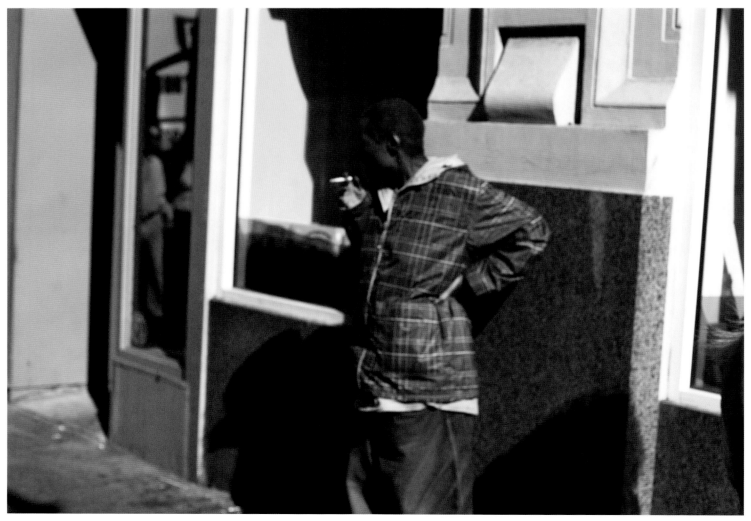

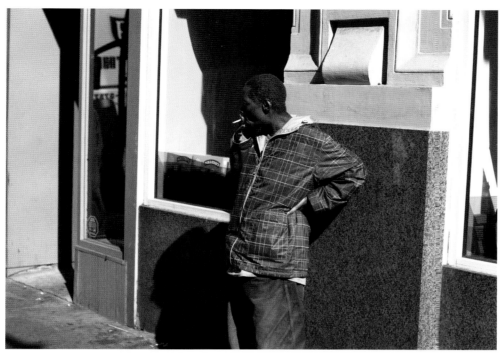

Aus/from *Luxury*, 2004–2011

MARTIN PARR

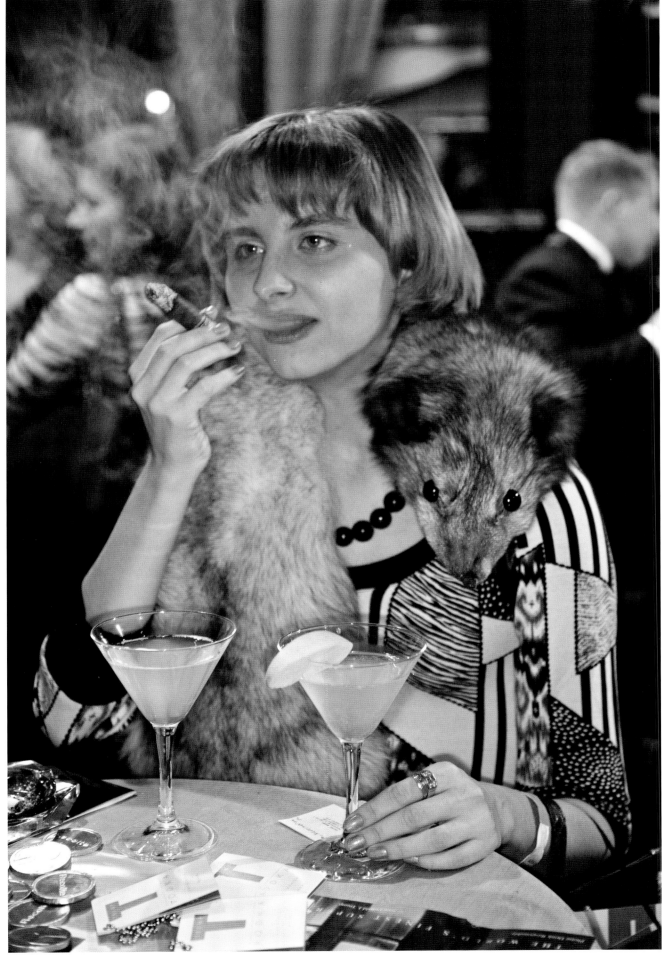

Aus/from *German Portraits*, 2008/2011

340–351 Alle Arbeiten ohne Titel/all works untitled

BORIS MIKHAILOV

344

SAMMLUNG UNSERER WÜNSCHE/JUST THE COLLECTION ALL OF US WOULD WISH FOR, Thomas Weski
ZUGESPITZTE MITTLERE BEFUNDE/UNCOMMON PICTURES OF THE COMMONPLACE, Inka Schube

Da ist zunächst der Ausstellungstitel, PHOTOGRAPHY CALLING!, der in Verbindung mit dem Ausrufezeichen an den bekannten Song „London Calling!" der Punkband *The Clash* von 1979 erinnert. Jenes drängende Rufen um Beachtung, Verlangen und Versuchung nimmt der Titel auf und setzt es für die Fotografie ein. Fotografie im Kunstmuseum, das ist noch immer ungewöhnlich, gibt es doch im wiedervereinigten Deutschland bei gutmütiger Zählweise immer noch nicht mehr als zwei Handvoll Museen, die sich kontinuierlich mit der Fotografie als Kunstform beschäftigen. Oft geschieht dies nur in Form von Ausstellungen, denn gerade einmal die Hälfte der Institutionen verfügt über eigene Sammlungen. Der Ausstellungstitel will also den Blick auf die Fotografie als Kunstform lenken und damit auf deren mangelnde Akzeptanz – trotz des großen Erfolgs der deutschen Fotografie auf dem internationalen Kunstmarkt in den letzten fünfzehn Jahren.

Zugleich strahlt der Titel einen Appell aus, der einen Beginn markieren will. Das Sprengel Museum Hannover hat seit seiner Gründung 1979 Fotografien gezeigt und damals eine Initiative hannoverscher Fotografen in das Haus integriert, die bereits 1971, und damit als Erste in Deutschland, einen Schauraum für Fotografie gegründet hatten. 1992 wurde im Rahmen der ersten Erweiterung des Museums eine Kuratorenstelle geschaffen und nach Amtsantritt des jetzigen Direktors Ulrich Krempel 1993 eine Abteilung und Sammlung für Fotografie und Medien gegründet. In einem Raum für Fotografie wurden seitdem zahlreiche Ausstellungen zur zeitgenössischen und historischen Fotografie durchgeführt und zusätzlich die Fotografie immer wieder in die Präsentation der Schausammlung der traditionellen Bildenden Künste integriert – und das zu einem Zeitpunkt, als die künstlerischen Techniken üblicherweise noch getrennt gezeigt wurden. Mit dem „SPECTRUM" Internationaler Preis für Fotografie der Stiftung Niedersachsen, der 1995 erstmals verliehen wurde, erhielt die Fotografie im Museum eine externe Lobby, die zugleich eine herausgehobene Präsenz für das Medium bedeutete, ist doch die Auszeichnung mit einer großen Präsentation der Preisträgerin oder des Preisträgers in der Wechselausstellungshalle und der Veröffentlichung eines Künstlerbuchs verbunden.

Wegen der angespannten Lage der öffentlichen Haushalte verfügt das Museum im Vergleich zu seinen Anfangsjahren nur noch über einen bescheidenen Ankaufsetat. Die Erschwerung von Zugriffsmöglichkeiten auf Kunstwerke, wie sie dem Sammlungsauftrag des Hauses entsprechen, führt dazu, dass wesentliche Arbeiten der Gegenwartskunst nicht mehr erworben werden können. Der Freundeskreis des Sprengel Museum Hannover reagiert gezielt auf dieses Defizit und sichert Werke für die Sammlung. So sehr dieses großzügige Engagement zu begrüßen ist, kann das Haus allein durch diese Unterstützung den zeitgenössischen Diskurs perspektivisch nicht mehr in seiner Sammlung belegen.

An dieser Stelle setzt das Förderengagement der Niedersächsischen Sparkassenstiftung ein. Als diese 1997 beschloss, im Rahmen des Kulturprogramms der Weltausstellung EXPO 2000 zwei große Projekte im Sprengel Museum Hannover zu realisieren, hat sie ihr eigenes Sammlungskonzept gezielt um die nationale und internationale Fotografie erweitert. Die im Vorfeld der Ausstellung *How you look at it. Fotografien des 20. Jahrhunderts* erworbenen Werkgruppen stilbildender Fotografen wurden schließlich 2000 im Rahmen dieser Präsentation in einen Dialog mit Gemälden und Skulpturen gesetzt. Seitdem hat die Stiftung auf Empfehlung ihres Beirats kontinuierlich weitere Arbeiten von Fotografinnen und Fotografen angekauft. Hier wurden vor allem Positionen von Künstlerinnen und Künstlern erworben, die mit den Mitteln der Schwarzweißfotografie arbeiten. Aufgrund der technischen Entwicklungen und des Einstellens der Produktion bestimmter fotografischer Materialien handelt es sich bei diesem Kunstmarktsegment um ein fast abgeschlossenes Sammlungsgebiet. Dabei galt es, vorrangig Werkgruppen jener Fotografinnen und Fotografen zu sichern, die ab den 1960er-Jahren tätig waren. Die Sammlung der Niedersächsischen Sparkassenstiftung umfasst Werkgruppen von über zwanzig Künstlerinnen und Künstlern, die sich in der Regel einer Fotografie im dokumentarischen Stil und ihrer Tradition verschrieben haben, und ist mit diesem Charakteristikum einmalig.

Der amerikanische Fotograf Walker Evans (1903–1975) hat den Begriff des dokumentarischen Stils 1971 geprägt. Als er zum Ende seines Lebens gefragt wurde, ob seine Fotografien Dokumente seien, antwortete er, die Polizei stelle fotografische Dokumente eines Tatorts her. Bei seinen Bildern aber handele es sich um Fotografien im dokumentarischen Stil. Nicht das Dokument im wissenschaftlichen Sinn ist also Ziel der in dieser Richtung agierenden Fotografen, sondern die subjektive Sicht im Ausdruck des Dokumentarischen. Somit geht es bei den Werkgruppen der in der Sammlung vertretenen Autorinnen und Autoren nicht um eine klassische Form der Dokumentarfotografie, deren Ziel die fotografische Verdoppelung des Motivs ist, sondern darum, eine persönliche Sehweise zu formulieren, die auch das Verhältnis des Fotografen zur Welt zeigt. Darüber hinaus verbindet die ausgewählten Fotografen ihr Interesse an einer gültigen Bildfindung. Ihre Werke dienen nicht vorrangig der Illustration gesellschaftlicher Themen. Vielmehr reflektieren ihre Arbeiten diese und beziehen ihren Stoff aus der Auseinandersetzung mit ihnen, sind aber als künstlerische Selbstäußerungen zu verstehen, die sich aus dem Dialog mit der realen Situation entwickeln. In ihren Fotografien formulieren sie einen Glauben an das Kunstwerk als ästhetisches Objekt mit eigenen Gesetzmäßigkeiten. Dabei ist die Darstellung der Realität immer das Resultat des individuellen künstlerischen Vorgehens, die Wirklichkeit in den Bildern als eine Konstruktion von Authentizität, als Vorstellung von Welt zu verstehen.

Die Bilder der in der Ausstellung gezeigten Fotografinnen und Fotografen aus der Sammlung der Niedersächsischen Sparkassenstiftung setzen nicht auf die Darstellung des

Sensationellen und überhöhen auch nicht das Alltägliche. Journalistische Fotografien hingegen müssen komplexe gesellschaftliche Zusammenhänge notwendigerweise zuspitzen, um in ihrem Verwertungszusammenhang zu funktionieren. Die Komprimierung des Wesentlichen führt aber bei ihnen zur Verkürzung der Aussage, und darüber hinaus verfügen diese Arbeiten aus dem angewandten Bereich auch über keine lange visuelle Haltbarkeit. Diesem schnellen Verfallsprozess setzen die im dokumentarischen Stil arbeitenden Fotografen vor allem das Moment einer Verlangsamung entgegen. Bedeutsam ist hier der subtile und zurückhaltende Einsatz der künstlerischen Mittel, der den Rezipienten auf der Basis eines Sehangebots aktiv miteinbezieht. Ein weiteres Moment besteht in einer Einordnung der als Einzelbilder komponierten Werke in einen Kontext – eine Serie, ein Tableau, eine Reihe. Die weitere Betrachtungsebene entsteht in der Summe der Exponate, auf deren Grundlage das jeweilige Einzelbild erst in seiner vollen formalen und inhaltlichen Bedeutung zu erfassen ist. Im Gegensatz zur Fotoreportage, die aus dem Nebeneinander visueller Superlative besteht, wird so eine Dramaturgie des Alltäglichen entwickelt, die auch das scheinbar Nebensächliche zulässt und ihm Bedeutung zugesteht. Die Ergebnisse dieser künstlerischen Konstruktion faszinieren nachhaltig, weil sie nicht einfach die Fantasie der Betrachter illustrieren oder sichtbare Phänomene bildlich überhöhen. Vielmehr haben die Fotografen die Objekte bei der Gestaltung ihrer Aufnahmen mit ihren Mitteln in einen beziehungsreichen Dialog gesetzt, an dem die Betrachter teilhaben können. Weil sie sie als gleichberechtigte Partner bei der Interpretation der Wirklichkeit begreifen und die Möglichkeit individueller Deutung zulassen, verankern sich die Bilder fest im Gedächtnis und entfalten dort ihre Wirkung. Nicht der schnelle Konsum der Fotografien steht also im Vordergrund, sondern ihr Verständnis auf bildlicher und inhaltlicher Ebene. Dieser Prozess kann in der Folge so sehr die Wahrnehmung beherrschen, dass bei der realen Begegnung mit den Objekten in diesen immer auch die Motive der künstlerischen Arbeit gesehen werden. Ist dies der Fall, hat der Fotograf das Unterbewusstsein des Betrachters kolonisiert und für ein verändertes Verständnis der Welt sensibilisiert.

Viele der in der Sammlung vertretenen Positionen sind mit einer fotografischen Auffassung verbunden, die der amerikanische Kurator John Szarkowski (1925–2007) ab 1962 im Museum of Modern Art in New York wesentlich gefördert hat. Fotografen wie Diane Arbus, Lee Friedlander und Garry Winogrand gehörten zu einer jüngeren Generation, die gegen das damals vorherrschende Establishment, die sogenannten Meisterfotografen, rebellierten. Im Gegensatz zu den Werken der Arrivierten waren ihre Fotografien nicht von technischer Perfektion, strenger Komposition und einem bedeutungsvoll überhöhten Inhalt gekennzeichnet. Sie stellten vielmehr die traditionellen Standards auf den Kopf, indem sie ihre unkonventionell formulierte, persönliche Sicht auf die Alltagswelt betonten. Eine Fotografie auszuüben, die persönlich, aber nicht privat war, die Authentizität in der Fotografie als ein Konstrukt ver-

stand, dessen fotografische Ergebnisse nur als formal gelöste Bilder ang dauernde Gültigkeit erlangen, zeichnete diese Fotografen aus. Ihre Einstellung erschien vielen in einer Zeit, in der der Journalismus mit der Berichterstattung eine letzte Blütezeit vor der Übernahme dieser reportierenden Tätigkeiten durch das Fernsehen genoss, als provokative Verweigerung.

Zu dieser Gruppe stilbildender Fotografinnen und Fotografen der 1960er-Jahre zählt auch der Amerikaner William Eggleston, den John Szarkowski 1976 in einer Soloshow vorstellte. Die Präsentation bestand aus farbgesättigten Dye-Transfer-Prints, einem damals in der Werbung eingesetzten Bildherstellungsverfahren, die in scheinbaren Schnappschüssen das direkte Umfeld des Fotografen zeigten. Die Besonderheit seiner Bildsprache liegt in der Konstruktion eines Paradoxes, das von Zugänglichkeit und Verfremdung geprägt ist. Die Farbe, die mittenbetonte Gestaltung seiner Aufnahmen, die scheinbar banalen Motive lassen an Erinnerungsfotos denken, aber zugleich verleiht der Autor seinen Gegenständen durch die gezielte Steuerung der Kolorierung, der Perspektive und des Motivanschnitts eine zusätzliche Bedeutungsebene und oft ein fremdartiges Eigenleben.

Zu diesen und anderen stilbildenden Positionen aus der Sammlung der Niedersächsischen Sparkassenstiftung, die etwa ein Drittel der Exponate von PHOTOGRAPHY CALLING! ausmachen, kommen Arbeiten von Fotografinnen und Fotografen, die in den letzten Jahren große internationale Beachtung gefunden haben, aber bislang nicht in der Sammlung vertreten sind. Dazu zählen zum Beispiel Werke von Thomas Demand, Andreas Gursky oder Jeff Wall. Diese Fotografen haben neben ihren individuellen Themen besondere Formen der Präsentation ihrer Arbeiten entwickelt und das Tafelbildformat in die Fotografie eingeführt. Während die eingangs erwähnten Fotografen noch ganz auf die Kraft ihrer Bilder vertrauten und sich kaum um die Form ihrer Präsentation kümmerten – eine prägende Ausnahme spielt hier der Berliner Fotograf Michael Schmidt, der bereits in den 1980er-Jahren unterschiedliche Präsentations- und Publikationsformen für seine Projekte realisierte –, übernahm die nachfolgende Generation besonders in Fragen der Repräsentanz, des Kontextes, der Distribution und Publikation ihres Werks eine Verantwortung, die bislang nur aus der Bildenden Kunst bekannt war. Inzwischen haben diese Fotografen einen vor Kurzem noch unvorstellbaren Erfolg auf dem Kunstmarkt, und ihre Werke erzielen Höchstpreise.

Seit einiger Zeit plant das Sprengel Museum Hannover einen Erweiterungsbau, der neben weiteren Sammlungs- und Ausstellungsräumen vor allem dringend benötigte Depots gewährleisten soll. Auch die Sammlung für Fotografie und Medien des Hauses soll geeignete Räume für ihre Bestände erhalten. Da heute die Mehrzahl der Fotografen mit Farbmaterial arbeitet, sind für die Aufbewahrung besondere Anforderungen zu beachten. In der Regel beginnt der Verfallsprozess eines Farbabzugs – wenn auch am Anfang nicht sichtbar – im Moment, in dem er die Entwicklungsmaschine im Labor verlässt. Während das Material Anfang der 1970er-Jahre sehr schnell alterte, der

Schichtträger brüchig wurde und sich die Farben zu einem monochromen Magenta veränderten, sind heutige Filme und Papiere länger beständig. Aber trotzdem verändern sich die Farben auch heute, vor allem wenn die Werke zu viel oder zu lange dem Licht und im Besonderen dem Tageslicht ausgesetzt sind. Der Verfallsprozess lässt sich durch eine Lagerung im Dunkeln und bei niedrigen Temperaturen hinauszögern. Eine Institution wie das Museum of Modern Art in New York, das über eine einzigartige Sammlung von Fotografien verfügt, lagert daher seine Prints in speziell ausgestatteten Räumen in eigens angefertigten Kühlschränken und verlängert so die Lebensdauer seiner Bestände. In Deutschland gibt es nicht eine einzige Institution, die über vergleichbare Einrichtungen verfügt. Konservatorisches Fachwissen haben in diesem Bereich nur einige wenige Fotografierestauratoren, keiner von ihnen ist an einem Haus angestellt. Dem Sprengel Museum Hannover bietet sich durch den angestrebten Erweiterungsbau die Chance, die Grundlagen zu schaffen, um bei der Fotografie auch im Bereich der Pflege, Aufbewahrung und Forschung ein Kompetenzzentrum zu werden und damit in Deutschland über ein Alleinstellungsmerkmal zu verfügen. PHOTOGRAPHY CALLING! steht auch für eine Partnerschaft zwischen dem Sprengel Museum Hannover und der Niedersächsischen Sparkassenstiftung, die nicht ausschließt, dass am Ende dieses Prozesses die Übergabe der Sammlung in einer noch näher zu definierenden Form an das Haus erfolgen könnte, um die Synergien vor Ort mit dem Ziel eines Ausstrahlens in den Norden zu bündeln.

Das letzte Drittel der Exponate der Ausstellung besteht aus Arbeiten von jüngeren oder im Moment noch weniger arrivierten Fotografinnen und Fotografen. Hier ist ein Zugang zur Fotografie zu beobachten, der sich bewusst auf die Geschichte des Mediums und ihre stilprägenden Protagonisten bezieht, Eingeführtes variiert und aktualisiert oder eine spielerische Souveränität dabei entwickelt, in die Grenzzonen des Mediums vorzustoßen. Die einzelnen Künstlerbeiträge dieser untereinander nicht immer eindeutig abzugrenzenden Gruppierungen, die aber durch die Haltung der künstlerischen Anwendung ihres Mediums vereint sind, werden in der Ausstellung in der Regel paarweise in einen fruchtbaren Dialog über individuellen Zugang und Thematik sowie über Raum und Zeit – und darüber hinaus auch noch generationenübergreifend – gesetzt.

PHOTOGRAPHY CALLING! vereint Aspekte einer Sammlungspräsentation und einer Ausstellung. Beiden ist gemeinsam, dass ihre zeitliche Dauer – im Bereich der Fotografie allein aus konservatorischen Gründen – begrenzt ist, aber ihre Tempi unterschiedlich sind. Die Sammlungspräsentation ist in der Regel langfristig angelegt, der Takt der Wechselausstellung auf wenige Wochen Laufzeit beschränkt. Diese Konvention erweitert PHOTOGRAPHY CALLING! durch die Einführung von drei zeitlich aufeinanderfolgenden Projekträumen im Rahmen der Ausstellung, die exemplarisch unterschiedliche Zugänge zur künstlerischen Fotografie aufzeigen: die des Künstlers Thierry Geoffroy, der sich Bilder der Alltagskultur aneignet und in einen neuen Kontext stellt, die des Bibliophilen Markus Schaden, der die Möglichkeiten des Fotografiebuchs demonstriert, und die des Sammlers Wilhelm Schürmann, der in seiner Installation die Fotografie in eine visuelle Beziehung zu den anderen Künsten setzt. In regelmäßigen Abständen erfährt PHOTOGRAPHY CALLING! so ein Addendum, ein Regulativ oder eine Kommentierung, die ihre autoritäre Geste, die jeder Präsentation innewohnt, infrage stellt und dem Statischen das Prozessuale hinzufügt. Die Ausstellung, die bereits das Ergebnis einer Ko-Kuratorenschaft ist und daher zwei Interpretationsansätze vereint, wird so punktuell um eine zusätzliche Lesart erweitert. Alles in allem will PHOTOGRAPHY CALLING! den Spagat wagen, die Fachwelt zu überraschen und einen ernsthaften Diskurs zu führen sowie die zeitgenössische künstlerische Fotografie auf hohem Niveau zu popularisieren und damit für eine größere Öffentlichkeit zugänglich zu machen.

Am Ende dieses Textes erlaube ich mir einen Traum, in dem wie in einem Märchen Wünsche erfüllt werden – in meinem habe ich drei Wünsche. Als Bernhard Sprengel seine Sammlung der Stadt Hannover und damit der Öffentlichkeit schenkte, hatte er auch den Bildungsauftrag eines Museums im Sinn. Das in das Haus führende Straßenpflaster und die offene Architektur stehen symbolisch für diese Öffnung, die Schwellenängste abbauen und Zugang zu Ergebnissen der Kulturproduktion ermöglichen will. Mein erster Wunsch ist, dass die Bürgerinnen und Bürger wieder kostenlosen Zugang zur Sammlung des Hauses, zu den Kunstwerken erhalten, die ihnen geschenkt wurden oder deren Ankauf sie mit ihren Steuermitteln ermöglicht haben. Mein zweiter Wunsch ist, dass das Sprengel Museum Hannover die Sammlung der Niedersächsischen Sparkassenstiftung dauerhaft erhält, diese damit in den ihr gebührenden öffentlichen Raum überführt wird und das Haus in diesem Bereich in der ersten Liga verankert. Mein dritter Wunsch ist, dass sich eine zusätzliche Lobby für die Fotografie als Kunstform bildet. Fast alle Werke, die nicht zum Sammlungsbestand gehören, werden zum Verkauf angeboten. Wenn sich die Partner, die Träger des Museums und der Förderer, verbinden und in einer außerordentlichen Kraftanstrengung diese Fotografien mithilfe weiterer Unterstützer sichern, solange es noch möglich ist, entsteht in der Folge eine einzigartige Sammlung *unserer* gemeinsamen Wünsche.

Thomas Weski

The first thing that strikes us is the title of the exhibition, PHOTOGRAPHY CALLING!, which in conjunction with its exclamation mark immediately calls to mind the title "London Calling!" of the 1979 album of the punk band *The Clash*. This time, however, the urgent cry for attention, concern and involvement is being made solely on behalf of photography. Photography at a German art museum—that is still something quite unusual, for not even in post-reunification Germany are there more than a couple of handfuls of art museums (by a generous count) that treat photography as an art genre, and more often than not in the form of visiting exhibitions, as only a good half of these museums have photography collections of their own. Thus the title of the present exhibition is meant to draw attention to photography as an art form and at the same time awaken awareness of its lack of acceptance in Germany despite the enormous success of German photography in the international art market during the last fifteen years.

The plea inherent in the title also marks the beginning of something new. Ever since its foundation in 1979, the Sprengel Museum Hannover has exhibited photography regularly and at that time also assimilated an initiative group of Hanover photographers who had set up a showroom for photography as early as 1971, the very first one in Germany. In 1992, as part of the first museum extension project, a curatorship of photography was created and then followed, in 1993, when the present director Ulrich Krempel first took office, by the establishment of a department and collection of photography and media. Since then, in a special room for photography, numerous exhibitions of contemporary and historical photography have been shown. In addition, works of photography have been integrated again and again into presentations of traditional art genres, even when it was still usual for works of art to be exhibited separately according to medium and technique. With the introduction of the "SPECTRUM" International Award for Photography of the Foundation of Lower Saxony, which was first awarded in 1995, the museum's commitment to photography now had the backing of an external lobby, which in turn meant a higher status for the medium, and not least because this award included a large presentation of the winner's works in the museum's temporary exhibition hall as well as the publication of an accompanying artist's book.

Due to the ongoing strain on public funds, the museum now has only a very modest acquisition budget at its disposal in comparison with its earlier years. This lack of the necessary means of collecting artworks in keeping with the museum's intended purpose has meant that it has no longer been possible to purchase key examples of contemporary art. While the Association of Friends and Patrons of the Sprengel Museum Hannover generously responds to this deficit with welcome acquisitions of works for the museum's collection, there is still a risk that this support alone will in the long run fail to sustain the contemporary discourse within the collection.

This is where the sponsoring commitment of the Niedersächsische Sparkassenstiftung comes in. With its decision in 1997 to realize two large-scale projects at the Sprengel Museum Hannover as part of the EXPO 2000 programme of cultural events, the foundation specifically extended the concept behind its own art collection to include both national and international photography. The groups of works by influential photographers purchased during the run-up to the exhibition *How you look at it. Photographs of the 20th Century* were then shown in this exhibition in a dialogue with paintings and sculptures. Since then, the said foundation has been regularly purchasing works of photography on the recommendations of its advisory board. The purchased works have primarily been those of photographers working in the medium of black and white. In consequence of subsequent further developments in the field of photography and the resulting cessation of the production of certain photographic materials, this segment of the art market virtually represents a closed chapter for the photography collector. It was not least for this reason that the foundation has focused its collection on the works of photographers from 1960 onwards. Besides the photographic works of local and regional artists, the collection of the Niedersächsische Sparkassenstiftung comprises comprehensive series of works by over twenty international photographers. Moreover, the collection is unique in as much as most of these photographers subscribe to the documentary style and tradition of photography.

The American photographer Walker Evans (1903–1975) coined the term "documentary style" in 1971. When he was asked towards the end of his life whether his photographs were documents, he replied that it was the police who made photographic documents of a crime scene while his images were photographs in the documentary style. Thus it is not documentation in the scientific or academic sense that is the aim of photographers who work in this style but rather a subjective view expressed documentarily. The photographers represented in the said collection are not therefore concerned with a classical form of documentary photography, the aim of which is basically an objective photographic reproduction of the motif, but rather with the formulation of a personal way of seeing things, of the way the photographer relates to the world. What the selected photographers also have in common is their interest in creating images of universal validity. Their works do not serve primarily to illustrate social issues but rather reflect upon them and draw their content from a subjective preoccupation with them. They must be understood, in other words, as works of artistic self-expression that have developed out of the artist's dialogue with the real situation. Through their photographs they articulate their belief in the work of art as an aesthetic object with its own inherent laws. The representation of reality in their photo-

graphs is always to be understood as the result of their individual approach, as their own construction of authenticity, as their own way of seeing the world.

The exhibited photographs from the collection of the Niedersächsische Sparkassenstiftung seek neither to represent the sensational nor to enhance the commonplace. In this regard they differ strongly from journalistic photographs, which must necessarily exaggerate complex social relationships in order to function within their context of use. The resulting contraction of essential content in turn results in a shortening and quickening of the message, such that the visual endurance of these photographs is limited. This rapid process of "visual decay" is countered by photographers working in the documentary style mainly by a moment of "visual deceleration" achieved through the subtle and restrained use of artistic devices that actively involve the viewer in what he sees. Such a decelerating device, for example, consists in the arrangement of individually composed images in a larger context—a series, a succession, a tableau—which, as the sum of the individual images, creates an additional level of reception, on the basis of which each individual image can first be fully grasped in terms of both its form and its content. Thus, unlike the juxtaposition of visual superlatives typical of reportage photography, a scenario of the commonplace unravels, involving even the seemingly unimportant and giving it meaning. These serial constructions sustain the viewer's interest because they do not simply illustrate the viewer's imagination or visually heighten visible phenomena. On the contrary, the photographers have arranged their motifs in a relational dialogue that also involves the viewer. As the viewer functions as an equal partner in the interpretation of reality and is therefore free to interpret this reality in his own individual way, the images become firmly anchored in his memory and exert their effect there. Thus it is not the rapid consumption of images that is uppermost, but rather our understanding of them both in form and in content. This process may dominate one's perception to such an extent that even when one is confronted by the depicted objects in reality one can still see the motifs of the artwork in one's mind's eye. Whenever this is indeed the case, the photographer has succeeded in colonizing the viewer's subconscious and sensitized it to a new and different understanding of the world.

Many of the photographers represented in the collection can be linked to an approach to photography that had essentially been furthered by the American curator John Szarkowski (1925–2007) at the Museum of Modern Art in New York after 1962. Such photographers as Diane Arbus, Lee Friedlander and Garry Winogrand belonged to a younger generation that was rebelling against the then prevailing establishment of so-called master photographers. Unlike their successful predecessors, these young photographers attached no importance to technical perfection, strictness of composition and heightened significance of content. Indeed, they upset traditional standards with their unconventionally articulated, personal views of the everyday world. These photographers were distinguished by a kind of photography that was personal but not private, a kind of photography for which authenticity was a construct, the photographic results of which could attain lasting validity only as formally resolved images. At a time when photojournalism was enjoying its last heyday before its reporting activities were taken over by television, this attitude was considered by many as a provocative denial.

One of the photographers who belonged to this influential group of the 1960s is the American photographer William Eggleston, whom John Szarkowski presented in a solo exhibition in 1976. The exhibits comprised highly color-saturated dye-transfer prints—photographs produced by an imaging process commonly used in advertising at that time—that captured in an apparent snapshot manner the immediate surroundings of the photographer. The peculiarity of Eggleston's visual language lies in his paradoxical combination of accessibility and alienation. While the colors, the centralized composition and the seemingly commonplace motifs remind one of souvenir snapshots, the photographer systematically controls the coloration, perspective and cropping of the image, giving the subject matter an additional level of meaning, not to say a strangeness all its own.

Accounting for approximately one third of the exhibits in the exhibition PHOTOGRAPHY CALLING!, these and other influential photographers from the collection of the Niedersächsische Sparkassenstiftung will be complemented by photographers—likewise one third—who have achieved great international acclaim in recent years but have so far not found their way into the collection. These exhibits include works by Thomas Demand, Andreas Gursky, Thomas Ruff, Thomas Struth and Jeff Wall. Besides their respective individuality of theme, these photographers have developed special forms of presentation for their works and have also introduced formats the size of panel paintings into photography. While the photographers mentioned at the beginning relied solely on the inherent strength of their images (with the exception of the Berlin photographer Michael Schmidt, who was already realizing different forms of presentation and publication for his projects in the 1980s), the photographers of the following generation assume much the same responsibility as painters and sculptors for the presentation of their works, especially where questions of representation, context, distribution and publication are concerned. These photographers have meanwhile been achieving an enormous success on the art market—unimaginable only a short time ago—and their works are now fetching the highest conceivable prices.

For some time now the Sprengel Museum Hannover has been planning an extension building that will provide not only additional space for exhibitions and collections but also urgently needed storage facilities. There will also be suitable storage rooms for the collection of the museum's department of photography and media. As the majority of photographers today work

in color, special requirements must be observed for this medium. As a rule, the deterioration of a color print—albeit not discernible at the beginning—commences immediately the print comes out of the developing machine. While photographic color prints at the beginning of the 1970s aged very quickly (the emulsion support became brittle and the colors changed to a monochrome magenta), today's films and papers are considerably more durable after processing. Nonetheless, even today, colors are still prone to change, above all if the prints are exposed to light, especially daylight. The deterioration process can be considerably delayed by storing the prints in the dark and at low temperatures. It is not without good reason that an institution like the Museum of Modern Art in New York, which owns a unique collection of photography, stores its prints in specially equipped rooms in custom-built refrigerators. There is not a single institution in Germany that has comparable facilities at its disposal. Only a few photography restorers possess the necessary conservation know-how to this end, and none of them works in the service of a museum. The Sprengel Museum Hannover could make its planned extension an opportunity to become a center of competence for conservation, storage and research precisely in this field. Indeed, it could boast the status of being the only competence centre of its kind in Germany. PHOTOGRAPHY CALLING! stands for a partnership between the Sprengel Museum Hannover and the Niedersächsische Sparkassenstiftung too, a partnership that does not preclude the possibility of a transfer of the collection to the museum, in some form yet to be determined, thus combining on-the-spot synergies with the foundation's set aim of reaching out to the North.

The last third of the exhibits comprises the works of younger photographers or of emerging photographers who have not yet attained full renown. These photographers in particular are marked by an approach to photography that consciously refers to the history of the medium and its influential protagonists, varying and actualizing the established or developing a playful mastery that enables them to push against the very frontiers of the medium. Although these artists' individual contributions to the exhibition do not always permit distinct categorization into this or that group, there is one thing that unites them all: their dedication to photography as an art form. Generally exhibited in pairs, the works of these young artists conduct a fruitful dialogue on their respective approaches and themes, a dialogue that seemingly reaches across time and space—and generations, too.

PHOTOGRAPHY CALLING! brings together two different kinds of presentation, that of a permanent collection and that of a temporary exhibition. What the two kinds of presentation have in common is their limited duration, not least for conservation reasons, although the actual durations differ. A presentation of works from a permanent collection is usually intended to run for a relatively long period, while the duration of a temporary exhibition is normally limited to just a few weeks. This convention has now been extended by PHOTOGRAPHY CALLING! through the inclusion of three project room exhibi-

tions scheduled to take place one after the other. These exhibitions will exemplify different approaches to artistic photography—that of the artist Thierry Geoffroy, who appropriates images of everyday culture and places them in a new context; that of the bibliophile Markus Schaden, who demonstrates the possibilities of the limited-edition photography book; and that of the collector Wilhelm Schürmann, whose installation creates a visual rapport between photography and the other arts.

PHOTOGRAPHY CALLING! will in other words be modified at regular intervals by different addenda that not only call in question the claim to authority that resides in every presentation but also augment the static with the dynamic. Thus the exhibition, which is the product of a joint curatorship and hence already unites two interpretative approaches, will be offering, successively, further openings for interpretation. All in all, PHOTOGRAPHY CALLING! will be risking a precarious balancing act between, on the one hand, surprising the art world and initiating a serious discourse and, on the other, popularizing high-level contemporary artistic photography and making it accessible to a wider audience.

I should like to conclude this essay by relating a dream in which I have three wishes, all of which come true, just as in a fairytale. When Bernhard Sprengel donated his collection to the City of Hanover, and hence to the public at large, he had the educational mission of a museum in mind. The street paving leading into the museum building and the building's open architecture together symbolize the free access to works of cultural production, where people need have no fears or inhibitions about crossing the museum's threshold. My first wish is that members of the public will again be afforded free-of-charge admission to the museum's collection, to the works of art that have been donated to them or acquired with public funds raised through their taxes. My second wish is that the Sprengel Museum Hannover will be permanently entrusted with the care of the collection of the Niedersächsische Sparkassenstiftung, thus enabling its accommodation in a befitting public place and, by the same token, raising its own standing in this field to that of a "top-of-the-league" museum. My third wish is that an additional lobby for photography as an art form will come into being. Almost all of the works not belonging to the collections are for sale. If the partners, the patrons of the museum and the private sponsor, were to join forces in an extraordinary effort to acquire these photographs for as long as they are still available, if necessary with the help of other donors, the result would be a most unique collection—in fact just the collection *all of us* would wish for.

PHOTOGRAPHY CALLING! ist, nach *How you look at it. Foto-grafien des 20. Jahrhunderts* im Jahr 2000[1] und *Cruel & Tender* im Jahr 2003/04[2], das dritte große europäische Ausstellungs-projekt, das sich – geleitet von dem 1971 von dem amerikani-schen Fotografen Walker Evans begründeten Begriff des „dokumentarischen Stils" – mit der jüngeren Geschichte der künstlerischen Fotografie und ihrer Gegenwart auseinandersetzt.

Die Sammlung der Niedersächsischen Sparkassen-stiftung konzentriert sich im Bereich der Fotografie auf Werk-gruppen, die eben diesem Stil zuzurechnen sind. Dies zeichnet sie aus und verleiht ihr eine auch im internationalen Vergleich herausragende innere Stringenz. Nun gilt es, diese Sammlung in die Zukunft zu denken und sie sowohl im Hinblick auf mögli-che institutionelle Partnerschaften – darüber ist in diesem Buch an anderer Stelle zu lesen – als auch inhaltlich weiterzuentwickeln.

Wie kann dies unter Beibehaltung ihrer besonderen Qualität geschehen?

Was meint „Fotografie im dokumentarischen Stil" heute – vierzig Jahre, nachdem Walker Evans diesen Begriff prägte?

Thomas Weski entwickelt anlässlich der Ausstellung *How you look at it* eine Geschichte dieses fotografischen Stils und seiner Charakteristika aus einem seit der Mitte des 19. Jahrhunderts geführten Disput zwischen unterschiedlichen fotografischen Strömungen[3]: Während auf der einen Seite bis über den Ersten Weltkrieg hinaus die Piktorialisten einen der Malerei ähnlichen Ausdruck ihrer Werke anstreben und sich dabei, den künstlerischen Strömungen ihrer Zeit gemäß, vor allem dem Symbolismus und dem Impressionismus verpflichtet fühlen, steht auf der anderen Seite eine „harte und reine Anwendung des Mediums". „[...] man komponiere das Bild, das man aufnehmen möchte, so gründlich, dass das Negativ absolut perfekt ausfällt und keiner oder nur geringer Manipulationen bedarf", definiert Sadakichi Hartmann 1914 den sinnverwandten Begriff der „straight photography".[4] In Deutschland prägt Gustav Hartlaub 1924 den Begriff der Neuen Sachlichkeit, „unter den im Bereich der Fotografie vor allem Albert Renger-Patzsch und August Sander fielen".[5] Die Wortkombination aus „dokumentarisch" und „Fotografie" ist wenig später in Frank-reich erstmals anzutreffen. Der Kritiker Christian Zervos verwendet ihn 1928 in einer Auseinandersetzung unter anderem mit Fotografien von Eugène Atget (1857–1927), André Kertész (1884–1985) und Charles Sheeler (1883–1965).[6]

In allen drei Fällen dienen die Begrifflichkeiten der Ab-grenzung von ästhetisch-fotografischen Praktiken, bei denen die Präzision fotografischer Wiedergabe durch Eingriffe und Überformungen im Sinne des Malerischen untergraben wird.

Für Walker Evans sind diese Debatten 1971 bereits Geschichte. Auf den Begriff der dokumentarischen Fotografie reagiert er mit einer Richtigstellung: „The term should be documentary style ... You see, a document has use, whereas art is really useless. Therefore art is never a document, although it can adopt that style."[7]

Was aber ist das Besondere dieses dokumentarischen Stils, was zeichnet ihn aus?

„Das ‚So ist es gewesen', die Wiedererkennbarkeit, die Übereinstimmung von Motiv und Bild", schreibt Thomas Weski, „garantiert ihren Erfolg. Nachvollziehbar, einzuordnen und vergleichbar müssen diese einem strengen Regelwerk unter-zogenen Bilder sein, um als Dokumente funktionieren zu können. Walker Evans interessierte sich genau für diese Eigenschaften einer dokumentarischen Fotografie, denn er wollte Klarheit, Präzision und Lesbarkeit in seine Form der Fotografie über-tragen. Seine Bilder sollten keine vordergründige künstlerische Handschrift tragen, die den Bildgegenstand überlagert, sondern diesen vielmehr zum Studium und zur Analyse freigeben. Ihre besondere Qualität beziehen die im Sinne des Konzeptes richtigen Fotografien, die den dokumentarischen Stil zitieren, aus der Differenz zwischen Motiv und Bild, aus der künstle-rischen Konstruktion auf der Grundlage der Wirklichkeits-beschreibung. Nicht die einfache Verdoppelung ist also gemeint, sondern der Wunsch, das Spezifische, das Unsag-bare, das Besondere auf der Folie des Bekannten durch das Ver-schieben der Betrachtungsperspektive zu betonen. Scheinbar vertraut und auf den ersten Blick der reinen Dokumentation zugeordnet, entwickeln diese Fotografien beim Betrachter erst mit der Zeit ihre Qualität und in der Folge ihre Akzeptanz als künstlerische Selbstäußerung im Dialog mit der Welt."[8]

PHOTOGRAPHY CALLING! weitet den hier beschrie-benen Rahmen. Auch wenn viele der vorgestellten Werk-gruppen „richtig" im Sinne von Walker Evans sein dürften, so werden ihnen künstlerische Positionen beigestellt, die sich an den Randzonen bewegen und die sich, wie etwa die des Fotografen Jochen Lempert, mit der historischen Konstruktion der Idee von Objektivität auseinandersetzen. Was bedeutet das Anknüpfen an fotografische Darstellungsweisen, die in ihrer strikten Orientierung auf das Objekt der Darstellung auf die Wissenschaftsfotografie des 19. Jahrhunderts Bezug nehmen? Schlagen sich hier Ordnungsvorstellungen und Kategorisierungs-bestrebungen nieder, die die Entwicklung des Mediums in seinen frühen Jahren begleitet haben? Oder werden diese Methoden eher auf subversiv-subjektive Weise zitiert, nachvoll-zogen und unterwandert? Zählen Arbeiten wie die von Thomas Demand dazu, die im Studio aus Pappe und Papier entstehen und Nachbauten bereits existierender fotografischer Wirklich-keitsausschnitte sind? Oder die von Thomas Ruff am Computer überformten NASA-Aufnahmen der Marsoberfläche? Wie weit lässt sich das Fassungsvermögen dieses Begriffes in die Gegenwart hinein weiten angesichts der Veränderungen in den Techniken unserer Wahrnehmung? Und ist diese Fotografie, als Kunst, wie Walker Evans meint, wirklich „useless" – zweckfrei?

Für die Wissenschaften des 19. Jahrhunderts bestand der Wert der Fotografie vor allem in ihrem Versprechen auf „urteilsfreie Wiedergabe". Die fotografische Maschine „war zugleich Beobachter und Zeichner, frei von inneren Verlockungen

zum Theoretisieren, Anthropomorphisieren, Verschönern oder Interpretieren der Natur. Was der menschliche Beobachter nur durch eiserne Selbstdisziplin erreichen konnte, schaffte die Maschine mühelos – so hoffte man jedenfalls."[9] Die Fotografie versprach eine (als Verfahren auch ethisch-moralisch unterlegte) „Selbstabbildung" der Phänomene und damit eine vorurteilsfreie Objektivität – auch wenn sie und gerade weil sie eine neue, überraschenderweise weniger „göttlich ideale" als vielmehr unvollkommene Natur offenbarte. Der britische Physiker Arthur Mason Worthington (1852–1916) war – bei seinen Studien über das Aufprallverhalten von Tropfen, die der Erforschung der Dynamik von Flüssigkeiten dienten – jahrelang dem „Augenschein nach" von der Schönheit der perfekten und symmetrischen Naturformen betört gewesen. Erst die Fotografie ließ ihn nach Bildern verlangen, die die physikalische Welt in ihrer ganzen Komplexität und asymmetrischen Individualität darstellten.[10]

Der in Hamburg lebende Fotograf ▸ JOCHEN LEMPERT (*1958) steht in einer solchen Tradition. Seine sich in Büchern und Wandinstallationen entfaltenden Bildkosmos berichten vom Miteinander unterschiedlicher Lebensformen. Sie sind zugleich komplexe Auseinandersetzungen an den Schnittstellen zwischen Fotografie- und Wissenschaftsgeschichte.

Jochen Lempert studierte Biologie und arbeitete gemeinsam mit Künstlerkollegen an Experimenten zur Vergänglichkeit filmischen Materials.[11] Seit Anfang der 1990er-Jahre untersucht er mittels der Fotografie – und parallel zu einer fortgesetzten Arbeit als Biologe – die wechselseitigen Beeinflussungen menschlicher, tierischer, pflanzlicher und mikroorganischer Lebensformen und die Möglichkeiten, diese abzubilden.

Lempert greift häufig auf fotografische Verfahren zurück, die in der Wissenschaftsfotografie des 19. Jahrhunderts zur Anwendung kamen und in der surrealistischen Fotografie auf subversive Weise wieder aufgenommen wurden. So sehr er damit einerseits jenseits einer technisch hoch aufgerüsteten Fotografie steht, so sehr ist er andererseits strengstens dem Fotografischen verpflichtet. „Kratzen und Kritzeln auf der Platte"[12] gibt es hier nicht, es sei denn, das zu „Dokumentierende" kratzt und kritzelt selbst, indem es über das lichtempfindliche Papier läuft, hüpft oder fließt. Folgt man den Spuren, die Lempert – wenn auch diskret – mittels der Titel seiner meist luftgetrockneten Baryt-Blätter in diesen poetischen Zeichenkosmos legt, so wird man eingeführt in einen ebenso spielerischen wie substanziellen Diskurs über das Medium im Kontext der Wissenschaftsgeschichte. Man erfährt, dass sich im Blatt *Subjektive Fotografie* die „objektive", da rein fotografische Aufzeichnung der Bewegung eines Himmelskörpers mit der Atem- und Herzschlagbewegung des Körpers des Fotografen überlagert; dass Rudolf Jakob Camerarius (1665–1721), dem zwei Blätter gewidmet sind (S. 200 f.), Mitbegründer einer experimentellen Biologie war und bahnbrechende Entdeckungen zur Sexualität der Pflanze machte; dass Anna Atkins (1799–1871), eine weitere Referenz (S. 194 f.), eine frühe fotografische Technik, die Cyanotypie, verwendete, um präzise

Dokumente wissenschaftlicher Präparate anzufertigen. Ihre Arbeiten werden heute auch ob ihres ästhetischen Reizes geschätzt. Die Aufnahme des Storches im Flug wiederum (S. 197) verweist auf Ottomar Anschütz (1846–1907) und seine berühmten Bilder desselben Motivs. Anschütz leistete mit der Erfindung des Schlitz- oder Rouleau-Verschlusses einen wichtigen Beitrag zur Entwicklung der Momentfotografie und dokumentierte 1893/94 die Flugexperimente Otto Lilienthals. Man muss dies alles nicht wissen, um von diesen Fotografien berührt zu werden: Sie führen ein poetisches Eigenleben, denn sie rufen „innere" Bilder auf. Einen Storch im Flug zu sehen versetzt für einen Moment in einen zeitlosen und utopisch friedvollen Raum. Die experimentell anmutenden Pflanzenaufnahmen erinnern vielleicht an die kindliche Neugier während des Biologieunterrichts. Und die abstrakte, helle Spur des Leuchtkäfers auf dem Fotopapier (S. 198 f.) ruft körperliche Erinnerungen an Fließendes, Gleitendes und Sanftes auf.

In der strengen Verpflichtung auf das Fotografische, in der Überlagerung von individuellen Assoziationen und konkreten Verweisen auf Kultur- und Kunstgeschichte, in ihrem doppelten Charakter als Projektionsflächen und konkretem Wissensspeicher und in der poetisch-subjektiven Subversion objektivierender Bildstrategien weist die ästhetische Praxis von Jochen Lempert wesentliche Merkmale einer Fotografie im dokumentarischen Stil auf. Auch das Serielle, die „Aufsplittung" der Erzählung in einzelne Zeichen[13] und die Notwendigkeit, diese „zerlegte" Welt beim Betrachten der Fotografie neu zusammenzusetzen, zeichnet sie aus. Dennoch ist sie keine Fotografie im dokumentarischen Stil. Aber sie vermag ihre Regeln – wenn auch auf zugespitzte Weise – zu veranschaulichen

Auch ▸ THOMAS DEMAND (*1964) ist, wie Jochen Lempert, niemand, der im Sinne von Walker Evans eine Fotografie im dokumentarischen Stil zitiert. Doch bietet sein Werk gleichfalls eine Annäherung an das Thema. Beider Arbeitsweisen stehen auf den ersten Blick im diametralen Gegensatz zueinander. Während sich bei Lempert die Lebensformen quasi selbst abzubilden scheinen, vermeidet Demand den direkten „Abdruck". Ihn interessiert stattdessen die bereits medial verarbeitete Spur. Er entwirft „Bilderinnerungen"[14], indem er Motive von Fotografien, die in das kollektive Gedächtnis der westlichen Welt eingegangen sind, aus Papier und Pappe in Originalgröße nachbaut. Er fotografiert sie und setzt sie in Tafelbilder um. Die „Modelle" werden zerstört. Es entstehen visuelle Attrappen, potemkinsche Oberflächen. Die zugrunde liegenden Ereignisse bzw. ihre Orte werden ein zweites Mal fiktionalisiert, aber auch „demokratisiert": Sie werden zu Jedermanns-Ding oder -Ort, zu scheinbar beliebigen Flur- oder Büroecken und Vorhängen. Offen bleibt, ob es Teil der künstlerischen Strategie ist, die zugrunde liegenden Ereignisse – wenn auch nicht im Titel, so doch „informell" – zu kommunizieren. Denn es ist eben auch diese Spannung zwischen Zeigen und Nichtzeigen, Nichtsagen und Sagen, in der die Werke von Thomas Demand eine geradezu surreale innere Gespanntheit entwickeln. Dass etwa als Vorlage für *Tribute* (S. 187) Bilder von

jenem Ort dienten, an dem am 24. Juli 2010 in Duisburg die Loveparade in einer Katastrophe mündete, muss man nicht zwingend wissen, um diese Arbeit als eine Auseinandersetzung mit kollektiven Gedenk- und Trauerritualen zu lesen. Doch weitet es den Referenzraum, in dem dieses Bild seine Kraft entwickelt, erheblich.

Was Demand zu interessieren scheint, ist – und dies bildet die Brücke zu dem so anderen Werk von Jochen Lempert – das mediale „Selbstabbildungsvermögen" der Ereignisse. Wo stand die Kamera, welchen Blickwinkel nahmen die Pressefotografen ein, welche Verteiler, welche Filter durchliefen diese Bilder, die nun als Vorlage dienen? Was erzählt dies über die Interessen, denen diese Bilder folgen? Auch Demand leistet Forschungsarbeit: Die Denkmodelle, die er mit seinen Bildern anbietet, konzentrieren sich in ihrer „bereinigten" Form auf ausgewählte Aspekte und sind zugleich neue, eigenständige Wirklichkeiten.

Der amerikanische Fotograf ▸ JOHN GOSSAGE (*1946) ist mit der Arbeit The Pond (S. 237 f.) in der Ausstellung vertreten. Die Serie wurde ursprünglich als Buch konzipiert und als solches 1984 erstmals publiziert. Gossage und viele andere der hier vertretenen Künstler sind durch die Erfahrung des Konzeptualismus geprägt. Auch eine fotografische Serie wie The Pond entwirft ein strukturelles System von Zeichen, doch variieren diese Zeichen hier – anders als bei Lempert – nur minimal: Gras, Wegrand und Gestrüpp, wohin man blickt. Die insgesamt 54 Schwarzweißfotografien beschreiben, so wird suggeriert, auf sehr stringente Weise eine Wanderung durch eine Landschaft an den Rändern eines Sees. Und auch hier geht es, wenn auch auf gänzlich andere Weise, um eine „Ko-Evolution", um das Miteinander von Mensch und Natur. Die nüchterne, mitunter sehr bodennahe Perspektive versagt sich jeder romantisierenden Attitüde. Struppig ist diese Landschaft, zerfurcht und widerborstig, und doch von spröder, sich im Detail offenbarender Schönheit: 1854 hatte Henry David Thoreau unter dem Titel Walden literarisch verdichtete Tagebuchaufzeichnungen veröffentlicht. Mehr als zwei Jahre hatte sich Thoreau aus der sich entwickelnden Industriegesellschaft zurückgezogen und an einem See namens Walden Pond in den Wäldern von Concord, Massachusetts, in einer Blockhütte gelebt. Beeinflusst von transzendentalem Gedankengut, suchte er hier nach einer Vertiefung und Intensivierung von Selbsterfahrung und Reflexionsvermögen durch eine spartanische Lebensführung. The Pond wird in den USA vor dem Hintergrund dieser schon im 19. Jahrhundert weit verbreiteten Schrift gelesen. Die Serie begründet sich für Gossage aber auch in anderen Zusammenhängen. Die Nähe zur Fotografie der New Topographics, zur Arbeit von Robert Adams und Lewis Baltz, mit denen Gossage befreundet ist, ist ebenso evident wie die zur amerikanischen Landschaftsfotografie des 19. Jahrhunderts. Interessanterweise ist es nicht wirklich ein See oder Weiher, der hier umrundet wird. Die Arbeit schließt einige unter anderem in Berlin entstandene Aufnahmen ein. The Pond wird damit zu einer fiktiven Ortsbeschreibung, zu einem poetisch gefassten

Denkmodell, das sich mit dem amerikanischen Mythos von den unerschlossenen Weiten der Natur auseinandersetzt.

Auch der kanadische Fotograf ▸ JEFF WALL (*1946) steht mit seinen fiktionalen Tableaus in der Nähe des Dokumentarischen. In seinen Bildern verbindet sich „die trügerische Authentizität der Fotografie mit der suggestiven Sprache des Films und dem Erzählgestus der klassischen Malerei"[15]. „Die teilweise lebensgroß präsentierten Bilder sind inhaltlich nie vordergründig und thematisch nur schwer auf einen Nenner zu bringen: Getarnt als Momentaufnahmen des modernen Alltags, sind sie vom Tafelbild der Malerei angeregte, visuelle Untersuchungen des modernen Lebens. Die Szenen spielen oft an den Rändern ausgefranster Metropolen und kommentieren in dezenter Manier Aspekte der Gegenwart."[16]

Walls Arbeiten entstehen häufig aus der Nachinszenierung medial oder real erfahrener Bilder und in einer intensiven Auseinandersetzung mit der älteren und jüngeren Kunstgeschichte. Die scheinbare Banalität, mit der krisenhafte Situationen an die Oberfläche treten, ist bezeichnend für viele seiner Werke: In Search of Premises (S. 232 f.) sichert eine kriminaltechnisch hochgerüstete Spezialeinheit in einer anonym und unbelebt wirkenden Wohnung Spuren. Offenbar war sie Ausgangs- oder Planungsort eines Verbrechens. Ähnlich wie Thomas Demand interessiert sich Jeff Wall weniger für konkrete Situationen oder Ereignisse als für die Fragen ihrer Repräsentation. Bis in die kleinsten Gesten hinein wird das Darzustellende mit den engagierten Schauspielern detailliert erarbeitet. Der Moment der Ent- und Verfremdung, der in diesem Prozess liegt, ist als Akt der nachvollziehenden und zugleich Distanz schaffenden Neuinterpretation des originären Ausgangsmaterials vielleicht der Arbeit von Thomas Demand am Modell verwandt.

Auch ▸ ANDREAS GURSKY (*1955) arbeitet am fotografischen Tafelbild. Doch anders als Jeff Wall interessiert ihn nicht die mögliche existenzielle Spannung in einer banal anmutenden Situation, sondern eine quasi idealtypische Umsetzung allgemeingültiger Metaphern gesellschaftlich erfahrbarer Zustände. Das mehr als fünf Meter breite Werk Cocoon II (S. 120 f.) entstand 2008 in dem Frankfurter Club gleichen Namens. Vor einer ausladenden, futuristisch-architektonischen Hintergrundkulisse scheint eine große Menge Jugendlicher auf den Beginn eines Raves zu warten: Ekstase ist hier kaum auszumachen. Die visuellen Korrespondenzen zwischen den Durchbrüchen im wabenartig schimmernden Hintergrund und den Köpfen der Jugendlichen zurren die Personnage zusätzlich fest. Der Widerspruch zwischen der Präzision der Wiedergabe, dem Reichtum der Details und der Leere, die dieses Bild dennoch vermittelt, ist höchst irritierend. Gursky schaut aus erhabener Perspektive auf das Geschehen. Es offenbart sich als ein quasi göttlicher Entwurf. Tatsächlich entstand Cocoon II über einen langwierigen Prozess digitaler Montage. Didaktischen Absichten folgend, montierten frühere Meister der Collage wie John Heartfield (1891–1968) fotografische Fragmente, um politisch-ökonomische Verwerfungen offenzulegen. Gursky geht den umgekehrten Weg: Er potenziert

die Glätte der Oberfläche über ein additiv-kompositorisches Verfahren und findet Bilder für wiederkehrende Muster innerhalb einer scheinbar durchindividualisierten Gemeinschaft. Doch ist Gurskys Blick keineswegs wertend. Die Nähe zu diesem wie auch zu vielen anderen seiner Motivfelder ist biografisch erwachsen. Die Formulierung des Bildes als verführerisch-schillerndes High-End-Produkt eines präzise gehandhabten hochtechnologischen Verfahrens, das so unmittelbar wie eben möglich für die Betrachtenden erfahrbar wird, indem es sie affektiv rhythmisch in eine „Ganzheit" einbindet, stellt *Cocoon II* in eine direkte Korrespondenz zu der synthetisch produzierten, vordergründig rhythmusorientierten Technomusik. Gursky vollzieht – betrachtet man seine Arbeitsweise in Relation zu Wissenschaftsfotografen des 19. Jahrhunderts wie dem eingangs erwähnten Arthur Mason Worthington – eine Wende. Während dieser, belehrt durch die Fotografie, seine Vorstellung von einer idealen Ordnung der physischen Welt aufgeben und ihre Komplexität und asymmetrische Individualität anerkennen musste, versetzt Gursky unsere Vorstellung von Welt in jene „Ganzheit" zurück, die Worthington verloren gegangen war.

JITKA HANZLOVÁ (*1958) widmet sich seit Anfang der 1990er-Jahre in ebenso zarten wie entschiedenen Beschreibungen den Menschen und ihren Lebensräumen im Porträt. Für *Forest* (S. 125 ff.) fotografierte sie zwischen 2000 und 2005 in einem Wald in der Nähe der Nordkarpaten. Hier bewegt sie sich in der Landschaft ihrer Kindheit und lädt ein, ihr in eine tiefe Stille und Einsamkeit zu folgen. Tages- und Jahreszeiten kommen und gehen. Sonnenlicht, Waldfinsternis, Schnee und Tau legen sich über Halme, Blätter und Zweige. Gelegentlich findet sich die Spur eines Tieres. Bemooste Stämme schimmern in der Dämmerung. „Es ist", schreibt John Berger zu den Fotografien von Jitka Hanzlová, „notwendig, einer Vorstellung von Zeit eine Absage zu erteilen, die in Europa während des 18. Jahrhunderts ihren Ausgangspunkt findet und die eng verbunden ist mit dem Positivismus und der linearen Berechenbarkeit des modernen Kapitalismus: die Vorstellung, dass eine einzige Zeit, die unilinear, planmäßig, abstrakt und unumkehrbar ist, alles in sich einschließe."[17]

In ihrer „Gegenwärtigkeit" können es diese Fotografien – trotz der deutlich kleineren Formate und des weitaus kontemplativeren Sujets – durchaus mit dem überdimensionalen *Cocoon II* von Andreas Gursky aufnehmen. Diese so zeitlos anmutenden Motive beziehen ihre verblüffende Modernität aus der äußersten Präzision, in der das Medium hier gehandhabt wird. In *Forest* legen sich, auf erstaunliche Weise, zwei Vorstellungen von Zeit übereinander: eine hochmoderne, die der fotografisch-technischen Umsetzung des Sujets eingeschrieben ist, und eine vorindustrielle, die das Sujet selbst bietet. Die flirrende Unruhe, die diese stillen Bilder auszulösen vermögen, entwickelt sich womöglich aus der Spannung, die hier entsteht.

Gursky und Hanzlová verbindet, wenn auch über eine große Distanz hinweg, als eine Art romantischer Grundgestus die Utopie des Aufgehens in einer „Ganzheit". Auf unterschiedliche, geradezu gegensätzliche Weise verbildlichen beide Künstler markante Eckpunkte einer Debatte um die Frage danach, wie humane Interessen mit hochtechnologischen Entwicklungen in Einklang zu bringen sind.

MAX BAUMANN (*1961) findet seit knapp zwei Jahrzehnten fotografische Bilder für die widerspruchsreiche Dialektik der Geschichte. Er fotografiert aufgelassene Armee- und sonstige ehemalige Nutzgelände, das Volkswagenwerk in Wolfsburg im Wandel zur Autostadt, genmanipulierte Pflanzen, Operationen am offenen Herzen und die Stadt Berlin als Feld wild wuchernder Zeichen von Geschichte und Gegenwart. Die immer streng komponierten Bilder feiern die Präzision fotografischer Wiedergabe und mit ihr die Schönheit des Details. Gleichzeitig finden sich in diesen Bildern häufig Zonen der Verweigerung: Zonen, die etwas Unsagbares, nicht (Mit-)Teilbares in Unschärfe formulieren. Sein kompositorisches Repertoire entstammte bisher vor allem einem romantisch gestimmten Konstruktivismus, den Baumann zu einer räumlich-malerischen Qualität führte. In seinen Arbeiten schwingt immer auch, ähnlich wie in den Arbeiten Hanzlovás, eine Spur von Sentiment nach: Sentiment als rebellischer Akt innerhalb einer möglichst affektbereinigten, da effizienzorientierten Gegenwart.

Erstmals zeigt Max Baumann mit *blindlings* (S. 215 ff.) nun Porträts. In Schwarzweiß entsteht eine Serie von Aufnahmen, die Gesichter von Menschen in ihren Dreißigern – die wesentlichen biografischen Entscheidungen sind getroffen – mit geschlossenen Augen zeigt. Baumann bittet sie in eine beruhigte Ateliersituation und ermöglicht es ihnen, sich vor der nahen Kamera und zwischen den Leuchten einzurichten. Die Fotografien entstehen in einem Moment innerer Ruhe, in dem etwas sichtbar wird, das über den Augenblick hinausweist. Nichts kann hier „übertüncht" oder hinter einer Fassade versteckt werden: Es ist eine Art Schälprozess, der sich hier vollzieht. Idealisierendes, Anekdotisches oder auch Psychologisierendes verweigern diese stillen Bilder. Sie geben Physiognomien frei, die in ihrer Zeitlosigkeit an mittelalterliche Bildschnitzereien etwa eines Tilman Riemenschneider (um 1460–1531) erinnern. Gleichzeitig sind sie äußerst gegenwärtig: Die in den Schärfensetzungen begründete Dichte der fotografischen Information zwingt das Auge zu einer präzisen, nahezu intimen Lektüre und führt zu grundsätzlichen Fragen über die Verfasstheit menschlicher Existenz.

WOLFGANG TILLMANS (*1968) sagt zu den seit 2009 entstehenden Tintenstrahldrucken, er sei „[...] fasziniert von der Koexistenz von Oberflächen, die darstellen, was sie sein wollen, was aber offensichtlich zugleich nicht gelingt. Dies kann man als kalt und unehrlich empfinden oder aber leidenschaftlich betrachten – als einen Weg, sein Abendbrot zu verdienen oder der Nachwuchs sicherzustellen. Dieser Moment verbindet den chinesischen Hochhausarchitekten, der seine Wolkenkratzerfassade komplett mit LED ausstattet, mit dem tropischen Vogel Tukan, der übertrieben grelle Farben trägt. In dieser Kälte Wärme zu finden, ist der Rückhalt meiner neuen Fotos."[18] Nach mehr als zehn Jahren der Beschäftigung mit kameralos entstehenden Abstraktionen, ihrem Verhältnis zur Figuration

und dem fotografischen Papier in seiner Materialität wendet sich Wolfgang Tillmans in diesen Tintenstrahldrucken der digitalen Fotografie zu. (S. 204 ff.) Er spricht von dem enormen Detailreichtum, der auch mit dieser Technik inzwischen möglich ist, und vom „Beifang", dem Zufälligen, das sich in großer Präzision abbildet.

Wolfgang Tillmans war in den vergangenen zwei Jahren mit der Kamera nicht allein in Berlin und London, sondern auch über den eigenen Lebensraum hinaus gezielt auf Motivsuche. In Argentinien, China, Tunesien, auf Feuerland und Lampedusa und anderswo entstanden „global snapshots"[19], globale Momentaufnahmen, die man, im Sinne des obigen Zitats, „Oberflächenstudien" zur Globalisierung nennen könnte. Wovon erzählen diese Oberflächen, welche Codes transportieren und was kaschieren oder verdecken sie? Und wo liegen die Grenzen ihrer Lesbarkeit angesichts der Menge digitaler Daten, denen sie sich verdanken? Wie viel von dieser Information kann wirklich verarbeitet werden? Welche Kriterien für die Ordnung dieser Daten existieren? Generieren sich diese gar selbst – so, wie die Globalisierung ein angeblich „naturwüchsiger" Prozess ist, in dem Verantwortlichkeiten anonym bleiben?

Eine ähnliche Frage stellt sich vor den großformatigen Mars-Landschaften, die ▶ THOMAS RUFF (*1958) mit den drei Werken aus der Arbeit ma.r.s. (S. 51 ff.) präsentiert. Es sind gestochen scharfe und nahsichtig anmutende Bilder von Oberflächen, die sich etwa fünfzig bis hundert Millionen Kilometer entfernt von uns befinden. Allein diese Vorstellung ist absurd und lässt Zweifel aufkommen: Doch als Ausgangsmaterial verwendet Ruff Aufnahmen, die die NASA mit hochauflösenden Kameras von einem Satelliten aus erstellt. Mithilfe des Computers wandelt Ruff die Aufsichten zu Ansichten um und koloriert sie. Es entstehen großformatige, hochästhetische Bilder, die wie abstrakte Malereien anmuten und doch die Erosionen in der für die Marsoberfläche typischen Farbigkeit zu meinen scheinen. ma.r.s. steht wie viele Werkgruppen Ruffs, die auf bereits existierendes Bildmaterial zurückgreifen, der Appropriation Art weitaus näher als der Fotografie im dokumentarischen Stil, doch simulieren diese Werke Realitätseffekte und -affekte, die eben diesem zugeschrieben werden. Das Diktum, nach dem die fotografische Abbildung eines Objekts zugleich dessen Existenzbeweis ist, wird hier auf subtile Weise unterwandert. Für Ruff zeigen sie „Wirklichkeit[en] einer eigenen Ordnung – und dies mit deutlichem, im Werk selbst erlebbaren Verweis auf die Fiktion von der Objektivität der Dokumentarfotografie", schreibt Annelie Pohlen 1991.[20]

In PHOTOGRAPHY CALLING! treffen diese Bilder von unvorstellbar fernen Orten auf Aufnahmen, die in Vorstadtlandschaften der Colorado Front Range entstanden. ▶ ROBERT ADAMS (*1937) hatte Ende der 1950er-Jahre seine Heimat verlassen, um in Kalifornien Literatur zu studieren und in diesem Fach zu promovieren. „[A]ls ich nach Colorado zurückkam, stellte ich fest, dass es inzwischen hier genauso aussah wie in Kalifornien. Plötzlich waren da Autobahnen und Smog. [...] Heimzukehren und diese Welt sozusagen in Scherben vorzufinden, war [...] ein heftiger Schock [...]. Irgendwie musste ich

mich mit der Landschaft aussöhnen, die ich nicht mehr zu mögen meinte. Die Fotografie hat mir das nach und nach ermöglicht [...]."[21]

Robert Adams zählt, wie Lewis Baltz und Bernd und Hilla Becher, zu den Teilnehmern einer Ausstellung, die unter dem Titel New Topographics: Photographs of a Man-Altered Landscape 1975 im International Museum of Photography and Film am George Eastman House in Rochester (New York, USA) gezeigt wurde. Sie gilt heute als Meilenstein der jüngeren Fotografiegeschichte und ist Ausgangspunkt zahlreicher kritischer Diskurse um Begriffe wie Stil, Objektivität und Dokument, aber auch um den amerikanischen Mythos der „Landnahme" und seinen Transfer in die europäische Fotografie.[22] Robert Adams steht wie andere Fotografen dieser Ausstellung in der Tradition der Landschaftsfotografie des 19. Jahrhunderts. Insbesondere Timothy H. O'Sullivan (um 1840–1882), der Forschungsexpeditionen in den bis dahin von weißen Siedlern noch nicht besiedelten Westen begleitet hatte, ist hier zu erwähnen. Die scheinbar „objektive", „stillose" Fotografie dieser „Ahnen" überlagert sich in der Landschaftsfotografie der ausgehenden 1960er- und frühen 1970er-Jahre mit Erfahrungen der Konzeptkunst, für die in diesem Zusammenhang insbesondere Ed Ruscha (*1937) steht. Die kompositorische Radikalität, die zu einer starken Geometrisierung und zu einer auf Allgemeingültigkeit zielenden Abstraktion der Motive führt, und die konzeptionelle Strenge zeichnen die jeweiligen Bildserien aus. In der Einleitung zu The New West schreibt Adams 1974: „Gegenstand dieser Bilder sind [...] nicht Fertighäuser oder Autobahnen; vielmehr ist ihr Sujet die Quelle aller Form: Das Licht. Die Front Range ist deshalb so überwältigend, weil sie vom Licht in derartiger Fülle überströmt wird, dass alle Banalität erlischt."[23] Die Arbeit umfasst 56 Schwarzweißfotografien, die in der Publikation zu fünf jeweils von einem knappen Text eingeleiteten Kapiteln geordnet sind. Sie beschreiben die zivilisatorische Überformung des amerikanischen Westens und formulieren, im Rückgriff auf die amerikanischen Gründungsmythen, „eine Stellungnahme zum Stand der amerikanischen Gesellschaft und Kultur"[24].

Im Gegenüber zu The New West (S. 58 ff.) lesen sich allerdings auch Ruffs ma.r.s.-Bilder als eine Art Fortschreibung dieses Frontier-Mythos in die „unendliche Weite" des Weltraums hinein. Etwa zu der Zeit, da Adams beginnt, sich fotografisch den Folgen von Zersiedelung und Ausbeutung im amerikanischen Westen zu widmen, verlassen Menschen erstmals die Umlaufbahn der Erde. Filme wie die der Serie Star Trek schließen nahtlos an die Erzählungen über die Eroberung des amerikanischen Westens an. Dass Ruffs digital überarbeitete Mars-Oberflächen auch an Nahaufnahmen von zerknautschten und geschundenen 1970er-Jahre-Edelmöbelbezügen denken lassen und damit an die Fiktionalität vermeintlicher fotografischer Dokumente von Weltraumexpeditionen, legt solche Assoziationen nahe.

Auch ▶ LEWIS BALTZ (*1945) zählt zu den Fotografen, deren Werke 1975 in der Ausstellung New Topographics gezeigt wurden. Auch er thematisiert die Veränderungen der

amerikanischen Landschaft in den Zonen des Aufeinandertreffens von Natur und Zivilisation, und auch er arbeitet in häufig umfangreichen, geschlossenen Werkgruppen. Doch ist Baltz auch von der Auseinandersetzung mit dem Surrealismus, insbesondere dem Werk Frederick Sommers (1905–1999) geprägt, „der in den 40er Jahren Elemente des europäischen Surrealismus mit der technischen Perfektion eines Edward Weston kombinierte und in seiner Landschaftsfotografie schon früh den Blick auf die Überreste menschlichen Lebens lenkte"[25]. 1978 entstand *Nevada* (S. 137 ff.), „das Porträt einer gesichtslosen Vorstadtsiedlung im Wechsel von Tag und Nacht"[26]. Baltz' fotografische Ästhetik ist – verglichen mit der essayhaften Erzählweise von Robert Adams – auf die zeichenhafte Aufladung und das Zusammenspiel einzelner Bildelemente konzentriert. Sie erinnert in der grafischen Reduktion stark an Stilmittel des Minimalismus, auf den der Fotograf sich gleichfalls bezieht. Die Lichtregie öffnet bühnenartige Räume, in denen die Zerstörung der Umwelt, der sich ablagernde Müll, das Provisorische der Bauten und des Lebens sich, wenn auch lautlos, so doch in kühler Dramatik entfalten. Baltz, der inzwischen in Paris und Venedig lebt, zeigt auch in Serien wie *San Quentin Point* (1986) oder *Candlestick Point* (1989) eine beispiellose Radikalität beim Beschreiben der Brutalität einer „vernacular landart".

▸ELISABETH NEUDÖRFL (*1968) knüpft in *Ökoton* (S. 148 ff.) ganz bewusst an die Tradition der *New Topographics* an. Ihre Bilder entstehen im Berliner Umland. Sie zeigen Platten- und Sandwege, dörfliche Reihenhaussiedlungen, leer stehende Bungalowsiedlungen, schlichte ländliche Zweckbauten, Erdaufschüttungen, militärisch genutzte Heiden, Birkenbüsche, schnöde Kiefernholzplantagen und frisch geschlagene Waldschneisen. Doch im Gegensatz zu Werken wie *Nevada*, in denen die Unordnung der suburbanen Zonen in geometrisierende Ordnungen überführt wird, scheint Neudörfl ihr „freien Lauf" lassen zu wollen. Das mag zum einen daran liegen, dass sie in Farbe fotografiert und die Vegetation sich nur bedingt in der grafischen Abstraktion verliert, aber wohl auch daran, dass der Himmel – als neutralisierender Hintergrund – über Brandenburg doch ein bisschen tiefer hängt als über Colorado. Die Wege und Straßen sind keine quer über den Kontinent führenden Highways, sondern von Traktoren und anderem robusten Gefährt befahrene Feldwege. *Ökoton* entwickelt in fast anarchischer Sprödheit eine detailreiche Erzählung nicht über die industrielle, sondern über die landwirtschaftlich verursachte Überformung von Natur. Schon in ihrer das Studium an der Fachhochschule Dortmund beschließenden Arbeit *venceremos* (1994) hatte Neudörfl danach gefragt, wie sich Geschichte in Landschaft und Vegetation einschreibt. In ihren häufig parallel als Buch konzipierten Serien interessiert sich Neudörfl vor allem für die unspektakulären, aber informationsreichen „Rückseiten" der Geschichte und des globalen Kapitalismus der Gegenwart. *Ökoton* beschreibt das Berliner Umland, Projektionsfläche für die Idyllen-Sehnsucht der Metropolenbewohner, als ein Territorium, das rohen Eingriffen und Wandlungen unterliegt. Tatsächlich ist die improvisierende „Kleinflächenkultur", die Neudörfl dokumentiert, angesichts der

globalen Interessen an nachwachsenden Rohstoffen, an großen, monokulturell zu bewirtschaftenden Flächen, fast schon ein historisches Phänomen. Der Begriff „Ökoton" benennt in der Biologie den Übergangsbereich zwischen zwei verschiedenen Ökosystemen, die sich mitunter durch einen besonderen Artenreichtum auszeichnen. Es sind, um auf Jochen Lemperts fotografisches Interesse zu verweisen, potenzielle Zonen beschleunigter Ko-Evolution. Dass Neudörfl dieses „Chaos" der Übergangszonen formal nicht glättet, sondern ästhetisch stimmige Bildformen für seine Offenheit findet, ist die besondere Stärke dieser Arbeit.

Natur oder das, was wir allgemein dafür zu halten geneigt sind, formuliert sich auf den Blumenbildern (S. 161 ff.) des in Düsseldorf lebenden ▸HANS-PETER FELDMANN (*1941) auf gänzlich andere Weise. In Tafelbildformaten zeigen sie vertraute Schnittblumen vor immer monochromem Hintergrund. Fast könnte man meinen, der Künstler hätte Postkarten aus den 1950er-Jahren reproduziert, wäre da nicht die enorme fotografische Präzision und die frische Strahlkraft der Farben. Die eigentliche Leidenschaft Hans-Peter Feldmanns gehört dem Sammeln von bereits existierenden Bildern und ihrer Neuordnung in Büchern und Ausstellungen. Einzelne Fotografien seien ihm zu bedeutungsschwanger: „Wenn die Dinge wiederholt werden, entsteht ein Durchschnittswert, der richtiger ist, als es ein einzelnes Bild sein kann."[27] Rosen und Lilien in ein solches, von in den 1950er-Jahren geborenen Düsseldorfer Künstlerkollegen für die Fotografie entwickeltes, großes Format zu bringen, ist für den „Nicht-Fotografen", der in den 1950erJahren nach dem damals üblichen Sprachgebrauch ein „Halbstarker" war, möglicherweise eine Herausforderung auf mehreren Ebenen. Für die Betrachter formuliert sich dieser fotografische Nachvollzug letztlich in Bildern, die an längst vergangene Ostergrüße, Funde in Großmutters Schublade oder Besuche auf Flohmärkten erinnern. Auch so unterschiedliche Bezugsfelder wie die Vanitasdarstellungen der holländischen Malerei des 17. Jahrhunderts, die beflissen-unheimliche Ordentlichkeit von Vorgärten und öffentlichen Rabatten und die Ökonomie des Blumengroßhandels scheinen hier auf. Hans-Peter Feldmann hält seine Bildwelten stets so allgemein, dass sie wie Schwämme alles aufzusaugen scheinen, was das kollektive wie individuelle Bewusst- und Unterbewusstsein zu der jeweiligen Motivwelt, aber auch zum jeweiligen Typus visueller Vergegenwärtigung bereithält. Und obwohl man Feldmann wohl kaum einer Fotografie im dokumentarischen Stil zuordnen kann, verbindet ihn gerade dieses Interesse an allgemeingültigen fotografischen Bildern mit ebenjener.

Dem Werk des in Berlin lebenden Fotografen ▸MICHAEL SCHMIDT (*1945) kommt in der Entwicklung einer solchen „Spezifik des Allgemeinen" und dem Transfer der ihr zugrunde liegenden Ideen zwischen den USA und Europa in der zweiten Hälfte des 20. Jahrhunderts eine entscheidende Rolle zu. Seine „[...] Absage an eine bis dato an die Abbildfunktion gekoppelte Einschätzung der dokumentarischen Fotografie hatte großen Einfluss auf junge deutsche, aber auch europäische Fotografen. Schmidts Anspruch an subjektive Autorschaft zielte dabei nicht

367

auf eine verfremdende Intervention, sondern auf die direkte Übertragung individueller Wahrnehmung als Ausgangspunkt einer additiven bildnerischen Arbeit."[28] Auch für Michael Schmidt entwickelt sich die Aussage weniger aus dem Einzelbild als aus der Korrespondenz zwischen den Bildern, in ihren Zwischenräumen. Buch und Ausstellung stehen als Repräsentationsformen gleichberechtigt nebeneinander. *Ihme-Zentrum* (S. 173 ff.) nimmt eine Sonderrolle ein, da das Künstlerbuch unter dem Titel *Ihme Zentrum. 4 Fotografien, 8 Ausschnitte* 2003, also zu einem Zeitpunkt erschien, da die Bilder in ihrer endgültigen Form noch nicht existierten. Die vier großen Formate verweisen im Bildtitel jeweils auf den Ort ihrer Entstehung, einen Architekturkomplex unweit des Sprengel Museum Hannover. Das Ihme-Zentrum, so Krystian Woznicki 2003, ist „[...] ein zwischen 1972–1975 gebauter Komplex, der im Kielwasser jener Euphorie der sechziger Jahre des 20. Jahrhunderts entstand, der die Stadtplaner zum Entwurf immer gigantischerer Großkomplexe trieb. Ein Relikt also aus der Phase des utopischen Bauens samt seiner technokratischen Vorstellung von der Planbarkeit gesellschaftlicher Prozesse – das einzige seiner Art in Hannover."[29] Für Michael Schmidt kam eine Realisierung im großen Format und auf analogem Wege nicht infrage. 2009 wurde die Arbeit digital ausgegeben.

Aus der Geometrie der Grafik und der minimalistisch-malerischen Grauskala entwickelt der Fotograf eine ins Extrem geführte Konfrontation mit architektonischen Fragmenten und Oberflächen, die auf mehrfache Weise aufgeladen sind. Bezüge auf die in den 1970er- und 1980er-Jahren in Berlin entstandenen Arbeiten Schmidts lassen sich ebenso finden wie solche zum Werk von Ed Ruscha und Lewis Baltz, aber auch zur konzeptuellen Malerei. In PHOTOGRAPHY CALLING! in einen Dialog mit den Blumenbildern von Hans-Peter Feldmann geführt, korrespondieren beider Werke über die wenn auch unterschiedlich gefasste Stringenz der ästhetischen Lösungen und die Verweise auf unterschiedliche Traditionen des Tafelbildes. Sie erzählen aber auch davon, wie sich die Sehnsüchte der Nachkriegsjahre an Vorstellungen von radikaler Aufgeräumtheit banden.

Für ▸ HEIDI SPECKER (*1962) wie für viele Fotografinnen und Fotografen ihrer Generation zählt Michael Schmidt zu den wesentlichen künstlerischen Impulsgebern. Architektonische Oberflächen und Strukturen als Träger von Informationen über die Präsenz von Geschichte und das Einzelbild als „Modul" in einer komplexen Bildererzählung prägen auch ihre künstlerische Arbeit. Über zwei Jahrzehnte hinweg hat sich dieses Werk parallel zur Entwicklung der technischen Möglichkeiten digitaler Fotografie ausgebildet. Mit den Anfang der 1990er-Jahre noch geringen Speicher- und Ausgabekapazitäten zielte sie auf große Formate, die in ihren Unschärfen an piktorialistische Bildfindungen erinnern. Spätestens seit der nach dem Architekten Peter Behrens benannten Arbeit aus dem Jahr 2000, endgültig aber mit *Im Garten* (2003/04), ist das Fotografische wieder unmissverständlich Referenzsystem ihres Tuns. *Termini* (S. 71 ff.) entstand während und infolge eines einjährigen Aufenthaltes

in Rom. Heidi Specker fotografiert Architekturen und Architekturelemente aus der Zeit der Regentschaft Mussolinis, im Casa Museo Giorgio de Chirico, flüchtige Straßenblicke und Momente des römischen Kulturbetriebes. Auch hier wieder transportieren die einzelnen Bilder Informationen und Überlegungen, die, in diesem Fall anhand von visuellen Indizien, zu einer assoziativ-poetischen Auseinandersetzung mit der jüngeren Geschichte Italiens und der Funktion und Funktionalisierung von Kunst und Ästhetik führen. Die skulpturalen Eigenschaften der Dinge, ihre Oberflächenstrukturen und ihre räumlichen Verhältnisse zueinander, das mal scharf und präzise und dann wieder flirrende oder sich spiegelnde Licht und der Wechsel von Schwarzweiß und Farbe entwickeln eine geradezu beredte Rhetorik. Die Künstlerin, 2010 Stipendiatin in der Deutschen Akademie Rom Villa Massimo, schließt die Befragung des eigenen Selbstverständnisses als ästhetisch Produzierende in diesen Diskurs ein. Auf einer der in der Ausstellung zu sehenden Fotografien spiegelt sie sich in der transparenten Folie der Arbeit *Auto Sex* (1999) von Franz West und Heimo Zobernig: Jenseits der Folie ist Platz für ein in einem autoerotischen Akt der Wahrnehmung zu erfahrendes Gegenüber.

In der Ausstellung treffen die digitalen Ausdrucke Heidi Speckers auf Dye-Transfer-Prints aus *14 Pictures* (S. 82 ff.). Es ist das erste, 1974 von ▸ WILLIAM EGGLESTON (*1939) herausgegebene Portfolio. „Als sich Mitte der 70er Jahre künstlerisch arbeitende Fotografen noch mehrheitlich mit Schwarzweißfotografie befassten, um sich von der in Werbung und Mode vorherrschenden Farbe zu distanzieren, zeigt William Eggleston 1976 in seiner ersten Einzelausstellung im New Yorker Museum of Modern Art ausschließlich Farbfotografien. [...] Eggleston fotografiert [seit 1958] zunächst in seiner Heimat, dem amerikanischen Süden, und zwar so gut wie alles, was ihm vor die Linse kommt, [...] oftmals aufgenommen in unkonventionellen Ausschnitten. Anfang der 80er Jahre fotografiert Eggleston auch in Europa und Afrika und entwickelt seine umherschweifende und dennoch genaue Art zu sehen weiter. Diese Methode des unhierarchischen Fotografierens bezeichnet er selbst als ‚demokratisch'."[30] In Egglestons Bildern ist eine Zeichenwelt versammelt, die die Mythen des Alltags der amerikanischen Provinz buchstabiert. Die räumliche Enge, die vielen seiner Bildkompositionen eigen ist, öffnet sich über die eigenwilligen Perspektiven und die Suggestivkraft der Farbe in einen Tiefenraum, in dem die banalen Dinge am Rande des Weges einen fast musikalischen Widerhall finden.

Während William Eggleston im Süden der USA die Farbe für sich entdeckt, entwickeln diesseits des Atlantiks ▸ HILLA und BERND BECHER (*1934 und 1931–2007) einen Werkansatz, der, wenn auch von gänzlich anderem Charakter, die Fotografie der kommenden Jahrzehnte ebenso intensiv prägt. Der präzisen Leichtigkeit, mit der der eine die Bilder am Wegesrand „auszuschneiden" scheint, steht eine langfristig systematisch angelegte Arbeitsweise entgegen. Bernd Becher hatte, wie Hilla Becher ein Jahr nach seinem Ableben in einem Interview[31] erzählte, gerne „fertig" werden wollen mit einem Lebensprojekt, an dem beide seit 1959 arbeiteten. Über mehr

als fünf Jahrzehnte hinweg entwickeln sie eine umfangreiche, systematisch angelegte Dokumentation von Industriebauten unterschiedlichen Typs in Schwarzweiß. „Die Gebäude werden beim stets gleichen, schattenlosen Licht und systematisch aus der Frontalperspektive – oft von mehreren Seiten – aufgenommen [...] Das Material wird schließlich nach Form, Funktion und Entstehungszeit in Gruppen geordnet und – zum Vergleich einladend – als Tableau oder Reihung präsentiert."[32] Beider Werk steht in der Tradition einer an der Objektivierung und Systematisierung der Erscheinungen interessierten Wissenschaftsfotografie des 19. Jahrhunderts ebenso wie in der Tradition von Fotografen wie Eugène Atget, August Sander oder Karl Blossfeldt. Bechers wollten und wollen ihr Werk nie „nostalgisch" im Sinne von rückwärtsgewandt oder Verluste betrauernd verstanden wissen. Die Leidenschaft, die sie für ihre Motivwelt entwickelt haben, ist biografisch begründet – Bernd Becher wuchs in dem durch Industriearchitektur geprägten Siegerland in Südwestfalen auf – und wird in eine ästhetisch-gestalterische Disziplin überführt. Die derart nach immer gleichen Kriterien geordneten Bildräume entwickeln, ähnlich wie die anderer in der Ausstellung vertretener Fotografinnen und Fotografen, gerade aus dieser Nüchternheit heraus ein hohes poetisches Potenzial.

In der Ausstellung treffen die Aufnahmen der Bechers auf Bilder von ▶ STEPHEN GILL (*1971). Sie entstammen dem insgesamt 97 Fotografien umfassenden Portfolio *Coming up for Air* (S. 32 ff.). Zwar ist auch Gills Blick ganz und gar urteilsfrei, doch geschieht dies überraschenderweise über den Weg einer radikalen Subjektivierung. Der in London lebende Fotograf entwickelte in relativ kurzer Zeit eine ganze Skala von immer präzise dem Thema und den Möglichkeiten der Annäherung erwachsenen Vorgehensweisen. Zu nahezu jeder der Serien entsteht ein Portfolio und ein Künstlerbuch, das in der immer originären Präzision der Umsetzung besticht und über die eigene Website vertrieben wird. *Coming up for Air* verdankt sich einem längeren Aufenthalt in Japan und der Erkenntnis, dass dieses Land mit seiner fremden Kultur und den hier geltenden visuellen Codes für einen Gast nicht wirklich lesbar ist. Er habe, so beschreibt es Gill, Japan wahrgenommen wie jemand, der sich unter Wasser befinde und vor allem die eigenen Körpergeräusche registriere. Schemenhaft, in radikalen, nie auf Ganzheit oder Überblick zielenden Anschnitten, mitunter vom Blitz der Kamera fast bis zur Unkenntlichkeit überblendet, geben sich diese Bilder. Es sind Spuren des Eigenen mehr als Abdruck des Fremden, und sie unterwandern die gängigen Muster der Repräsentation. Hier wie in allen seinen Arbeiten fokussiert Gill vor allem das Periphere, scheinbar Banale: unbedeutende Dinge am Wegesrand oder solche, die an ihm kurz und überraschend aufleuchten. Menschen, Tiere und Gegenstände, durch die Kamera aus ihren funktionalen Zusammenhängen gerissen, fügen sich „unter der Wasseroberfläche" zu einem Strom des Halbbewussten, ohne dass das Unterbewusste sein Spiel mit ihnen treiben könnte. Insofern waltet in Gills Arbeit jene hier schon mehrfach zur Sprache gekommene Distanz. Sie überführt die Motive nicht in Objekte

des Begehrens: Sie belässt sie an jener Schwelle, an der Eigenes und Fremdes sich mit freundlichem Respekt begegnen.

Die Ukrainerin ▶ RITA OSTROWSKAJA (*1953) zeigt unter dem Titel *Anwesenheit* (S. 285 ff.) Fotografien, die sich als Selbstporträts begreifen lassen. Die Serie sepiagetönter Mehrfachbelichtungen nimmt 1995 ihren Ausgang. Damals lebte Ostrowskaja, die seit 2001 in Kassel wohnt, noch in Kiew. Sie leitete eine Schule für Kinder- und Jugendfotografie und arbeitete an der Publikation zu der Arbeit *Juden in der Ukraine, 1989–1994. Schtetls*, für die sie 1994 mit dem Albert-Renger-Patzsch-Preis ausgezeichnet wurde. Die diesem Buch zugrunde liegenden Fotografien zeigen jene Kultur und religiöse Praxis, der sie selbst intensiv verbunden und die im Osten Europas am Verschwinden ist. Ostrowskaja arbeitet fern vom Kunstbetrieb. Für eine Professionalisierung nach westlich geprägten Vorstellungen fehlten in Kiew und erst recht in der Emigration in Göttingen nicht zuletzt die familiären Rahmenbedingungen. Auch mutet ihre Bildwelt aufgrund der Spezifik ihrer auf Empathie basierenden Auseinandersetzung mit der jüdischen Identität mitunter geradezu vormodern an. Dennoch ist ihre Arbeitsweise von einem stark dokumentarischen Impetus getragen. Ihr komplexes, thematisch stringentes Werk steht in der Besonderheit dieser Innen-Ausleuchtung einer für Europa so evidenten und doch kaum sichtbaren Erfahrung als Solitär in der jüngeren Fotografiegeschichte. Es verortet sich, unter historisierendem Blickwinkel, jenseits jenes Grades, an dem die diskursiv-problematisierenden Strategien eines Boris Mikhailov ansetzen.

Die Selbstvergewisserung Ostrowskajas als Mitglied einer durch eine spezifische Erfahrung und Kultur geprägten Gemeinschaft zeichnet auch die Serie *Anwesenheit* aus. Die feinst durchnuancierten Langzeitbelichtungen zeigen die Fotografin als halbtransparente Figur in verschiedenen privaten Situationen: in der Küche, zwischen Arbeitsutensilien, mit Freunden, Verwandten oder Kollegen. Unwillkürlich stellen sich Assoziationen zur Geisterfotografie in okkultischen Zusammenhängen ein. Doch sind es eher die Möglichkeiten des menschlichen Miteinanders und die intime Befragung des eigenen Selbstverständnisses, die hier, in einem tatsächlich vormodern anmutenden, „zeitlosen" Sinne, ins Bild gebannt werden.

▶ HELGA PARIS (*1938) beginnt im Alter von 43 Jahren mit einer Reihe von Selbstporträts, an der sie bis heute in loser Folge arbeitet. Ein vorläufiges Ende findet diese Arbeit in einer Fassung, die, datiert 1981 bis 1989, hier vorgestellt wird (S. 296 ff.). Auch dieser Serie liegt die Erfahrung der Doppelrolle als in diesem Fall alleinerziehende Mutter und Fotografin zugrunde. Und auch hier entwickelt sich die fotografische Arbeit in einem politischen Kontext, in dem private und öffentliche Sphären in einem diametralen Gegensatz zueinander stehen. Ein Markt für Bilder, welcher Art auch immer – ein „Fluss" von Bildern an der Oberfläche der Gesellschaft –, existiert in der DDR nicht. Dennoch sind die 1980er-Jahre für die Fotografin enorm produktiv. Es entstehen Serien wie *Berliner Jugendliche* (1981/82), *Georgien* (1982), *Frauen im Bekleidungswerk Treff-Modelle* (1984) oder *Häuser und*

Gesichter, Halle (1983–1985). Die *Selbstporträts* folgen einem vorerst ganz und gar persönlichen Impuls. Helga Paris ist erstaunt über die Art und Weise, in der ihr die durchlebten Konflikte und Anstrengungen im Spiegel ihres Badezimmers begegnen. Sie beschließt, dies zu dokumentieren. An eine Veröffentlichung denkt sie nicht. Spiegelbilder existieren im Werk von Helga Paris mehrfach, doch sind sie als dezidierte Einzelbilder häufig eingebunden in eher essayhafte Bilderzählungen. In den *Selbstporträts* bleibt der Aufnahmemodus über die Jahre konstant. Die reflektierende Fläche selbst ist nicht mehr sichtbar. Die klar gezeichneten Lineaturen der Physiognomie und die Körperhaltung entwickeln sich vor dem immer gleichen monochromen Hintergrund zu einer Abfolge von Variationen des in seinem Grundbestand konstanten, grafischen Liniengefüges. Gerahmt wird dies von verschiedenen Kleidungsstilen, die ein ganzes Spektrum von Weiblichkeitsmustern repräsentieren. Im spiegelverkehrten „Selbst" wird die Erfahrung der individuell gelebten Biografie in einen überindividuellen Zusammenhang eingebettet und erfahrbar.

„Seit den 60er Jahren zählt ▸ LEE FRIEDLANDER [*1934] neben Walker Evans und Robert Frank zu den bedeutenden amerikanischen Vertretern einer fotografischen Haltung, die der direkten, unmanipulierten Wiedergabe der Realität verpflichtet ist und sich gleichzeitig als individuelle Sichtweise zu erkennen gibt. [...] In seinen genau komponierten Bildern, die zum Teil wie Montagen wirken, arbeitet Friedlander bevorzugt mit extremen Ausschnitten, verwirrenden Perspektiven, Spiegelungen und ‚Bild im Bild'-Motiven und bricht dabei mit ästhetischen Konventionen."[33] Lee Friedlander schreibt im Vorwort zu der 1970 erschienenen Publikation *Self Portrait* (S. 272 ff.): „Es ist vermutlich Eigeninteresse, das einen dazu bringt, auf sich selbst und die eigene Umgebung zu blicken. Dieses Bedürfnis ist persönlich veranlasst und mit Sicherheit Grund und Motiv meines Fotografierens. Die Kamera ist mehr als ein Teich, der einem sein Spiegelbild zurück wirft, und Fotografien sind durchaus nicht das Spieglein Spieglein an der Wand, das mit falscher Zunge spricht. Denn im Augenblick des Fotografierens, der zugleich sehr einfach und überaus komplex ist, wird Zeugnis abgelegt und fügen sich Puzzlestücke zusammen. Der geistige Finger drückt auf den Auslöser der unwissenden Maschine, die dann die Zeit stoppt und festhält, was ihre Blendenlamellen umgreifen und was das Licht malen mag."[34]

Die „unwissende Maschine", von der Friedlander spricht, verweist erneut auf die eingangs zitierte Erkenntnis des Naturwissenschaftlers Arthur Mason Worthington und seine Entdeckung, dass die physikalische Welt mithilfe der Fotografie in ihrer ganzen Komplexität und asymmetrischen Individualität darstellbar sei. Dass dies – im Rahmen des strengen Regelwerks, das die fotografischen Programme vorgeben – eine der am schwierigsten zu lösenden Aufgaben der Fotografie als „straight photography" ist, wird angesichts der Selbstporträts Friedlanders auf beglückende Weise evident. Seine Bildkompositionen scheinen den Raum häufig regelrecht zu sprengen, ihn immer wieder neu strukturieren zu wollen. Hell-Dunkel-Kontraste, mal fein ziselierte, mal elementar grafisch sich entwickelnde strukturelle Setzungen, der dynamische Wechsel zwischen Vorder- und Hintergrund vitalisieren diese fotografischen Oberflächen. Harmonie entsteht hier aus permanenter Beunruhigung. Friedlanders Fotografien verführen nicht und laden auch nicht ein. Sie sind direkte, unmittelbare Konfrontationen mit einer anderen Art von Wirklichkeit. Das verbindet sie – und wieder wird hier eine überraschende Parallele sichtbar – mit den von Stephen Gill in Japan aufgenommenen Bildern.

▸ BORIS MIKHAILOV (*1938) gilt als fotografischer Dokumentarist der Geschichte der UdSSR und ihrer Nachfolgestaaten, als Dokumentarist der Auswirkungen der politischen Veränderungen auf den Einzelnen und das Gemeinwesen. Seit Ende der 1960er-Jahre entwickelte er ein nahezu beispiellos umfangreiches, vielschichtiges Werk, in dem sich seit Mitte der 1990er-Jahre auch die Erfahrung des Pendelns zwischen seiner Heimatstadt Charkow und Berlin einschreibt. In Braunschweig – Boris Mikhailov war einer Einladung des Festivals Theaterformen und des Sprengel Museum Hannover gefolgt – entstand 2008 *Maquette Braunschweig*, ein Disput über Krieg und Frieden in vier Akten. Den Hintergrund bot eine von der Regisseurin Claudia Bosse (*1969) eingerichtete Inszenierung der Tragödie *Die Perser* von Aischylos (525–456 v. Chr.). Etwa 300 Bürger waren dem Aufruf „Sei Perser!" gefolgt und gaben den Chor der von den Griechen besiegten Perser. Nicht nur das erste Antikriegsstück der Menschheitsgeschichte, auch die Tatsache, dass Adolf Hitler in Braunschweig 1932 wenige Wochen vor den Reichspräsidentenwahlen nach mehreren vergeblichen Versuchen an anderen Orten mit der Ernennung zum Regierungsrat die deutschen Staatsbürgerrechte zugesprochen bekam, geben den Hintergrund für die Arbeit.

Auch hier wieder interessiert Mikhailov der Zustand des Gemeinwesens. Die sich über Monate erstreckenden Probenarbeiten bieten ihm erstmalig in Deutschland die Gelegenheit, dieses Gemeinwesen in der neuen Heimat wenn auch als Gast, so doch aus großer Nähe und am Beispiel kulturell aufgeschlossener und engagierter Bürger wahrzunehmen.

Die Porträts dieser Bürger bilden als *German Portraits* das erste Kapitel der *Maquette Braunschweig*. Der Fotograf verweist auf sein Interesse an den Porträtdarstellungen der deutschen Renaissancemalerei, die ihn schon als Jugendlicher außerordentlich fasziniert hätten.[35] Doch auch Darstellungen auf Münzen und Briefmarken transportieren das Profil als etwas, was ideale Wertsetzung verspricht. Mikhailov überprüft das Ideal im Angesicht eines konkreten, gegenwärtigen Befundes. Das irritierend Schillernde dieser Fotografien entsteht an dem sich unerwartet auftuenden Bruch zwischen der unbewussten, vorkonditionierten Erwartung des Ideals und der Realität. Sind es Bilder jener Menschen, die, verantwortlich, tolerant und selbstbewusst, die Mitte eines demokratischen Staates ausmachen? Schlägt sich das Ideal einer Gesellschaft in seinem visuellen Erscheinungsbild nieder? Für den von jüdischen Vorfahren abstammenden Fotografen – auch aus der eugenisch begründeten Fotografie ist die Profilerfassung bekannt – ist dies eine der wesentlichen Fragen, die diese Fotografien stellen.

Die Frage nach den Möglichkeiten der fotografischen Visualisierung einer „gesellschaftlichen Mitte" stellt sich auch angesichts der Fotografien der amerikanischen Fotografin ▶ DIANE ARBUS (1923–1971). „Ausdrucksstarke Porträts von gesellschaftlichen Außenseitern oder entfremdet wirkenden Vertretern der gehobenen Mittelschicht machen die Fotografin Ende der 60er Jahre bekannt."[36] Anfänglich als Modefotografin arbeitend, belegt sie Fotografiekurse bei Lisette Model an der New School for Social Research in New York. „Lisette Models Vorstellung von der Kamera als einem ,Instrument der Entdeckung' und ihr Ratschlag, nur dann zu fotografieren, wenn das Motiv ,mit voller Macht in die Magengrube trifft', prägt Diane Arbus' fotografische Sichtweise und ihre Entwicklung als Porträtfotografin."[37] Nach wie vor zählt Arbus zu den einflussreichsten Künstlerpersönlichkeiten des 20. Jahrhunderts. Die im Einverständnis mit ihren Modellen entstandenen Porträts führen die Fotografie an eine Grenze des Sichtbaren – dorthin, wo die „Kluft zwischen Absicht und Wirkung"[38] sich in radikaler Offenheit preisgibt.

Das Portfolio *A Box of Ten Photographs* (S. 20 ff.) wurde zwischen 1963 und 1970 zusammengestellt, von Arbus selbst wurden nur vier der 50 existierenden Exemplare verkauft. Es enthält Schlüsselbilder wie *Identical Twins, Roselle, 1967* und umreißt exemplarisch die ganze Spanne der Bildwelt von Arbus. Der Kleine, der Große, die viel und wenig auf der Haut Tragenden, die Lockenwickler- und Kreissägenträger, die hinreichend Wohlhabenden, die weniger Betuchten und die Identischen geben sich hier, quasi unter dem Weihnachtsbaum, ein Stelldichein. Allein mit dieser Auswahl von zehn Fotografien gibt Arbus ein zutiefst demokratisches Credo, und es gelingt ihr zudem, in jedem Repräsentanten zugleich eine zugespitzte Typisierung zu entwerfen. Die konzeptionelle Entschiedenheit, mit der diese Auswahl getroffen wurde, spricht für die auch intellektuelle Brillanz, mit der die Fotografin ihre Bildwelt zu entwickeln wusste.

Die ästhetische Praxis des Briten ▶ MARTIN PARR (*1952) scheint ganz wesentlich von der Idee des Sammelns bestimmt zu sein. Dies betrifft seine Arbeit als Fotograf, als Publizist und Kurator. Parr ist Mitglied der Agentur Magnum, die, 1949 gegründet, die Entwicklung einer journalistischen Autorenfotografie im Nachkriegseuropa und in den vergangenen Jahrzehnten wesentlich geprägt hat.

Die Leidenschaft für das Sammeln ist nicht allein der Idee des sukzessiven Zustandekommens eines Selbstporträts, eines Selbstausdrucks, in der Sammlung geschuldet. Parrs Arbeit begleiten, über die Jahrzehnte hinweg, Fragen nach dem Zustand des Gemeinwesens. Das Typische eines Gemeinwesens, sein Mittelwert, ergibt sich aus der Quersumme unzähliger einzelner Befunde – darauf weist Hans-Peter Feldmann hin. Worin findet dieses Gemeinwesen seinen visuellen Ausdruck – eine Frage, die wiederum auch Boris Mikhailov beschäftigt. Parrs eloquente Fotografien, die ihre Kraft häufig aus der kompositorischen, auf Zuspitzung zielenden Komposition beziehen, stellen ganz naheliegende Fragen: Wie zeigen sich die Gesichter, die Körper? Wie kleiden, schmücken sich die

Menschen, was essen sie, wie gehen sie miteinander um, wie erholen sie sich und wie feiern sie? Parr fotografiert das, was gezeigt wird, die trivialen, zunehmend grellen äußeren Zeichen und Symbole, über die sich das Gemeinwesen entäußert. Er betreibt empirische Feldforschung im klassischen Sinne. Folgt man seinem Werk über die Jahrzehnte, so zeigt sich, dass Parr Chronist und Seismograf kultureller und gesellschaftlicher Wandlungen ist. Für *Luxury* (S. 329 ff.) fotografiert er die „Superreichen" der globalen Welt: jene dünne Oberschicht, deren selbstgefällige Präsentation des Überflusses ihm willkommene Motive bietet. Er fotografiert sie während ihrer Feiern und Feste, auf Automessen und in Kunstausstellungen – wo immer sie zu finden sind. In den Bildern dieses grellen Wohlstandes findet Parr zu Aussagen über die Nutznießer der sich immer schamloser und schneller organisierenden Kapitalströme. Dass Globalisierung kein quasi „naturwüchsiger Prozess" ist, ist die aufklärerische Mitteilung dieser Arbeit.

Der britische, heute in den USA lebende Fotograf ▶ PAUL GRAHAM (*1956) studierte in den 1970er-Jahren Mikrobiologie, doch war gegen Ende des Studiums klar, dass die Fotografie sein zukünftiges Betätigungsfeld sein würde. William Egglestons „elliptisch e[r]" und von der herkömmlichen fotografischen Praxis so weit entfernt[er]"[39] fotografischer Ansatz, der so „lässig wirkende, im Grunde aber profunde Bruch mit sämtlichen bis dahin gültigen dokumentarischen Strategien"[40], hinterlässt einen tiefen Eindruck bei dem jungen Fotografen. Aber auch mit dem Berliner Kreis um Michael Schmidt und Volker Henze in Essen stand Graham in engem Austausch. Die Arbeit *Beyond Caring* (1984/85) entstand in den Warteräumen und Fluren britischer Arbeitsämter und setzt sich, wie andere Serien dieser Jahre auch, mit den Auswirkungen der Regierung Margaret Thatchers in den Jahren von 1979 bis 1990 auseinander. Sie führt die Farbe in die europäische dokumentarische Praxis, die bis dato der Schwarzweißfotografie vorbehalten war, ein. Die Art und Weise, mit der Graham die Auseinandersetzung mit dem Erbe der amerikanischen Fotografie auch in Serien wie *Troubled Land* (1984–1986), *Television Portraits* (1986–1990), *New Europe* (1986–1992) oder *Empty Heaven* (1989–1995) in einen völlig anderen Kontext einbringt, hat weitreichende Folgen für die Entwicklung einer dokumentarisch-künstlerischen Fotografie mit politischem Impetus in Europa.

„Im Sommer 2004 begab sich der Fotograf Paul Graham auf eine Reise kreuz und quer durch die USA. Seine Fahrten hatten kein Ziel, keine Richtung, gingen nach Norden, nach Süden, oft hinaus aufs Land und dann im großen Bogen zurück. Die Streckenplanung wurde dem Zufall überlassen, die Straßen bis zu einem gewissen Punkt abgefahren, dann wieder gewendet, Städte wurden besucht und dann wieder verlassen oder gar nicht besucht, links liegen gelassen hinter den Autobahnkreuzen, die ihre eigene, andere Geschichte erzählen. Es gab keinen Ort, an dem er sein musste, kein Zeitdruck, und als Neuankömmling in Amerika hatte er nur wenige Freunde, die es unterwegs zu besuchen galt. Dieses Amerika war überall und nirgendwo, und das Gefühl der Freiheit öffnete ihm einen großen Raum mit viel Platz zum Atmen."[41] Es entsteht *A Shimmer of*

Possibility (S. 316 ff.), ein Werk in zwölf detailreichen, komplexen und filigranen Erzählungen über den amerikanischen Alltag in der Provinz, von denen in der Ausstellung zwei vorgestellt werden. Vielleicht kann man dieses Land nicht fotografieren, ohne dass der Mythos der Glück versprechenden, zu erobernden Weite sich in die Bilder legt. Auch hier bietet er den Hintergrund, und Graham dekonstruiert ihn gründlich. Doch gibt es hier auch Momente der Erhabenheit. Sie entwickeln sich in Details und Gesten: aus einer im Abendlicht leuchtenden Horizontlinie, aus dem Licht, das sich auf Hände legt, die sich auf dem Deckel einer Mülltonne um das Öffnen eines Loses bemühen. Wie sagte Robert Adams? „Die Front Range ist deshalb so überwältigend, weil sie vom Licht in derartiger Fülle überströmt wird, dass alle Banalität erlischt."

Dennoch vermeidet es Graham, sein Sujet ästhetisch zu „zwingen". Sein Erzählfluss ist eine immer offene Bewegung. Graham behauptet keine Wahrheiten, sondern Ansichten von der Wirklichkeit. „Die Einfachheit dieser Aufzeichnungen, die sich jeder fotografischen Raffinesse so resolut verschließen, lenkt die Aufmerksamkeit auf das Privileg des Sehens und was daraus gelernt und gewonnen werden kann."[42]

▶ RINEKE DIJKSTRA (*1959) ist eine der wegweisenden Porträtfotografinnen der Gegenwart. Anknüpfend an Traditionslinien, die in Bildnisdarstellungen der Renaissance ihre Vorläufer und in der Fotografie eine Fortsetzung im Schaffen August Sanders (1876–1964) finden, entwickelte Dijkstra eine sachlich wirkende und zugleich höchst subjektive Porträtform.

In PHOTOGRAPHY CALLING! zeigt sie Bilder (S. 308 ff.), die 1994 entstanden. Damals hatte sie junge Mütter kurz nach der Entbindung fotografiert. Es sind Momente des Übergangs, die sie festhält: Frauen kurz nach einer existenziellen Erfahrung, aufrecht stehend, Spuren des Schmerzes vorweisend, doch schon jenseits dieses Schmerzes. Erstaunlicherweise weiß Dijkstra ihre Modelle gleichzeitig vorzuzeigen und zu schützen. Die „Objektivierung", die sich in dieser doch eigentlich hochemotionalen Situation – über die Wahl des nüchternen Hintergrundes, die disziplinierte Farbigkeit, den aufrechten Stand und den Blick in die Kamera – vollzieht, richtet sich nicht gegen die allerhöchstens spärlich bekleideten Frauen, sondern arbeitet für sie. Die sich auf diese Weise formulierende Nüchternheit schützt sie vor Übergriffen des betrachtenden Blicks. Sie sind präsent und doch auch abwesend, in einem jeweils eigenen, imaginären Raum des Übergangs, dem, in dieser Nüchternheit der Betrachtung, etwas zutiefst Humanes und Überindividuelles innewohnt.

Sechzehn Jahre später porträtiert Dijkstra die Jugendlichen, die damals, als eben erst Geborene, noch fast unsichtbar in den Armen ihrer Mütter lagen. Stolz und eigenwillig, ja geradezu herausfordernd treten sie dem betrachtenden Blick entgegen. Auch sie befinden sich an einer Schwelle: Vermutlich werden sie in Kürze die Schule beenden und wegweisende Entscheidungen für ihr Leben treffen müssen.

Zeitlichkeit ist diesen Bildern eingeschrieben – auf andere, weitaus manifestere Weise, als dies bei Paul Graham der Fall ist. Rineke Dijkstras Arbeiten entwickeln ihre besondere Faszination aus dem vermeintlichen Angebot einer Begegnung mit einem höchst individuellen Gegenüber und der gleichzeitigen, nahezu überzeitlich wirkenden Allgemeingültigkeit der Erfahrung, von der hier erzählt wird.

Der in Berlin lebende ▶ TOBIAS ZIELONY (*1973) berichtet in seinen fotografischen Serien von der Erfahrung, sich in Übergangszonen dauerhaft einrichten zu müssen. Es sind Räume ohne Funktion, Schlafstätten, Transit allerhöchstens noch für Durchreisende, die hier nichts zum Einkehren einlädt. Tobias Zielony fotografiert Jugendliche, die hier leben und ihre eigenen Formen der Selbstdarstellung entwickeln müssen. In einer Art Langzeitprojekt suchte er Orte dieser oder ähnlicher Art weltweit auf. Wie gestalten sich, innerhalb der globalen Ökonomie, die einzelnen lokalen Lebensräume, und welche Möglichkeiten bieten sie den Jugendlichen? Wie verhalten sie sich zu der Perspektivlosigkeit, in der sie aufwachsen?

„Sie kennen nicht mehr die Sicherheit eines erlernten Berufs", beschreibt es der Regisseur Christian Petzold (*1960). „Wenn sie mit dir in Berührung kommen, haben sie ein ganzes Arsenal an Posen, die sie ausprobiert haben, nicht vor dem Fotoapparat, sondern vor allem vor ihren Freunden oder vor dem Spiegel."[43]

Tobias Zielony spricht von der Durchlässigkeit zwischen medialen Bildern und der eigenen Lebenswirklichkeit. „Unbewusst verhält man sich so, als wäre man Teil eines Films, und sieht auch andere so. Das sagt viel über die Komplexität unserer visuellen Erfahrung. Als Fotograf ist für mich natürlich die Frage interessant, für welche Geschichte diese Bilder stehen. Können sie eigentlich für eine Geschichte stehen? Oder müssen die Bilder nicht vielmehr die Erwartung einer Narration bestätigen und gleichzeitig unterlaufen?"[44]

In *Trona – Armpit of America* (S. 109 ff.) ist das Licht von erbarmungsloser Härte, die Vegetation spärlich und die Architektur eine Ansammlung provisorischer Bauten. Die Bergbausiedlung ist weniger als 100 Jahre alt und war bis in die frühen 1990er-Jahre Chemiestandort. Die Arbeitslosigkeit ist hoch, gleich hinter dem Ort hat der Bergbau und die Industrie die Landschaft verwüstet. Die preiswerte, aufputschende und schnell zu physischen und psychischen Veränderungen führende Droge Crystal Meth bestimmt den Alltag vieler.

Trona erzählt vom Ende des amerikanischen Frontier-Traums. Vielleicht erzählt es zugleich von den verloren gehenden Bildern, vom Ende der Reichweite der Medien- und Spiegelbilder, an denen sich Jugendliche an anderen Orten noch zu orientieren vermögen.

Wie Botschaften aus einer besseren Zeit muten da im Vergleich die 25 Jahre früher entstandenen Bilder des Amerikaners ▶ NICHOLAS NIXON (*1947) an. Nixon „[...] setzt sich seit den 80er Jahren in seinen fotografischen Langzeitprojekten mit den Grundwerten menschlicher Existenz auseinander und verbindet dabei künstlerische Fragestellungen mit sozialem Engagement. [...] Obwohl der Fotograf mit einer unhandlichen Großbildkamera arbeitet, die die Ausmaße eines tragbaren Fernsehers hat und nur mit Stativ benutzt werden kann, wirken seine Schwarz-Weiß-Aufnahmen oftmals so lebendig und

spontan, als wenn sie mit einer Kleinbildkamera aufgenommen wären. Peter Galassi hat in diesem Zusammenhang darauf hingewiesen, dass Nixon dazu beitrug, die Großbildkamera und die formale Kunstfertigkeit wieder zu beleben, an denen Edward Weston und Walker Evans so viel lag, und die über eine Generation lang aus der Mode gekommen waren."[45] Die 40 Fotografien der Serie *Photographs from One Year* (S. 95 ff.) entstanden in den Jahren 1981 und 1982. Sie zeigen Familien, Geschwister oder Freunde im Miteinander auf den Schwellen und Stufen oder in den Türrahmen ihrer Häuser, in Städten wie Boston, Cambridge oder Somerville. Man kann die in den Bildtiteln benannten Straßenzüge via Google Earth besuchen, und man stellt fest: Dort, wo Nixon vor dreißig Jahren seine Aufnahmen machte, ist die Welt ein bisschen heiler als in Trona. Nixons detailreiche und präzise, teils wie Bühnenbilder aufgebaute Fotografien erzählen von einem Miteinander, das sich stark körperlich artikuliert. Man berührt sich, umarmt sich, wendet sich einander zu oder voneinander ab. Es sind gewachsene, familiäre Bindungen, die hier die Gemeinschaft tragen. Diese Fotografien haben die suggestive Kraft von Standbildern: In ihnen konzentrieren sich filmische Erzählungen mit dramatischem Potenzial. Der Fotograf Robert Adams, der Literatur studiert hatte, weist auf die literarische Qualität dieser Bilder hin. Diese Dichte an Information verdanken sie nicht zuletzt der Großformattechnik, die Nixon so meisterlich handhabt.

▸ THOMAS STRUTH (*1954) gehört wie Andreas Gursky und Thomas Ruff zur ersten Generation der Studenten von Bernd Becher an der Kunstakademie Düsseldorf. Er war über die Malerei zur Fotografie gekommen und hatte ursprünglich bei Gerhard Richter studiert. In seinem konzentrierten Werk, das streng einer dokumentarischen Grundhaltung verpflichtet ist, nehmen Aufnahmen von urbanen Situationen schon früh eine zentrale Position ein. „Die Architekturaufnahmen von Thomas Struth, die Fotografien von Straßen und Städten", schreibt Julian Heynen, „sind menschenleer. Und wo man auf den zweiten Blick dennoch einige Passanten entdecken kann, geraten sie nicht in den Mittelpunkt der Aufmerksamkeit. Sie bleiben Marginalien in diesen Räumen, werden nie Akteure, das sind die Straßen selbst. Was könnte diese Abwesenheit von Menschen bedeuten? Man mag sie als indirekten Hinweis auf das Unterbewusste lesen, jenen Ort, an dem der öffentliche Raum verinnerlicht ist. Aber sind sie in den Bildern tatsächlich abwesend? Haben sie nicht vielmehr überall Spuren hinterlassen?"[46]

Die Fotografien von Thomas Struth besitzen jene merkwürdige Transparenz, die auf exemplarische Weise auch in den Werken von Rineke Dijkstra zum Tragen kommt und auf die sich Hans-Peter Feldmann in seinen Blumenbildern bezieht. Solche Fotografien vereinen, davon war bereits die Rede, mehrere Zeitebenen in sich. Sie scheinen den Gegenstand ihrer Darstellung in seiner Individualität hinter einer transparenten Wand schützen zu wollen und bieten ihn zugleich als Projektionsfläche für Eigenes, für Bewusstes und Unbewusstes an. Die vier Aufnahmen der Arbeit *South Lake Street Apartments, Chicago* (S. 263 ff.) zeigen eine ebenso kompakte wie fein gegliederte skulpturale Form aus vier verschiedenen Perspektiven und

geben den Blick auf ein zweites, offenbar baugleiches Gebäude frei. Die simultane Zeiterfahrung, die den Fotografien von Thomas Struth eingeschrieben ist, wird, in der quasi filmischen Sequenz und in der Verdoppelung des Motivs, um ein Vielfaches gesteigert.

Auch in der Arbeit *Color Lab Club* (S. 250 ff.) der jungen Leipziger Fotografin ▸ LAURA BIELAU (*1981) spielt die Simultaneität des Erfahrens von Zeit und das „Drehen" und Umrunden eines Gegenstandes oder Themas vor der Kamera eine wesentliche Rolle. In diesem Fall ist es die Geschichte der Fotografie, die aus unterschiedlichen Blickwinkeln betrachtet wird. Das Verfahren ähnelt in gewisser Weise jenem, das in der Arbeit von Jochen Lempert zur Anwendung kommt. Stationen der Geschichte des Mediums werden in den Einzelbildern aufgerufen, auf ihren gegenwärtigen Befund hin überprüft, neu interpretiert und im Zusammenspiel der Bilder zu einer poetischen Erzählung verbunden. Allein die Reihe kleinformatiger Aufnahmen von jungen Frauen im „Rotlichtmilieu" der Dunkelkammer enthalten, im Zitat auf das in der zweiten Hälfte des 19. Jahrhunderts gebräuchliche Format der Carte de Visite, einen ganzen Komplex von Verweisen. Da ist das Verlangen nach Bildern, ein wesentlicher und lustbesetzter Antrieb für das fotografische Tun. Da ist die sich im Gebrauch der Carte de Visite ausdrückende Idee der Lesbarkeit des Bildes als Text: Sie ersetzte, wie es ihr Name sagt, phasenweise die Visitenkarte. Da ist der Verweis darauf, wie sehr fotografische Darstellungen weiblicher Körper die Wahrnehmung der Frau, ihr Selbstbild und ihre Selbstdarstellung verändert haben. Aber auch der Hinweis auf das emanzipatorische Potenzial, das der Beruf der Fotografin für Frauen insbesondere in den 1920er-Jahren bereithielt, ist in diesen Bildern enthalten. Das Denkmal für Nicéphore Niépce (1765–1833), einen der Erfinder der Fotografie, die Fototaube, das Stillleben nach Man Ray, die Fototechnik oder die Fotografin in unterschiedlicher Positionierung – alle diese Bilder stehen für ein ähnlich vielschichtiges Gefüge von Verweisen auf Tatsachen und deren Bedeutungen für die Fotografin.

Laura Bielau veranschaulicht in *Color Lab Club* exemplarisch, wie komplex jedes fotografische Bild in einem imaginären Korpus bereits existierender Bilder und Lesarten verankert ist. Sie leistet Forschungsarbeit an der Fotografiegeschichte und der Geschichte ihrer Interpretation.

Dass eine verbale Annäherung letztlich immer nur unter Verlust der poetischen Komplexität der Bilder und gleichfalls nur subjektiv, unter einer individuell geprägten Perspektive, möglich ist, ist unvermeidbar. Jede der hier vorgestellten Positionen steht als „Wirklichkeit eigener Ordnung" als Erstes für sich selbst. Und jede der hier vorgestellten Positionen hält für jeden Betrachtenden einen jeweils anderen, neuen Kosmos von Bedeutungen und Assoziationen bereit.

Walker Evans' Aussage über eine Fotografie, die den dokumentarischen Stil zwar zitiere, selber aber keine Dokumente produziere, da sie, wie die Kunst, zweckfrei sei, zielte 1971 womöglich vor allem auf die Abgrenzung von einer Indienstnahme künstlerischer Bilder durch politisch-propagandistische

Interessen, wie sie die fotografische Ausstellungspolitik des Museum of Modern Art unter der Leitung von Edward Steichen (1879–1973) in den Jahren von 1947 bis 1962 betrieben hatte. Für Steichen war die Fotografie im MoMA ein im Zweiten Weltkrieg und im Kalten Krieg erprobtes Instrument möglichst massenwirksamer Propaganda. Sein Nachfolger John Szarkowski (1925–2007) hatte sie für die diskursive Auseinandersetzung mit individuell geprägten Verfahren der Weltaneignung und für die Auseinandersetzung mit ihrer ästhetischen Wirkungsweise zurückerobert. Der „white cube" des Ausstellungsraumes ist so verstanden kein Anbetungstempel hehrer, genialer Subjektivität und auch kein von der Welt unberührter „Elfenbeinturm". Er ist vielmehr eine Art Labor: Radikal zugespitzte visuelle Formulierungen ermöglichen exemplarisch zugespitzte Auseinandersetzungen mit der Wahrnehmung von Welt. Die Bildwelt der Massenmedien ist nicht ausgeschlossen – sie liegt den hier vorgestellten 30 künstlerischen Positionen ebenso zugrunde wie die Kunstgeschichte. Die unterschiedlichen Gebrauchsweisen des Mediums schließen sich nicht aus. Vielmehr überlagern und beeinflussen sie sich, wie in den Werken von Thomas Demand, Jochen Lempert, Martin Parr, Thomas Ruff oder Tobias Zielony und anderen sichtbar wird.

PHOTOGRAPHY CALLING! lädt daher drei Gastkuratoren ein, innerhalb der Ausstellung jeweils für einen Monat eine spezifische Sicht auf das Medium Fotografie zu entwickeln. Unter wechselnden Perspektiven stellt sich hier die Frage nach verschiedenen Gebrauchsweisen, aber auch nach unterschiedlichen Methoden des Sammelns.

Der in Frankreich geborene und in Kopenhagen lebende Künstler ▸ THIERRY GEOFFROY/COLONEL (*1961) macht den Anfang. Geoffroy verfolgt einen diskursiv-aktionistischen Ansatz, der stark vom Situationismus und einer Auseinandersetzung mit der französischen, soziologisch argumentierenden Fotokritik geprägt ist. Er entwickelt unterschiedliche „Formate", klar umrissene „Handlungsstrategien", die in unterschiedlichen Situationen jeweils modifiziert zum Einsatz kommen. (S. 392 ff.) Geoffroy nimmt den Titel der Ausstellung ernst: PHOTOGRAPHY CALLING! Wer ruft wen und warum und zu welchen Zwecken? An welchen Orten existieren heute die quantitativ größten Bewegungen von Bildern, mit welchen Interessen sind diese Bewegungen unterlegt und wie verändert dies unseren Umgang mit ihnen? Beeinflusst dies unsere Bildpraktiken? Welche Rolle spielen die sozialen Netzwerke im Internet, zu denen nur Zutritt bekommt, wer das Copyright an den – häufig sehr persönlichen – einzustellenden Text- und Bildmaterialien abgibt? Gilt der Slogan der 1968er, dass das Private politisch sei, auch heute noch, und wenn ja, unter welchen Bedingungen? Meint „öffentlich" gleich „politisch"? Welche politischen Interessen finden dann auf Facebook und in ähnlichen sozialen Netzwerken ihren Ausdruck? Mit dem Format „Biennalist" untersucht Thierry Geoffroy Kunstbiennalen. Er begreift sie als Orte hoher Konzentration intellektuellen Potenzials, fragt nach nachhaltigen Wirksamkeiten solcher kultureller Gipfeltreffen, initiiert öffentliche Diskussionen und generiert

Aufmerksamkeiten für globale politische Problematiken. In Vorbereitung von PHOTOGRAPHY CALLING! war er mit einem Team von Biennalisten auf der Biennale di Venezia 2011 unterwegs. In Hannover arbeitet er mit Personen, die gemäß ihrem Berufsstand Kontroll-, Regelungs- und Sorgfaltspflicht für den öffentlichen Raum innehaben: mit der berittenen Polizei Hannovers und mit Hannoveraner Politessen. Welche Bilder sammeln sie auf ihren alltäglichen Wegen, und wie gehen sie mit ihnen um? Wo liegt für sie die Grenze zwischen „privat" und „öffentlich"? Welche Möglichkeiten existieren, das Bewusstsein für mögliche Überlappungen und eine Indienstnahme durch Dritte, die sich gegen eigene, substanzielle Interessen richtet, zu stärken?

▸ MARKUS SCHADEN (*1965) richtet den darauf folgenden Projektraum ein. Er konzentriert sich auf das Fotobuch als „Speichermedium". Ausgehend von Stephen Shores Fotografie *La Brea* aus dem Jahr 1975, blättert er quasi exemplarisch die Komplexität des Wissens auf, das sich in diese Fotografie bis heute, vermittelt über die Rezeptionsweisen, latent eingeschrieben hat. (S. 404 ff.) Er fragt nach der Wirkungsgeschichte dieses Bildes, die sich über die Reproduktion in den unterschiedlichsten Zusammenhängen mit hoher Wahrscheinlichkeit weitaus nachhaltiger entfaltet als über Ausstellungen des Originals.

Schließlich richtet der Fotograf, Fotografiehistoriker und Sammler ▸ WILHELM SCHÜRMANN (*1946) im Rückgriff auf die Sammlung Gabriele und Wilhelm Schürmann einen Raum ein. (S. 416 ff.) In der Zusammenstellung für PHOTOGRAPHY CALLING! folgt die Auswahl einem „wilden Denken", in dem sich Visuelles assoziativ-poetisch miteinander verknüpft. Skulptur, Malerei, Zeichnung und Fotografien aus unterschiedlichen Zusammenhängen entwickeln einen Dialog miteinander, in dessen Zentrum nicht mehr und nicht weniger als die Gegenwart der Bilder steht. Die Geschichte der Fotografie schreibt sich als Geschichte der Visualität der vergangenen gut anderthalb Jahrhunderte – in zahlreichen Zitaten und Bezügen, die die Medien untereinander bieten – wie selbstverständlich ein.

Die Ausstellung PHOTOGRAPHY CALLING! ruft nicht nur ihr Publikum. Sie ruft auch nach einem Ort, an dem die hochkarätige fotografische Sammlung der Niedersächsischen Sparkassenstiftung sich zukünftig, eingebettet in derart gattungsübergreifende Zusammenhänge, der Öffentlichkeit darzubieten vermag.

Die Ausstellung ruft nicht zuletzt diejenigen, die die politischen Entscheidungen für die Schaffung eines solchen Ortes zu treffen vermögen, dazu auf, eine solche Aufgabe anzunehmen. Fotografie im dokumentarischen Stil erzählt nicht allein von der Welt. Sie hilft, die Konventionen, denen unsere Bilder von der Welt folgen, zu verstehen, sie kritisch zu hinterfragen und neu zu bewerten. Sie führt die „Mittelwerte" unserer Wahrnehmung in zugespitzter Form vor. Und sie schafft, dies vor allem, neue, subjektive Bildwirklichkeiten, die auf besondere Weise exemplarisch für unser In-der-Welt-Sein stehen.

Diese Bildwirklichkeiten der Nachwelt zu überliefern ist nur dann möglich, wenn wir dafür Verantwortung übernehmen.

Das Signal, das das Sprengel Museum Hannover und die
Niedersächsische Sparkassenstiftung mit der Ausstellung
PHOTOGRAPHY CALLING! gemeinsam senden, zeigt, dass
die Grundlagen dafür auf denkbar günstige Weise gelegt sind.

1 Sprengel Museum Hannover sowie Städelsches Kunstinstitut und
 Städtische Galerie Frankfurt am Main, kuratiert von Heinz Liesbrock
 und Thomas Weski.
2 Tate Modern, London, und Museum Ludwig, Köln, kuratiert von
 Emma Dexter und Thomas Weski.
3 Thomas Weski, „Gegen Kratzen und Kritzeln auf der Platte", in:
 How you look at it. Fotografien des 20. Jahrhunderts, Kat. Sprengel
 Museum Hannover, hg. von Heinz Liesbrock und Thomas Weski,
 Sprengel Museum Hannover, Städelsches Kunstinstitut und Städti-
 sche Galerie Frankfurt am Main, Köln 2000, S. 19 ff.
4 Beaumont Newhall, „Reine Photographie", in: Geschichte der Photo-
 graphie, München 1984, S. 173, zit. nach Weski 2000, (wie Anm. 3) S. 21.
5 Weski 2000 (wie Anm. 3), S. 22.
6 Abigail Solomon-Godeau, „Wer spricht so? Einige Fragen zur Doku-
 mentarfotografie", in: Diskurse der Fotografie. Fotokritik am Ende
 des fotografischen Zeitalters, hg. von Herta Wolf, Frankfurt am Main
 2003, S. 54.
7 „Der Begriff sollte ‚dokumentarischer Stil' lauten ..., ein Dokument hat
 einen Zweck, verstehen Sie, wohingegen Kunst wirklich zweckfrei ist.
 Daher ist Kunst niemals ein Dokument, obgleich sie sich diesen Stil an-
 zueignen vermag." [Übersetzung: Miriam Wiesel] Leslie Katz, „Inter-
 view with Walker Evans", in: Art in America, March/April 1971, S. 85 ff.
8 Weski 2000 (wie Anm. 3), S. 30.
9 Loraine Daston, Peter Galison, Objektivität, Frankfurt am Main 2007,
 S. 147.
10 Ebd., S. 14.
11 Der Gruppe „Schmelzdahin", die von 1983 bis 1989 existierte, gehör-
 ten Jochen Lempert, Jochen Müller und Jürgen Reble an.
12 Vgl. Anm. 3.
13 Die Fotohistorikerin Rosalind Krauss verwendet, Max Ernst zitierend,
 für diesen Vorgang den Begriff des Spacing, Rosalind E. Krauss,
 „Der Surrealismus in der Fotografie – Fotografie und Surrealismus",
 in: Camera Austria, 10, 1982, S. 16.
14 Hermann Pfütze, „Thomas Demand, Nationalgalerie", in: Kunstforum,
 Bd. 200, 2011, S. 228.
15 Pressemitteilung der Staatlichen Kunstsammlungen Dresden zur
 Ausstellung Jeff Wall. Transit, 20. Juni bis 10. Oktober 2010.
16 Markus Frehrking, „Jeff Wall", in: How you look at it (wie Anm. 3),
 a. a. O., S. 510.
17 John Berger, „Between Forest", in: Jitka Hanzlová, Forest, Göttingen
 2006, o. S.
18 Wolfgang Tillmans im Gespräch mit Maren Lübbke-Tidow und Tobias
 Zielony, in: Camera Austria, 114, 2011, S. 47.
19 Leah Ollman, „Wolfgang Tillmans at Regen Projects II", in: Los Angeles
 Times, April 1, 2011.
20 Annelie Pohlen, zit. nach Thomas Seelig, „Thomas Ruff", in: How you
 look at it (wie Anm. 3), a. a. O., S. 496.
21 Michael Köhler, „Interview mit Robert Adams", in: Camera Austria, 9,
 1983, S. 2.

22 Siehe u. a. The New Topographics, Text: Britt Salvesen, Göttingen
 2010; Julia Galandi-Pascual, Zur Konstruktion amerikanischer
 Landschaft, Freiburg 2009.
23 Robert Adams, Einleitung, 1974, zit. nach: Robert Adams. The New
 West, hg. im Auftrag der Niedersächsischen Sparkassenstiftung von
 Heinz Liesbrock und Thomas Weski, Köln 2000, S. Xvi.
24 Heinz Liesbrock, „Vision und Revision des amerikanischen Westens.
 Zur Neuauflage von ‚The New West'", in: Robert Adams, ebd., S. Xxii.
25 Markus Frehrking, „Lewis Baltz", in: How you look at it (wie Anm. 3),
 a. a. O., S. 463.
26 Ebd.
27 „Hans-Peter Feldmann im Gespräch mit Kasper König", in: Hans-
 Peter Feldmann. Another Book, hg. von Helena Tatay, London und
 Düsseldorf 2010, deutsche Textbeilage, S. 11.
28 Ute Eskildsen, „In leidenschaftlichem Widerstreit zwischen Ab-
 bildung und Darstellung", in: Fotografie seit 1965. Michael Schmidt,
 Folkwang Museum Essen, o. J. [1995], S. 13.
29 www.diamondpaper.de/pdfs/dp02_de.pdf (Zugriff am 18. Juli 2011).
30 Markus Frehrking, „William Eggleston", in: How you look at it (wie
 Anm. 3), a. a. O., S. 474.
31 Hilla Becher, zit. nach „Klar waren wir Freaks", Interview mit Tobias
 Haberl und Dominik Wichmann, Süddeutsche Zeitung Magazin, 20,
 2008.
32 Markus Frehrking, „Bernd und Hilla Becher", in: How you look at it
 (wie Anm. 3), a. a. O., S. 465.
33 Ulrike Schneider, „Lee Friedlander", in: How you look at it (wie Anm. 3),
 a. a. O., S. 481.
34 Lee Friedlander, zit. nach Ulrike Schneider, ebd., S. 482.
35 Boris Mikhailov im Gespräch mit Stefan Schmidtke und der Autorin,
 Berlin, 13. März 2009.
36 Ulrike Schneider, „Diane Arbus", in: How you look at it (wie Anm. 3),
 a. a O., S. 460.
37 Ebd.
38 Diane Arbus, zit. nach Ulrike Schneider, ebd., S. 461.
39 David Chandler, „Eins gab es, das wichtig war", in: Paul Graham,
 hg. von Paul Graham und Michael Mack, Göttingen 2009, S. 23.
40 Ebd.
41 Ebd., S. 19.
42 Ebd., S. 20.
43 Tobias Zielony, „Dann wird es hell. Christian Petzold im Gespräch
 mit Tobias Zielony", in: Tobias Zielony. Story/No Story, hg. von Maik
 Schlüter, Florian Waldvogel u. a., Ostfildern 2010, S. 126.
44 Ebd., S. 125.
45 Ulrike Schneider, „Nicholas Nixon", in: How you look at it (wie Anm. 3), a.
 a. O., S. 490.

46 Julian Heynen, „Als ihre eigenen Schauspieler. Familienformeln
 – Lebensweisen", in: Texte zum Werk von Thomas Struth, hg. von
 Thomas Struth, München 2009.

PHOTOGRAPHY CALLING! presents 30 photographic perspectives in selected work groups. Following *How you look at it. Photographs of the 20th Century* it in the year 2000[1] and *Cruel and Tender* in 2003/04[2], it is the third major European exhibition project dealing with the recent history and current state of art photography and is derived from "documentary style," the authoritative term originated by the American photographer Walker Evans in 1971.

In the field of photography, the collection of the Niedersächsische Sparkassenstiftung concentrates on the sorts of work groups that are attributable to this style—a focus that distinguishes it and lends it a marvelous internal cogency. Now it is time to think about the future of this collection and develop it further with regard to both possible institutional partnerships—a matter that is addressed elsewhere in this book—and to content. How can this remarkable collection continue to evolve without sacrificing its special quality? What does "documentary style" photography mean today, fourty years after Walker Evans first coined the expression?

In the context of the exhibition *How you look at it*, Thomas Weski developed a history of this style of photography and its characteristics based on the dispute between the various photographic tendencies that had been going on since the mid-19th century[3]: whereas on the one hand, until after the First World War, the pictorialists aimed at an artistic expression in their work similar to painting and, complying with the artistic trends of their era, were indebted to Symbolism and Impressionism in particular, on the other there was a "rigorous and pure application of the medium." Defining the term "straight photography" in 1914[4], Sadakichi Hartmann said, "You compose the picture that you want to take so carefully that the negative turns out absolutely perfect and requires very little or no manipulation." In 1924, Gustav Hartlaub coined the expression "New Objectivity" (Neue Sachlichkeit), a category which, "in the realm of photography, applied particularly to Albert Renger-Patzsch and August Sander."[5] One first comes across the combination of the words "documentary" and "photography" a little later in France. The critic Christian Zervos used it in 1928 in an analysis of photographs by Eugène Atget (1857–1927), André Kertész (1884–1985) and Charles Sheeler (1883–1965).[6]

In all three cases, the concepts were aimed at excluding aesthetic-photographic practices that undermined the precision of photographic reproduction by employing the sort of interventions and transformations used in painting.

For Walker Evans in 1971, these debates were already long past. Considering the term "documentary photography," he suggested an adjustment: "The term should be documentary style ... You see, a document has use, whereas art is really useless. Therefore art is never a document, although it can adopt that style."[7] But what is so special about "documentary style," what makes it stand out?

"The 'that's how it was,' the recognizability and the harmony of motif and picture guarantee their success," Thomas Weski writes. "These pictures, which are subject to strict rules, have to be comprehensible and open to classification and comparison if they are going to function as a document. Walker Evans was interested in precisely those qualities in documentary photography, because he wanted to carry clarity, precision and legibility over into his form of photography. He did not want his pictures to bear any ostensible artistic signature to interfere with the subject of the picture but instead wanted to make them accessible to study and analysis. Photographs which wholly fulfill the concept and cite the documentary style derive their particular quality from the disparity between motif and image, from the artistic construction erected on the foundation of the reality described. What is meant is not simple duplication, but the desire to highlight the specific, the unsaid, the particular against the background of the familiar, and to do so by adjusting the point of view. Seemingly well known and taken as a piece of documentation at first glance, it is only after a while, as one looks at them, that these photographs reveal their quality and in consequence gain acceptance as artistic statements in a dialog with the world."[8]

PHOTOGRAPHY CALLING! expands the scope outlined above. Even though many of the workgroups on show may be "correct" according to Walker Evans' definition, they are, for example, endowed with artistic perspectives circulating on the fringes, such as those by the photographer Jochen Lempert that deal with the historical construction of the concept of objectivity. What is the significance of linking methods of photographic representation that refer in their strict orientation to the object being represented with 19th century scientific photography? Does it reflect a sense of order and the attempt to categorize things that accompanied the development of the medium in its early years? Or are these methods rather being cited, understood and undermined in a subversive-subjective way? Do works like those by Thomas Demand, which are created out of paper and cardboard in the studio as reconstructions of real-life photographs, count? What about Thomas Ruff's computer-manipulations of NASA shots of the surface of Mars? How far can we stretch this term today to take in changes in the way we perceive things? And is this form of photography really as "useless" as Walker Evans claimed?

For 19th century science, the merit of photography was mainly in its promise of "unbiased reproduction." The photographic machine was "at once observer and artist, free from the inner temptation to theorize, anthropomorphize, beautify, or interpret nature. What the human observer could achieve only by iron self-discipline, the machine effortlessly accomplished—such, at least, was the hope."[9] Photography pledged unprejudiced objectivity, a self-image of phenomena that was also based on ethics and morals—even if and precisely because it revealed a Nature that was new and surprisingly less "divinely ideal" than it was inchoate. In his studies of the impact behavior of drops of liquid that was part of his research into fluid dynamics, the British physicist Arthur Mason Worthington (1852–1916)

was for years beguiled by what was "to all appearances" the beauty of perfect and symmetrical natural forms. Only with the advent of photography did he wish for pictures showing the physical world in all its complexity and asymmetrical individuality.[10]

The photographer ▸ JOCHEN LEMPERT (*1958), living in Hamburg, is heir to such a tradition. The poetical universes unfolding in his books and wall installations tell of the co-existence of different life forms. They are also complex analyses of the interfaces between photographic and scientific history.

Jochen Lempert studied biology and collaborated with fellow artists in experiments concerning the perishability of film material.[11] Since the beginning of the 1990s, parallel to his ongoing work as a biologist, he has been using photography to study the way human, animal, plant and micro-organic life forms influence each other and how to show it.

Lempert frequently falls back on photographic processes that were used in scientific photography in the 19th century and have been readopted in a subversive manner in surrealist photography. As far beyond a technically upgraded form of photography as he may be on the one hand, on the other he is absolutely committed to the photographic. There is no "scratching and doodling on the plate" here[12], unless that which is being "documented" itself scratches and doodles by running, hopping or flowing across the light-sensitive paper. If you were to follow the trails that Lempert—albeit discretely—lays in this poetic cosmos of symbols through the titles of his usually air-dried silver bromide, then you would be inducted into a discourse on the medium in the context of the history of science that is as playful as it is substantive. In *Subjektive Photographie* (subective photography), one learns that the "lenses" superimpose the breath and heartbeat movements of the photographer's own body on the purely photographic record of the movement of a celestial body; that Rudolf Jakob Camerarius (1665–1721), to whom the two sheets are dedicated (pp. 200 f.), founded an experimental form of biology and made pioneering discoveries about the sexuality of plants; and that Anna Atkins (1799–1871), another reference (p. 194), used cyanotype, an early photographic technique, in order to produce precise documents of scientific specimens. Their works are also admired today for their aesthetic value. The shot of a stork in flight (p. 197), on the other hand, refers to Ottomar Anschütz (1846–1907) and his famous photographs of flying storks. With his discovery of the Rouleau shutter, Anschütz made an important contribution to the development of the snapshot and in 1893/94 documented Otto Lilienthal's early attempts at flight. It is not necessary to know any of this in order to be moved by these photographs. They possess an independent poetic existence because they call forth "internal images": to see a stork in flight takes you momentarily to a timeless and utopian place. The seemingly experimental plant pictures could recall a child's curiosity in a biology lesson. And the light, abstract trail a firefly leaves on the photographic paper (pp. 198 f.) awakens flowing, sliding and soft bodily memories.

In their strict adherence to the photographic, in the overlapping of individual associations and concrete references to cultural and art history, in their dual character as projection surface and concrete store of knowledge, and in the poetic-subjective subversion of objectifying image strategies, Jochen Lempert's aesthetic practices display significant characteristics of cocumentary style photography. They are characterized by the serial, the breaking down of the narrative into individual images[13]—and the necessity of recomposing this "dismembered" world when looking at the photographs. Nevertheless, it is not documentary style photography, although—albeit also in an exaggerated manner—it illustrates its rules.

▸ THOMAS DEMAND (*1964) is, like Jochen Lempert, not a prototypical representative of documentary style photography, but his work also offers an approach to the topic. At first glance, both ways of working are diametrically opposed to one another. While in Lempert's case, the life forms almost appear to reproduce themselves, Demand avoids any direct "imprint." Instead, he is interested in the tracks once they have been medially processed. He designs "image memories"[14] by reconstructing the motifs of photographs that have entered the collective memory of the Western world from paper and cardboard in their original size. He then photographs them and turns them into panels. The "models" are destroyed. Visual fakes and Potemkin surfaces are created. The underlying events, or rather their locations, are fictionalized for a second time, but also "democratized" as well: they turn into something or somewhere for everyone, into apparently random corners of corridors or offices and drapery. It is not clear whether communicating the underlying events so "informally" even if they are not in the title is still part of the artistic strategy. This is, of course, the suspense between showing and not showing, not saying and saying, where Demand's works develop an almost surreal internal tension. For example, you don't necessarily have to know that shots of the actual place in Duisburg where the Love Parade turned into a catastrophe on July 24, 2010 were used as the model for *Tribute* (p. 187) in order to read this work as dealing with collective rituals memorial and mourning. However, it does considerably expand the frame of reference within which this picture develops its power.

What clearly seems to interest Demand—and this forms the bridge to the very different work of Jochen Lempert—is the medial "self-illustration capability" of events. Where was the camera, which camera angle did the press photographers use, which controller or filter did these pictures that now serve as a model pass through? What does this say about the interests that these pictures follow? Demand also carries out research: the hypotheses he puts forward with his pictures concentrate in their "cleaned up" form on selected aspects and are at the same time new independent realities.

The American photographer ▸ JOHN GOSSAGE (*1946) is represented in the exhibition with the *The Pond* (pp. 237 f.). The series was originally conceived in the narrative form of a book and was first published as such in 1984. Gossage and many other artists represented here have been influenced by the experience of conceptualism. A photographic series like *The Pond* drafts a structural system of symbols, yet here these

symbols, unlike in Lempert's case, vary only minimally: grass, wayside scrub and undergrowth wherever you look. The total of 54 black-and-white photographs describe—so it is suggested—a walk through the landscape on the shores of a lake in a very compelling way. This is also about co-evolution and the coexistence of Man and Nature, although in a completely different way than in the works of Jochen Lempert. The sober, sometimes very low-level perspectives deny themselves any romanticizing attitude. It is a scrubby, rutted and unruly landscape, yet one of fragile beauty manifesting itself in details: In 1854, Henry David Thoreau published literarily compressed sketches from his diary under the title *Walden*. Thoreau had withdrawn from the developing industrial society and had been living in a log cabin for more than two years by a lake called Walden Pond in the woods of Concord, Massachusetts. Influenced by transcendentalism, he sought deeper and more intense self-awareness and reflectivity through a Spartan lifestyle. In the USA, *The Pond* was read against the background of this book, which was already widely circulated during the 19th century. However, for Gossage, the series was also based in other associations. His affinity to the photography of the New Topographics, to the work of Robert Adams and Lewis Baltz, with whom Gossage is friends, is just as evident as his closeness to 19th century American landscape photography. Interestingly enough, it is not a real lake or pond that is being walked around here. Among other things, the work includes several photographs taken in Berlin. This turns *The Pond* into a fictional topography, a poetically composed hypothesis investigating the American myth of the unexplored vastness of Nature.

With his fictitious tableaux, the Canadian photographer ▸ JEFF WALL (*1946) is another one with an affinity to the documentary. In his pictures, he combines "the deceptive authenticity of photography with the suggestive language of film and the narrative gesture of painting."[15] "The contents of these (at times life-size) images are never obvious and it is hard to define any common denominator: posing as snapshots of the everyday, they are in fact visual explorations of modern life, drawing on the traditions of easel-painting. The scenes are often set on the margins of urban living and make restrained comment on aspects of the present."[16]

Wall's works frequently emerge from the reproduction of either medially or actually experienced images and as part of an intensive involvement with both older and more recent art history. The apparent banality with which critical situations surface is characteristic of many of his works: In *Search of Premises* (pp. 232 f.), a well-equipped team of forensic specialists looks for clues in an anonymous and seemingly deserted apartment—apparently the place where a crime was either planned or launched. Just like Thomas Demand, Wall is less interested in concrete situations or events than in the manner of their representation. The scene is carefully worked out right down to the last detail using committed actors. The moment of alienation and estrangement that lies in this process is, as an act of comprehending and at the same time distancing reinter-

pretation of the original initial material, possibly akin to Thomas Demand's work on the model.

▸ ANDREAS GURSKY (*1955) also works in the photographic version of the panel painting. However, unlike Jeff Wall, he is not interested in the potential existential tension in a banal-seeming situation, but in a quasi-ideal application of universal metaphors for socially tangible conditions. The work *Cocoon II* (pp. 120 f.) is over five meters wide and was created in the Frankfurt club of the same name in 2008. A large crowd of young people appear to be waiting in front of a sprawling, futuristic-architectonic backdrop for a rave to begin: little ecstasy is in evidence here. The visual correlations between the openings in the glinting honeycomb-like background and the heads of the young people anchor the characters even further. The contradiction between the precision of the reproduction, the wealth of detail and the emptiness that this picture still conveys is highly irritating. Gursky looks down on the action from a lofty perspective. It reveals itself as an almost divine concept. In actual fact, *Cocoon II* was the result of a tedious process of digital montage. With didactic intent, earlier masters of this process such as John Heartfield (1891–1968) built collages from photographic fragments with the aim of exposing political-economic imbalances. Gursky takes the opposite tack: through photography, he exponentiates the slickness of the surface using an additive-compositional process and finds pictures to illustrate recurring patterns within an apparently highly individualistic society. But Gursky's view is in no way judgmental. The closeness to this, as to many of his motif areas, is biographically conditioned. *Cocoon II* directly correlates the formulation of the picture as a seductive, glistening high-end product of a precisely controlled high-tech process, which viewers experience as directly as possible because it affectively incorporates them rhythmically into a "whole," with synthetically produced, ostensibly rhythm-oriented techno music. If you consider his way of working in relation to that of the scientific photographers of the 19th century such as Arthur Mason Worthington, who was mentioned earlier, Gursky has made a completed turnaround. While photography disabused Worthington of his concept of an ideal order in the physical world and forced him to recognize its complexity and asymmetrical individuality, Gursky returns our idea of the world to the very "whole" that Worthington lost.

Since the beginning of the 1990s, ▸ JITKA HANZLOVÁ (*1958) has devoted herself to gentle and by the same token forthright descriptions of people and their environments in portraits. For *Forest* (pp. 125 ff.), she took photographs in a forest near the northern Carpathian Mountains between 2000 and 2005. She moves through the landscape of her childhood and invites the viewer to follow her into a deep silence and solitude. The times of the day and the seasons come and go. Sunlight, the gloom under the trees, snow and dew lying on stalks, leaves and twigs. Every now and then there are animal tracks. Moss-covered trunks glimmer in the dusk. As John Berger writes on Jitka Hanzlová's photography, "... it is necessary

to reject the notion of time, that began in Europe during the 18th century and is closely linked with the positivism and linear accountability of modern capitalism: the notion that single time, which is unilinear, regular, abstract and irreversible, carries everything."[17] In their actuality, these photographs—in spite of their much smaller format and the much more contemplative subject matter—could easily be incorporated into Andreas Gursky's large-scale *Cocoon II*. This motif, which appears so timeless, derives its startling modernity from the extreme precision with which the medium is handled here. In *Forest*, two different temporal perceptions are superimposed on one another in a remarkable fashion: a highly modern one aimed at the photo-technical realization of the subject, and a pre-industrial one that offers up the subject itself. The shimmering disquiet that these pictures can engender develops if anything from the tension that emerges here.

Gursky and Hanzlová are linked by the Utopia of absorption into a "wholeness" as a sort of fundamental romantic gesture, albeit across a great distance. In the dichotomy of their respective internal constitution, both of them mark out distinct vertices of social debates about present and future.

For nearly two decades, ▸ MAX BAUMANN (*1961) has been finding photographic images for the contradiction-laden dialectics of history. He photographs abandoned barracks and other formerly utilitarian sites: the Volkswagen factory in Wolfsburg in the process of becoming the Autostadt, genetically modified plants, open heart surgery and the city of Berlin as a fast-growing symbol of history and the present day. The consistently rigorously composed images celebrate the precision of photographic reproduction and with it the beauty of detail. At the same time, zones of denial can also be frequently found in these pictures: zones that formulate the inexpressible, information that cannot be shared, in fuzziness. Baumann's compositional repertoire harks back to the 1920s, to a romantically disposed Constructivism in particular, which he steers towards a spatial-painterly quality. A trace of sentiment also reverberates in his works, similar to the way it does in Hanzlová's: Sentiment as an act of rebellion within a present day that has been purged of emotion by its focus on efficiency.

In *blindlings* (blindly) (pp. 215 ff.), Baumann displays portraits for the first time. A series of black-and-white photos shows the faces of people in their thirties—their most important biographical decisions already behind them—with their eyes closed. Baumann invites them into a calm studio situation and allows them to make themselves comfortable in front of the large format camera and between the lights. The photographs are taken at a moment of inner peace, when something that extends beyond that instant in time becomes visible. Nothing here can be whitewashed or hidden behind a façade: It is a type of peeling process that occurs between the lights and the photographer, who has become invisible under the sheet behind the camera. These silent pictures withhold anything idealizing, anecdotal or even psychologizing. They reveal physiognomies that, in their timelessness, recall the medieval

sculptures of someone like Tilman Riemenschneider (ca. 1460–1531). Yet, at the same time, they are extremely contemporary: The density of the photographic information originating from the focus compels the eye towards a precise, almost intimate reading and leads to fundamental questions about the constitution of human existence.

Referring to the ink-jet images he started creating in 2009, ▸ WOLFGANG TILLMANS (*1968) says he is "fascinated by the coexistence of surfaces that represent what they want to be, but which they can obviously not achieve. One can find it cold and dishonest or consider it passionately—as a way of earning one's dinner or ensuring offspring. This moment links the Chinese skyscraper architect, who completely covers his skyscraper façade with LED, with the tropical bird toucan, which has ostentatiously bright feathers. Finding warmth in this coldness is the backing for my new photos."[18] After more than ten years working on abstractions created without a camera, on their relationship with figuration and the materiality of photographic paper, Tillmans has turned to digital photography in his ink-jet prints. (pp. 204 ff.) He talks about the great richness of detail that is now possible using this technology, and about the "bycatch," the accidental, that is shown more precisely.

Over the last two years, Wolfgang Tillmans did not just take his camera to Berlin and London; he also intentionally sought out motifs beyond his own habitat. In Argentina, China, Tunisia, Tierra del Fuego, Lampedusa and elsewhere, he took "global snapshots"[19] that could, in keeping with the above quotation, be called "surface studies" of globalization. What do these surfaces tell us, what codes are they transporting and what are they concealing? And where are the limits of their legibility in the light of the amount of digital data that has given rise to them? How much of this information can really be processed? What criteria exist for the organization of this data, and do they generate themselves—like globalization, another supposedly "natural" process in which responsibilities remain anonymous?

The large format Mars-scapes that ▸ THOMAS RUFF (*1958) presents with three examples from his work *ma.r.s.* (pp. 51 ff.), pose a similar question. These are high-resolution, seemingly close-up pictures of surfaces that are between approximately 50 to 100 million kilometers away from us. The idea alone is ridiculous and gives rise to doubts: however, Ruff took shots taken by NASA from a satellite using high-resolution cameras as his initial material and then used a computer to change the overhead shots into scenes and colors. This results in large, highly aesthetic images resembling abstract paintings yet which still seem to allude to erosions in the coloration typical of the Martian surface. Like many of Ruff's workgroups based on already existing footage, *ma.r.s.* is much closer to Appropriation Art, but these works still simulate the effect or affect of reality attributed to "documentary style." This subtly subverts the dictum that the photographic representation of an object is simultaneously evidence of its existence. As Annelie Pohlen wrote in 1991, Ruff himself sees his photographs „as the reality

of an order that exists in its own right—at the same time pointing clearly to the fiction of objectivity in documentary photography."[20]

In PHOTOGRAPHY CALLING!, these pictures of unimaginably distant places are juxtaposed with photographs taken in the suburban landscapes of the Colorado Front Range.

▸ROBERT ADAMS (*1937) left his home turf at the end of the 1950s to study literature and do doctoral work in the subject. "When I went back to Colorado, I found that it had in the meantime come to look just like California. Suddenly there were freeways and smog. To go back home and find this world in pieces, so to speak, was [...] a great shock. Somehow I had to come to terms with the landscape, which I felt I no longer liked. Photography gradually allowed me to do that [...]."[21]

Like Lewis Baltz and Bernd and Hilla Becher, Robert Adams was one of the participants in an exhibition at the George Eastman House International Museum of Photography and Film in Rochester (New York, USA) in 1975 entitled *New Topographics: Photographs of a Man-Altered Landscape*. It is seen as a milestone in recent photographic history and is the origin of many critical discourses about terms such as "style," "objectivity," and "document," as well as the American pioneering myth and its transfer into European photography. Robert Adams and the other photographers in this exhibition are all in the tradition of 19th century landscape photography.[22] In particular, Timothy O'Sullivan (around 1840–1882), who accompanied expeditions of exploration into areas of the western United States not yet occupied by white settlers, is important in this context. In the landscape photography of the late 1960s and early 1970s, the apparently "objective", "style-less" photography of these "forebears" overlapped with the experiences of conceptual art, represented in this context in particular by Ed Ruscha (*1937). Each series of images was characterized by both a compositional radicalism leading to a bold geometrization and abstraction of the motif aimed at a universal validity and a conceptual rigor. In the introduction to *The New West*, the photographer wrote in 1974 that: "The subject of these pictures are [...] not prefab houses or freeways; rather their subject is the source of all form: light. That is why the Front Range is so awesome, because it is flooded with such an abundance of light that any banality ceases to exist."[23] The work comprises 56 black-and white photographs, which were arranged in the publication in five chapters, each with a brief introductory text. They describe the civilizational transformation of the American West and, drawing on America's founding myths, make "a statement about the state of American society and culture."[24]

Unlike *The New West* (pp. 58 ff.), however, Ruff's *ma.r.s.* images read like some sort of extrapolation of this frontier myth into the infinite vastness of outer space. Around the time when Adams was starting to devote himself to photographing the consequences of the settlement and exploitation of the American West, men departed Earth's orbit for the first time. The American West and the films about the *Star Trek* follow the same narrative patterns. Such associations are suggested by the fact that Ruff's digitally manipulated Martian surfaces also remind one of close-ups of the crumpled, mangled upholstery of posh 1970s furniture and hence the fictional nature of alleged photographic records of expeditions into space.

▸LEWIS BALTZ (*1945) is another photographer whose works were featured in the 1975 *New Topographics* exhibition. He too addresses the changes in the American landscape where Nature and civilization come into conflict, and he also frequently works in extensive, comprehensive series. However, Baltz has also been influenced by Surrealism and especially the work of Frederick Sommer. "In the 1940s, Sommer combined elements of European Surrealism with the technical perfections of Edward Weston and his landscape photographs were among the first to draw attention to the detritus of human habitation."[25] *Nevada* (pp. 137 ff.), "the portrait of a faceless suburban estate by day and night,"[26] dates from 1978. Compared with Robert Adams' essay-like narrative style, Baltz's photographic aesthetic focuses on the symbolic priming and interplay of individual picture elements. In its graphical reduction, it is strongly reminiscent of the stylistic devices of Minimalism, to which the photographer likewise makes reference. The use of light opens up stage-like spaces, where the destruction of the environment, the piles of trash and the transitory nature of the buildings and life all unfold—albeit silently—in a chilling drama. In series such as *San Quentin Point* (1986) and *Candlestick Point* (1989), Baltz, who now lives in Paris and Venice, also displays an unequaled radicalism in his descriptions of the brutality of "vernacular land art."

In *Ökoton* (Ecotone) (pp. 148 ff.), ▸ELISABETH NEUDÖRFL (*1968) quite consciously draws on the tradition of the New Topographics. Her pictures are taken in the area around Berlin. They show flagstone and sandy paths, rural settlements of terraced houses, empty bungalow resorts, plain functional rustic buildings, earth mounds, heaths used by the military, birch copses, vile pine plantations and freshly cut clearings in the woods. However, unlike works such as *Nevada*, where the disorder of the suburban belts is transformed into geometric order, Neudörfl apparently wants to give it free rein. On the one hand, that may be because she photographs in color and the vegetation is only partly lost in graphical abstraction, but on the other, it could be that because—as a neutralizing background—the sky over Brandenburg is a bit lower than it is over Colorado. The paths and roads are not cross-continental highways but tracks used by tractors and other robust vehicles. With an almost anarchic brittleness, *Ökoton* develops a detailed narrative of the transformation of Nature wrought by agriculture, not industry. In *venceremos* (1994), her final work for her studies at the technical college in Dortmund, Neudörfl was already asking how history leaves its mark on landscape and vegetation. In her series, which are frequently conceived as books, Neudörfl is especially interested in the unspectacular but informative "flipsides" of history and present-day global capitalism. *Ökoton* depicts the area around Berlin, a screen onto which the residents of the metropolis project their idyllic yearnings, as a territory that, thanks to its mostly improvised uses, is liable to crude encroachments and changes. In actual

fact, the improvisational "small plot" culture that Neudörfl documents is, in view of the global interest in renewable commodities and large areas for single-crop farming, already almost a thing of the past. In biology, the term "Ökoton"—in English, "ecotone"—signifies the area of transition between two difference ecosystems that sometimes feature a particular shared biodiversity. To refer back to Jochen Lempert's photographic concerns, these are potential zones of accelerated co-evolution. The fact that Neudörfl does not formally smooth out this "chaos" of transitional zones but instead finds aesthetically consistent poetical forms for its artlessness is the particular strength of her work.

Nature, or that which we generally tend to see as Nature, is framed in a totally different way in the flower pictures (pp. 161 ff.) of Düsseldorf resident ▶ HANS-PETER FELDMANN (*1941). They show familiar cut flowers against unchangingly monochrome backgrounds in panel formats. If it were not for the great photographic precision and vivid radiance of the colors, one might almost think the artist had reproduced postcards from the 1950s. Hans-Peter Feldmann's real passion is collecting existing photographs and rearranging them for books and exhibitions. For him, individual photographs are too fraught with meaning: "Repeating things gives an average value that's closer to the truth than any individual picture can be."[27] For a "non-photographer" who was, in the parlance of the 1950s, a "yob," putting roses and lilies in the large formats developed for photography by a fellow Düsseldorf artist born in the 1950s is possibly a great challenge on a number of levels. For the viewer, this photographic consummation is ultimately framed in images recalling Easter greetings long past, things found in grandmother's drawer and visits to the flea market. Fields of references as diverse as the *vanitas* depictions of Dutch 17th-Century painting, the eerily assiduous orderliness of front gardens and public flowerbeds and the economy of the wholesale flower trade also make an appearance here. Feldmann keeps his imagery so general that, like sponges, it seems to soak up everything that both collective and individual consciousness and subconscious hold in readiness, not only in respect of the range of motifs in question but also of the type of visual realization involved in each case. And, although one can hardly associate Feldmann with documentary style photography at all, it is exactly this interest in universal photographic images that links him to it.

The work of the Berlin-based photographer ▶ MICHAEL SCHMIDT (*1945) has been assigned a decisive role in the development of this sort of "universal specifics" and the transfer of its underlying ideas between the USA and Europe in the second half of the 20th century. His "[...] rejection of the appraisal of documentary photography that had been hitherto linked with its representational function had a great influence on both young German and European photographers. Schmidt's insistence on subjective authorship in the process was not aiming for any alienating intervention but for the direct communication of individual perception as the starting point for an additive creative activity."[28] For Schmidt, too, the assertion typically derives less from the individual image than from the correspondence between images, from their interstices. As representational forms, books and exhibitions are on an equal footing. *Ihme-Zentrum* (pp. 173 ff.) plays a special role in that the artist's book had the title *Ihme Zentrum. 4 Fotografien, 8 Ausschnitte,* as it appeared in 2003 at a time when the pictures did not yet exist in their final form. The four large-scale images refer to their place of origin. The Ihme Center, Krystian Woznicki noted in 2003, is "[...] a complex built between 1972 and 1975 in the wake of the euphoria of the 1960s that drove the urban planners to design increasingly gigantic structures. In other words, it's a left-over from the utopian construction era along with its technocratic vision of the possibility of planning social processes—the only one of its kind in Hanover."[29] For Michael Schmidt, executing the work in a large format and using analog processes was out of the question. It was released digitally in 2009.

Out of the graphical geometry and the minimalist, painterly grayscale, the photographer takes a confrontation with variously charged architectonic fragments and surfaces to extremes. References to Schmidt's own work from Berlin in the 1970s and 1980s can be identified, as can references to works by Ed Ruscha and Lewis Baltz, as well as to Conceptual Painting. Ranged alongside Hans-Peter Feldmann's flower pictures in PHOTOGRAPHY CALLING!, the works of both artists enter into a dialog about the—albeit differently conceived—rigor of aesthetic solutions and references to the various traditions of the panel painting. However, they also relate how the aspirations of the postwar years were bound up with notions of radical orderliness.

As with many photographers of her generation, ▶ HEIDI SPECKER (*1962) counts Michael Schmidt as one of her most important artistic influences. Her artistic work is also characterized by architectonic surfaces and structures as information carriers, the presence of history and the individual image as a "module" in a complex poetical narrative. For more than two decades, this work has been developing parallel to advances in the technical possibilities of digital photography. With the still meager storage and output capacities of computers at the beginning of the 1990s, she went for large formats, the fuzziness of which recalled pictorial inventions. At the latest since the piece named for the architect Peter Behrens from the year 2000, and definitively since *Im Garten* (In the Garden; 2003/04), photography has become the unmistakable reference system behind her activities. *Termini* (pp. 71 ff.) was created during and as a result of a year spent in Rome. Heidi Specker took photographs of architecture and architectural elements from the time of Mussolini's rule, in the former residential block that now houses the Giorgio de Chirico Museum and of fleeting street views and glimpses of Roman cultural life. Once again, the individual images transport information and reflections, leading in this case to an associative-poetic investigation into recent Italian history and the function and functionalization of art and culture. The sculptural characteristics of things, their surface structures and their special interrelationships, the

sometimes vivid and precise and then once more shimmering or reflected light and the interplay of black and white and color generate a literal eloquence. The artist, who was a stipendiary at the German Academy at the Villa Massimo in Rome in 2010, also addresses the question of her own self-image as a creative producer in this discourse. In one of the photographs on display in the exhibition, she reflects herself in the transparent reflective foil of Franz West and Heimo Zobernig's work *Autosex* (1999): Beyond the foil, there is room for an opposite number to be experienced in an autoerotic act.

In the exhibition, Heidi Specker's digital prints are juxtaposed with dye transfer prints from *14 Pictures* (pp. 82 ff.), the first portfolio released by ▶ WILLIAM EGGLESTON (*1939) in 1974. "While many art photographers were still involved with black and white in order to distance themselves from the colors predominant in advertising and fashion, William Eggleston displayed only color photographs in his first solo exhibition at the Museum of Modern Art in New York in 1976. [...] [In 1958] Eggleston started taking photographs in his homeland, the American South, of just about anything that crossed his lens, [...] often from unconventional angles. In the early 1980s, Eggleston also worked in Europe and Africa and further developed his wide-ranging yet precise vision. He himself has described this non-hierarchical method as 'democratic.'"[30] Mustered in Eggleston's images is a world of signs spelling out the myths of everyday life in the American boondocks. Through the idiosyncratic perspectives and the suggestive power of the colors, the spatial constriction in many of his image compositions opens into a deep space where banal things by the wayside meet with an almost musical echo.

While William Eggleston was discovering color in the southern USA, on this side of the Atlantic, ▶ HILLA and BERND BECHER (*1934 resp. 1931–2007) were developing an approach that, albeit of a completely different character, would exert just as much of an influence on the photography of the coming years. Behind the effortless precision with which one of them appeared to "excise" images out of the wayside was a systematic working method that was used over many years. Bernd Becher, who, as Hilla Becher explained in an interview a year after his death[31], was originally a draughtsman, would have liked to have "finished" a life-long project that they both began with in 1959. Across more than five decades, they worked out a black and white system of classification for various types of industrial buildings. "The buildings and structures are always in the same shadowless light, head on, often from different sides: [...] Finally the material is ordered into groups according to form, function, and date of making, to be presented as comparable tableaux and sequences."[32] Their work is in the tradition of the strain of 19th century scientific photography interested in the objectification and systematization of phenomena as well as the tradition of photographers such as Eugène Atget, August Sander and Karl Blossfeldt. The Bechers never acknowledged any "nostalgia" in their work in the sense of it being backward-looking or mourning loss. The passion they developed for their world of motifs was biographically conditioned—Bernd Becher

grew up in the Siegerland, an area of southern Westphalia characterized by its industrial architecture—and transformed into a creative aesthetic discipline. Similar to the works by the other photographers represented in the exhibition, the image spaces, which are always organized according to the same criteria, develop great poetic potential out of this very sobriety.

In the exhibition, the Bechers' photographs are juxtaposed with images by ▶ STEPHEN GILL (*1971). These originate from the portfolio *Coming up for Air* (pp. 32 ff.), which comprises a total of 97 photographs. Although Gill's eye is also totally unprejudiced, this actually occurs, surprisingly enough, through a radical process of subjectivization. The London-based photographer has, in a relatively short period of time, developed a whole range of approaches that are always precisely tailored to the theme and the possibility of approximation. For almost every series, there is a portfolio and an artist's book that are impressive in their always distinct precision and which the artist distributes through his own website. *Coming up for Air* was inspired by a long stay in Japan and the realization that, with its foreign culture and visual codes, a guest can never really read this country. Gill says he experienced Japan like someone who is under water and who registers mainly the sounds of his own body. The images are shadowy, in radical bleed-offs that never aim at any wholeness or overview, sometimes almost dissolved into unrecognizability by the camera's flash. They are the artist's own traces rather than impressions of the alien and they subvert established patterns of representation. As in all his works, Gill focuses here mainly on the peripheral, the apparently banal: insignificant things by the wayside that afford him brief and startling flashes of illumination. People, animals and things, torn from their functional contexts by the camera, merge "beneath the surface of the water" into a semi-conscious stream, with which the subconscious is unable to play its games. In this respect, the distance that has already been discussed many times also prevails in Gill's work. It does not turn the motifs into objects of desire, leaving them instead on that threshold where things that are one's own and things which are not encounter each other with friendly respect.

Under the title *Presence* (pp. 285 ff.), the Ukrainian ▶ RITA OSTROVSKAYA (*1953) exhibits photographs that can be understood as self-portraits. The series of sepia-toned multiple exposures stops at 1995, when Ostrovskaya, who has lived in Kassel since 2001, was still living in Kiev, where she was principal of a school for child and youth photography and worked on the publication accompanying the work *Jews in the Ukraine 1989–1994. Shtetls*, for which she received the Albert Renger-Patzsch Award in 1994. The photographs on which this book was based illustrate a culture and religious practice with which she is closely associated and which has disappeared from Eastern Europe. Ostrovskaya works far from the art market. The domestic framework for any professionalization in accordance with western-influenced perceptions was absent in Kiev and even more so as an immigrant in Göttingen. Also, due to the specific nature of her empathy-based involvement with Jewish identity, her imagery sometimes seems downright

pre-modern. Nonetheless, her work is sustained by a strong documentary impetus. In the peculiarity of its internal/external illumination of an experience that is for Europe so evident and yet hardly visible, her complex, thematically rigorous work stands alone in recent photographic history. From a historicizing point of view, it is located beyond the degree at which the strongly discursive, problematizing strategies of a Boris Mikhailov ensue.

The series *Anwesenheit* (Presence*)* also signalizes Ostrovskaya's self-assurance as a member of a society influenced by a specific experience and culture. The ultra-highly nuanced time exposures show the photographer as a semi-transparent figure in various private situations: in the kitchen, surrounded by tools, or with friends, relations or colleagues. Associations with spirit photography in occult contexts arise unbidden. But it is rather the possibility of human coexistence and the intimate examination of one's own self-image that are captured in the picture here in a "timeless" sense that really does seem pre-modern.

At the age of forty-three, ▶ HELGA PARIS (*1938) started a series of self-portraits on which she occasionally works even now. A preliminary end to this work can be found in a version dated 1981 to 1989, which is presented here (pp. 296 ff.). This series is also founded by the experience of playing a double role, in this case of single mother and photographer. And here too, the photographic work is developed in a political context in which the private and public spheres are diametrically opposed. There was no market for any kind of art—i.e. the "flow" of pictures onto the surface of society—in the GDR. However the 1980s were enormously productive for the photographer. She created series such as *Berliner Jugendliche* (Berlin Youth; 1981/82), *Georgien* (Georgia; 1982), *Frauen im Bekleidungswerk Treff-Modelle* (Women at the Clothing Manufacturer Treff-Modelle; 1984) and *Häuser und Gesichter, Halle* (Houses and Faces, Halle; 1983–1985). The *Selbstporträts* (self-portraits) initially followed a totally personal impulse. Helga Paris was astonished at the way in which the conflicts and exertions she had experienced faced her in her bathroom mirror and decided to document them. Mirror images frequently exist in Paris' work, but they tend to be integrated into somewhat essay-like picture narratives as specific individual images. The shooting method in the self-portraits remained constant for years. The reflective surface itself is no longer visible. The clearly outlined linear form of the physiognomy and the bearing unfold before an unchanging monochrome background into a sequence of variations on a graphic arrangement of lines that remains essentially constant. This is framed by various styles of dress representing a complete spectrum of models of femininity. In the mirror-inverted "self", the experience of the individually-lived biography therefore becomes embedded in a supraindividual context and can thus be experienced.

"Since the 1960s, ▶ LEE FRIEDLANDER [*1934], together with Walker Evans and Robert Frank, has been regarded as one of the leading American exponents of an approach to photography that aims at the direct, unmanipulated representation of reality but which is at the same time recognizable for the individuality of its vision.[...] In carefully composed pictures, which at times seem like montages, Friedlander worked with extreme cuts, confusing perspectives, reflections, and 'picture-within-a-picture' motifs, thereby radically breaking with aesthetic convention."[33] In the foreword to *Self Portraits* (pp. 272 ff.), a publication that appeared in 1970, Lee Friedlander writes, " t is probably self-interest that makes you look at yourself and your surroundings. This need is self-induced and with certainty the reason and motive behind my photography. The camera is more than a pond that throws your reflection back at you, and photographs are definitely not the mirror-mirror-on-the-wall that speaks with forked tongue. The instant of photographing, which is simultaneously simple and extremely complex is a testimony, and pieces of the puzzle come together. The mental finger presses the shutter release of the unknowing machine which thereupon stops time and records what its diaphragm blades encompass and what the light may have painted—namely the instant in which the landscape speaks to the observer."[34]

The "unknowing machine" which Friedlander is talking about once again refers to the insight of the scientist Arthur Mason Worthington that was cited at the beginning of this survey and his discovery that the physical world could be shown in all its complexity and asymmetrical individuality with the aid of photography. That this is one of the most difficult tasks of photography as "straight photography"—within the strict body of rules that predetermine the photographic program—becomes evident in a delightful way in the context of Friedlander's self-portraits. His image compositions appear positively to force open the space and restructure it repeatedly. Contrasts between light and shade, structural interventions—sometimes finely chiseled, sometimes elementarily graphical—and the dynamic interchange between fore- and background give these photographic surfaces their vitality. Harmony emerges from permanent unrest. Friedlander's photographs do not seduce and do not invite. They are direct, immediate confrontations with a different sort of reality. That links them—and once again a surprising parallel becomes evident—to the pictures taken by Stephen Gill in Japan.

▶ BORIS MIKHAILOV (*1938) is considered a photo-documentarist of the history of the USSR and its successors and of the effects of political change on the individual and the collective. Since the end of the 1960s, he has been evolving a comprehensive and multilayered work that is almost without parallel, into which he has also, since the mid-1990s, integrated the experience of shuttling between his hometown, Kharkov, and Berlin. In Braunschweig (Brunswick) in 2008 (Mikhailov had received an invitation from the Theaterformen Festival and the Sprengel Museum Hannover), he created *Maquette Braunschweig*, a dispute about war and peace in four acts. The background for this can be found in one of director Claudia Bosse's (*1969) productions of the tragedy *The Persians* by Aeschylus (525–456 B.C.). Some 300 locals followed the call to "be Persians" and made up the chorus of the Persians besieged

by the Greeks. The setting for this work is provided not only by the fact that this is the first anti-war play in the history of mankind, but also the fact that it was in Braunschweig in 1932, just a few weeks before the German presidential elections, that Adolf Hitler was granted German citizenship upon his appointment as councilor after several unsuccessful attempts in other places.

Here again, Mikhailov is interested in the condition of the common weal. For the first time in Germany, the months of rehearsals gave him an opportunity to observe this polity in his new home at first hand, albeit as a guest, using the example of culturally broadminded and involved citizens.

The portraits of these citizens in *German Portraits* form the first chapter of the *Maquette Braunschweig*. The photographer also makes reference to his own interest in the portraiture of German Renaissance painting, which he had found extraordinarily fascinating even as a young man.[35] Yet depictions on coins and postage stamps also convey the idea of the profile as something that pledges ideal values. Mikhailov examines the ideal in the light of concrete, present-day findings. The irritating shimmer of these photographs emerges from an unexpectedly yawning chasm between the unconscious, preconditioned anticipation of the ideal and reality. Are these not pictures of the very people who—responsible, tolerant, and self-confident—constitute the heart of a democratic state? Is the ideal of a society reflected in its visual appearance? For a photographer of Jewish extraction—and profile measurement is also familiar from eugenic photography—that is the fundamental question posed by these photographs.

The question of the possibilities of photographically visualizing a "center of society" also crops up with regard to the photographs of the American photographer ▶ DIANE ARBUS (1923–1971). "Powerfully expressive portraits of outsiders, images of apparently alienated members of the upper middle classes—these were the photographs that made Diane Arbus famous in the late 1960s."[36] Initially working as a fashion photographer, she took courses in photography with Lisette Model at the New School for Social Research in New York. "Model's notion of the camera as an 'instrument of discovery' and her advice only to take a picture if the subject 'hit you hard in the solar plexus' had an enduring effect on Diane Arbus' vision and development as a portrait photographer."[37] Arbus is still one of the most influential artistic personalities of the 20th century. The portraits that she took with the permission of her models take photography to the edge of the visible—where the 'gap between intention and effect'[38] reveals itself in radical candor."

The portfolio *A Box of Ten Photographs* (pp. 20 ff.) was compiled between 1963 and 1970 and Arbus herself sold just four of the 50 existing copies. It contains key pictures such as *Identical Twins, Roselle*, and *1967* and gives an outline of the whole range of Arbus' imagery. The large, the small, those who are wearing more or less, those carrying hair tongs or circular saws, the adequately well-off and the less wealthy are all on display here as if under the Christmas tree, like a tryst. With this selection of ten photographs alone, Arbus presents an extremely democratic credo, and at the same time she also manages to create an exaggerated typecast in every representative. The conceptual certainty of her selection is also indicative of the intellectual sparkle, which the photographer well knew how to employ in developing her imagery.

The aesthetic praxis of the British photographer ▶ MARTIN PARR (*1952) appears to be very much defined by the idea of collecting. This applies to his work as a photographer, journalist and curator in equal measure. Parr is a member of the Magnum agency, which was founded in 1949 and had a significant influence on the development of auteur photography in journalism in postwar Europe and over the past decades.

The concept of collecting does not just owe something to the idea of the gradual development of a self-portrait, an expression of the self, in a collection. Over the years, Parr's work has been accompanied by questions as to the state of the common weal. As Hans-Peter Feldmann points out, what typifies a community, its mean average, is accrued from the checksum of countless individual findings. Wherein does this common weal find its visual expression? This is a question that has in turn also preoccupied Boris Mikhailov. Parr's eloquent photographs, which frequently draw their force from their escalatory compositional nature, pose quite obvious questions: what do the faces and bodies look like? How do people dress and adorn themselves, what do they eat, how do they treat each other, how do they relax and how do they celebrate? Parr photographs what is on display, the trivial, increasingly garish external signs and symbols through which the community realizes itself. He carries out field research in the classical sense. If one looks at his work across the decades, it becomes apparent that Parr is a chronicler and seismographer of cultural and social change. For *Luxury* (pp. 329 ff.), he photographed the "super-rich" of the globalized world: that thin upper crust that provides him with welcome motifs in its complacent celebration of excess. He photographs them wherever they are to be found—at their parties, at car shows and art exhibitions. In his images of gaudy affluence, Parr passes comment on the beneficiaries of the increasingly blatant and rapidly organizing flows of capital. The enlightening message of this work is that globalization is not a "quasi-natural process."

The British photographer ▶ PAUL GRAHAM (*1956), who today lives in the USA, studied microbiology in the 1970s. However, by the end of his studies, it was clear to him that photography would be his future field of activity. William Eggleston's photographic approach, "elliptical and so far from conventional photographic practice,"[39] which nevertheless represented such "a seemingly casual but fundamentally profound break with all previously accepted documentary strategies,"[40] made a deep impression on the young photographer. However, Graham also collaborated closely with the Berlin circle surrounding Michael Schmidt and with Volker Henze in Essen. The work *Beyond Caring* (1984/85) originated in the waiting rooms and corridors of British labor exchanges and, like other series from those years, addressed the impact of Margaret Thatcher's government between 1979 and 1990. It

introduced color into European documentary practice, which until then had been the preserve of black and white photography. The way Graham also put the legacy of American photography into a completely different context in series such as *Trouble Land* (1984–1986), *Television Portraits* (1986–1990), *New Europe* (1986–1992) and *Empty Heaven* (1989–1995), has had wide-reaching consequences for the development of politically motivated documentary-artistic photography in Europe.

"In the summer of 2004, the photographer Paul Graham crisscrossed the USA. His travels had no destination and no direction; they headed north, then south, often went into rural areas, and then doubled back on themselves. The itinerary was left to chance: he followed roads to particular points, then turned back, and visited cities and then left them again, or did not visit them at all, turning his back on them after highway interchanges that had their own, different story to tell. There was no place he had to go to, no time pressure and, as a newcomer to America, he had only a few friends he had to visit on the way. This America was everywhere and nowhere, and this feeling of freedom opened up a great space where he had a lot of room to breathe."[41] This led to *A Shimmer of Possibility* (pp. 316 ff.), a work comprising twelve highly detailed, complex and sophisticated narratives about everyday life in the boondocks of America, two of which are on display in the exhibition. Perhaps it is impossible to photograph this country without the myth of a vast expanse promising happiness, just waiting to be conquered, evaporating from the pictures. Here too it provides the backdrop, and Graham deconstructs it thoroughly. However, there are also moments of grandeur here. They emerge in details and gestures: in a horizon illuminated by the evening light; in the light falling on hands that are trying to open a lottery ticket on the lid of a trashcan. What does Robert Adams say? "... the Front Range is so awesome, because it is flooded with such an abundance of light that any banality ceases to exist."

Nevertheless, Graham avoids "forcing" his subject aesthetically. His narrative flow is always open-ended. Graham does not suggest truths, merely presents views of reality. "The simplicity of these chronicles, which so resolutely precludes any photographic sophistication, directs the attention to the privilege of seeing and what can be learnt and gained from it."[42]

▸ RINEKE DIJKSTRA (*1959) is one of the groundbreaking portrait photographers of modern times. Following a tradition with it roots in the portraiture of the Renaissance as well as, in photography, a continuation of the work of August Sander (1876–1964), Dijkstra has developed a form of portrait that seems both objective and highly subjective at one and the same time.

In PHOTOGRAPHY CALLING! she exhibits pictures (pp. 308 ff.) that she took in 1994, photographing mothers shortly after childbirth. What she captured were moments of transition: women after an existential experience, standing upright, showing signs of pain, but pain that they had already transcended. Remarkably, Dijkstra manages to show off and protect her models at the same time. The "objectification" that takes place in what is actually a highly emotional situation, communicated through the photographer's approach—through her choice of a sober background, her disciplined chromaticity, the upright posture and the gaze into the camera—is not directed at the (at the very most) scantily-clad women but works instead in their favor. The sobriety thus formulated protects them from any assault by the eye of the beholder. They are present yet also absent, each in her own imaginary transitory space where something deeply human and supraindividual inheres in sober contemplation.

Sixteen years later, Dijkstra portrayed the young people who back then, as firstborn, lay nearly invisible in their mothers' arms. Proud and headstrong almost to the point of defiance, they face down her scrutiny. They are also at a threshold: they will probably be finishing school soon and will have to make important decisions about their future.

Temporality is always inherent in these pictures—but in a different, much more manifest way than as is the case with Paul Graham. Rineke Dijkstra's work fascinates due to the acute presence of a counterpart and the systematic fixation of a "now" that contains a large measure of universal validity.

In his photographic series, the Berlin-based photographer ▸ TOBIAS ZIELONY (*1973) tells of the experience of constantly having to cope with zones of transition. These are places devoid of function, sleeping accommodation or transit places for people just passing through, if that, with nothing to induce one to drop in. Zielony photographs the young people who live here and have to find their own forms of self-expression. In a quasi long-term project, he seeks out places like this around the world. How are individual local living spaces organized in the global economy, and what possibilities do they offer young people? What is their attitude to the lack of prospects that they grow up with?

"They no longer have the security of a trade," says director Christian Petzold (*1960). "When they come into contact with you, they have a whole arsenal of poses that they've already tried out—not in front of the camera but in front of their friends or the mirror."[43]

Tobias Zielony talks about the interpermeability of media images and everyday reality. "You unconsciously behave as if you were part of a film and look on others the same way. That says a lot about the complexity of our visual experience. As a photographer, I'm naturally interested in what story these pictures represent. Can they actually tell a story at all? Or don't pictures rather have to both confirm the expectations of a narrative and avoid it at the same time?"[44]

The light in *Trona – Armpit of America* (pp. 109 ff.) is mercilessly hard, the vegetation sparse and the architecture a conglomeration of makeshift structures. The mining village is less than 100 years old and was the site of a chemical plant from the early 1990s. Unemployment is high, and mining and industry has devastated the landscape immediately behind the settlement. The cheap narcotic crystal meth, a powerful stimulant that quickly causes physical and psychological changes, shapes the day-to-day life of many.

Trona tells of the end of the dream of the American Frontier. At the same time, it also maybe tells of lost pictures, of the limits of the media and mirror images that young people in other places want to be guided by.

In comparison, the pictures of ▶ NICHOLAS NIXON (*1947), which were taken 25 years earlier, seem like messages from better times. "Since the 1980s, the American Nicholas Nixon has been pursuing long-term photographic projects looking at the basic values of human existence and, in the process, combining artistic issues with social commitment. [...] Although he works with a relatively awkward large-format camera—the size of a portable television—his black-and-white shots often seem as lively and spontaneous as if they had been taken with a small hand-held camera. As Peter Galassi has pointed out, Nixon 'helped to lead a revival of the large-format camera and the formal craft favored by Edward Weston and Walker Evans, which had been out of fashion for over a genera-tion.'"[45] The 40 photographs in the series *Photographs from One Year* (pp. 45 ff.) originated in 1981 and 1982. They show families, siblings and friends together on the thresholds and stoops or in the doorways of their houses in cities such as Boston, Cambridge or Somerville. You can visit the streets named in the titles of the pictures via Google Earth and then it becomes clear: the places where Nixon took his photographs thirty years ago are a somewhat more intact world than in Trona. Nixon's detailed and precise photographs, many of which are constructed like stage sets, tell of a strongly physically-articulated togetherness. People touch, embrace and turn to or away from each other. They are accumulated family ties that support the community there. Even more than those of Tobias Zielony, these photographs have the suggestive power of stills: they display a concentration of cinematic narratives with dramatic potential. The photographer Robert Adams, who had studied literature, drew attention to the literary qualities of these images. This information density is due not least to the large-format technique that Nixon handles in such a masterly way.

Like Andreas Gursky and Thomas Ruff, ▶ THOMAS STRUTH (*1954) belongs to the first generation of Bernd Becher's students at the Kunstakademie Düsseldorf. He came to photography via painting and originally studied under Gerhard Richter. Shots of urban situations took on a central importance quite early on in his concentrated work, which is strongly committed to a basic documentary approach. "Thomas Struth's architectural pictures, his photographs of streets and cities," writes Julian Heynen, "are empty of people. And even when, at second glance, you do manage to discover a few passers-by, they still don't become the center of attention. They remain marginal in these spaces and never become actors, because the streets themselves play that role. You might read them as an indirect allusion to the subconscious, the place where public space is internalized. But are they really absent in the pictures? On the contrary, haven't they left traces everywhere?"[46]

Struth's photographs have the same remarkable trans-parence that is brought to bear in such an exemplary way in the works of Rineke Dijkstra and to which Hans-Peter Feldmann refers in his flower pictures. As noted earlier, photographs like these combine several different temporal levels within them-selves. They appear to want to protect the object of their representation in all its individuality behind a transparent wall and at the same time offer it as a projection surface for that which is one's own and for the conscious and unconscious. The four images in the work *South Lake Street Apartments, Chicago* (pp. 263 ff.) show a form that is as compact as it is finely structured from four different angles and offer a view of a second, apparently identical building. The simultaneous experience of time attributed to Thomas Struth's photographs is, in their virtually cinematic progression and the duplication of the motifs, enhanced many times over.

The simultaneity of temporal experience and the "turning" of an object or theme in front of the camera also play a signifi-cant role in *Color Lab Club* (pp. 250 ff.), a work by the young photographer ▶ LAURA BIELAU (*1981) from Leipzig. In this case, the history of photography is considered from various angles. The process is to a certain extent similar to that used in the work of Jochen Lempert. Stages in the history of the medium are invoked in individual images, examined for contem-porary features, reinterpreted and, interacting with the pictures, woven into a poetic narrative. The miniatures of young women in the "red light milieu" of the darkroom contain, with a nod to the carte de visite format common in the second half of the 19th century, a complex web of references. The longing for pictures is a vital and libidinous drive behind photographic activity, as is the idea of the legibility of the image as text behind the use of the carte de visite: as the name suggests, the idea was a substitute for the visiting card itself at various times. There is also the reference to the great extent to which photo-graphic depictions of the female body have altered the perception of women and their self-image and self-expression. Neverthe-less, these pictures also refer to the emancipatory potential the profession of photographer offered to women in the 1920s. The memorial to one of the inventors of photography, Nicéphore Niépce (1765–1833), the "pigeon photographer", the still-life in the style of Man Ray, photographic techniques or the photog-rapher in various different positions—all these images stand for a similarly multi-layered fabric of circumstances and its significance for the photographer herself.

In *Color Lab Club*, Laura Bielau illustrates in examples how complex the process of incorporating each photographic image into an imaginary corpus of existing pictures and read-ings really is. She is carrying out research both into the history of photography and the history of its interpretation.

It is inevitable that any verbal approach will ultimately detract from the poetic complexity of the pictures and can like-wise only be subjective, influenced by an individual perspective. Every one of the photographs presented here ultimately stands for its own individual "reality in its own right." And, for every viewer as well, each of the works presented here contains a different, new cosmos of meanings and associations in each case.

Walker Evans' statement about a form of photography that, although it cites documentary style, does not produce any documents itself because it is, like art, useless, was in 1971 if anything intended to distinguish it from the exploitation of artistic images by political-propaganda interests. Such interests were exemplified by the photograph exhibition policies of the Museum of Modern Art under the direction of Edward Steichen (1879–1973) in the period between 1947 and 1962. For Steichen, photography at MoMA was the most effective possible instrument of propaganda, tried and tested in the Second World War and the Cold War. His successor, John Szarkowski (1925–2007), reclaimed it for the discursive examination of different individual global appropriation processes and their aesthetic effects. Seen that way, the "white cube" of the exhibition space is not a temple of prayer to a noble, brilliant subjectivity, nor is it an "ivory tower" unruffled by the world outside. It is rather a sort of laboratory: radically exaggerated visual formulations make possible exemplary provocative analyses of perceptions of the world. Mass-media imagery is not excluded—it is just as much behind the 30 artistic perspectives here as art history is. The different ways the medium is used do not cancel each other out, but rather overlap and influence each other, as can be intrinsically experienced in the works of Jochen Lempert, Thomas Demand, Martin Parr, Thomas Ruff, and Tobias Zielony.

This is the reason why PHOTOGRAPHY CALLING! has invited three guest curators to develop a particular approach to photography as a medium for one month each during the exhibition. The question of different ways of using photography as well as that of different methods of collecting it will be examined in the light of their alternating points of view.

The French artist ▶ THIERRY GEOFFROY/COLONEL (*1961) who lives in Copenhagen, will launch the series. Goeffroy takes a discursive-actionist approach strongly influenced by Situationism and an involvement with French photographic criticism, which is characterized by sociological argumentation. He develops various "formats," clearly defined strategies adapted for use in different situations. (pp. 392 ff.) Geoffroy takes the title of the exhibition seriously: PHOTOGRAPHY CALLING! Who is calling whom, why and to what ends? Where is the most activity in terms of quantity today, and what are the underlying interests? How does this format our approach to them? And does this influence our pictorial practices? What role do the social networks of the Internet play, to which only those have access who surrender the copyright to the frequently very personal text and picture material they have uploaded? Does the slogan of the 1968 generation—that the private is political—still apply today, and if so, under what conditions? Does "public" mean the same as "political"? Which political interests are finding expression on Facebook and in similar social networks? Thierry Geoffroy uses the "biennalist" format to investigate art biennales. He sees them as places with a great concentration of intellectual potential, looks at what sort of lasting impact such "summit meetings" actually have, initiates public discussions and draws attention to global political problems. During the preparations for PHOTOGRAPHY CALLING!, he took a team of "biennalists" to the 2011 Venice Biennale. In Hanover, he works with people who by dint of their professions are responsible for the control and regulation of public spaces and the application of due diligence: the city's mounted police and traffic wardens. What images do they collect as they go about their daily business, and how do they deal with them? Where is the dividing line between "private" and "public"? And how "political" is the way in which "private" and "public" are understood today? What can be done to raise awareness of potential overlaps or exploitation by third parties that run counter to our own substantial interests?

▶ MARKUS SCHADEN (*1965) is responsible for the next project area, which focuses on the photo book as a "storage medium." Basing his enquiry on Stephen Shore's 1975 photograph *La Brea*, he quasi exemplarily opens up the complexity of the knowledge that has latently accrued in this photograph down to the present day, conveyed through its mode of reception. (pp. 404 ff.) He investigates the impact this image has had, which, because it has been reproduced in the most widely varying contexts, has in all probability been far more sustained than the impact made by the exhibition of the original itself.

Finally, the photographer, photographic historian and collector ▶ WILHELM SCHÜRMANN (*1946) is using the Gabriele and Wilhelm Schürmann collection to show what a collection can look like if it develops out of the purely private, personal passion of a married couple. (pp. 416 ff.) The selection made especially for PHOTOGRAPHY CALLING! follows a process of "free association" that links the visual in an associative-poetic way. Sculpture, painting, drawing and photography taken from various contexts enter into a dialog with one another, at the heart of which is nothing less than the presence of the images itself. In the countless quotations and references with which the media cross-pollinate each other, the history of photography has as a matter of course made its mark as the history of the visuality of the past century and a half or more.

The exhibition PHOTOGRAPHY CALLING! does not merely address its own audience but also calls for a place in which it will be possible to present the first class photographic collection of the Niedersächsische Sparkassenstiftung to the public in such a cross-genre context in the future.

Not least, the exhibition is also calling on those in a position to take the political decisions to create such a place to accept the challenge to do so. Documentary style photography does not just address the world itself. It also helps us to understand the conventions that govern our images of the world, to subject them to critical scrutiny and to reevaluate them. They demonstrate the "average value" of our perception in a provocative manner. And, above all, they create new, subjective image-realities that exemplify our "being-in-the-world" in a very special way.

It will only be possible to bequeath these image realities to posterity if we accept the responsibility for doing so. The signal the Sprengel Museum Hannover and the Niedersächsische

Sparkassenstiftung are together sending out with the exhibition PHOTOGRAPHY CALLING! shows that the best possible foundations for it have already been laid.

1 Sprengel Museum Hannover, Städelsches Kunstinstitut and Städtische Galerie Frankfurt am Main, curated by Heinz Liesbrock and Thomas Weski.
2 Tate Modern, London, and Museum Ludwig, Cologne, curated by Emma Dexter and Thomas Weski.
3 Thomas Weski, "No Scrawling, Scratching, and Scribbling on the Plate", in: *How you look at it : Photographs of the 20th Century,* Cat. Sprengel Museum Hannover, ed. by Heinz Liesbrock and Thomas Weski, Sprengel Museum Hannover, Städelsches Kunstinstitut and Städtische Galerie, Frankfurt am Main. London: Thames & Hudson, 2000, pp. 18 ff.
4 Beaumont Newhall, "Reine Photographie", in: *Geschichte der Photographie,* Munich 1984, p. 173, quoted in Weski 2000 (see note 3) , p. 21.
5 Weski 2000 (see note 3), p. 22.
6 Abigail Solomon-Godeau, "Who Is Speaking Thus? Some Questions about Documentary Photography, in: ibid, *Photography at the Dock. Essay on Photographic History, Institutions, and Practices*, Minneapolis: University of Minnesota Press 1991, pp. 169 ff.
7 Leslie Katz, "Interview with Walker Evans," in: *Art in America,* March/April 1971, pp. 85 ff.
8 Weski 2000 (see note 3), p. 30.
9 Loraine Daston & Peter Galison, *Objectivity,* New York 2007, p. 147.
10 Ibid., p. 14.
11 Jochen Lempert, Jochen Müller and Jürgen Reble belonged to the "Schmelzdahin" group, which existed from 1983 to 1989.
12 Cf. Footnote 3.
13 Citing Max Ernst, the photographic historian Rosalind Krauss used the term "spacing" for this process: Rosalind E. Krauss, "Der Surrealismus in der Fotografie – Fotografie and Surrealismus," in: *Camera Austria,* 10, 1982, p. 16.
14 Hermann Pfütze, "Thomas Demand, Nationalgalerie" in: *Kunstforum,* Vol. 200, 2011, p. 228.
15 Press release from the Staatliche Kunstsammlungen Dresden on the exhibition *Jeff Wall. Transit,* 20 June to 10 October 2010.
16 Markus Frehrking, "Jeff Wall," in: *How you look at it* (see note 3), loc. cit. p. 510.
17 John Berger, "Between Forest," in: Jitka Hanzlová, *Forest,* Göttingen, 2006, n. p.
18 Wolfgang Tillmans talking to Maren Lübbke-Tidow and Tobias Zielony, in: *Camera Austria,* 114, 2011, p. 47.
19 Leah Ollman, "Wolfgang Tillmans at Regen Projects II" in: *Los Angeles Times,* April 1, 2011.
20 Annelie Pohlen, quoted in Thomas Seelig, "Thomas Ruff," in: *How you look at it* (see note 3), loc. cit., p. 496.
21 Michael Köhler, "Interview mit Robert Adams" in: *Camera Austria,* 9, 1983, p. 2.

22 Cf. et al. *The New Topographics,* Text: Britt Salvesen, Göttingen, 2010; Julia Galandi-Pascual, *Zur Konstruktion amerikanischer Landschaft,* Freiburg 2009.
23 Robert Adams, Introduction, 1974, in: *Robert Adams. The New West,* eds. Heinz Liesbrock and Thomas Weski on behalf of the Niedersächsische Sparkassenstiftung, Cologne, 2000, p. Xvi.
24 Heinz Liesbrock, "Vision and Revision des amerikanischen Westens. Zur Neuauflage von 'The New West,'" in: *Robert Adams,* ibid., p. Xxii.
25 Markus Frehrking, "Lewis Baltz," in: *How you look at it* (see note 3), loc. cit., p. 463.
26 Ibid.
27 "Hans-Peter Feldmann im Gespräch mit Kasper König," in: *Hans-Peter Feldmann. Another Book,* ed. by Helena Tatay, London and Düsseldorf, 2010, p. 60.
28 Ute Eskildsen, "In leidenschaftlichem Widerstreit zwischen Abbildung und Darstellung," in: *Fotografie seit 1965. Michael Schmidt,* Folkwang Museum Essen, undated [1995], p. 13.
29 www.diamondpaper.de/pdfs/dp02_de.pdf (Access on July 18, 2011).
30 Markus Frehrking, "William Eggleston," in: *How you look at it* (see note 3), loc. cit., p. 474.
31 Hilla Becher, quoted in "Klar waren wir Freaks," Interview with Tobias Haberl and Dominik Wichmann, in: *Süddeutsche Zeitung Magazin,* 20, 2008.
32 Markus Frehrking, "Bernd and Hilla Becher," *in: How you look at it* (see note 3), loc. cit., p. 465.
33 Ulrike Schneider, "Lee Friedlander," in: *How you look at it* (see note 3), loc. cit., p. 481.
34 Lee Friedlander, quoted in Ulrike Schneider, ibid., p. 482.
35 Boris Mikhailov talking with Stefan Schmidtke and the author, Berlin, March 13, 2009.
36 Ulrike Schneider, "Diane Arbus," in: *How you look at it* (see note 3), loc. cit., p. 460.
37 Ibid.
38 Diane Arbus, quoted in Ulrike Schneider, ibid., p. 461.
39 David Chandler, "Eins gab es, das wichtig war," in: *Paul Graham,* ed. by Paul Graham and Michael Mack, Göttingen, 2009, p. 23.
40 Ibid.
41 Ibid., p. 19.
42 Ibid., p. 20.
43 Tobias Zielony, "Dann wird es hell. Christian Petzold im Gespräch mit Tobias Zielony," in: *Tobias Zielony. Story/No Story,* ed. by Maik Schlüter, Florian Waldvogel et al., Ostfildern, 2010, p. 126.
44 Ibid., p. 125.
45 Ulrike Schneider, "Nicholas Nixon," in: *How you look at it* (see note 3), loc. cit., p. 490.
46 Julian Heynen, "Als ihre eigenen Schauspieler. Familienformeln – Lebensweisen," in: *Texte zum Werk von Thomas Struth,* ed. Thomas Struth, Munich, 2009.

Projektraum/Project Space *Photography Calling*

THIERRY GEOFFROY/
COLONEL

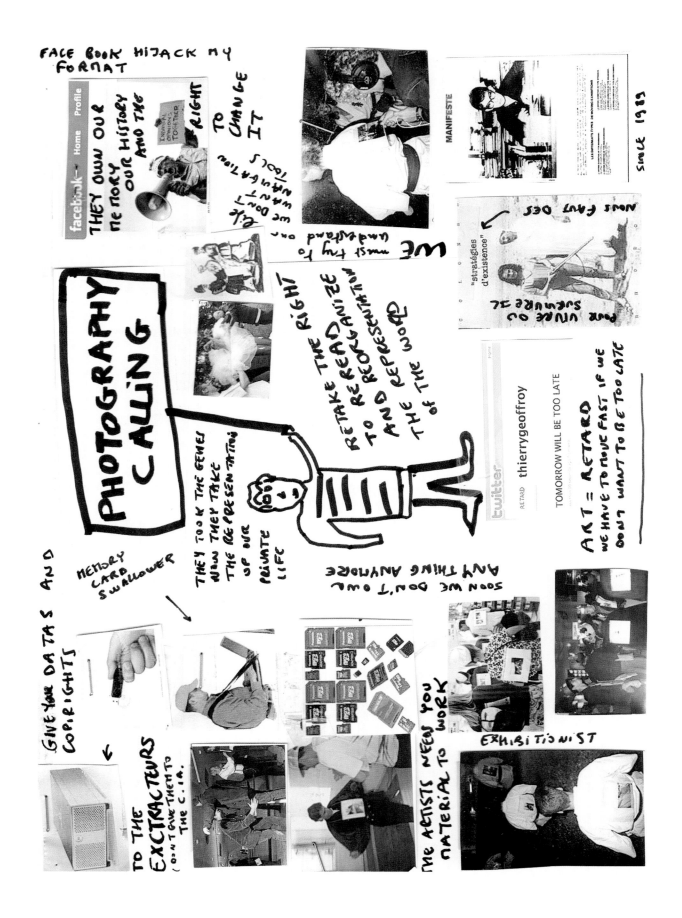

Give My Format Back/The facebook inspiration case, Venedig Biennale, 2011

MANIFESTE

La MOVING EXHIBITION définition: c'est le créateur en perpétuelle recherche. La Moving EXHIBITION est mobile dans l'espace, et mobile dans son expression puisqu'elle s'adapte à la vie. Son abréviation est M.E. car elle est profondément liée au moi de l'exhibitionniste. Elle est introspective et autobiographique. La M.E. avoue actuellement la photographie et la performance. Le 13 Novembre 1989 SPORT ART est né.

LES DIFFERENTS TYPES DE MOVING EXHIBITIONS

LA MOVING EXHIBITION DE TYPE BOURGEOISE :
C'est le créateur en milieu confortable : Seul avec lui-même
a l'abri d'un public, ou en compagnie de ceux qui le comprenne.

LA MOVING EXHIBITION DE TYPE SEMI-BOURGEOISE :
M.E. dans un lieu public avec accord préalable pour l'utilisation
des murs. (Exposition changeant constamment, car tenant compte
des états d'âme du créateur confronté à un public). La M.E.
semi-bourgeoise peut devenir conviviale en invitant le public
a s'exprimer.

LA MOVING EXHIBITION DE TYPE OFFENSIVE :
M.E. dans un lieu d'art (musée, gallerie) au moment d'un
vernissage. Squattage. Utilise les principes de la guérilla.
Accord non indispensable du responsable du lieu. Cas de ralliement, cas d'expulsion. La M.E. de type offensive est
révolutionnaire, elle se manifeste actuellement sous forme
d'exposition piétonne ou volante (FLYING EXHIBITION).

LA MOVING EXHIBITION DE TYPE VAGABONDE :
M.E. dans un lieu étranger à l'art (ex. ambassade, métro, rue,
supermarché...)

LA MOVING EXHIBITION DE TYPE EXHIBITIONNISTE :
Elle invite des "AMIS" a s'exposer une photo d'eux-même
dans le but de devenir ainsi des "exhibitionnistes". Les images
exposées appartiennent ensuite à la FONDATION qui se charge de
les "immortaliser".

Moving Exhibition Manifeste/Die fünf Arten der Moving Exhibition, 1989

1988 *L'art est un cadeau/Kunst ist ein Geschenk*:
Anlässlich der FIAC Paris kooperiert T.G./C. mit den Radiostationen Europe 2, Radio Tour Eiffel, Radio Enghien, Radio Latino und Radio Beaubourg. Er fordert die Hörer auf, Fotografien aus dem Privatbesitz auf ihrem Rücken zu dem jeweiligen Sender zu tragen. Ca. 30 Hörer kommen. T.G./C. krönt sie mit Burger King-Kronen.

1990 *What about Tourism? Forbidden for Voyeurs*, Einzelausstellung, Billedhuset, Kopenhagen:
Gezeigt wird eine Sammlung von Urlaubsbildern, die T.G./C. vor einem Fix-Foto-Labor in Bangkok von Touristen erbittet. Von den jeweils
vier Fotografien zeigt jeweils eines den jeweiligen Touristen. Beigestellt sind die Namen und Angaben zu Beruf und Dauer der Reise.
Zusätzlich werden die während der Reisen entstandenen Farbfotografien T.G./C.s und Aufnahmen aus dem Familienalbum Geoffroy
gezeigt, die in den frühen 1960er-Jahren entstanden. Zutritt zur Ausstellung gewährt die Art Police nur denjenigen Besuchern, die auf
ihrem Rücken schriftliche und/oder fotografische touristische Selbstkritik üben.

1990 *Sport Art Show*, Roskilde Festival:
Die Aktivitäten der seit November 1989 bestehenden *Sport Art Group* finden, unter Mitwirkung von 200 Kendo-, Tae-Kendo-, Karate- und Roller Skate-Sportlern ihren finalen Höhepunkt. Präsentiert werden, fixiert auf der Kleidung der Teilnehmer, Fotografien aus der Sammlung „Goodie's Live" und, in der *Moving Exhibition Exhibitionist*, private Bilder der Teilnehmer (die anschließend in die Stiftung übernommen werden). Die Winston and Lincoln Art Police kontrolliert die Einhaltung der Regeln. Der TV-Sender tv2 berichtet über dieses Ereignis in den Abendnachrichten.

1988 *Slideshow*, Galerie Billedhuset, Kopenhagen:
Während der Ausstellung der Fotografin Ann Nordans in der Galerie Billedhuset, Kopenhagen, erscheint T.G./C. mit vier Freunden zu einer *Moving Exhibition Offensive*. Im Rhythmus von 15 Minuten wechseln die vier Protagonisten die Bilder der Moving Exhibition, die sie auf dem Rücken tragen. Es sind Aufnahmen T.G./C.s, die Militärs in Uniform zeigen und mit dem Schriftzug WAR unterschrieben sind. Die *Moving Exhibition Offensive* wird zur *Moving Exhibition Exhibitionist*, indem die Teilnehmer die Fotografien mit eigenen privaten Aufnahmen ergänzen. Anschließend wird die Ausstellung durch die Stadt getragen: Sie wird zur *Moving Exhibition Vagabonde*.
Im Café TICTAC zeigt T.G./C. *I want to be King* – Ausschnitte aus dem Burger King-Projekt. Eine Arbeit aus dieser Serie wird als Transparent erneut in einer *Moving Exhibition Vagabonde* gezeigt. Abschließend führt T.G./C. mit den Teilnehmern Tonbandinterviews.

Texte aus: http://www.conclusionism.com/dictionary/chronologie.html

Einige der „Schätze" der *Fondation Moving Exhibition* (1988–1990): Diese Sammlung von Fotografien von „FRIENDS", im Din-A4-Format präsentiert, werden als wertvoll und erhaltenswert betrachtet und nehmen als so genannte Treasures/Schätze Eingang in die Sammlung der Stiftung. Die Teilnehmer der Performances (*Moving Exhibition Offensive* oder *Vagabonde*) übergeben die Bilder inklusive ihres Copyrights daran. Als einige Jahre später die auf Datensammlungen basierende Kommunikations- und Bildplattform *Facebook* auftaucht, zeigt sich interessanterweise, dass sie mit den gleichen Schlüsselwörtern arbeitet, die T.G./C. in

seinen Formaten anwendet, zum Beispiel „Freunde", „Freundes-
gruppen", „Neuigkeiten", „Veranstaltungen", und mit ähnlichen
Elementen wie das Sammeln von Daten, der Interaktion in Echt-
zeit, das Angeben des „Status" und als Plattform, die Möglichkeit
zu Flashmops, einer sozialen Choreographie des Protestes,

Debatten über Partizipationsbedingungen etc. bietet. Bereits
seit 1988 schafft T.G./C. in den *Moving Exhibition Exhibitionist*
Formate, die eine Freimütigkeit und Offenheit im Sinne eines
„Sich-öffnens" (openness) fördern.

2011 *Extracteur/Memory Cards (Datenkarte)*, Venedig Biennale:
Von einem Pool an Leuten werden die Datenchips oder -karten ihrer Kameras erbeten. Sie werden zufällig ausgewählt und kooperieren, indem sie akzeptieren, den kompletten Inhalt ihrer Datenkarten kopieren zu lassen. Die Menschen nehmen die Extraktion durch den Extracteur an und stimmen weiterhin zu, Thierry Geoffroy ihr vollständiges Copyright zur weiteren Verwendung zur Verfügung zu stellen.

EXTRACTEUR ist ein neues Format.

**RETAKE THE RIGHT
TO REREAD
AND REORGANIZE
THE REPRESENTATION
OF THE WORLD**

http://www.emergencyrooms.org/sprengelmuseum/

Projektraum/Project Space *The "La Brea" Photobookstud*y

MARKUS SCHADEN

THE «LA BREA» PHOTOBOOKSTUDY

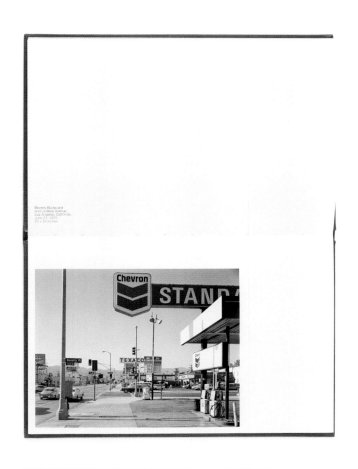

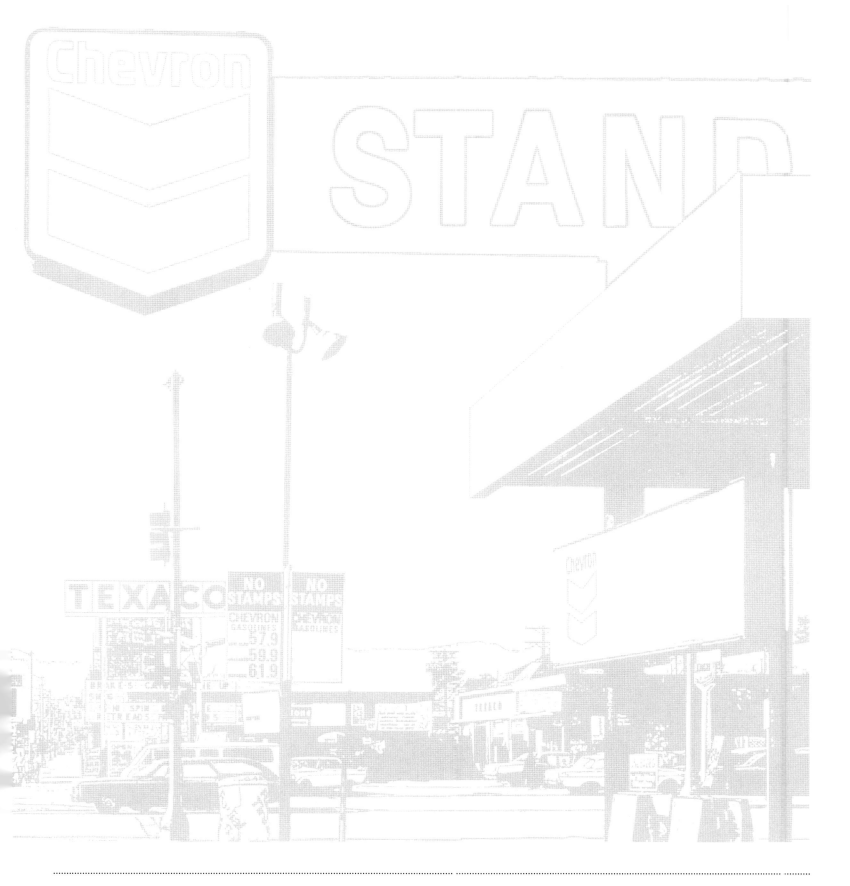

What spheres of influence are there within photography?

How can we grasp reception history in a specific case?

How can we recognize the references of creative works?

The Picture*

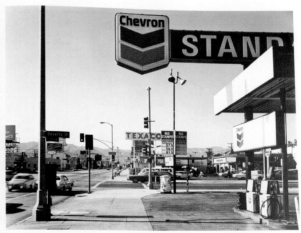

The Picture*

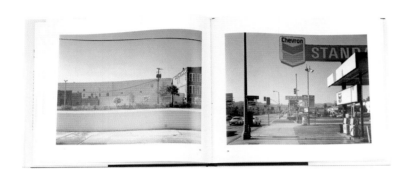

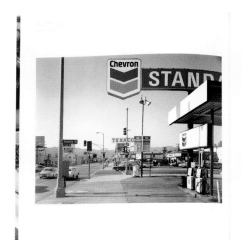

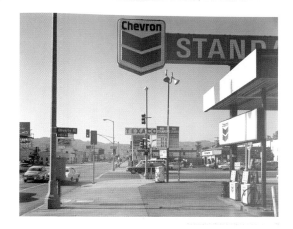

,La brea' is Spanish for ,tar'. The La Brea Tar Pits are a well known cluster of tar pits in urban Los Angeles, near the Miracle Mile district. La brea is thus a reference to asphalt and street surfaces. A street that runs from north to south through Los Angeles bears the name La Brea Avenue.

On 21 June 1975, the intersection of Beverly Boulevard and La Brea Avenue entered photographic history.

This is where Stephen Shore, who alongside William Eggleston is considered the leading protagonist of the New Color movement, took his legendary photograph in front a Chevron gas station. The following day he took another picture at the same place.

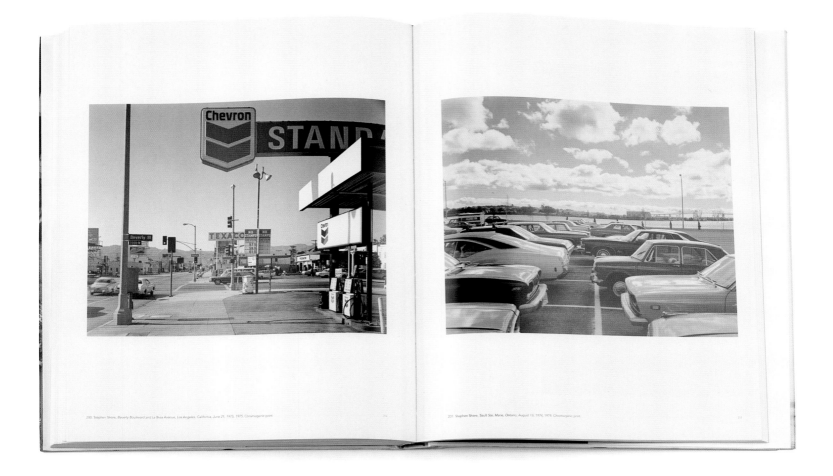

«Hilla once said, looking at my pictures of main streets, that what should I do is
take hundreds and hundreds of pictures of main streets, and then I realized, no,
that's not what I wanted to do. I want to find that quint-essential main street.
And I realized the difference between our approach at that point.» *Stephen Shore (2001)*

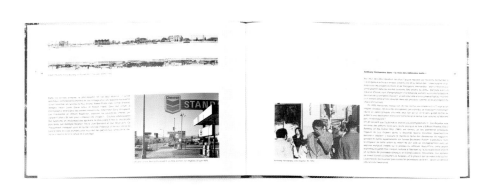

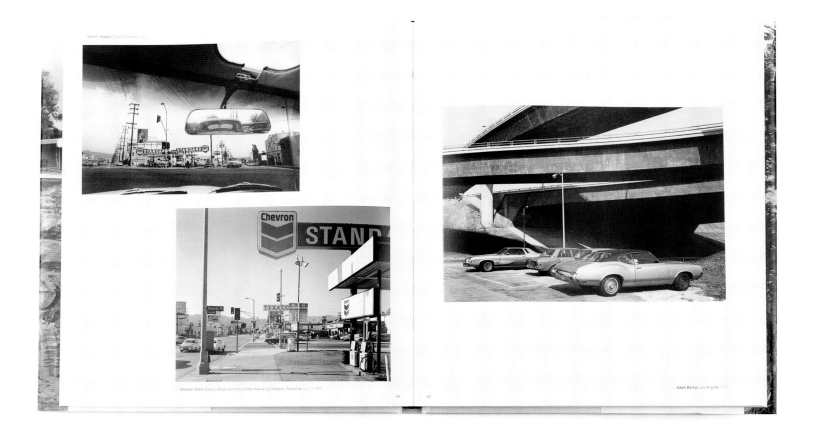

Looking at Los Angeles*

The Reference Index*

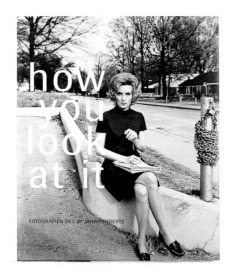

Projektraum/Project Space *The Sound of Downloading Makes Me Want to Upload*

WILHELM SCHÜRMANN

Hubert Becker, after Ansel Adams, 2010, drawing, gelatine silver print

John Sherwood, The Monolith Monsters, 1957, vintage gelatine silver print

Torsten Slama, Friesenhaus mit Reetdach und Newton-Prisma, 2011, drawing

Wilhelm Schürmann, Kohlscheid-Bank, 2011, archival pigment print

Klaus Merkel, 10.11.01 Spalier, 2010, oil on canvas, 60 x 45 cm

Boris Gaberšcik, Crucifixion, homage à J. R. Tintoretto, 1987, vintage gelatine silver print

Unknown, Im Schatten unserer Blödheit, ca 2004, discovered at mistakes @ fotocommunity.com

Jan Paul Evers, Modernismus fängt zu Hause an, 2009, gelatine silver print

Albrecht Schäfer, Malewitsch Museum Biberach Innenansicht 2, 2002, drawing, 100 x 70 cm

Jerry McMillan, Ed Ruscha with six of his books balanced on his head, 1970, gelatine silver print

Raymond Pettibon, untitled (What's better science …), 1985, ink on paper

▸ ROBERT ADAMS

1937 geboren/born in Orange, NJ
Ph. D. in English, University of Colorado, Boulder, CO
Lebt/lives in Astoria, OR

EINZELAUSSTELLUNGEN/SOLO EXHIBITIONS (Auswahl/selection)
1971 Colorado Springs Fine Arts Center, Colorado Springs, CO
1973 *Landscape/Cityscape,* The Metropolitan Museum of Art, New York
1979 *Prairie,* Denver Art Museum, Denver, CO
 Werkstatt für Photographie, Berlin
1981 *The New West: Photographs by Robert Adams,* Philadelphia Museum of Art, Philadelphia, PA
1986 *Summer Nights,* Denver Art Museum, Denver, CO
1989 *To Make It Home: Photographs of the American West 1965–1986,*
 Philadelphia Museum of Art, Philadelphia, PA
1994 *Listening to the River,* Sprengel Museum Hannover/Hanover
1995 *What We Bought: The New World. Scenes from the Denver Metropolitan Area 1970–1974,* „SPECTRUM" Internationaler Preis für Fotografie der
 Stiftung Niedersachsen, Sprengel Museum Hannover/Hanover
2005 *Turning Back,* Haus der Kunst, München/Munich; San Francisco Museum of Modern Art, San Francisco, CA
2010 *The Place We Live: A Retrospective Selection of Photographs,* Vancouver Art Gallery, Vancouver; Denver Art Museum, Denver, CO; Los Angeles County
 Museum of Art, Los Angeles, CA; Museo Nacional Centro de Arte Reina Sofia, Madrid; National Media Museum, London

GRUPPENAUSSTELLUNGEN/GROUP EXHIBITIONS (Auswahl/selection)
1970 *New Acquisitions,* The Museum of Modern Art, New York
 Photographs by Robert Adams and Emmet Gowin, The Museum of Modern Art, New York
1975 *New Topographics: Photographs of a Man-Altered Landscape,* George Eastman House, Rochester, NY
1978 *Amerikanische Landschaftsphotographie 1860–1978,* Die Neue Sammlung, München/Munich
1997 Documenta 10, Kassel
1999 *The American Century Art and Culture: 1900–2000,* Whitney Museum of American Art, New York
2000 *How you look at it. Fotografien des 20. Jahrhunderts,* Sprengel Museum Hannover/Hanover; Städelsches Kunstinstitut – Das Städel, Frankfurt am Main
2003 *Cruel & Tender: The Real in the 20th Century Photograph/Fotografie und das Wirkliche,* Tate Modern, London; Museum Ludwig, Köln/Cologne

BIBLIOGRAFIE/BIBLIOGRAPHY (Auswahl/selection)
Robert Adams: White Churches of the Plains: Examples from Colorado. Boulder: Colorado Associated University Press, 1970 (Einleitung/introduction: Thomas
 Hornsby Ferril)
Robert Adams: The New West: Landscapes along the Colorado Front Range. Boulder: Colorado Associated University Press, 1974 (Einleitung/introduction:
 John Szarkowski)
Robert Adams: Denver: A Photographic Survey of the Metropolitan Area. Boulder: Colorado Associated University Press, 1977 (Text: Robert Adams)
Robert Adams: From the Missouri West. New York: Harper & Row, 1980 (Text: Robert Adams)
Beauty in Photography: Essays in Defense of Traditional Values. New York: Aperture, 1981 (Text: Robert Adams)
Robert Adams: Our Lives & Our Children: Photographs Taken near the Rocky Flats Nuclear Weapons Plant. New York: Aperture, 1983 (Text: Robert Adams)
Robert Adams: To Make It Home: Photographs of the American West. New York: Aperture, 1989 (Text: Robert Adams)
Robert Adams: Why People Photograph: Selected Essays and Reviews by Robert Adams. New York: Aperture, 1994 (Text: Robert Adams)
Robert Adams: What We Bought: The New World. Scenes from the Denver Metropolitan Area 1970–1974. Hg. von/ed. by Stiftung Niedersachsen. Hannover:
 Sprengel Museum Hannover, 1995 (Text: Robert Adams)
Robert Adams: West from the Columbia: Views at the River Mouth. New York: Aperture, 1995
Robert Adams: Notes For Friends: Along Colorado Roads. Niwot, CO: Center of the American West/University Press of Colorado, 1999 (Text: Robert Adams)
Robert Adams: Time Passes. Paris: Fondation Cartier pour l'art contemporain, 2007 (Text: Robert Adams)
Robert Adams: Gone: Colorado in the 1980s. Göttingen: Steidl, 2010 (Text: Heinz Liesbrock)
Robert Adams: What Can We Believe Where: Photographs of the American West. New Haven: Yale University Art Gallery, 2010 (Text: Robert Adams; Nach-
 wort/afterword: Joshua Chang, Jock Reynolds)

▸ DIANE ARBUS

1923 geboren/born in New York; 1971 gestorben/died in New York
New School for Social Research, New York

EINZELAUSSTELLUNGEN/SOLO EXHIBITIONS (Auswahl/selection)
1972 *Retrospective,* The Museum of Modern Art, New York
1973 Seibu Museum of Art, Tokio/Tokyo
1974 Hayward Gallery, London
 Rijksmuseum Vincent van Gogh, Amsterdam
1975 Städtische Galerie im Lenbachhaus, München/Munich
 Von der Heydt Museum, Wuppertal
 Stedelijk Van Abbemuseum, Eindhoven
1976 Frankfurter Kunstverein, Frankfurt am Main
1980 Musée nationale d'art moderne, Centre Pompidou, Paris
1984 *Magazine Work,* Spencer Museum of Art - University of Kansas, The University of Kansas, Lawrence, KS
1985 La Fundacio Caixa de Pensions, Barcelona
1988 *Untitled,* Fraenkel Gallery, San Francisco, CA
1995 *The Movies,* Robert Miller Gallery, New York
1996 *Diane Arbus. Photographien ohne Titel,* Kunsthalle Bielefeld

2000 *Fairy Tales for Grown-ups,* The National Gallery of Canada, Ottawa
2003 *Revelations*, San Francisco Museum of Modern Art, San Francisco, CA; Los Angeles County Museum of Art, Los Angeles, CA; The Museum of Fine
 Arts, Houston, TX; The Metropolitan Museum of Art, New York; Museum Folkwang, Essen; The Victoria and Albert Museum, London; Walker Art
 Center, Minneapolis, MN

GRUPPENAUSSTELLUNGEN/GROUP EXHIBITIONS (Auswahl/selection)
1967 *New Documents,* The Museum of Modern Art, New York
1972 36. Biennale di Venezia, Venedig/Venice
1977 Documenta 6, Kassel
1978 *Mirrors and Windows: American Photography since 1960,* The Museum of Modern Art, New York
2000 *How you look at it. Fotografien des 20. Jahrhunderts,* Sprengel Museum Hannover/Hanover; Städelsches Kunstinstitut – Das Städel, Frankfurt am Main
2003 *Cruel & Tender: The Real in the 20th Century Photograph/Fotografie und Wirklichkeit,* Tate Modern, London; Museum Ludwig, Köln/Cologne
2011 *Streetlife and Homestories. Fotografien aus der Sammlung Goetz,* Museum Villa Stuck, München/Munich

BIBLIOGRAFIE/BIBLIOGRAPHY (Auswahl/selection)
Diane Arbus. Hg. von/ed. by Doon Arbus, Marvin Israel. New York: Aperture, 1972
Diane Arbus: Magazine Work. Hg. von/ed. by Doon Arbus, Marvin Israel. New York: Aperture, 1984 (Texte/texts: Diane Arbus, Thomas Southall; dt. Ausgabe:
 Zeitschriften Arbeit, Frankfurt am Main: Zweitausendeins, 1984)
Diane Arbus: Untitled. Hg. von/ed. by Doon Arbus, Yolanda Cuomo. New York: Aperture, 1995 (Nachwort/afterword: Doon Arbus; dt. Ausgabe: *Ohne Titel,*
 Frankfurt am Main: Zweitausendeins, 1996)
Diane Arbus: Revelations. München: Schirmer/Mosel, 2003 (Texte/texts: Doon Arbus, Sandra Philipps, Jeff L. Rosenheim, Neil Selkirk, Elisabeth Sussman)
Diane Arbus: Family Album. New Haven: Yale University Press, 2003
Diane Arbus: The Libraries. San Francisco: Fraenkel Gallery, 2005

▸ LEWIS BALTZ

1945 geboren/born in Newport, CA
San Francisco Art Institute, in San Francisco, CA
Claremont Graduate University, Claremont, CA
Lebt in/lives in Paris und/and Venedig/Venice

EINZELAUSSTELLUNGEN/SOLO EXHIBITIONS (Auswahl/selection)
1971 Castelli Graphics, Castelli Gallery, New York
1976 The Museum of Fine Arts, Houston, TX
1979 Nova Scotia College of Art and Design, Halifax, Kanada/Canada
1980 Werkstatt für Photographie, Berlin
1985 The Victoria and Albert Museum, London
1990 *Rule Without Exception,* P.S.1 Contemporary Art Center, New York
1992 *Ronde de Nuit,* Musée national d'art moderne, Centre Pompidou, Paris; Seibu Contemporary Art, Tokio/Tokyo; Stedelijk Museum, Amsterdam;
 Los Angeles County Museum of Art, Los Angeles, CA
1993 *Regel ohne Ausnahme,* Fotomuseum Winterthur; Musée d'art moderne de la Ville de Paris
1998 The Museum of Contemporary Art, Los Angeles, CA
2004 *Sites of Technology,* Galerie Thomas Zander, Köln/Cologne
2010 *Lewis Baltz: Prototypes/Ronde de Nuit,* Art Institute of Chicago, IL; National Gallery of Art, Washington D.C.

GRUPPENAUSSTELLUNGEN/GROUP EXHIBITIONS (Auswahl/selection)
1975 *New Topographics: Photographs of a Man-Altered Landscape,* George Eastman House, Rochester, NY
1977 *Biennial Exhibition,* Whitney Museum of American Art, New York
1978 *Mirrors and Windows: American Photography since 1960,* The Museum of Modern Art, New York
1989 *Dialectical Landscapes: Nuovo paessagio americano,* Palazzo Fortuny, Venedig/Venice
1993 *Photographs from the Real World,* Lillehammer Art Museum, Lillehammer
2000 *How you look at it. Fotografien des 20. Jahrhunderts*, Sprengel Museum Hannover/Hanover; Städelsches Kunstinstitut – Das Städel, Frankfurt am Main
2003 *Cruel & Tender: The Real in the 20th Century Photograph/Fotografie und das Wirkliche,* Tate Modern, London; Museum Ludwig, Köln/Cologne
2004 *Evidence of Impact: Art and Photography 1963–1978,* Whitney Museum of American Art, New York
2006 *TRANS EMILIA. Collection Linea di Confine,* Fotomuseum Winterthur; SK-Stiftung, Köln/Cologne
2010 *Anonymous America: photography and film,* Le Bal, Paris
 Hyper Real. Realismen in Malerei und Fotografie, MUMOK, Museum moderner Kunst Stiftung Ludwig, Wien/Vienna; Ludwig Forum für Internationale
 Kunst, Aachen

BIBLIOGRAFIE/BIBLIOGRAPHY (Auswahl/selection)
Lewis Baltz: The New Industrial Parks Near Irvine, California. New York: Castelli Graphics, 1975
Lewis Baltz: Nevada. New York: Castelli Graphics, 1978 (Neuauflage/new edition Göttingen: Steidl, 2001)
Lewis Baltz: Park City. (Mit/with Gus Blaisdell). New York: Castelli Graphics/Aperture, Inc., 1981
Lewis Baltz: San Quentin Point. Paris: Editions de la Difference; New York: Aperture, 1986 (Text: Mark Haworth-Booth)
Lewis Baltz: Candlestick Point. Tokio: Min Gallery, 1989 (Text: Gus Blaisdell; Neuauflage/new edition Göttingen: Steidl, 2010)
Lewis Baltz: Rule Without Exception. Hg. von/ed. by Julia Brown Turrell. Albuquerque: University of New Mexico Press/Des Moines Art Center, 1991
 (dt. Auf-lage: *Regel ohne Ausnahme.* Hg. von/ed. by Urs Stahel. Berlin/New York/Zürich: Scalo, 1993)
Lewis Baltz: Ronde de Nuit. (Mit/with Olivier Boissiere). Paris: Musée national d'art moderne, Centre Pompidou, 1992
Lewis Baltz: Les Morts de Newport Beach. Valenciennes: Editions de l'Aquarium Agnostique, 1995
Lewis Baltz: Geschichten von Verlangen und Macht. (Mit/with Slavica Perkovic). Berlin/New York/Zürich: Scalo, 1996
Lewis Baltz: The Politics of Bacteria, Docile Bodies, Ronde de Nuit. Los Angeles: The Museum of Contemporary Art/RAM, 1998
Jeff Rian, Lewis Baltz. London: Phaidon, 2001
Lewis Baltz: The Prototype. New York: Whitney Museum of American Art; Göttingen: Steidl; Los Angeles: RAM, 2005
Lewis Baltz: The Tract Houses. Göttingen: Steidl; Los Angeles: RAM, 2005 (Text: Sheryl Conkleton)
Lewis Baltz: 89/91 Sites of Technology. Göttingen: Steidl, 2007

▶ MAX BAUMANN

1961 geboren/born in Meißen
Architekturstudium/architecture studies, TU Dresden
Möbel & Ausbau/furniture & extension, Burg Giebichenstein, Halle/Saale
Fotografiestudium/photography studies, Hochschule für Grafik und Buchkunst, Leipzig
Kunstakademie Düsseldorf/Dusseldorf
Meisterschüler von/master pupil of Prof. Timm Rautert, Leipzig
Lebt/lives in Schortewitz

EINZELAUSSTELLUNGEN/SOLO EXHIBITIONS (Auswahl/selection)
1995 *Chlorophyll,* Galerie Treptow, Berlin
1996 *zusehends,* Galerie in der Brotfabrik, Berlin
2001 *sprachlos,* Moskovskoj Fond Kultury, Moskau/Moscow
2002 *Abgefangen,* Sprengel Museum Hannover/Hanover
2003 *Eigenwelt,* Künstlerhof Buch, Berlin
2005 *Freiraum/Berlin,* Berlinische Galerie – Landesmuseum für Moderne Kunst, Fotografie und Architektur, Berlin
2008 *Zeitwinkel. Analoge Fotografie,* Technische Sammlungen Dresden
2009 *lichtgrau,* Raum Hellrot, Halle/Saale

GRUPPENAUSSTELLUNGEN/GROUP EXHIBITIONS (Auswahl/selection)
1996 *Dokumentarfotografie Förderpreis 1994/95,* Kunstverein Ludwigsburg
2000 *Here and Now: Positions, Attitudes, Actions,* Foto Biennale Rotterdam
2001 *Ich. Das Auge. Toter Winkel,* Tanztheaterproduktion (Bühnenbild und Projektion) mit/dance theater production (stage design and projection) with Jo Fabian (bis/until 2003)
2002 *Erinnerungslandschaften,* Brandenburgische Kunstsammlung Cottbus/Brandenburgische Kulturstiftung Cottbus
2003 *ZEITNAH. Werkstatt Junge Akademie 2003,* Akademie der Künste, Berlin
2004 *Soziale Kreaturen. Wie Körper Kunst wird,* Sprengel Museum Hannover/Hanover
2006 *Zeit Raum Bild. 10 Jahre Dokumentarfotografie. Förderpreise der Wüstenrot Stiftung,* Sonderausstellungshalle Kulturforum, Berlin
 East. City Scape East/Stadt Land Ost. Die Fotografische Sammlung der VNG – Verbundnetz Gas AG Leipzig, Landesvertretung Sachsen-Anhalt, Brüssel/Brussels
2009 *Solitude – Gefährdete Landschaften,* Neues Kunsthaus Ahrenshoop
 Stadt Land Fluss, Sprengel Museum Hannover/Hanover
 Berlin 89/09. Kunst zwischen Spurensuche und Utopie, Berlinische Galerie - Landesmuseum für Moderne Kunst, Fotografie und Architektur, Berlin
2010 *East. For the Record/Zu Protokoll,* Galerie für Zeitgenössische Kunst, Leipzig

BIBLIOGRAFIE/BIBLIOGRAPHY (Auswahl/selection)
Das Bitterfeld. Oberhausen: Ludwig-Institut Oberhausen, Städtische Galerie Schloß Oberhausen, 1992 (Text: Bernhard Mensch)
Max Baumann: Chlorophyll. Oberhausen: Plitt Druck und Verlag GmbH, 1994 (mit zwei Dramen von/with two dramas by Georg Seidel)
Vor Ort. Eine Sammlung topografischer Fotografien Ostdeutschlands. Leipzig: Verbundnetz Gas AG Leipzig, 1994 (Einleitung/introduction: Rolf Sachsse)
Dokumentarfotografie Förderpreis 1994/95. Ludwigsburg: Wüstenrot Stiftung Deutscher Eigenheimverein e. V., 1996 (Einleitung/introduction: Ute Eskildsen; Texte/texts: Reinhard Matz, Brigitte Werneburg)
Die Konstruktion des Raumes. Berlin: Verlag der Kunst, 1997 (Texte/texts: Barbara Köhler, Inka Schube, Satish Sharma)
Peripherie als Ort. Das Hellersdorf Projekt. Stuttgart: Arnoldsche Verlagsanstalt, 1999 (Einleitung/introduction: Ulrich Domröse; Texte/texts: Alexander Osang, Rolf Schneider, Gerwin Zohlen)
Max Baumann: Abgefangen. Hannover: Sprengel Museum Hannover, 2002 (Text: Inka Schube)
Soziale Kreaturen. Wie Körper Kunst wird. Ostfildern: Hatje Cantz, 2004 (Texte/texts: Patricia Drück, Inka Schube)
Max Baumann: Zeitwinkel. Analoge Fotografie. Dresden: Technische Sammlungen Dresden, 2008 (Text: Andreas Krase)
Solitude – Gefährdete Landschaften. Ahrenshoop: Edition Hohes Ufer Ahrenshoop, 2009 (Einleitung/introduction: Gerlinde Creutzburg)

▶ BERND BECHER

1931 geboren/born in Siegen; 2007 gestorben/died in Rostock
Akademie der Künste, Stuttgart
Kunstakademie Düsseldorf/Dusseldorf

▶ HILLA BECHER (geb. Wobeser)

1934 geboren/born in Potsdam
Ausbildung zur Fotografin/apprenticeship as photographer
Kunstakademie Düsseldorf/Dusseldorf
Lebt/lives in Düsseldorf/Dusseldorf

EINZELAUSSTELLUNGEN/SOLO EXHIBITIONS (Auswahl/selection)
1967 *Industriebauten 1830–1930,* Die Neue Sammlung, München/Munich
1969 *Anonyme Skulpturen,* Kunsthalle Düsseldorf/Dusseldorf
1970 Moderna Museet, Stockholm
1972 Sonnabend Gallery, New York
1975 The Museum of Modern Art, New York
1981 Stedelijk Van Abbemuseum, Eindhoven
1989 Dia Art Foundation, New York

1990 44. Biennale di Venezia, Deutscher Pavillon/German Pavilion, Venedig/Venice
2004 *Typologien,* Kunstsammlung Nordrhein-Westfalen, Düsseldorf/Dusseldorf; Haus der Kunst, München/Munich; Museé national d'art moderne, Centre Pompidou, Paris; Staatliche Museen zu Berlin – Deutsches Centrum für Photographie im Hamburger Bahnhof, Berlin
2008 *Landscape/Typology,* The Museum of Modern Art, New York
2010 *Bergwerke und Hütten. Industrielandschaften,* Josef Albers Museum Quadrat, Bottrop

GRUPPENAUSSTELLUNGEN/GROUP EXHIBITIONS (Auswahl/selection)
1972 Documenta 5, Kassel
1975 *New Topographics: Photographs of a Man-Altered Landscape,* George Eastman House, Rochester, NY
1977 Documenta 6, Kassel
1981 *Absage an das Einzelbild,* Museum Folkwang, Essen
1982 Documenta 7, Kassel
1984 *Von hier aus. Zwei Monate neue deutsche Kunst in Düsseldorf,* Messehalle Düsseldorf/Dusseldorf
1991 *Aus der Distanz,* Kunstsammlung Nordrhein-Westfalen, Düsseldorf/Dusseldorf
1992 *Photographie in der deutschen Gegenwartskunst/Photography in Contemporary German Art,* Walker Art Center, Minneapolis, MN; Museum Ludwig, Köln/Cologne
1997 *Vergleichende Konzeptionen,* Die Photographische Sammlung/SK Stiftung Kultur, Köln/Cologne
2002 Documenta 11, Kassel
2010 *Ruhrblicke/Ruhr Views,* Sanaa-Gebäude, Zeche Zollverein, Essen

BIBLIOGRAFIE/BIBLIOGRAPHY (Auswahl/selection)
Industriebauten 1830–1930. Eine photographische Dokumentation von Bernd und Hilla Becher. München: Staatliches Museum für angewandte Kunst, 1967
Bernd und Hilla Becher: Anonyme Skulpturen. Eine Typologie technischer Bauten. Düsseldorf: Art-Press-Verlag, 1970
Bernd und Hilla Becher: Wassertürme. München: Kunstverein München, 1988 (Text/text: Reyner Banham)
Bernd und Hilla Becher: Hochöfen. München: Schirmer/Mosel, 1990
Bernd und Hilla Becher: Pennsylvania Coal Mine Tipples. München: Schirmer/Mosel, 1991 (Vorwort/foreword: Charles B. Wright)
Bernd und Hilla Becher: Häuser und Hallen. Frankfurt am Main: Museum für Moderne Kunst, 1992 (Text: Susanne Lange)
Bernd und Hilla Becher: Fabrikhallen. München: Schirmer/Model, 1994 (Text: Susanne Lange)
Industriephotographie. Hg. von/ed. by Monika Steinhauser in Zusammenarbeit mit/in collaboration with Kai-Uwe Hemken. Düsseldorf: Richter, 1994
Bernd und Hilla Becher: Zeche Hannibal. München: Schirmer/Mosel, 1999 (Text: Susanne Lange)
Bernd und Hilla Becher: Hochöfen. München: Schirmer/Mosel, 2002
Bernd und Hilla Becher: Typologien industrieller Bauten. München: Schirmer/Mosel, 2003 (Texte/texts: Ludger Derenthal, Susanne Lange, Thomas Weski, Armin Zweite)
Was wir tun, ist letztlich Geschichten erzählen ... Bernd und Hilla Becher. Leben und Werk. Hg. von/ed. by Susanne Lange. München: Schirmer/Mosel, 2005
Bernd und Hilla Becher: Bergwerke und Hütten. München: Schirmer/Mosel, 2010

▸ LAURA BIELAU

1981 geboren/born in Halle/Saale
Grafik/Design, Halle/Saale
Ausbildung zur Fotografin/apprenticeship as photographer
Hochschule für Grafik und Buchkunst, Leipzig (bei/with Prof. Timm Rautert)
University for Art and Design, Helsinki
Meisterschülerin von/master pupil of Prof. Peter Piller
Lebt/lives in Leipzig

EINZELAUSSTELLUNGEN/SOLO EXHIBITIONS (Auswahl/selection)
2005 *Kisahalli,* Galerie Emmanuel Post, Leipzig
2007 Hochschule für Grafik und Buchkunst, Leipzig
 Goethe Institut Helsinki
 Photographic Gallery Hippolyte, Helsinki
2008 *Color Lab Club,* Galerie Emmanuel Post, Leipzig
2011 Galerie Emmanuel Post, Leipzig

GRUPPENAUSSTELLUNGEN/GROUP EXHIBITIONS (Auswahl/selection)
2003 *Auf der Suche nach Identität. Boris Mikhailov und Studierende,* Hochschule für Grafik und Buchkunst, Leipzig
2005 *Zwischenraum,* Marta Hoepffner Preis, Stadtmuseum, Hofheim am Taunus
2006 Kunsthalle Villa Kobe, Halle/Saale
2007 1. Internationales Fotografiefestival Leipzig, *F/Stop*
2008 *Randbelichtung. Klasse Peter Piller Leipzig,* Palais für aktuelle Kunst, Kunstverein Glückstadt
 Marion Ermer Preis 2008, Neues Museum, Weimar
 gute aussichten. junge deutsche fotografie/young german photographers, Deichtorhallen Hamburg; DZ Bank, Frankfurt am Main; Goethe Institut, Washington D.C.
2010 *Noir Complex: City, Story, Destruction & Death,* Magazin 4, Bregenzer Kunstverein, Bregenz; Brandenburgischer Kunstverein, Potsdam
2011 *Leipzig. Fotografie seit 1839,* Museum der bildenden Künste, Leipzig

BIBLIOGRAFIE/BIBLIOGRAPHY (Auswahl/selection)
Laura Bielau: Color Lab Club/Scud. Hg. von/ed. by Marion Ermer Stiftung. Weimar: Verlag der Bauhaus Universität, 2008
Noir Complex: City, Story, Destruction & Death. Hg. von / ed. by Maik Schlüter. Leipzig: Spector Books, 2010
Leipzig. Fotografie seit 1839. Hg. von/ed. by Thomas Liebscher. Leipzig: Passage-Verlag, 2010 (Texte/texts: Florian Ebner, Wolfgang Hesse, Wolfgang Kil, Andreas Krase, Christoph Tannert u. a.)

▶ THOMAS DEMAND

1964 geboren/born in München/Munich
Akademie der Bildenden Künste, München/Munich
Kunstakademie Düsseldorf/Dusseldorf
Goldsmiths College, London
Lebt/lives in Berlin

EINZELAUSSTELLUNGEN/SOLO EXHIBITIONS (Auswahl/selection)
1992 Galerie Tanit, München/Munich
1997 Galerie Monika Sprüth, Köln/Cologne
1999 *Tunnel,* Art Now 17, Tate Britain, London
2000 Fondation Cartier, Paris
2001 *Report*, Sprengel Museum Hannover/Hanover
2002 Städtische Galerie im Lenbachhaus, München/Munich
2003 Louisiana Museum of Modern Art, Humlebaek
2004 *Phototrophy*, Kunsthaus Bregenz
 São Paulo Biennale, Deutscher Pavillon/German Pavilion, São Paulo
2005 The Museum of Modern Art, New York
2006 Serpentine Gallery, London
2008 *Camera,* Hamburger Kunsthalle, Hamburg
2009 *Nationalgalerie*, Neue Nationalgalerie, Berlin
 Embassy: Presidency, MUMOK, Museum Moderner Kunst Stiftung Ludwig, Wien/Vienna
2010 *La carte d'après nature*, Nouveau Musée National de Monaco

GRUPPENAUSSTELLUNGEN/GROUP EXHIBITIONS (Auswahl/selection)
1994 *Scharf im Schauen,* Haus der Kunst, München/Munich
1995 *Ars Viva 1995 – Thomas Demand, Wolfgang Tillmans, Barbara Probst und Jochen Lempert,* Frankfurter Kunstverein, Frankfurt am Main; Kunsthalle
 Nürnberg; Anhaltische Gemäldegalerie, Dessau
1997 *Positionen künstlerischer Photographie in Deutschland seit 1945*, Berlinische Galerie im Martin-Gropius-Bau, Berlin
1999 *Große Illusionen – Demand, Gursky, Ruscha*, Kunstmuseum Bonn
2001 *Trade*, Fotomuseum Winterthur
2006 *Der Blaue Reiter im 21. Jahrhundert*, Lenbachhaus München/Munich
2008 *Reality Check*, The Metropolitan Museum of Art, New York
 11th International Architecture Biennale, Belgischer Pavillon/Belgian Pavilion, Venedig/Venice
2009 *Waiting for Video: Works from the 1960s to Today*, The National Museum of Modern Art, Tokio/Tokyo
2010 *Realismus. Das Abenteuer Wirklichkeit. Courbet – Hopper – Gursky*, Kunsthalle Emden; Hypokulturstiftung, München/Munich; Kunsthalle Rotterdam
2011 *Deutsche Börse Photography Prize 2011*, Ambika P3, Westminster University, London

BIBLIOGRAFIE/BIBLIOGRAPHY (Auswahl/selection)
Positionen künstlerischer Photographie in Deutschland seit 1945. Hg. von/ed. by Ludger Derenthal, Ulrich Domröse. Köln: Dumont, 1997
Thomas Demand. Hg. von/ed. by Bernhard Bürgi, Stuart Morgan. Zürich: Kunsthalle Zürich, 1998
Thomas Demand. Hg. von/ed. by Francesco Bonami. London/New York: Thames & Hudson, 2000
Thomas Demand. Hg. von/ed. by Marcella Beccaria. Turin: Castello di Rivoli, Museo d'Arte Contemporanea, 2003
Thomas Demand: Phototrophy. Hg. von/ed. by Eckhard Schneider. München: Schirmer/Mosel, 2004
Spectacular City: Photographing the Future. Hg. von/ed. by Jean-François Chevrier, Emiliano Gandolfi, Steven Jacobs. Rotterdam: NAI, 2006
Thomas Demand. Madrid: Fundación Telefonica, 2008
Thomas Demand. London: MACK, 2010
Thomas Demand: Nationalgalerie. Göttingen: Steidl, 2010

▶ RINEKE DIJKSTRA

1959 geboren/born in Sittard, Niederlande/Netherlands
Gerrit Rietveld Akademie Amsterdam
Lebt/lives in Amsterdam

EINZELAUSSTELLUNGEN/SOLO EXHIBITIONS (Auswahl/selection)
1984 *Paradiso Portretten*, de Moor, Amsterdam
1996 Le Consortium, Dijon
1998 Museum Boijmans Van Beuningen, Rotterdam
 Menschenbilder, Museum Folkwang, Essen
 The Buzzclub, Liverpool, UK/Mysteryworld, Zaandam, NL, 1996/97, Sprengel Museum Hannover/Hanover
2001 *Israel Portraits*, The Herzliya Museum of Art, Herzliya, Israel
2005 *Portraits*, Galerie Nationale Jeu de Paume, Paris; Fotomuseum Winterthur; Fundació la Caixa d'Estalvis Pensions, Barcelona; Stedelijk Museum,
 Amsterdam
2006 *Portraits*, Rudolfinum, Prag/Prague
2007 *Park Portraits*, Marian Goodman Gallery, New York
2009 *Park Portraits*, La Fabrica, Madrid

GRUPPENAUSSTELLUNGEN/GROUP EXHIBITIONS (Auswahl/selection)
1993 Foto Festival Naarden, Niederlande/Netherlands
1994 *Der ander, der Andere, l'autre: Werner Mantz Prize*, Het Domain, Sittard; Ludwig Forum für Internationale Kunst, Aachen
1996 *100 fotos uit dee collectie*, Stedelijk Museum, Amsterdam

1997 *New Photography 13*, The Museum of Modern Art, New York
 Photowork(s) in Progress/Constructing Identity: Rineke Dijkstra, Wendy Ewald, Paul Seawright, Nederlands Fotoinstituut, Rotterdam
2000 *How you look at it. Fotografien des 20. Jahrhunderts*, Sprengel Museum Hannover/Hanover; Städelsches Kunstinstitut – Das Städel, Frankfurt am Main
2002 *Remix: Contemporary Art & Pop*, Tate Liverpool
 Moving Pictures, Solomon R. Guggenheim Museum, New York
2003 *Rineke Dijkstra/Paula Modersohn-Becker. Portraits*, Kunstsammlungen Böttcherstraße, Bremen
2005 Sharjah Biennial 7, *Belonging*, Sharjah, Vereinigte Arabische Emirate/United Arab Emirates
2006 *Click Doubleclick – das dokumentarische Moment/the documentary factor*, Haus der Kunst, München/Munich; Palais des Beaux Arts, Brüssel/Brussels
2008 *Street & Studio: An Urban History of Photography*, Tate Modern, London; Museum Folkwang, Essen
2010 *The Temporary Stedelijk,* Stedelijk Museum, Amsterdam

BIBLIOGRAFIE/BIBLIOGRAPHY (Auswahl/selection)
Rineke Dijkstra: Beaches. Zürich: Codax Publisher, 1996 (Text: Birgid Uccia)
Rineke Dijkstra: Location. London: The Photographers' Gallery, 1997
Rineke Dijkstra: Menschenbilder. Essen: Museum Folkwang, 1998 (Texte/texts: Ute Eskildsen, Ulf Erdmann Ziegler)
Rineke Dijkstra: The Buzzclub, Liverpool, GB/Mysteryworld, Zaandam, NL, 1996/97. Hannover: Sprengel Museum Hannover, 1998 (Text: Thomas Weski)
Die Berliner Zeit. Rineke Dijkstra, Bart Domburg. Berlin: daad, 2000 (Text: Friedrich Meschede)
How you look at it. Fotografien des 20. Jahrhunderts. Hg. von/ed. by Heinz Liesbrock, Thomas Weski. Köln: Verlag der Buchhandlung Walther König, 2000
Rineke Dijkstra. Ostfildern: Cantz, 2001
Rineke Dijkstra: Portraits. München: Schirmer/Mosel, 2004
Click Doubleclick – Das dokumentarische Moment/the documentary factor. Köln: Verlag der Buchhandlung Walther König, 2006
Dutch Eyes. A Critical History of Photography in the Netherlands. Ostfildern: Cantz, 2007
Rineke Dijkstra: Art Photography Now. Hg. von/ed. by Susan Bright. Heidelberg: Edition Braus, 2008

▸WILLIAM EGGLESTON

1939 geboren/born in Sumner, MS
University of Mississippi, Oxford, MS; ohne Abschluss/non-degreed
Lebt/lives in Memphis, TN

EINZELAUSSTELLUNGEN/SOLO EXHIBITIONS (Auswahl/selection)
1974 *Photographs by William Eggleston*, Jefferson Place Gallery, Washington D.C.
1975 *Recent Photographic Work of William Eggleston*, Carpenter Center, Harvard University, Cambridge, MA
1976 *Photographs by William Eggleston*, The Museum of Modern Art, New York
1983 Werkstatt für Photographie, Berlin
1989 Spectrum Photogalerie, Sprengel Museum Hannover/Hanover
1990 *The Democratic Forest*, Corcoran Gallery of Art, Washington D.C.
1992 *Colour Photographs: Ancient and Modern*, Barbican Art Gallery, London
1999 *Photographs 1966–1971*, Cheim & Read, New York
 1998 Hasselblad Award Winner, Hasselblad Center, Göteborg/Goteborg
2000 Fondation Cartier pour l'art contemporain, Paris; Hayward Gallery, London
2003 *Los Alamos*, Museum Ludwig, Köln/Cologne; Museu Serralves, Porto; Museum for Samtidskunst, Oslo; Louisiana Museum of Modern Art, Humlebaek; San Francisco Museum of Modern Art, San Francisco, CA; Albertina, Wien/Vienna; Dallas Museum of Art, Dallas, TX
2008 *Democratic Camera: Photographs and Video, 1961–2008*, Whitney Museum of American Art, New York; Haus der Kunst, München/Munich; Corcoran Gallery of Art, Washington D.C.; Art Institute of Chicago, IL; Los Angeles County Museum of Art, Los Angeles, CA

GRUPPENAUSSTELLUNGEN/GROUP EXHIBITIONS (Auswahl/selection)
1975 *14 American Photographers*, Baltimore Museum of Art, Baltimore, MD
1978 *Amerikanische Landschaftsphotographie 1860-1978*, Die Neue Sammlung, München/Munich
 Mirrors and Windows: American Photography since 1960, The Museum of Modern Art, New York
1980 *Amerikanische Farbphotographie*, Galerie Kicken, Köln/Cologne
 Aspekte Amerikanischer Farbfotografie, Spectrum Photogalerie, Sprengel Museum Hannover/Hanover
1985 *American Images: Photography from 1945–1980*, Barbican Art Gallery, London
1987 *Dialectical Landscapes. Nuovo paesaggio americano*, Palazzo Fortuny, Venedig/Venice
1989 *Photography Until Now,* The Museum of Modern Art, New York
2000 *How you look at it. Fotografien des 20. Jahrhunderts*, Sprengel Museum Hannover/Hanover; Städelsches Kunstinstitut – Das Städel, Frankfurt am Main
2002 Documenta 11, Kassel
2003 *Cruel & Tender: The Real in the 20th Century Photograph/Fotografie und das Wirkliche*, Tate Modern, London; Museum Ludwig, Köln/Cologne

BIBLIOGRAFIE/BIBLIOGRAPHY (Auswahl/selection)
William Eggleston's Guide. New York: The Museum of Modern Art, 1976 (Text: John Szarkowski)
William Eggleston: The Democratic Forest. New York: Doubleday, 1989 (Einführung/Introduction: Eudora Welty)
William Eggleston: Ancient and Modern. New York: Random House, 1992 (Einführung/Introduction: Mark Holborn)
William Eggleston: 2 ¼. Santa Fe: Twin Palms, 1999
William Eggleston: The Hasselblad Award 1998. Göteborg: Hasselblad Center, 1999 (Texte/texts: Walter Hopps, Thomas Weski; Interview: Ute Eskildsen mit/with William Eggleston)
William Eggleston: Los Alamos. Berlin/New York/Zürich: Scalo, 2003 (Texte/texts: Walter Hopps, Thomas Weski)
William Eggleston: 5×7. Santa Fe: Twin Palms, 2006
William Eggleston: Democratic Camera – Photographs and Video, 1961–2008. Hg. von/ed. by Elisabeth Sussman, Thomas Weski. New Haven: Yale University Press, 2008 (Texte/texts: Stanley Booth, Tina Kukielski, Donna de Salvo, Elisabeth Sussman, Thomas Weski)
William Eggleston: For Now. Santa Fe: Twin Palms, 2010 (Texte/texts: Michael Almereyda, Lloyd Fonvielle, Greil Marcus, Kristine McKenna, Amy Taubin)
William Eggleston: Before Color. Hg. von/ed. by Chris Burnside, John Cheim, Winston Eggleston, Howard Read, Thomas Weski. Göttingen: Steidl, 2010 (Text: Dave Hickey)

HANS-PETER FELDMANN

1941 geboren/born in Düsseldorf/Dusseldorf
Lebt/lives in Düsseldorf/Dusseldorf

LEE FRIEDLANDER

1934 geboren/born in Aberdeen, WA
Art Center School of Design, Los Angeles, CA; ohne Abschluss/non-degreed
Lebt/lives in New City, NY

EINZELAUSSTELLUNGEN/SOLO EXHIBITIONS (Auswahl/selection)
1963 George Eastman House, Rochester, NY
1974 The Museum of Modern Art, New York
1976 The Photographers' Gallery, London
1977 *The American Monument*, The Institute of Contemporary Art, Boston, MA
1978 *Photographs*, Hudson River Museum, Yonkers, NY
1982 *Factory Valleys*, Akron Art Museum, Akron, OH
1986 *Eine Retrospektive*, Museum Folkwang, Essen; ICA – Institute of Contemporary Arts, London
1989 *Like a One-Eyed Cat: Photographs by Lee Friedlander 1956–1987*, Seattle Art Museum, Seattle, WA
1991 *Nudes*, The Museum of Modern Art, New York; San Francisco Museum of Modern Art, San Francisco, CA
1993 *Letters from the People*, Walker Art Center, Minneapolis, MN
2003 *At Work*, SK Stiftung Kultur, Köln/Cologne; The Columbus Museum of Art, Ohio, OH
2005 *Photographs 1965–2004*, The Museum of Modern Art, New York; Haus der Kunst, München/Munich
 Hasselblad Award Winner 2005, Hasselblad Center, Göteborg/Goteborg

GRUPPENAUSSTELLUNGEN/GROUP EXHIBITIONS (Auswahl/selection)
1963 *Photography '63*, George Eastman House, Rochester, NY
1964 *The Photographer's Eye*, The Museum of Modern Art, New York
1967 *Toward a Social Landscape*, George Eastman House, Rochester, NY
 New Documents, The Museum of Modern Art, New York
1975 *14 American Photographers*, The Baltimore Museum of Art, Baltimore, MD
1978 *Mirrors and Windows: American Photography since 1960*, The Museum of Modern Art, New York
1988 *Three on Technology*, Massachusetts Institute of Technology, Cambridge, MA
1989 *Photography Now*, The Victoria and Albert Museum, London
1990 *Photography Until Now*, The Museum of Modern Art, New York
 The Past and Present of Photography, The National Museum of Modern Art, Tokio/Tokyo
1999 *My Culture – My Self,* Ydessa Hendeles Art Foundation, Toronto
2000 *Walker Evans & Company*, The Museum of Modern Art, New York
 How you look at it. Fotografien des 20. Jahrhunderts, Sprengel Museum Hannover/Hanover; Städelsches Kunstinstitut – Das Städel, Frankfurt am Main
2003 *Cruel & Tender: The Real in the 20th Century Photograph/Fotografie und das Wirkliche,* Tate Modern, London; Museum Ludwig, Köln/Cologne

BIBLIOGRAFIE/BIBLIOGRAPHY (Auswahl/selection)
Work from the Same House: Lee Friedlander and Jim Dine. London: Trigram Press, 1969
Lee Friedlander: Self Portrait. New York: Haywire Press, 1970 (Text: John Szarkowski)
Lee Friedlander: The American Monument. New York: The Eakins Press Foundation, 1976 (Text: Leslie George Katz)
Lee Friedlander: Photographs. New York: Haywire Press, 1978
Lee Freedlander: Factory Valleys: Ohio & Pennsylvania. New York: Callaway Editions IV, 1982 (Text: Leslie George Katz)
Lee Freedlander: Portraits. Boston: New York Graphic Society, 1985 (Text: R. B. Kitaj)
Lee Friedlander: Like a One-Eyed Cat: Photographs 1956–1987. New York: Harry N. Abrams, 1989 (Text: Rod Slemmons)
Lee Freedlander: Nudes. Hg. von/ed. by Mark Holborn. New York: Pantheon Books, 1991 (Text: Ingrid Sischy)
Lee Freedlander: Letters from the People. Hg. von/ed. by Lee Friedlander, Mark Holborn. New York: D.A.P., 1993
Lee Friedlander: The Desert Seen. New York: D.A.P., 1996 (Text: Lee Friedlander)
Lee Friedlander: Sticks & Stones: Architectural America. San Francisco: Fraenkel Gallery, 2004 (Text: James Enyeart)
Friedlander. New York: The Museum of Modern Art, 2005 (Texte/texts: Richard Benson, Peter Galassi)
Lee Freedlander: America by Car. San Francisco: Fraenkel Gallery, 2010

STEPHEN GILL

1971 geboren/born in Bristol
Fotografie-Grundkurs am/basic photography course at Tilton College, Bristol
Lebt/lives in London

EINZELAUSSTELLUNGEN/SOLO EXHIBITIONS (Auswahl/selection)
2001 *Audience,* Pentagram Gallery, London
2003 *The Wick,* The Photographers' Gallery, London
2004 Rencontres Internationales de la Photographie, Arles
 September, The State Centre of Architecture, Moskau/Moscow
2005 The Architectural Association, London
 Invisible/Lost Series, Photo Espagne 05, Madrid
2007 *Anonymous Origami/Buried,* Leighton House Museum, London

2008 *Hackney Wick,* Decima Gallery, London
 A Series of Disappointments, Gungallery, Stockholm
2009 *Hackney Flowers,* Gaain Gallery, Seoul; G/P Gallery, Tokio/Tokyo
2010 *Coming up for Air,* G/P Gallery, Tokio/Tokyo
2011 *Outside In,* G/P Gallery, Tokio/Tokyo; Gungallery, Stockholm

GRUPPENAUSSTELLUNGEN/GROUP EXHIBITIONS (Auswahl/selection)
2001 *British Artists Exhibition,* National Portrait Gallery, London
2003 *Photo London,* The Photographers' Gallery, London
2004 *A Gentle Madness,* National Museum of Photography, Film and Television, Bradford, UK
2006 *Click Doubleclick – das dokumentarische Moment/the documentary factor,* Haus der Kunst, München/Munich; Palais des Beaux-Arts, Brüssel/Brussels
 Toronto Photography Festival, Toronto
2007 *Terrains D'Entente, Paysages Contemporains,* Rencontres Internationales de la Photographie, Arles
 Photography and Cinema, Tri Postal, Lille
 Something That I'll Never Really See, The Victoria and Albert Museum, London; Bhau Daji Lad, Mumbai, Indien/India
 State of Work, Fotohof Gallery, Salzburg
2008 *What You See Is What You Get,* CNA, Luxemburg/Luxembourg
 Anonymous Origami and Disappointments, St. Ann's Warehouse, New York
 Parrworld, Haus der Kunst, München/Munich
 European Eyes on Japan, Kagoshima Museum of Art, Kagoshima
2009 *I am by birth a Genevese*, Vegas Gallery, London
 That Rose-Red Empire, Danielle Arnaud Gallery, London
 After Color, Bose Pacia, New York
 Sound Escapes, Space, Hackney, London
2010 *The New Old,* Invisible-Exports, New York
 Accrochage, Galerie Zur Stockeregg, Zürich/Zurich
 Outside In/Strange & Familiar, Brighton Museum & Art Gallery, Brighton
 Reading Landscape: Contemporary Landscape Photography, AA Gallery, London

BIBLIOGRAFIE/BIBLIOGRAPHY (Auswahl/selection)
Stephen Gill: A book of field studies. London: Boot, 2004
Stephen Gill: Invisible. London: Nobody, 2005
Stephen Gill: Hackney Wick. London: Nobody, 2005
Stephen Gill: Archeology in Reverse. London: Nobody, 2007
Stephen Gill: A Series of Disappointments. London: Nobody, in association with the Archive of Modern Conflicts, 2008
Stephen Gill: A Book of Birds. London: Super Labo/Nobody, 2010
Stephen Gill: Outside In. London: Archive of Modern Conflict and Photoworks, 2010
Stephen Gill: Coming up for Air. London: Nobody, 2010

▶ JOHN GOSSAGE

1946 geboren/born in New York
Privatunterricht von/private instruction by Alexej Brodovich, Bruce Davidson, Lisette Model
Lebt/lives in Washington D.C.

EINZELAUSSTELLUNGEN/SOLO EXHIBITIONS (Auswahl/selection)
1963 Camera Infinity Gallery, New York
1971 Ohio University, Athens, OH
1976 *The Better Neighborhoods of Greater Washington,* Corcoran Gallery of Art, Washington D.C.
1978 *Gardens*, Castelli Gallery, New York; Werkstatt für Photographie, Berlin
1982 Spectrum Photogalerie, Sprengel Museum Hannover/Hanover
1987 *Stadt des Schwarz*, Castelli Gallery, New York
1989 *Photographs of Berlin*, Cleveland Museum of Art, Cleveland, OH
1990 *LAMF*, Sprengel Museum Hannover/Hanover
1993 *The Photograph and its Double*, C. Grimaldis Gallery, Baltimore, MD
1996 *There and Gone*, Sprengel Museum Hannover/Hanover; Brandenburgische Kunstsammlungen, Cottbus; Museum of Contemporary Photography, Chicago, IL
2000 *Empire*, Roth Horowitz, New York
2004 *13 Ways to Miss a Train,* Linea di Confine, Rubiera, Italien/Italy
2005 *Berlin in the Time of the Wall*: *The Proofs*, J. J. Heckenhauer Galerie, Berlin
2010 *The Pond*, Smithsonian Museum of American Art, Washington D.C.

GRUPPENAUSSTELLUNGEN/GROUP EXHIBITIONS (Auswahl/selection)
1968 *All Kinds of People*, Washington Gallery of Modern Art, Washington D.C.
1975 *14 American Photographers*, Baltimore Museum of Art, Baltimore, MD
1981 *American Images*, George Eastman House, Rochester, NY; Institute of Contemporary Art, Philadelphia, PA
1986 *La Photographie Créative*, Bibliothèque Nationale, Paris
1987 *Dialectical Landscape: Nuovo paesaggio americano*, Palazzo Fortuny, Venedig/Venice
1992 Fotografie Biennale, *Wasteland*, Rotterdam
1997 *Absolute Landscapes*, Yokohama Museum of Art, Yokohama
1998 *The American Lawn*, Canadian Centre for Architecture, Montreal
2005 *Im Rausch der Dinge*, Fotomuseum Winterthur und Fotostiftung Schweiz; Museo Fotografia Contemporanea, Cinisello Balsamo, Mailand/Milan

BIBLIOGRAFIE/BIBLIOGRAPHY (Auswahl/selection)
John Gossage: Gardens. New York: Castelli Graphics, 1978 (Text: Walter Hopps)
The Pond: A book of 49 photographs by John Gossage. New York: Aperture, 1985 (Text: Denise Sines)
Stadt des Schwarz: 18 Photographs of Berlin by John Gossage. Washington D.C.: Loosestrife Editions, 1987 (Texte/texts: Jane Livingston, Peter Lloyd)
There and Gone: 124 photographs by John Gossage. Berlin: Nazraeli Press; New York: NH, 1997 (Texte/texts: John Gossage, Thomas Weski)
Empire: A History Book, by Mr. J. R. Gossage & Dr. H. W. Vogel. San Francisco: Nazraeli Press; Manchester: Cornerhouse, 2000
John Gossage: The Romance Industry. Tucson: Nazraeli Press, 2002 (Texte/texts: Gus Blaisdell, John Gossage, Sandro Mescola, Thomas Weski)
John Gossage: Berlin in the Time of the Wall. Bethesda, MD: Loosestrife Editions, 2004 (Text: Gerry Badger)
John Gossage: Putting Back the Wall. Washington D.C.: Loosestrife Editions, 2007
John Gossage: The Thirty-Two Inch Ruler/Map of Babylon. Göttingen: Steidl, 2010

▸ PAUL GRAHAM

1956 geboren/born in Stafford, UK
Lebt/lives in New York

EINZELAUSSTELLUNGEN/SOLO EXHIBITIONS (Auswahl/selection)
1988 Spectrum Photogalerie, Sprengel Museum Hannover/Hanover
1993 *New Europe,* Fotomuseum Winterthur
1994 *Television Portraits,* Galerie Paul Andriesse, Amsterdam
1996 *Hypermetropia,* Tate Britain, London
1998 *End of an Age,* Galerie Bob Van Orsouw, Zürich/Zurich
2000 *Paintings,* Lawrence Rubin Greenberg Van Boren Fine Art Inc., New York; Anthony Reynolds Gallery, London
2003 *American Night,* P.S.1/The Museum of Modern Art, New York
2004 Greenberg Van Doren Gallery, St. Louis, MO; Fundación Telefonica, Madrid
2006 *A Shimmer of Possibility,* La Fabrica, Madrid; The Museum of Modern Art, New York; Foam, Amsterdam
2009 *Fotografien 1981–2006,* Museum Folkwang, Essen; Haus der Photographie, Deichtorhallen Hamburg; Whitechapel Art Gallery, London

GRUPPENAUSSTELLUNGEN/GROUP EXHIBITIONS (Auswahl/selection)
1998 Rencontres Internationales de la Photographie, Arles
2000 *Some Parts of This World,* Finnish Museum of Photography Helsinki
2001 49. Biennale di Venezia, Venedig/Venice
2003 *Cruel & Tender: The Real in the 20th Century Photograph/Fotografie und das Wirkliche,* Tate Modern, London; Museum Ludwig, Köln/Cologne
2004 *MoMA Opening Exhibition,* The Museum of Modern Art, New York
2005 *Arbeit – Work, Labour,* Galerie im Taxispalais, Innsbruck
2006 *Click Doubleclick – das dokumentarische Moment/the documentary factor,* Haus der Kunst, München/Munich; Palais des Beaux-Arts, Brüssel/Brussels
2007 *How We Are: Photographing Britain,* Tate Britain, London
2008 *Street & Studio,* Tate Modern, London; Museum Folkwang, Essen

BIBLIOGRAFIE/BIBLIOGRAPHY (Auswahl/selection)
Paul Graham: A1 – The Great North Road. London: Grey, 1983
Paul Graham: Beyond Caring. London: Grey, 1986
Paul Graham: Troubled Land. London: Grey, 1987
Paul Graham: God in Hell. London: Grey, 1993
Paul Graham. London: Phaidon, 1996
Paul Graham: End of an Age. Berlin/New York/Zürich: Scalo, 1998
Paul Graham: Paintings. New York: Lawrence Rubin Greenberg Van Doren Fine Art; London: Anthony Reynolds Gallery, 2000
Paul Graham: American Night. Hg. von/ed. by Michael Mack. Göttingen: Steidl, 2003
Paul Graham. Madrid: Fundación Telefonica/Photo Espagne 04, 2004
Paul Graham: A Shimmer of Possibility. Göttingen: SteidlMACK, 2007
Paul Graham. Göttingen: SteidlMACK, 2009
Paul Graham: Films. London: MACK, 2011

▸ ANDREAS GURSKY

1955 geboren/born in Leipzig
Folkwangschule Essen
Staatliche Kunstakademie Düsseldorf/Dusseldorf
Meisterschüler von/master pupil of Prof. Bernd Becher
Seit/since 2010 Professor, Staatliche Kunstakademie Düsseldorf/Dusseldorf
Lebt/lives in Düsseldorf/Dusseldorf

EINZELAUSSTELLUNGEN/SOLO EXHIBITIONS (Auswahl/selection)
1988 Galerie Johnen & Schöttle, Köln/Cologne
1992 Kunsthalle Zürich/Zurich
1994 *Fotografien 1984–1993,* Deichtorhallen Hamburg; De Appel Foundation, Amsterdam
1997 *Fotografien 1984–1998,* Kunstmuseum Wolfsburg
 Fotografien 1984 bis heute, Kunsthalle Düsseldorf/Dusseldorf
2001 The Museum of Modern Art, New York
2002 Musée national d'art moderne, Centre Pompidou, Paris

2007 Haus der Kunst, München/Munich; Istanbul Museum of Modern Art, Istanbul; Sharjah Art Museum, Sharjah, Vereinigte Arabische Emirate/United Arab Emirates; National Gallery of Victoria, Melbourne; Museum für Gegenwartskunst/Kunstmuseum Basel
2008 Museum für Moderne Kunst, Frankfurt am Main; Haus Lange und Haus Esters, Krefeld; Moderna Museet, Stockholm; Vancouver Art Gallery, Vancouver

GRUPPENAUSSTELLUNGEN/GROUP EXHIBITIONS (Auswahl/selection)
1986 *7 Fotografen,* Galerie Rüdiger Schöttle, München/Munich
1989 *The Periphery, Part I: Andreas Gursky and Thomas Struth,* P.S.1, Contemporary Art Center, New York
1990 *De Afstand,* Witte de With, center for contemporary art, Rotterdam
1994 *The Epic and the Everyday: Contemporary Photographic Art,* Hayward Gallery und/and South Bank Centre, London
1997 *Positionen künstlerischer Fotografie in Deutschland nach 1945,* Martin-Gropius-Bau, Berlin
2000 *Walker Evans & Company,* The Museum of Modern Art, New York
2003 *Cruel & Tender: The Real in the 20th Century Photograph/Fotografie und das Wirkliche,* Tate Modern, London; Museum Ludwig, Köln/Cologne
2006 *Click Doubleclick – das dokumentarische Moment/the documentary factor,* Haus der Kunst, München/Munich; Palais des Beaux-Arts, Brüssel/Brussels
2007 *Depth of Field: Modern Photography at the Metropolitan,* Metropolitan Museum of Art, New York
2008 *Vertrautes Terrain. Aktuelle Kunst in und über Deutschland,* ZKM – Zentrum für Kunst und Medientechnologie, Karlsruhe
Objectivités – La photographie à Düsseldorf, Musée d'art moderne de la Ville de Paris
2010 *Ruhrblicke/Ruhr Views,* Sanaa-Gebäude, Zeche Zollverein, Essen

BIBLIOGRAFIE/BIBLIOGRAPHY (Auswahl/selection)
Andreas Gursky. Hg. von/ed. by Bernhard Bürgi. Köln: Walther König, 1992
Andreas Gursky: Fotografien 1984–1993. Hg. von/ed. by Zdenek Felix. München: Schirmer/Mosel, 1994 (Text: Rudolf Schmitz)
Andreas Gursky: Fotografien von 1984 bis heute. Hg. von/ed. by Marie Luise Syring. München: Schirmer/Mosel, 1998 (Texte/texts: Lynne Cooke, Marie Luise Syring u. a./et al.)
Peter Galassi, *Andreas Gursky.* New York: Harry N. Abrams; Ostfildern-Ruit: Hatje Cantz, 2001
Andreas Gursky. Hg. von/ed. by Thomas Weski. Köln: Snoeck, 2007 (Texte/texts: Don DeLillo, Thomas Weski)
Andreas Gursky. Ostfildern: Hatje Cantz, 2007
Andreas Gursky: Werke/works 80–08. Hg. von/ed. by Martin Hentschel. Ostfildern: Hatje Cantz, 2008
Andreas Gursky. New York: Rizzoli, 2010 (Texte/texts: Norman Bryson, Werner Spies)

▶ JITKA HANZLOVÁ

1958 geboren/born in Náchod, Tschechische Republik/Czech Republic
Universität/Gesamthochschule Essen
2006 Gastprofessur, Hochschule für Bildende Künste, Hamburg
Lebt/lives in Essen

EINZELAUSSTELLUNGEN/SOLO EXHIBITIONS (Auswahl/selection)
1995 Galerie db-s, Antwerpen/Antwerp
1996 Frankfurter Kunstverein, Frankfurt am Main
1998 Goethe-Institut, Budapest
2000 *Fotografien,* Deichtorhallen Hamburg
2001 Stedelijk Museum, Amsterdam
Rokytník/Bewohner, Fotomuseum Winterthur
2005 *Forest,* Museum Folkwang, Essen
2007 „denn Bleiben ist nirgends", Galerie Kicken, Berlin
2008 *Forest,* KUB-Billboards, Kunsthaus Bregenz
2010 *Hier,* Galerie Kicken, Berlin

GRUPPENAUSSTELLUNGEN/GROUP EXHIBITIONS (Auswahl/selection)
1992 *Czech Photography in Exile,* Mánes, Prag/Prague
1996 Manifesta 1, Museum Chabot, Rotterdam
1999 *Stadtluft,* Hamburger Kunstverein, Hamburg
2000 *Die Welt als Ganzes. Fotografie aus Deutschland nach 1989/The World as One: Photography from Germany after 1989,* eine Ausstellung des Instituts für Auslandsbeziehungen/presented by the Institute for Foreign Relations, kuratiert von/kurated by Ulf Erdmann Ziegler
2003 Citibank Photography Prize, The Photographers' Gallery, London
2005 *Der Traum vom Ich, der Traum von der Welt,* Fotomuseum Winterthur
2006 *In the Face of History: European Photographers in the 20th Century,* Barbican Art Gallery, London
2007 *What does the jellyfish want. Fotografien von Man Ray bis James Coleman,* Museum Ludwig, Köln/Cologne
2009 *Tschechische Fotografie des 20. Jahrhunderts,* Bundeskunsthalle Bonn
2010 *Ruhrblicke/Ruhr Views,* Sanaa-Gebäude, Zeche Zollverein, Essen

BIBLIOGRAFIE/BIBLIOGRAPHY (Auswahl/selection)
Jitka Hanzlová: Bewohner. Düsseldorf: Richter, 1996
Jitka Hanzlová: Rokytník. Velbert-Neviges: Museum Schloss Hardenberg, 1997
Jitka Hanzlová: Female. München: Schirmer/Mosel, 2000
Die Welt als Ganzes. Fotografie aus Deutschland nach 1989. Ostfildern-Ruit: Hatje Cantz, 2000
Yes Yes Yes Yes. Differenz und Wiederholung in Bildern der Sammlung Olbricht. Heidelberg: Edition Braus, 2005
Jitka Hanzlová: Forest. Göttingen: Steidl, 2006
Das Porträt – Fotografie als Bühne. Nürnberg: Verlag für Moderne Kunst, 2009
Ruhrblicke/Ruhr Views. Ein Fotografieprojekt der Sparkassenfinanzgruppe. Hg. von/ed. by Heike Kramer, Thomas Weski. Köln: Verlag der Buchhandlung Walther König, 2010 (Texte/texts: Sigrid Schneider, Thomas Weski)

▶ JOCHEN LEMPERT

1958 geboren/born in Moers
Studium der Biologie/studies biology, Friedrich-Wilhelms-Universität, Bonn
Lebt/lives in Hamburg

EINZELAUSSTELLUNGEN/SOLO EXHIBITIONS (Auswahl/selection)
1992 *365 Tafeln zur Naturgeschichte*, Galerie am Schlachthof, Köln/Cologne; Bonner Kunstverein, Bonn
 Werkstatt des Demiurgen, Künstlerhaus, Hamburg
1998 *Physiognomische Versuche*, Galerie Sabine Schmidt, Köln/Cologne
2000 *Phantastische Wissenschaft*, Gabriele-Peters-Preis, Zoologisches Museum, Hamburg
2004 *Fisionomies*, ProjecteSD, Barcelona
2005 *Ko-Evolution*, Museum für Gegenwartskunst, Siegen
2006 Edwin-Scharff-Preis, Haus der Photographie, Deichtorhallen Hamburg
2008 *Jochen Lempert in der Sammlung Ann und Jürgen Wilde*, Sprengel Museum Hannover/Hanover
2009 Domaine de Kerguéhennec, Centre d'Art Contemporain, Bignan, Frankreich/France
 Field Work, Culturgest, Lissabon/Lisboa
2010 Museum Ludwig, Köln/Cologne
 Onychophora, Art 3 valence art contemporain, Valence, Frankreich/France

GRUPPENAUSSTELLUNGEN/GROUP EXHIBITIONS (Auswahl/selection)
1996 *Ars Viva 95/96. Photographie*, Anhaltische Gemäldegalerie, Dessau; Frankfurter Kunstverein, Frankfurt am Main
1997 *Wirklich. 7 Positionen zeitgenössischer Fotografie in Deutschland*, Fotomuseum im Münchner Stadtmuseum, München/Munich
1999 *New Natural History*, National Museum of Photography, Film & Television, Bradford, UK; Hasselblad Center, Göteborg/Goteborg
2001 *Transfer*, Sala Rekalde, Bilbao; Museum Abteiberg, Möchengladbach; Zeche Zollverein, Essen
2002 *Das Tier in mir. Die Mensch-Tier-Verwandtschaft in der zeitgenössischen Kunst*, Staatliche Kunsthalle Baden-Baden
2003 *Zeitgenössische deutsche Fotografie. Stipendiaten der Alfried Krupp von Bohlen und Halbach-Stiftung, 1982–2002*, Museum Folkwang, Essen
2005 *Das Tier – nützlich, süß und museal – Tiere sehen uns an*, Museum Folkwang, Essen
2007 *Forschen und Erfinden. Die Recherche mit Bildern in der zeitgenössischen Fotografie/Research and Invention: Investigations with Images in Contemporary Photography*, Fotomuseum Winterthur
2010 *Front Room*, Contemporary Art Museum, St. Louis, MO
 From the nature, Graphische Sammlung der ETH, Zürich/Zurich
 Milk Drop Coronet. 30 Ausstellungen zur Virtuosität des Dinglichen/30 Exhibitions on the Virtuosity of Thingness, Camera Austria, Kunsthaus Graz
2011 *Eins Plus Eins*, M1, Arthur Boskamp Stiftung, Hohenlockstedt

BIBLIOGRAFIE/BIBLIOGRAPHY (Auswahl/selection)
Jochen Lempert: 365 Tafeln zur Naturgeschichte. Bonn: Bonner Kunstverein; Freiburg: Kunstverein Freiburg, 1997 (Texte/texts: Stephan Berg, Annelie Pohlen)
Jochen Lempert: Ko-evolution. Köln: Verlag der Buchhandlung Walther König, 2006 (Texte/texts: Eva Schmidt, Ulf Erdmann Ziegler)
Jochen Lempert: 6CO2+12H2O=C6H12O6+6H2O+6O2. Köln: Korridor-Verlag, 2007
Jochen Lempert: Recent Field Work. Köln: Verlag der Buchhandlung Walther König, 2009
Jochen Lempert: Drift. Köln: Verlag der Buchhandlung Walther König, 2010
Jochen Lempert: 4 frogs. Valence: Editions P., Co-édition avec art3, 2010

▶ BORIS MIKHAILOV

1938 geboren/born in Charkow/Kharkov, Ukraine
Studium der Ingenieurswissenschaften/studies engineering sciences
Lebt/lives in Kharkov und/and in Berlin

EINZELAUSSTELLUNGEN/SOLO EXHIBITIONS (Auswahl/selection)
1986 *Another Russia,* The Museum of Modern Art, Oxford
1990 Museum of Contemporary Art, Tel Aviv
 The Missing Picture, List Visual Arts Center, MIT, Cambridge, MA
1991 The Hasselblad Center, Göteborg/Goteborg
1992 *Werke von 1970–1991,* Forum Stadtpark, Graz
1993 *I am not I,* Photo-Postscriptum Gallery, St. Petersburg
1994 *Salt Lake*, Galerie in der Brotfabrik, Berlin
1995 *After the Fall,* The Institute of Contemporary Art, Philadelphia, PA; Portikus, Frankfurt am Main
 If I were a German ..., Galerie in der Brotfabrik und/and Galerie Andreas Weiss, Berlin
1996 Kunsthalle Zürich/Zurich
 A Retrospective, Soros Center of Contemporary Art, Kiew/Kiev
1997 *Photomania,* daadgalerie, Berlin
 Crimean Grafomania, Galerie in der Brotfabrik, Berlin
1998 *Boris Michailov. Les Misérables,* Sprengel Museum Hannover/Hanover
2000 *2000 Hasselblad Award Winner*, Hasselblad Center, Göteborg/Goteborg
2003 *Private Freuden, lastende Langeweile, öffentlicher Zerfall – eine Retrospektive*, Fotomuseum Winterthur
2005 *Look at me I look at Water*, Centre de la Photographie, Genf/Geneva; Sprengel Museum Hannover/Hanover
2011 *Case History*, The Museum of Modern Art, New York
 Black Archive 1968–1979, Tea Coffee Cappuccino 2000–2010, Galerie Barbara Weiss, Berlin

GRUPPENAUSSTELLUNGEN/GROUP EXHIBITIONS (Auswahl/selection)
1989 *Ny Sovjetisk Fotografi*, Museet for Fotokunst, Odense
1993 *New Photography 9*, The Museum of Modern Art, New York
1999 *After the Wall. Kunst und Kultur im postkommunistischen Europa*, Moderna Museet, Stockholm; Ludwig Museum, Budapest
2000 *How you look at it. Fotografien des 20. Jahrhunderts*, Sprengel Museum Hannover/Hanover; Städelsches Kunstinstitut – Das Städel, Frankfurt am Main
2003 *Cruel & Tender: The Real in the 20th Century Photograph/Fotografie und das Wirkliche*, Tate Modern, London; Museum Ludwig, Köln/Cologne
2004 *Soziale Kreaturen. Wie Körper Kunst wird,* Sprengel Museum Hannover/Hanover
2007 52. Biennale di Venezia, Ukrainischer Pavillon/Ukrainian Pavilion, Venedig/Venice
2010 *Sexuality and transcendence*, Pinchu<ArtCentre, Kiew/Kiev
2011 *Ostalgia*, New Museum, New York

BIBLIOGRAFIE/BIBLIOGRAPHY (Auswahl/selection)
Another Russia. Oxford: The Museum of Modern Art, 1986 (Texte/texts: Daniela Mrázková, Vladimir Remes)
Boris Michailov. Hg. von/ed. by Brigitte Kölle. Stuttgart: Oktagon, 1995
Boris Michailov, Sergej Solonskij, Sergej Bratkov: Wenn ich ein Deutscher wäre. Dresden/Basel: Verlag der Kunst, 1995
Boris Michailov: Am Boden. Hg. von/ed. by Brigitte Kölle. Köln: Verlag der Buchhandlung Walther König, 1996
Boris Michailov: Die Dämmerung. Hg. von/ed. by Brigitte Kölle. Köln: Verlag der Buchhand ung Walther König, 1996
Boris Mikhailov: Unvollendete Dissertation. Berlin/New York/Zürich: Scalo, 1998 (Text: Margarita Tupitsyn)
Boris Michailov: Les Misérables. Hannover: Sprengel Museum Hannover, 1998 (Text: Victor Tupitsyn)
Boris Mikhailov: Case History. Berlin/New York/Zürich: Scalo, 1999
Boris Mikhailov: Private Freuden, lastende Langeweile, öffentlicher Zerfall – eine Retrospektive. Hg. von/ed. by Urs Stahel. Berlin/New York/Zürich: Scalo, 2003
Boris Mikhailov: Look at me I look at Water. Göttingen: Steidl, 2004
Boris Mikhailov: Suzi et cetera. Köln: Verlag der Buchhandlung Walther König, 2006
Boris Mikhailov: Yesterday's Sandwich. London: Phaidon, 2009
Boris Mikhailov: Maquette Braunschweig. Göttingen: Steidl, 2011 (Text: Inka Schube)
Boris Mikhailov: Tea Coffee Cappuccino. Köln: Verlag der Buchhandlung Walther König, 2011

▶ELISABETH NEUDÖRFL

1968 geboren/born in Darmstadt
Ausbildung zur Fotografin/apprenticeship in photography Fachhochschule Dortmund
Hochschule für Grafik und Buchkunst, Leipzig
Meisterschülerin von/master pupil of Prof. Joachim Brohm
Seit/since 2009 Professorin, Folkwang Universität der Künste, Essen
Lebt/lives in Berlin und/and Essen

EINZELAUSSTELLUNGEN/SOLO EXHIBITIONS (Auswahl/selection)
1990 Hochschule für Grafik und Buchkunst, Leipzig
1995 *venceremos*, Galerie in der Brotfabrik, Berlin
1998 *der Stadt*, Galerie in der Brotfabrik, Berlin
2002 *Future World*, Sprengel Museum Hannover/Hanover
2009 *von der Straße*, Galerie Barbara Wien, Berlin
2010 *Habitat*, Galerie Barbara Wien/Wilma Lukatsch, Berlin

GRUPPENAUSSTELLUNGEN/GROUP EXHIBITIONS (Auswahl/selection)
1993 *Focus 93 – Haltbar*, Museum für Kunst- und Kulturgeschichte, Dortmund
1994 *Schäfchen. Die Ordnung der Bilder*, Panzerhallen der Fachhochschule Potsdam
1998 *Berlin. Stadt im Wandel*, Neuer Berliner Kunstverein, Berlin
2000 *Here and Now: Positions, Attitudes, Actions*, Foto Biennale Rotterdam
2001 *New Ideas – Old Tricks*, Hartware Projekte, Dortmund
2003 *Leben und Arbeiten in der Bienenwabe*, Galerie am Prater, Berlin
2005 *Expanded Media. Medien im Raum*, Württembergischer Kunstverein, Stuttgart
 Pingyao International Photography Festival, Pingyao, China
 Seven Floors, Niedersächsisches Ministerium für Wissenschaft und Kultur, Hannover/Hanover
2006 *Asia City Strangers*, Galerie Fotohof, Salzburg
2007 *Wege zur Selbstverständlichkeit. Aus der Sammlung des Fotomuseum Winterthur*, Fotomuseum Winterthur
 Hyper Cities. Über Städte, Museum für Asiatische Kunst, Berlin
2010 *Ruhrblicke/Ruhr Views*, Sanaa-Gebäude, Zeche Zollverein, Essen
2011 *Leipzig. Fotografie seit 1839*, Museum der bildenden Künste, Leipzig

BIBLIOGRAFIE/BIBLIOGRAPHY (Auswahl/selection)
Camera Austria, 51/52, 1995
Berlin. Stadt im Wandel, Berliner Festspiele 99/01–Das Neue Berlin. Berlin 1998
Bettina Lockemann, Elisabeth Neudörfl: Plan. Leipzig: Institut für Buchkunst an der Hochschule für Grafik und Buchkunst, 1999
Elisabeth Neudörfl: Future World. Hannover: Sprengel Museum Hannover, 2002
Elisabeth Neudörfl: Super Pussy Bangkok. Leipzig: Institut für Buchkunst an der Hochschule für Grafik und Buchkunst, 2006
Asia City Strangers. Salzburg: Fotohof (Edition Fotohof 73), 2006
Wege zur Selbstverständlichkeit. Aus der Sammlung des Fotomuseum Winterthur. Winterthur: Fotomuseum Winterthur, 2007
Elisabeth Neudörfl: E.D.S.A.: Epifanio Delos Santos Avenue. Berlin: Wiens Verlag, 2010
Ruhrblicke/Ruhr Views. Ein Fotografieprojekt der Sparkassenfinanzgruppe. Hg. von/ed. by Heike Kramer, Thomas Weski. Köln: Verlag der Buchhandlung
 Walther König, 2010 (Texte/texts: Sigrid Schneider, Thomas Weski)

‣NICHOLAS NIXON

1947 geboren/born in Detroit, MI
Master of Fine Arts, University of New Mexico, Albuquerque, NM
Seit/since 1975 Professor, Massachusetts College of Art, Boston, MA

EINZELAUSSTELLUNGEN/SOLO EXHIBITIONS (Auswahl/selection)
1976 The Museum of Modern Art, New York
1980 Fraenkel Gallery, San Francisco, CA
1983 *Photographs from One Year*, Friends of Photography, Carmel, CA
1985 Art Institute of Chicago, IL
1988 The Museum of Modern Art, New York
1989 *Pictures of People*, San Francisco Museum of Modern Art, San Francisco, CA
1990 Saint Louis Museum of Art, St. Louis, MO
1991 San Diego Art Museum, San Diego, CA
1994 *Familienbilder*, Sprengel Museum Hannover/Hanover
1995 *Nicholas Nixon: Pictures of People*, Musée d'art moderne de la Ville de Paris
2001 *Human Experience: Photographs by Nicholas Nixon*, Cincinnati Art Museum, Cincinnati, OH
2003 Musrara Museum, Jerusalem
2005 *The Brown Sisters*, National Gallery of Art, Washington D.C.
2007 *30 Years of Photography*, Saint Louis Art Museum, St. Louis, MO
 The Naked Portrait, Scottish National Portrait Gallery, Edinburgh
2009 *City & Self*, Fraenkel Gallery, San Francisco, CA
 Old Home, New Pictures, Pace/MacGill Gallery, New York
2010 *Family Album*, Museum of Fine Arts, Boston, MA

GRUPPENAUSSTELLUNGEN/GROUP EXHIBITIONS (Auswahl/selection)
1975 *New Topographics: Photographs of a Man-Altered Landscape,* George Eastman House, Rochester, NY
1977 *Court House*, The Museum of Modern Art, New York
1978 *Mirrors and Windows*, The Museum of Modern Art, New York
1979 *American Images*, Corcoran Gallery of Art, Washington D.C.
1990 *Photography Until Now*, The Museum of Modern Art, New York
1992 *Pleasures and Terrors of Domestic Comfort*, The Museum of Modern Art, New York
 Eadweard Muybridge and Contemporary American Photography, The Addison Gallery of American Art, Andover, MA
1995 *Visions of Childhood*, Bard College, Annandale-on-Hudson, NY
2000 *How you look at it. Fotografien des 20. Jahrhunderts*, Sprengel Museum Hannover/Hanover; Städelsches Kunstinstitut – Das Städel, Frankfurt am Main
2003 *Family Ties*, Peabody Essex Museum Salem, MA
 Cruel & Tender: The Real in the 20th Century Photograph/Fotografie und das Wirkliche, Tate Modern, London; Museum Ludwig, Köln/Cologne
2009 *New Topographics: Photographs of a Man-Altered Landscape*, George Eastman House, Rochester, NY; Los Angeles County Museum of Art, Los Angeles, CA; Center for Creative Photography, Tucson, AZ; San Francisco Museum of Modern Art, San Francisco, CA; Photographische Sammlung Stiftung Kultur, Köln/Cologne; Nederlands Fotomuseum, Rotterdam; Bilbao Fine Arts Museum, Bilbao

BIBLIOGRAFIE/BIBLIOGRAPHY (Auswahl/selection)
Nicholas Nixon: Photographs from One Year. Carmel, CA: Friends of Photography, 1983 (Text: Robert Adams)
Nicholas Nixon: Pictures of People. New York: The Museum of Modern Art, 1988 (Text: Peter Galassi)
Nicholas Nixon: Family Pictures: Photographs by Nicholas Nixon. Washington D.C.: Smithsonian, 1991
Nicholas Nixon: People With AIDS. Boston: David R. Godine, 1991 (Vorwort/Foreword: Bebe und/and Nicholas Nixon; Text: Bebe Nixon)
Nicholas Nixon: Familienbilder. Hannover: Sprengel Museum Hannover, 1994 (Vorwort/Foreword: Ulrich Krempel; Text: Thomas Weski)
Nicholas Nixon: School Photographs from Three Schools by Nicholas Nixon. New York: Bulfinch/Little, Brown, 1989 (Text: Robert Coles)
Nicholas Nixon: The Brown Sisters. New York: The Museum of Modern Art, 1999 (Texte/texts: Peter Galassi, Nicholas Nixon)
Nicholas Nixon. Madrid: TF Editores, 2003
Nicholas Nixon: At Home. Ottsville, PA: Lodima, 2004
Nicholas Nixon: The Brown Sisters: Thirty-three Years. New York: The Museum of Modern Art, 2007 (Text: Peter Galassi)
Nicholas Nixon: Live Love Look Last. Göttingen: Steidl 2009

‣RITA OSTROWSKAJA/OSTROVSKAYA

1953 geboren/born in Kiew/Kiev
Kinotechnologie- und Bildjournalismusstudium/studies cinema technology and photojournalism, Kiew/Kiev,
2001 Umzug nach Deutschland/moves to Germany
Studium Visuelle Kommunikation/studies visual communication, Kunsthochschule Kassel
Lebt/lives in Kassel

EINZELAUSSTELLUNGEN/SOLO EXHIBITIONS (Auswahl/selection)
1987 *Portraits,* Galerie der Universität Leipzig 1992
 Schargorod, Université de Nancy
1995 *Mein Zuhause, Aktporträts, Lebensatem,* Galerie in der Brotfabrik, Berlin

1996 *Juden in der Ukraine,* Galerie im NRZ-Forum, Essen
 Juden in der Ukraine, 1989–1995. Schtetls, Fotogalerie Kulturamt Friedrichshain, Berlin
1998 *Lebensatem. Fünf Projekte,* Museet for Fotokunst, Odense
 Juden in der Ukraine, 1989–1995. Schtetls, Haus des Künstlers, Kiew/Kiev
2000 *Erosionen,* Zürcher Lehrhaus, Zürich/Zurich
2005 *Anwesenheit,* Hessiale 2005, Kulturbahnhof Kassel

GRUPPENAUSSTELLUNGEN/GROUP EXHIBITIONS (Auswahl/selection)
1989 *150 Jahre Fotografie*, Manege, Moskau/Moscow
1991 *Moderne russische Fotografie,* Roy Boyd Galerie, Chicago, IL
1993 1. Internationales Fotofestival, Moskau/Moscow („Fotografin des Jahres"/"photographer of the year")
1998 *Prospekt der peripheren Vision,* Soros Zentrum, Galerie für moderne Kunst, Kiew/Kiev
2004 *Fotografie, Radierung, Zeichnung,* Galerie AAA, Kassel
2007 *One Shot Each,* Brandts Museet for Fotokunst, Odense
2009 *Ukrainische Fotografie/Ukrainian Photography 1989–2009,* Mesiac Fotografie/Month of Photography, Výstavná sieň Klarisky, Bratislava

BIBLIOGRAFIE/BIBLIOGRAPHY (Auswahl/selection)
Rita Ostrowskaja: Juden in der Ukraine 1989–1994. Städtl. Ostfildern-Ruit: Cantz 1996 (Text: Wladimir Oks)

▸HELGA PARIS

1938 geboren/born in Gollnow (heute/now Goleniów, Polen/Poland)
Ingenieursschule für Bekleidung/School of Engineering for the Clothing Industry, Berlin
Lebt/lives in Berlin

EINZELAUSSTELLUNGEN/SOLO EXHIBITIONS (Auswahl/selection)
1982 *In Siebenbürgen. Fotografien 1982,* Galerie Sophienstraße 8, Berlin
1986 Fotogalerie des Künstlerverbandes der Litauischen SSR, Kaunas
 Gesichter. Frauen in der DDR, Literaturhaus Fasanenstraße, Berlin/West
1989 *New York,* Burg-Galerie, Halle/Saale
1990 *Häuser und Gesichter. Halle 1983–85. Fotografien von Helga Paris,* Galerie Marktschlösschen, Halle/Saale
1997 *Fotografien von 1993 bis 1997,* Fotogalerie Kulturamt Friedrichshain, Berlin
2000 *Fotografien 1983 und 1993,* Galerie Haus 23, Cottbus
2004 *Fotografien,* Sprengel Museum Hannover/Hanover
 Hannah-Höch-Preis 2004, Berlinische Galerie – Landesmuseum für Moderne Kunst, Fotografie und Architektur, Berlin

GRUPPENAUSSTELLUNGEN/GROUP EXHIBITIONS (Auswahl/selection)
1985 *DDR-Künstlerinnen. Malerei, Graphik, Plastik,* Galerie unterm Turm, Stuttgart
1989 *Ansichten. 25 Fotografen im Marstall*, Berlin
1990 *DDR-Frauen fotografieren,* Galerie Haus am Lützowplatz, Berlin
 La Photographie de l'Est, Musée de l'Elysée, Lausanne
 L'autre Allemagne hors les murs, Grande Halle de la Villette, Paris
1997 *Bohème und Diktatur in der DDR. Gruppen, Konflikte, Quartiere. 1970–1989,* Deutsches Historisches Museum, Berlin
1999 *Peripherie als Ort. Das Hellersdorf-Projekt*, Neue Gesellschaft für Bildende Kunst und HO-Galerie, Berlin
2003 *Kunst in der DDR. Eine Retrospektive der Nationalgalerie,* Neue Nationalgalerie, Berlin
 Berlin – Moskau, Moskau – Berlin 1950–2000, Martin-Gropius-Bau, Berlin
2005 *ostPUNK! – too much future,* Künstlerhaus Bethanien, Berlin
2009 *Art of Two Germanys/Cold War Cultures,* Los Angeles County Museum of Art, Los Angeles, CA
 Gender Check. Rollenbilder in der Kunst Osteuropas, MUMOK, Museum Moderner Kunst Stiftung Ludwig Wien/Vienna
 Kunst und Kalter Krieg. Deutsche Positionen 1945–1989, Deutsches Historisches Museum, Berlin
 Kunst und Revolte '89. Übergangsgesellschaft, Akademie der Künste, Berlin
 As Time Goes By. Kunstwerke über Zeit, Berlinische Galerie – Landesmuseum für Moderne Kunst, Fotografie und Architektur, Berlin
2011 *Ostalgia,* New Museum, New York

BIBLIOGRAFIE/BIBLIOGRAPHY (Auswahl/selection)
Helga Paris: In Siebenbürgen. Fotografien. Hg. von/ed. by Stefan Orendt. Berlin: Galerie Sophienstraße, 1982 (Text: Elke Erb)
Fotografien. Helga Paris. Hg. von/ed. by Heidrun Dauert. Berlin: Fotogalerie am Helsingforser Platz, 1988 (Text: Gabriele Muschter)
Helga Paris: Diva in Grau. Häuser und Gesichter in Halle. Hg. von/ed. by Jörg Kowalski, Dagmar Winklhofer. Halle/Saale: Mitteldeutscher Verlag, 1991
 (Texte/texts: Wilhelm Bartsch, Heinz Czechowski, Elke Erb u. a./et al.)
Nichts ist so einfach wie es scheint. Ostdeutsche Photographie 1945–1989. Hg. von/ed. by Ulrich Domröse, Andreas Krase. Berlin: Berlinische Galerie – Museum
 für Moderne Kunst, Fotografie und Architektur, 1992 (Texte/texts: Ulrich Domröse, Andreas Krase)
Erzählen. Eine Anthologie von Michael Glasmeier. Berlin: Akademie der Künste; Ostfildern: Cantz, 1994
Peripherie als Ort. Das Hellersdorf-Projekt. Hg. von/ed. by Ulrich Domröse, Jack Gelfort. Stuttgart: Arnoldsche Verlagsanstalt, 1999 (Texte/texts: Ulrich
 Domröse, Alexander Osang)
Foto-Anschlag. Vier Generationen ostdeutscher Fotografen. Hg. von/ed. by Zeitgeschichtliches Forum Leipzig, Stiftung Haus der Geschichte der Bundesrepublik
 Deutschland. Leipzig: Seemann, 2001
Helga Paris. Fotografien. Berlin: Holzwarth Publications, 2004 (Texte/texts: Helmut Brade, Jean-François Chevier, Elke Erb, Helga Paris, Inka Schube)

▶ MARTIN PARR

1952 geboren/born in Epsom, UK
Manchester Polytechnic, Manchester
Lebt/lives in Bristol

EINZELAUSSTELLUNGEN/SOLO EXHIBITIONS (Auswahl/selection)
1974 *Home Sweet Home,* Impressions Gallery, York
1977 Photographers' Gallery, London
1986 Rencontres Internationales de la Photographie, Arles
1987 *Spending Time,* Centre National de la Photographie, Paris
1989 *The Cost of Living,* Royal Photographic Society, Bath
1992 *Signs of the Times*, Janet Borden Gallery, New York
1993 *Home and Abroad,* Watershed Gallery, Bristol
1995 *Small World,* Photographers' Gallery, London
1999 *Common Sense,* Amsterdam Centrum voor Fotografie, Amsterdam
2002 *Retrospective,* Barbican Art Gallery, London; National Museum of Photography, Film and Television, Bradford, UK
2008 *Parrworld,* Haus der Kunst, München/Munich; Jeu de Paume, Paris; Baltic, Gateshead
2011 Bogotá Photography Festival, *Luxury,* Bogotá

GRUPPENAUSSTELLUNGEN/GROUP EXHIBITIONS (Auswahl/selection)
1972 *Real Britain: 10 from Co-optic,* Jordan Gallery, London
1978 *Art for Society,* Whitechapel Art Gallery, London
1989 *Through the Looking Glass: British Photography 1945-1989,* Barbican Art Gallery, London
1990 *The Past and Present of Photography,* Museum of Modern Art, Tokio/Tokyo
1991 *British Photography from the Thatcher Years*, The Museum of Modern Art, New York
1993 *Photographs from the Real World,* Lillehammer Art Museum, Lillehammer
1999 *Our Turning World: Magnum Photographers 1989-1999,* Barbican Art Gallery, London
2000 *At Sea,* Tate Liverpool
2003 *Cruel & Tender: The Real in the 20th Century Photograph/Fotografie und das Wirkliche,* Tate Modern, London; Museum Ludwig, Köln/Cologne
2006 *Click Doubleclick – das dokumentarische Moment/the documentary factor,* Haus der Kunst, München/Munich; Palais des Beaux-Arts, Brüssel/Brussels
2008 *Street & Studio,* Tate Modern, London

BIBLIOGRAFIE/BIBLIOGRAPHY (Auswahl/selection)
Martin Parr: Home Sweet Home. York: Impressions Gallery, 1974
Martin Parr: Bad Weather. London: Zwemmers, 1982
Martin Parr: A Fair Day. Bristol: Promenade Press, 1984
Martin Parr: The Cost of Living. Manchester: Cornerhouse, 1989
Martin Parr: Home and Abroad. London: Jonathan Cape, 1993
Martin Parr: Small World: A Global Photographic Project, 1987–94. Stockport: Dewi Lewis, 1995
Martin Parr: Common Sense. Stockport: Dewi Lewis, 1999
Martin Parr: Autoportrait. Stockport: Dewi Lewis, 2000
Martin Parr. Hg. von/ed. by Val Williams. London: Phaidon Press, 2000
Martin Parr: The Phone Book. London: Rocket Gallery, 2002
Martin Parr: Parrworld: Postcards & Objects. London: Boot, 2008 (Texte/texts: Martin Parr, Thomas Weski)

▶ THOMAS RUFF

1958 geboren/born in Zell am Harmersbach
Staatliche Kunstakademie Düsseldorf/Dusseldorf
Meisterschüler von/master pupil of Prof. Bernd Becher
Lebt/lives in Düsseldorf/Dusseldorf

EINZELAUSSTELLUNGEN/SOLO EXHIBITIONS (Auswahl/selection)
1981 Galerie Rüdiger Schöttle, München/Munich
1988 Museum Schloss Hardenberg, Velbert; Portikus, Frankfurt am Main
1995 46. Biennale di Venezia, Deutscher Pavillon/German Pavilion, Venedig/Venice (mit/with Katharina Fritsch)
2000 Museum Haus Lange und Haus Esters, Krefeld
2001 *Fotografien 1979 – heute,* Kunsthalle Baden-Baden
2003 Kestner-Gesellschaft, Hannover/Hanover
2007 *Das Sprengel Projekt,* Sprengel Museum Hannover/Hanover
 jpegs, Moderna Museet, Stockholm
2009 Museum für Neue Kunst, Freiburg
 Oberflächen, Tiefen, Kunsthalle Wien/Vienna
2011 *Stellar Landscapes,* LWL – Landesmuseum für Kunst und Kulturgeschichte Münster
 MCA DNA: Thomas Ruff, Museum of Contemporary Art, Chicago, IL
 ma.r.s., Galerie Mai 36, Zürich/Zurich

GRUPPENAUSSTELLUNGEN/GROUP EXHIBITIONS (Auswahl/selection)
1986 *Reste des Authentischen,* Museum Folkwang, Essen
1991 *Metropolis,* Martin-Gropius-Bau, Berlin
 Aus der Distanz, Kunstsammlung Nordrhein-Westfalen, Düsseldorf/Dusseldorf
1992 Documenta 9, Kassel
 Photography in Contemporary German Art: 1960 to the Present, Walker Art Center, Minneapolis, MN

1998 *Wounds: Between Democracy and Redemption in Contemporary Art*, Moderna Museet, Stockholm
2000 *How you look at it. Fotografien des 20. Jahrhunderts*, Sprengel Museum Hannover/Hanover; Städelsches Kunstinstitut – Das Städel, Frankfurt am Main
2001 *Mies in Berlin*, The Museum of Modern Art, New York
2005 51. Biennale di Venezia, *L'Esperienza dell'Arte*, Venedig/Venice
Rückkehr ins All, Hamburger Kunsthalle, Hamburg
2006 *Click Doubleclick – das dokumentarische Moment/the documentary factor,* Haus der Kunst, München/Munich; Palais des Beaux-Arts, Brüssel/Brussels
2007 *What does the jellyfish want?,* Museum Ludwig, Köln/Cologne
2008 *Objectivités. La Photographie à Düsseldorf,* Musée d'art moderne de la Ville de Paris

BIBLIOGRAFIE/BIBLIOGRAPHY (Auswahl/selection)
Thomas Ruff: Porträts. Köln: Verlag der Buchhandlung Walther König, 1988 (Text: Julian Heynen)
Boris von Brauchitsch, *Thomas Ruff.* Frankfurt am Main: Schriften zur Sammlung des Museums für Moderne Kunst, 1992
Thomas Ruff. Paris: Centre National de la Photographie, 1997 (Text und/and Interview: Régis Durand)
Thomas Ruff: Fotografien 1979–heute. Köln: Verlag der Buchhandlung Walther König, 2001 (Texte/texts: Per Boym, Ute Eskildsen, Valeria Liebermann, Matthias Winzen)
Thomas Ruff: Photography 1979 to the Present. Köln: Verlag der Buchhandlung Walther König, 2003
Thomas Ruff: Nudes. München: Schirmer/Mosel, 2003 (mit einer Kurzgeschichte/with a short story von/by Michel Houellebecq)
Thomas Ruff: Maschinen/Machines. Ostfildern-Ruit: Hatje Cantz, 2004 (Texte/texts: Caroline Flosdorff, Veit Görner)
Thomas Ruff: Surfaces, Oberflächen, Tiefen. Nürnberg: Verlag für Moderne Kunst, 2009 (Text: Gerald Matt)

▸MICHAEL SCHMIDT

1945 geboren/born in Berlin
Lebt/lives in Berlin und/and Schnackenburg a. d. Elbe

EINZELAUSSTELLUNGEN/SOLO EXHIBITIONS (Auswahl/selection)
1973 *Ausländische Mitbürger*, Rathaus Kreuzberg, Berlin
Kreuzberger Motive, Berlin Museum, Berlin
1975 Galerie Springer, Berlin
1981 *Stadtlandschaften*, Museum Folkwang, Essen
1983 *Berlin Kreuzberg. Stadtbilder*, POLLstudio SO 36, Berlin
1987 *Bilder 1979–1986*, Spectrum Photogalerie, Sprengel Museum Hannover/Hanover
Waffenruhe, Berlinische Galerie im Martin-Gropius-Bau, Berlin; The Museum of Modern Art, New York; Museum Folkwang, Essen
1995 *Fotografien seit 1965*, Museum Folkwang, Essen; Gallery of Photography, Dublin; Berlinische Galerie im Martin-Gropius-Bau, Berlin; The Photographer's Gallery, London
1996 *EIN-HEIT/U-NI-TY*, The Museum of Modern Art, New York; Sprengel Museum Hannover/Hanover; Staatliche Kunstsammlungen Dresden
1998 *Landschaft – Waffenruhe – Selbst – Menschenbilder (Ausschnitte)*, Westfälischer Kunstverein, Münster
2000 *Frauen – EIN-HEIT – Menschenbilder*, Kunstverein in der Kunsthalle Düsseldorf/Düsseldorf
2005 *Irgendwo*, Kunstverein Heilbronn; Oldenburger Kunstverein, Oldenburg; Arp Museum, Rolandseck, Remagen; Lindenau-Museum, Altenburg
2009 *Fotografien*, Galerie Nordenhake, Berlin
2010 *Grau als Farbe. Fotografien bis 2009*, Haus der Kunst, München/Munich

GRUPPENAUSSTELLUNGEN/GROUP EXHIBITIONS (Auswahl/selection)
1977 *Michael Schmidt und Schüler*, Werkstatt für Photographie, Berlin
1979 *In Deutschland*, Rheinisches Landesmuseum, Bonn
1980 *Absage an das Einzelbild. Erfahrungen mit Bildfolgen in der Fotografie der 70er Jahre*, Museum Folkwang, Essen
1984 *Photography from Berlin*, Castelli-Graphics, New York
1986 *Reste des Authentischen*, Museum Folkwang, Essen
1989 *Photography Now*, The Victoria and Albert Museum, London
1990 *Photography Until Now*, The Museum of Modern Art, New York
1997 *Positionen künstlerischer Photographie in Deutschland seit 1945*, Martin-Gropius-Bau, Berlin
2000 *Walker Evans & Company*, The Museum of Modern Art, New York
How you look at it. Fotografien des 20. Jahrhunderts, Sprengel Museum Hannover/Hanover; Städelsches Kunstinstitut – Das Städel, Frankfurt am Main
2003 *Cruel & Tender: Photography and the Real in the 20th Century Photograph/Fotografie und das Wirkliche*, Tate Modern, London; Museum Ludwig, Köln/Cologne
2005 *Zwischen Wirklichkeit und Bild. Positionen deutscher Fotografie der Gegenwart*, The National Museum of Modern Art, Tokio/Tokyo; The National Museum of Modern Art, Kyoto; Marugame Genichiro Inokuma Museum of Contemporary Art, Shikoku
2006 4. Berlin Biennale, Berlin
2010 6. Berlin Biennale, Berlin
2011 *Ostalgia*, New Museum, New York

BIBLIOGRAFIE/BIBLIOGRAPHY (Auswahl/selection)
Michael Schmidt: Berlin. Stadtlandschaft und Menschen. Berlin: Stapp, 1978 (Text: Heinz Ohff)
Michael Schmidt: Waffenruhe. In Zusammenarbeit mit/in collaboration with Einar Schleef. Berlin: Dirk Nishen, 1987 (Texte/texts: Janos Frecot, Einar Schleef)
Michael Schmidt: Fotografien seit 1965. Essen: Museum Folkwang, 1995 (Text: Ute Eskildsen)
Michael Schmidt: EIN-HEIT/U-NI-TY. Hg. von/ed. by Thomas Weski. Berlin/New York/Zürich: Scalo, 1996
Michael Schmidt: Landschaft, Waffenruhe, Selbst, Menschenbilder (Ausschnitte). Hg. von/ed. by Heinz Liesbrock. Münster: Westfälischer Kunstverein; München: Kunstbunker Tumulka, 1998 (Texte/texts: Heinz Liesbrock, Susanne Meyer-Büser)
Michael Schmidt: Frauen. Hg. von/ed. by Heinz Liesbrock, Thomas Weski. Köln: Verlag der Buchhandlung Walther König, 2000
Michael Schmidt: Ihme-Zentrum 1997/98. 4 Fotografien/8 Ausschnitte. Hg. von/ed. by Karsten Heller, Thomas Scheibitz. Berlin: Diamondpaper #02, 2003
Michael Schmidt: Irgendwo. Köln: Snoeck, 2005 (Interview: Dietmar Elger mit/with Michael Schmidt)
Michael Schmidt: Berlin nach 1945. Hg. von/ed. by Ute Eskildsen. Göttingen: Steidl, 2005 (Text: Janos Frecot)
Michael Schmidt: 89/90. Hg. von/ed. by Thomas Weski. Köln: Snoeck, 2010 (Text: Chris Dercon)

▶ HEIDI SPECKER

1962 geboren/born in Damme
Fachhochschule Bielefeld
Hochschule für Grafik und Buchkunst, Leipzig
Meisterschülerin/master pupil von/of Prof. Joachim Brohm
Seit/since 2010 Professorin, Hochschule für Grafik und Buchkunst, Leipzig
Lebt/lives in Berlin

EINZELAUSSTELLUNGEN/SOLO EXHIBITIONS (Auswahl/selection)
1995 *Speckergruppen,* Kunstverein Elsterpark, Leipzig
1998 *Teilchentheorie,* Künstlerhaus Stuttgart
2002 *Tribute,* ehemalige Staatsbank, Berlin
2004 *Concrete,* Galerie in der Brotfabrik, Berlin
2005 *Im Garten/Bangkok,* Sprengel Museum Hannover/Hanover
2008 *Landhaus Lemke – Mies van der Rohe,* Mies van der Rohe Haus, Berlin
2010 Galerie Sassa Trülzsch, Berlin

GRUPPENAUSSTELLUNGEN/GROUP EXHIBITIONS (Auswahl/selection)
1994 *Fotografinnen der Gegenwart,* Museum Folkwang, Essen
2001 *Circles 5 Montana Sacra,* ZKM – Zentrum für Kunst und Medientechnologie, Karlsruhe
2002 *In Szene gesetzt,* Museum für Neue Kunst, Karlsruhe
2005 *Berlinskaja Lazur,* Haus der Fotografie, Moskau/Moscow
 Arbeit an der Wirklichkeit. German Contemporary Photography, The National Museum of Modern Art, Tokio/Tokyo; The National Museum of Modern Art, Kyoto; Marugame Genichiro-Inokuma Museum of Contemporary Art, Marugame
2006 *Click Doubleclick – das dokumentarische Moment/the documentary factor,* Haus der Kunst, München/Munich; Palais des Beaux-Arts, Brüssel/Brussels
 artconneXions, ifa-Galerie Berlin
 Spectacular City: Photographing the Future, NAI, Rotterdam
2007 *NEUERWERBUNGEN der Berlinischen Galerie,* Berlinische Galerie – Landesmuseum für Moderne Kunst, Fotografie und Architektur, Berlin
2009 *Strange Places: Urban Landscape Photography,* Stanley Picker Gallery at Kingston University, Kingston upon Thames
2011 *Things are Queer. Highlights der Sammlung UniCredit,* MARTa Herford
 Leipzig. Fotografie seit 1839, Museum der bildenden Künste Leipzig

BIBLIOGRAFIE/BIBLIOGRAPHY (Auswahl/selection)
Heidi Specker: RGB manual. Berlin: Selbstverlag, 1993
Wenn Berlin Biarritz wäre ... Architektur in Bildern der fotografischen Sammlung im Museum Folkwang, Essen. Göttingen: Steidl, 2001
Yet Untitled. Hg. von/ed. by Susanne Pfleger, Thomas Seelig. Ostfildern-Ruit: Hatje Cantz, 2003
Heidi Specker: ABC C. Berlin: Selbstverlag, 2003
Heidi Specker: Im Garten. Hg. von/ed. by Inka Schube. Göttingen: Steidl, 2005
Bangkok. Heidi Specker/Germaine Krull. Hg. von/ed. by Ann und/and Jürgen Wilde. Hannover: Sprengel Museum Hannover, 2005 (Texte/texts: Ankana Kalantananda, Heidi Specker)
Hilf mir, ich bin blind/Help me I am blind. Heidi Specker, Theo Deutinger. Zürich: Christoph Keller Edition & JRP/Ringier, 2010

▶ THOMAS STRUTH

1954 geboren/born in Geldern
Staatliche Kunstakademie Düsseldorf/Dusseldorf
Meisterschüler von/master pupil of Prof. Bernd Becher
Lebt/lives in Berlin

EINZELAUSSTELLUNGEN/SOLO EXHIBITIONS (Auswahl/selection)
1978 P.S.1 Contemporay Art Center, New York
1980 Galerie Rüdiger Schöttle, München/Munich
1987 *Unbewusste Orte/Unconscious Places,* Kunsthalle Bern; Portikus, Frankfurt am Main; Westfälisches Landesmuseum Münster; Fruitmarket Gallery, Edinburgh
1993 *Museum Photographs,* Hamburger Kunsthalle, Hamburg
1997 *Portraits,* „SPECTRUM" Internationaler Preis für Fotografie der Stiftung Niedersachsen, Sprengel Museum Hannover/Hanover
2002 *Thomas Struth 1977–2002,* Dallas Museum of Art, Dallas, TX; Museum of Contemporary Art, Chicago, IL; The Metropolitan Museum of Art, New York; Museum of Contemporary Art, Los Angeles, CA
2004 *Pergamon Museum I – VI,* Hamburger Bahnhof – Museum für Gegenwart, Berlin
2005 *Thomas Struth. Imágenes del Perú,* Museo de Arte Lima
2007 Museo del Prado, Madrid
2008 Museo d'Arte Contemporanea Donna Regina, Neapel/Naples
2010 *Fotografien 1978–2010,* Kunsthaus Zürich/Zurich; Kunstsammlung Nordrhein-Westfalen, Düsseldorf/Dusseldorf; Whitechapel Art Gallery, London; Museu de Serralves, Museu de Arte Contemporânea, Porto

GRUPPENAUSSTELLUNGEN/GROUP EXHIBITIONS (Auswahl/selection)
1979 *In Deutschland. Aspekte gegenwärtiger Dokumentarfotografie,* Rheinisches Landesmuseum Bonn
1988 *Another Objectivity,* ICA – Institute of Contemporary Arts, London
1992 Documenta 9, Kassel
2000 *How you look at it. Fotografien des 20. Jahrhunderts,* Sprengel Museum Hannover/Hanover; Städelsches Kunstinstitut – Das Städel, Frankfurt am Main
2004 26th Biennale de São Paulo
 3. Berlin Biennale, Berlin

2005 *Contemporary Voices: Works from the UBS Collection,* The Museum of Modern Art, New York
2006 *Click Doubleclick – das dokumentarische Moment/the documentary factor,* Haus der Kunst, München/Munich; Palais des Beaux-Arts, Brüssel/Brussels
2008 *Fluid Street,* Museum of Contemporary Art Kiasma, Helsinki
2009 *The Making of Art,* Schirn Kunsthalle Frankfurt
 Düsseldorfer Schule. Photographien von 1970 bis 2008 aus der Sammlung Lothar Schirmer, Bayerische Akademie der Schönen Künste, München/Munich
2010 *Ruhrblicke/Ruhr Views,* Sanaa-Gebäude, Zeche Zollverein, Essen
 Dreamlands, Musée national d'art moderne, Centre Pompidou, Paris

BIBLIOGRAFIE/BIBLIOGRAPHY (Auswahl/selection)
Thomas Struth: Unbewusste Orte/Unconscious Places. Köln: Verlag der Buchhandlung Walther König, 1987 (Texte/texts: Ingo Hartmann, Ulrich Loock, Friedrich Meschede)
Thomas Struth: Museum Photographs. München: Schirmer/Mosel, 1993 (Text: Hans Belting)
Thomas Struth: Portraits. München: Schirmer/Mosel, 1997 (Texte/texts: Norman Bryson, Benjamin H. D. Buchloh, Thomas Weski)
Thomas Struth: 1977–2002. München: Schirmer/Mosel, 2002 (Texte/texts: Douglas Eklund, Ann Goldstein, Maria Morris Hambourg, Charles Wylie)
Thomas Struth: Familienleben. München: Schirmer/Mosel, 2008
Thomas Struth: Fotografien 1978–2010. München: Schirmer/Mosel, 2010 (Texte/texts: Tobias Bezzola, Anette Kruzynski, James Lingwood, Armin Zweite)
Thomas Struth. New York: Marian Goodman Gallery, 2010

▶ WOLFGANG TILLMANNS

1968 geboren/born in Remscheid
Bournemouth and Poole College of Art and Design, Bournemouth
Seit/since 2003 Professor, Städelschule, Frankfurt am Main
Lebt/lives in London und/and Berlin

EINZELAUSSTELLUNGEN/SOLO EXHIBITIONS (Auswahl/selection)
1988 *Approaches,* Café Gnosa, Hamburg
1993 Galerie Daniel Buchholz, Köln/Cologne
1994 Andrea Rosen Gallery, New York
 Interim Art, London
1995 Kunsthalle Zürich/Zurich
 Portikus, Frankfurt am Main
1996 *Wer Liebe wagt lebt morgen,* Kunstmuseum Wolfsburg
2001 *Aufsicht/View from Above,* Deichtorhallen Hamburg
 Super Collider, Galerie Daniel Buchholz, Köln/Cologne
2003 *if one thing matters, everything matters,* Tate Britain, London
2006 *Freedom from the Known,* Museum of Contemporary Art, Chicago, IL; P.S.1/The Museum of Modern Art, New York; Hammer Museum, Los Angeles, CA; Hirshhorn Museum, Washington D.C.; Museu Tamayo Arte Contemporanea, Mexico City
2007 *Bali,* Kestnergesellschaft, Hannover/Hanover
2008 *Lighter,* Hamburger Bahnhof – Museum für Gegenwart, Berlin
2010 Serpentine Gallery, London

GRUPPENAUSSTELLUNGEN/GROUP EXHIBITIONS (Auswahl/selection)
1989 *Die Hamburg Schachtel,* Museum für Kunst und Gewerbe, Hamburg
1994 *L'Hiver de l'Amour,* Musée d'art moderne de la Ville de Paris
1996 *New Photography 12,* The Museum of Modern Art, New York
2000 *Turner Prize,* Tate Britain, London
 Apocalypse, Royal Academy of Arts, London
 Protest and Survive, Whitechapel Art Gallery, London
2002 *Remix: Contemporary Art & Pop,* Tate Liverpool
2005 *Arbeit an der Wirklichkeit. German Contemporary Photography,* The National Museum of Modern Art, Tokio/Tokyo; The National Museum of Modern Art, Kyoto; Marugame Genichiro-Inokuma Museum of Contemporary Art, Marugame
2006 *Click Doubleclick – das dokumentarische Moment/the documentary factor,* Haus der Kunst, München/Munich; Palais des Beaux-Arts, Brüssel/Brussels
2006 *Into Me/Out of Me,* P.S. 1, Long Island, NY; KW Institute for Contemporary Art, Berlin; Macro Museo d'Arte Contemporanea, Rom/Rome
2009 53. Biennale di Venezia, Venedig/Venice
2010 *Not in Fashion. Mode und Fotografie in den 90er Jahren,* Museum für Moderne Kunst, Frankfurt am Main

BIBLIOGRAFIE/BIBLIOGRAPHY (Auswahl/selection)
Wolfgang Tillmans. Köln: Taschen, 1995 (Neuauflage 2002)
Wolfgang Tillmans: Wer Liebe wagt lebt morgen. Ostfildern-Ruit: Hatje Cantz, 1996
Wolfgang Tillmans: Soldiers: The Nineties. Köln: Verlag der Buchhandlung Walther König, 1999
Wolfgang Tillmans: Aufsicht/View from Above. Hg. von/ed. by Zdenek Felix. Ostfildern-Ruit: Hatje Cantz, 2001
Wolfgang Tillmans: Portraits. Köln: Verlag der Buchhandlung Walther König, 2001
Wolfgang Tillmans. London/New York: Phaidon, 2002 (Texte/texts: Peter Halley, Midori Matusri, Jan Verwoert)
Wolfgang Tillmans: if one thing matters, everything matters. Ostfildern-Ruit: Hatje Cantz, 2003
Wolfgang Tillmans: truth study center. Köln : Taschen, 2005
Wolfgang Tillmans: Sprengel-Installation (+4), Hannover: Sprengel Museum Hannover, 2007 (Text: Inka Schube)
Hans Ulrich Obrist: *The Conversation Series Vol. 6 – Wolfgang Tillmans.* Köln: Verlag der Buchhandlung Walther König, 2007
Wolfgang Tillmans: Lighter. Ostfildern: Hatje Cantz, 2008
Wolfgang Tillmans: Wako Book 4. Tokyo: Wako Works of Art, 2008
Wolfgang Tillmans: Abstract Pictures. Ostfildern-Ruit: Hatje Cantz, 2011

▶ JEFF WALL

1946 geboren/born in Vancouver
Studium der Kunstgeschichte/studies art history, University of British Columbia
Courtauld Institute of Art, London
Lebt/lives in Vancouver

EINZELAUSSTELLUNGEN/SOLO EXHIBITIONS (Auswahl/selection)
1978 Nova Gallery, Vancouver
1984 *Transparencies,* ICA – Institute of Contemporary Arts, London; Kunsthalle Basel
 Galerie Rüdiger Schöttle, München/Munich
1989 Marian Goodman Gallery, New York
1996 *Space and Vision,* Städtische Galerie im Lenbachhaus, München/Munich
2002 *Photographs: 2002 Hasselblad Award Winner Exhibition,* Hasselblad Center, Göteborgs Konstmuseum, Göteborg/Goteborg
2005 *Photographs 1978–2004,* Schaulager, Basel; Tate Modern, London
2007 *Jeff Wall: In His Own Words,* The Museum of Modern Art, New York; The Art Institute of Chicago, IL; San Francisco Museum of Modern Art,
 San Francisco, CA
 Deutsche Guggenheim, Berlin
2008 Vancouver Art Gallery, Vancouver
2010 *Transit,* Kunsthalle im Lipsiusbau, Staatliche Kunstsammlungen, Dresden
2011 *The Crooked Path,* Palais des Beaux Arts, Brüssel/Brussels

GRUPPENAUSSTELLUNGEN/GROUP EXHIBITIONS (Auswahl/selection)
1969 *Focus '69,* Bau-Xi Gallery, Vancouver
1981 *Westkunst – heute. Zeitgenössische Kunst seit 1939,* Rheinhallen Messegelände, Köln/Cologne
1982 Documenta 7, Kassel
1987 Documenta 8, Kassel
1989 *Les Magiciens de la Terre,* Musée national d'art moderne, Centre Pompidou, La Grande Halle – La Villette, Paris
1991 *Metropolis,* Martin-Gropius-Bau, Berlin
1997 Documenta 10, Kassel
2000 *How you look at it. Fotografien des 20. Jahrhunderts,* Sprengel Museum Hannover/Hanover; Städelsches Kunstinstitut – Das Städel, Frankfurt am Main
2001 49. Biennale di Venezia, Venedig/Venice
2002 Documenta 11, Kassel
2006 *Click Doubleclick – das dokumentarische Moment/the documentary factor,* Haus der Kunst, München/Munich; Palais des Beaux-Arts,
 Brüssel/Brussels

BIBLIOGRAFIE/BIBLIOGRAPHY (Auswahl/selection)
Jeff Wall: Transparencies. München: Schirmer/Mosel, 1986
Jeff Wall: Space and Vision. München: Schirmer/Mosel, 1996
Jeff Wall: Photographs: The Hasselblad Award 2002. Göttingen: Steidl, 2002
Jeff Wall. Hg. von/ed. by Thierry de Duve, Boris Groys, Arielle Pelenc. London/New York: Phaidon, 1996 (2. Auflage/2nd edition 2002, Text: Jean-François
 Chevrier)
Jeff Wall: Catalogue Raisonné 1978–2004. Hg. von/ed. by Heidi Naef, Theodora Vischer. Göttingen: Steidl, 2005
Jeff Wall. Hg. von/ed. by Jean-François Chevrier. Paris: Hazan, 2006
Jeff Wall. Hg. von/ed. by Peter Galassi. New York: The Museum of Modern Art, 2007
Jeff Wall: Transit. Hg. von/ed. by Ulrich Bischoff, Mathias Wagner. München: Schirmer/Mosel, 2010
Jeff Wall: The Crooked Path. Hg. von/ed. by Hans de Wolf. Brüssel: Bozar Books; Antwerpen: Ludion, 2011

▶ TOBIAS ZIELONY

1973 geboren/born in Wuppertal
Studium Kommunikationsdesign/studies communications design, Fachhochschule für Technik und Wirtschaft, Berlin
Documentary Photography, University of Wales, Newport
Hochschule für Grafik und Buchkunst, Leipzig
Meisterschüler von/master pupil of Prof. Timm Rautert
Lebt/lives in Berlin

EINZELAUSSTELLUNGEN/SOLO EXHIBITIONS (Auswahl/selection)
2004 Quartiers Nord, Institut Français, Leipzig
2006 *Some Sin for Nothing,* Kunsthaus Glarus, Schweiz/Switzerland
 Behind the Block, Plan B Gallery, Cluj, Rumänien/Romania
 Big Sexyland, Centre de la Photographie, Genf/Geneva
 AGIP/GULF/ARAL, Museum am Ostwall, Dortmund
2007 Garage, Galerie BWA, Zielona Góra, Polen/Poland
 The Cast, C/O Berlin
 The Hidden, Galerie Lia Rumma, Mailand/Milan
2008 *Story/No Story,* Photomuseum Braunschweig
2009 *Trona – Armpit of America,* Centre PasquArt, Biel
2010 *Vele,* Kunstverein Dortmund
 Story/No Story, Hamburger Kunstverein, Hamburg
 Kunsthalle Wien, Ursula Blickle Videolounge, Wien/Vienna
2011 *Live Cinema,* Philadelphia Museum of Art, Philadelphia, PA
 Manitoba, Camera Austria, Graz
 Dabeisein. Fotografien von Jürgen Heinemann und Tobias Zielony, Folkwang Museum, Essen

GRUPPENAUSSTELLUNGEN/GROUP EXHIBITIONS (Auswahl/selection)

2003 *Silver & Gold*, Kunstfonds des Freistaates Sachsen, Dresden; Städtische Galerie Wolfsburg
 öffentlich – privat, Galerie für Zeitgenössische Kunst, Leipzig
2004 *Shrinking Cities,* KW Institute for Contemporary Art, Berlin; Museum of Contemporary Art Detroit, MI; Museum am Ostwall, Dortmund
2005 *Populism,* Stedelijk Museum, Amsterdam; Frankfurter Kunstverein, Frankfurt am Main; Centre for Contemporary Arts, Vilnius; Museum for Architecture, Art and Design, Oslo
 Projekt Migration, Kölnischer Kunstverein, Köln/Cologne
2006 *Street,* Witte de With, center for contemporary art, Rotterdam
2007 *Made in Germany,* Sprengel Museum Hannover/Hanover
 State of Work, Fotohof Salzburg
2008 *Close the Gap. Studium der Fotografie bei Timm Rautert,* Städtische Galerie Kiel
2009 *Mit Abstand – Ganz nah. Fotografie aus Leipzig,* Brandenburgische Kunstsammlungen Cottbus, Kunstmuseum Dieselkraftwerk, Cottbus
2010 *The Lucid Evidence,* Museum für Moderne Kunst, Frankfurt am Main
 Versteckte Öffentlichkeiten/Hidden Publics, rotor – Verein für zeitgenössische Kunst, Graz
 The 6th Seoul International Biennale of Media Art, *Trust,* Seoul
 2,5 dimensional: film featuring architecture, deSingel, Antwerpen
2011 *Number Five: Cities of Gold and Mirrors*, Julia Stoschek Collection, Düsseldorf/Dusseldorf
 Streetlife and Homestories. Fotografien aus der Sammlung Goetz, Museum Villa Stuck, München/Munich
 Leipzig. Fotografie seit 1839, Grassi Museum, Leipzig
 Angry – Young and Radical, Nederlands Fotomuseum, Rotterdam

BIBLIOGRAFIE/BIBLIOGRAPHY (Auswahl/selection)

Silber & Gold. Klasse Rautert Fotografie. Köln: Verlag der Buchhandlung Walther König, 2003
Tobias Zielony. Hg. von/ed. by Marion Ermer Stiftung. Weimar: Universitäts Verlag, 2004
Tobias Zielony: Behind the Block. Leipzig: Institut für Buchkunst der Hochschule für Buchkunst und Grafik, 2004
Vor aller Augen. Fotografie aus Leipzig. Hg. von/ed. by Matthias Kleindienst, Timm Rautert. Bielefeld: Kerber Verlag, 2005 (Texte/texts: Sabine Belz, Florian Ebner, Arno Gisinger)
Tobias Zielony: The Cast. Hg. von/ed. by Jutta von Zitzewitz. Berlin/München: Deutscher Kunstverlag, 2007
Tobias Zielony: Trona – Armpit of America. Leipzig: Spector Books, 2008
Tobias Zielony: Story/No Story. Ostfildern: Hatje Cantz, 2010
Dabeisein. Fotografien von Jürgen Heinemann und Tobias Zielony. Göttingen: Steidl, 2011

▶ THIERRY GEOFFROY/COLONEL

Thierry Geoffroy/Colonel, geboren 1961 in Nancy, Frankreich, ist ein dänisch-französischer „Formatkünstler" (format artist). Er lebt und arbeitet in Kopenhagen. 1989 verfasste und publizierte er das Manifest *Moving Exhibitions*. Es beschreibt fünf unterschiedliche Typen von Ausstellungen und liegt bis heute seiner künstlerischen Praxis zugrunde.
Ausgehend von diesen Ausstellungsformen entwickelt Thierry Geoffroy/Colonel Formate, die immer Ereignischarakter tragen und auf bereits bestehende Situationen reagieren, sie kommentieren und verändern. „Emergency" ist ein zentraler Begriff im Schaffen des Künstlers. Er bezieht ihn auf den Zustand politischer, sozialer und ökonomischer Mikro- wie Makrostrukturen: Die Formate, die häufig ineinandergreifen, dienen dazu, bereits existierende Kanäle der Informations- und Bildverbreitung zu besetzen, ihre Inhalte zu hinterfragen und Wahrnehmung und Auseinandersetzung zu aktivieren. So lädt er im Format *Emergency Room*, realisiert unter anderem 2007 im P.S.1/The Museum of Modern Art, New York, Künstlerinnen und Künstler ein, im 24-Stunden-Rhythmus auf Tagesereignisse zu reagieren und die entstehenden künstlerischen Positionierungen im täglichen Wechsel zu präsentieren. Das Format *Biennalist* dringt in Kunstbiennalen ein und setzt sich mit deren Themen und Fragestellungen auseinander. Das Format *Critical Run*, bereits ebenfalls weltweit realisiert, verbindet die politische Debatte mit der körperlichen Bewegung und lädt, wie auch *Debate Rave* und *Slow Dance*, auf freundlich kommunikative Weise Nichtkünstler zur Teilnahme ein. Andere Formate, wie *Penetration* oder *Debate Fight*, setzen ganz gezielt auf die Störung und Zuspitzung einer bereits existierenden Situation. Das Format *Extracteur* beschäftigt sich mit der Bildpolitik von Facebook und anderen sogenannten sozialen Netzwerken des Internets und ihren Auswirkungen auf unsere Vorstellungen von und unseren Umgang mit „privat" und „öffentlich".
Die Aktionen und Aktivitäten verstärken ihr symbolisches Potenzial in den Dokumentationen, die der Künstler in unterschiedlichste Medienkanäle einspeist.
Bei Revolver Publishing, Berlin, erschien zuletzt *Emergency Room Dictionary* (2010).

Thierry Geoffroy/Colonel, born in Nancy, France, in 1961, is a French "format artist." He lives and works in Copenhagen.
In 1989 he wrote and published the *Moving Exhibitions Manifeste* in which he describes five different types of exhibition and has since based his work as an artist on them.
On the basis of these exhibition forms, Thierry Geoffroy/Colonel develops formats that always have the character of a happening and respond to, comment on and modify existing situations. "Emergency" is a central concept in the artist's work that he applies to the state of political, social and economic micro- and macro-structures. These formats, which often intermesh, have the function of occupying existing channels of data and image dissemination, calling their content into question and stimulating perception and reflection. In the format *Emergency Room*, realized among other things at P.S.1/The Museum of Modern Art, New York, in 2007, he invites artists to respond every 24 hours to daily events and presents a daily succession of the artists' reactions. Thrusting itself into art biennials, the format *Biennalist* addresses their themes and issues. The format *Critical Run*, also already realized worldwide, links political debate with physical exercise and, like *Debate Rave* and *Slow Dance*, engagingly and communicatively invites non-artists to take part. Other formats like *Penetration* and *Debate Fight* deliberately attempt to disrupt existing situations and bring them to a head. The format *Extracteur* is concerned with the image policy of Facebook and other so-called social networks on the Internet and their effects on our conceptions of and treatment of the "private" and the "public."
These happenings and activities reinforce their symbolic potential in the documentation that the artist feeds into a wide range of media channels.
His *Emergency Room Dictionary* was issued by Revolver Publishing, Berlin, in 2010.

▶ MARKUS SCHADEN

Markus Schaden, geboren 1965 in Bonn, lebt und arbeitet in Köln.
Schaden arbeitet seit 1985 als Buchhändler und eröffnete 1998 in Köln seinen eigenen Fotobuchladen Schaden.com. 1995 gründete er zusammen mit seinem Bruder Christoph den Schaden Verlag, der limitierte Fotoeditionen und Sonderausgaben herausgibt. 2009 gewann er den Red Dot Design Award, einen internationalen Preis des Design Zentrums Nordrhein-Westfalen. Seit 2006 arbeitet der international anerkannte Fotobuchexperte in der Redaktion des internationalen Fotomagazins *Foam*, das vierteljährlich vom Foam Fotografiemuseum, Amsterdam, herausgegeben wird. Markus Schaden war Vize-Präsident der Deutschen Gesellschaft für Photographie. Er saß in der Jury verschiedener Fotofestivals, darunter Mannheim, Arles, Paris, Krakau und Los Angeles. 2008 initiierte er in Los Angeles das Künstlerprogramm „The La Brea Matrix". Seit 2009 unterrichtet er in Workshops an der Kölner Kunsthochschule für Medien und hat dort mit *Love on the Left Bank* von Ed van der Elsken das Projekt „PhotoBookStudies#" begonnen.

Markus Schaden, born 1965 in Bonn, lives and works in Cologne.
He has been a book seller since 1985 and, in 1998, he opened the Photobook Store Schaden.com in Cologne. In 1995 he and his brother Christoph founded the Schaden publishing house, which publishes limited photography editions and special releases. In 2009 he won the Red Dot Design Award (an international design prize awarded by the Design Zentrum Nordrhein-Westfalen). Since 2006, this acknowledged expert on photography books has worked as an editorial journalist for the international photographic magazine *Foam*, which is published quarterly by the Foam Fotografiemuseum, Amsterdam. Markus Schaden was Vice President of German Society of Photography. He has served on the juries of photography festivals in Mannheim, Arles, Paris, Cracow, and Los Angeles. In 2008 he initiated the Artist Program "The La Brea Matrix" in Los Angeles. Since 2009 he gives Workshops and a Masterclass at the Media Academy Cologne on his new program "PhotoBookStudies#" starting with *Love on the Left Bank* by Ed van der Elsken.

▶ WILHELM SCHÜRMANN

Wilhelm Schürmann, geboren 1946 in Dortmund, lebt und arbeitet in Herzogenrath.
Nach einem Chemiestudium an der RWTH Aachen von 1966 bis 1971 begann Schürmann 1972 mit einer Sammlung für Fotografie. 1973 bis 1977 betrieb er die Galerie Schürmann & Kicken in Aachen. 1981 bis 2011 war er Professor für Fotografie an der FH Aachen. Seit 1981 sammelt er Gegenwartskunst und unterhielt von 2006 bis 2010 den Ausstellungsraum SchürmannBerlin.
Die *Sammlung Schürmann* wurde bereits in vielen großen Ausstellungshäusern gezeigt, u. a. im Ludwig Forum, Aachen (1992), den Deichtorhallen Hamburg (1994), der Kunsthalle Basel (2000), der Kunstsammlung Nordrhein-Westfalen, Düsseldorf (2002), oder dem Museum Abteiberg, Mönchengladbach (2011).

Wilhelm Schürmann, born in Dortmund in 1946, lives and works in Herzogenrath.
Having studied chemistry at RWTH Aachen University from 1966 to 1971, Schürmann started collecting photography in 1972. From 1973 to 1977 he ran the gallery Schürmann & Kicken in Aachen. From 1981 to 2011, he was Professor of Photography at Aachen University of Applied Sciences. He has been collecting contemporary art since 1981 and managed the SchürmannBerlin exhibition room from 2006 to 2010.
The *Schürmann Collection* has already been shown in many large exhibition houses. These include the Ludwig Forum, Aachen (1992), Deichtorhallen Hamburg (1994), Kunsthalle Basel (2000), Kunstsammlung Nordrhein-Westfalen, Dusseldorf (2002), and the Museum Abteiberg, Mönchengladbach (2011).

▶ ROBERT ADAMS

Sämtliche Exponate aus/all exhibits from *The New West,* 1968–1971

Farm Road and Cottonwood, South of Raymer, Silbergelatineabzug/gelatin silver print, 15,1 × 15,1 cm/6 × 6 in
Gazing Land with Pines near Falcon, Silbergelatineabzug/gelatin silver print, 14,2 × 15 cm/5 ⅝ × 5 ⅞ in
Along Interstate 25, Silbergelatineabzug/gelatin silver print, 14,2 × 15,3 cm/5 ⅝ × 6 in
On Interstate 25, Silbergelatineabzug/gelatin silver print, 12,9 × 15,1 cm/5 ¾ × 6 in
Pikes Peak, Colorado Springs, and the Higway from the Prairie, Silbergelatineabzug/gelatin silver print, 14,1 × 15 cm/5 ½ × 5 ⅞ in
Basement for a Tract House, Colorado Springs, Silbergelatineabzug/gelatin silver print, 13,2 × 15,1 cm/5 ⅛ × 6 in
Newly occupied Tract Houses, Colorado Springs , Silbergelatineabzug/gelatin silver print, 14,5 × 15 cm/5 ¾ × 5 ⅞ in
Jefferson County, Silbergelatineabzug/gelatin silver print, 13,9 × 14,9 cm/5 ½ × 5 ⅞ in
Pikes Peak Park, Colorado Springs, Silbergelatineabzug/gelatin silver print, 14,8 × 15 cm/5 ⅞ × 5 ⅞ in
Colorado Springs, Silbergelatineabzug/gelatin silver print, 12,7 × 12,8 cm/5 × 5 in
New Subdivisions, Arvada, Silbergelatineabzug/gelatin silver print, 13,1 × 15 cm/5 ⅛ × 5 ⅞ in
Colorado Springs, Silbergelatineabzug/gelatin silver print, 14,9 × 15 cm/5 ⅞ × 5 ⅞ in
Sunday School. A Church in a new Tract, Colorado Springs, Silbergelatineabzug/gelatin silver print, 14,2 × 15 cm/5 ⅝ × 5 ⅞ in
Almeda Avenue, Denver, Silbergelatineabzug/gelatin silver print, 14,7 × 14,7 cm/5 ¾ x 5 ¾ in
Federal Boulevard, Denver, Silbergelatineabzug/gelatin silver print, 15 × 15 cm/5 ⅞ x 5 ⅞ in
Drugstore, Lakeside, Silbergelatineabzug/gelatin silver print, 15,2 × 15,1 cm/6 × 6 in
The Center of Denver, four Miles Distant, Silbergelatineabzug/gelatin silver print, 14,4 × 15 cm/5 ⅝ × 5 ⅞ in
Buffalo for sale, Silbergelatineabzug/gelatin silver print, 13,8 × 15 cm/5 ½ × 5 ⅞ in
Motel, Silbergelatineabzug/gelatin silver print, 14,7 × 15 cm/5 ¾ × 5 ⅞ in
From Lookout Mountain, Silbergelatineabzug/gelatin silver print, 15 × 15 cm/5 ⅞ x 5 ⅞ in
Green Mountain, Silbergelatineabzug/gelatin silver print, 14,4 × 15 cm/5 ⅝ × 5 ⅞ in
Pikes Peak, Silbergelatineabzug/gelatin silver print, 13,8 × 15 cm/5 ½ × 5 ⅞ in
Federal 40, Mount Vernon Canyon, Silbergelatineabzug/gelatin silver print, 15 × 15 cm/5 ⅞ × 5 ⅞ in
Clear Creek Canyon, near Idaho Springs, Silbergelatineabzug/gelatin silver print, 13,4 × 15,1 cm/5 ¼ × 6 in
Pioneer Cemetery, near Empire, Silbergelatineabzug/gelatin silver print, 14,7 × 15,2 cm/5 ¾ × 6 in

Niedersächsische Sparkassenstiftung, Hannover/Hanover, © Robert Adams

▶ DIANE ARBUS

Sämtliche Exponate aus dem Portfolio/all exhibits from the portfolio *A Box of Ten Photographs,* 1971

Retired Man and His Wife at Home in a Nudist Camp One Morning, N.J., 1963, Silbergelatineabzug/gelatin silver print, 36,5 × 38 cm/14 ⅜ × 15 in
Xmas Tree in a Living Room in Levittown, L.I., 1963, Silbergelatineabzug/gelatin silver print, 37 × 36,4 cm/14 ½ × 14 ⅜ in
A Young Brooklyn Family Going for a Sunday Outing, N.Y.C., 1966, Silbergelatineabzug/gelatin silver print, 39,2 × 38,3 cm/15 ⅜ × 15 ⅛ in
A Young Man in Curlers at Home on West 20th Street, N.Y.C., 1966, Silbergelatineabzug/gelatin silver print, 38,6 × 36,6 cm/15 ¼ × 14 ⅜ in
A Family on their Lawn One Sunday in Westchester, N.Y., 1968, Silbergelatineabzug/gelatin silver print, 37,2 × 37,8 cm/14 ⅝ × 14 ⅞ in
A Jewish Giant at Home With His Parents in the Bronx, N.Y., 1970, Silbergelatineabzug/gelatin silver print, 38 × 37,8 cm/15 × 14 ⅞ in
The King and Queen of a Senior Citizens' Dance, N.Y.C., 1970, Silbergelatineabzug/gelatin silver print, 37,4 × 36,7 cm/14 ¾ × 14 ½ in

Niedersächsische Sparkassenstiftung, Hannover/Hanover, © The Estate of Diane Arbus, LLC

▶ LEWIS BALTZ

Nevada, 1977

Reno – Sparks, Looking South, Silbergelatineabzug/gelatin silver print, 16,2 × 24,2 cm/6 ⅜ × 9 ½ in
Hidden Valley, Looking South, Silbergelatineabzug/gelatin silver print, 16,2 × 24,2 cm/6 ⅜ × 9 ½ in
Hidden Valley, Looking Southwest, Silbergelatineabzug/gelatin silver print, 16,2 × 24,2 cm/6 ⅜ × 9 ½ in
Fluorescent Tube, Silbergelatineabzug/gelatin silver print, 16,2 × 24,2 cm/6 ⅜ × 9 ½ in
US 50, East of Carson City, Silbergelatineabzug/gelatin silver print, 16,2 × 24,2 cm/6 ⅜ × 9 ½ in
New Construction, Shadow Mountain, Silbergelatineabzug/gelatin silver print, 16,2 × 24,2 cm/6 ⅜ × 9 ½ in
Night Construction, Reno, Silbergelatineabzug/gelatin silver print, 16,2 × 24,2 cm/6 ⅜ × 9 ½ in
Model Home, Shadow Mountain, Silbergelatineabzug/gelatin silver print, 16,2 × 24,2 cm/6 ⅜ × 9 ½ in
B Street, Sparks, Silbergelatineabzug/gelatin silver print, 16,2 × 24,2 cm/6 ⅜ × 9 ½ in
Mill Street, Reno, Silbergelatineabzug/gelatin silver print, 16,2 × 24,2 cm/6 ⅜ × 9 ½ in
Lemmon Valley, Looking North, Silbergelatineabzug/gelatin silver print, 16,2 × 24,2 cm/6 ⅜ × 9 ½ in
Lemmon Valley, Looking Northeast, Silbergelatineabzug/gelatin silver print, 16,2 × 24,2 cm/6 ⅜ × 9 ½ in
Lemmon Valley, Looking Northwest, towards Stead, Silbergelatineabzug/gelatin silver print, 16,2 × 24,2 cm/6 ⅜ × 9 ½ in
Nevada 33, Looking West, Silbergelatineabzug/gelatin silver print, 16,2 × 24,2 cm/6 ⅜ × 9 ½ in
Mustang Bridge Exit, Interstate 80, Silbergelatineabzug/gelatin silver print, 16,2 × 24,2 cm/6 ⅜ × 9 ½ in

Niedersächsische Sparkassenstiftung, Hannover/Hanover, © Lewis Baltz

▶ MAX BAUMANN

Sämtliche Exponate aus/all exhibits from *blindlings/blindly,* 2011, 2 × 8 Silbergelatineabzüge/gelatine silver prints, je ca. 35,7 × 24,3 cm/each approx. 14 × 9 ½ in

Besitz des Künstlers/owned by the artist, © Max Baumann

▶ BERND und HILLA BECHER

Fabrikhallen/Factory Buildings, 1963–1994, geprinted/printed in 1996, 21-teilige Typologie/typology, set of 21

Grube Anna, Alsdorf/Aachen, D, 1992, Silbergelatineabzug/gelatin silver print, 31,3 × 40 5 cm/12 ⅜ × 16 in
Zeche Friedrich der Große, Herne, Ruhrgebiet, D, 1978, Silbergelatineabzug/gelatin silver print, 31 × 40,4 cm/12 ¼ × 15 ⅞ in
Zeche Werne, Werne, Ruhrgebiet, D, 1976, Silbergelatineabzug/gelatin silver print, 30,9 × 40,3 cm/12 ⅛ × 15 ⅞ in
Zeche Pluto, Wanne-Eickel, Ruhrgebiet, D, 1981, Silbergelatineabzug/gelatin silver print, 31 × 40,4 cm/12 ¼ × 15 ⅞ in
Dortmund-Hörde, D, 1989, Silbergelatineabzug/gelatin silver print, 31 × 40,4 cm/12 ¼ × 15 ⅞ in
Rombas, Lorraine, F, 1992, Silbergelatineabzug/gelatin silver print, 31 × 40,4 cm/12 ¼ × 15 ⅞ in
Mines de Roton, Charleroi, B, 1976, Silbergelatineabzug/gelatin silver print, 31 × 40,4 cm/12 ¼ × 15 ⅞ in
Grube Anna, Alsdorf/Aachen, D, 1992, Silbergelatineabzug/gelatin silver print, 31 × 40,4 cm/12 ¼ × 15 ⅞ in
Schafstädt, Merseburg, Sachsen-Anhalt, D, 1994, Silbergelatineabzug/gelatin silver print, 31 × 40,4 cm/12 ¼ × 15 ⅞ in
Zeche Lothringen, Bochum, Ruhrgebiet, D, 1980, Silbergelatineabzug/gelatin silver print, 31 × 40,4 cm/12 ¼ × 15 ⅞ in
Zeche Concordia, Oberhausen, Ruhrgebiet, D, 1967, Silbergelatineabzug/gelatin silver print, 30,9 × 40,1 cm/12 ⅛ × 15 ¾ in
Zeche Zollern II, Dortmund, D, 1971, Silbergelatineabzug/gelatin silver print, 33,1 × 38,3 cm/13 × 15 ⅛ in
Siège Simon, Forbach, Lorraine, F, 1989, Silbergelatineabzug/gelatin silver print, 31 × 40,4 cm/12 ¼ × 15 ⅞ in
Werdohl, Sauerland, D, 1985, Silbergelatineabzug/gelatin silver print, 31,7 × 40,5 cm/12 ½ × 16 in
Zeche Werne, Werne, Ruhrgebiet, D, 1976, Silbergelatineabzug/gelatin silver print, 31 × 40,5 cm/12 ¼ × 16 in
Calais, F, 1985, Silbergelatineabzug/gelatin silver print, 31,3 × 40,4 cm/12 ⅜ × 15 ⅞ in
Harlingen, NL, 1963, Silbergelatineabzug/gelatin silver print, 30,7 × 40,1 cm/12 ⅛ × 15 ¾ in
Charleroi-Montigny, B, 1984, Silbergelatineabzug/gelatin silver print, 30,9 × 40,4 cm/12 ⅛ × 15 ⅞ in
Rodange, Luxembourg, 1979, Silbergelatineabzug/gelatin silver print, 31,4 × 40,5 cm/12 ⅝ × 16 in
Calais, F, 1995, Silbergelatineabzug/gelatin silver print, 31,5 × 40,4 cm/12 ⅜ × 15 ⅞ in
Werdohl, Sauerland, D, 1985, Silbergelatineabzug/gelatin silver print, 31 × 40,3 cm/12 ¼ × 15 ⅞ in

Aufbereitungsanlagen/Preparation Plants, 1974–1987, 16-teilige Typologie/typology, set of 16

Marvin Breaker/Scranton, Pennsylvania, USA, 1974, Silbergelatineabzug/gelatine silver print, ca. 31 × 40 cm/approx. 12 ¼ × 15 ¾ in
Salem Creek Breaker/Harrisburgh, Pennsylvania, USA, 1975, Silbergelatineabzug/gelatine silver print, ca. 31 × 40 cm/approx. 12 ¼ × 15 ¾ in
Glen Lyon Breaker, Glen Lyon, Pennsylvania, USA, 1974, Silbergelatineabzug/gelatine silver print, ca. 31 × 40 cm/approx. 12 ¼ × 15 ¾ in
Breaker/Trevorton, Pennsylvania, USA, 1975, Silbergelatineabzug/gelatine silver print, ca. 31 × 40 cm/approx. 12 ¼ × 15 ¾ in
Llewellyn Breaker/Pottsville, Pennsylvania, USA, 1974, Silbergelatineabzug/gelatine silver print, ca. 31 × 40 cm/approx. 12 ¼ × 15 ¾ in
Lansford Breaker, Tamaqua, Pennsylvania, USA, 1974, Silbergelatineabzug/gelatine silver print, ca. 31 × 40 cm/approx. 12 ¼ × 15 ¾ in
Jeddo No 7 Breaker, Hazleton, Pennsylvania, USA, 1974, Silbergelatineabzug/gelatine silver print, ca. 31 × 40 cm/approx. 12 ¼ × 15 ¾ in
Moffat Breaker, Scranton, Pennsylvania, USA, 1974, Silbergelatineabzug/gelatine silver print, ca. 31 × 40 cm/approx. 12 ¼ × 15 ¾ in
St. Niclas Breaker, Mahanoy City, Pennsylvania, USA, 1974, Silbergelatineabzug/gelatine silver print, ca. 31 × 40 cm/approx. 12 ¼ × 15 ¾ in
Llewellyn Breaker/Pottsville, Pennsylvania, USA, 1974, Silbergelatineabzug/gelatine silver print, ca. 31 × 40 cm/approx. 12 ¼ × 15 ¾ in
Loomis Breaker/Wilkes Barre, Pennsylvania, USA, 1974, Silbergelatineabzug/gelatine silver print, ca. 31 × 40 cm/approx. 12 ¼ × 15 ¾ in
Joliet Breaker/Pottsville, Pennsylvania, USA, 1975, Silbergelatineabzug/gelatine silver print, ca. 31 × 40 cm/approx. 12 ¼ × 15 ¾ in
Breaker/West Pittston, Pennsylvania, USA, 1975, Silbergelatineabzug/gelatine silver print, ca. 31 × 40 cm/approx. 12 ¼ × 15 ¾ in
Breaker/Shenandoah, Pennsylvania, USA, 1987, Silbergelatineabzug/gelatine silver print, ca. 31 × 40 cm/approx. 12 ¼ × 15 ¾ in
Hazleton Shaft Breaker, Hazleton, Pennsylvania, USA, 1974, Silbergelatineabzug/gelatine silver print, ca. 31 × 40 cm/approx. 12 ¼ × 15 ¾ in
Blue Creek No 3, Adger, Alabama, USA, 1983, Silbergelatineabzug/gelatine silver print, ca. 31 × 40 cm/approx. 12 ¼ × 15 ¾ in

Niedersächsische Sparkassenstiftung, Hannover/Hanover, © Hilla Becher

▶ LAURA BIELAU

Sämtliche Exponate aus/all exhibits from *Color Lab Club*, 2007/08

Fototaube/pigeon photographer, 2007, C-Print, 31,7 × 24,4 cm/12 ½ × 9 ⅝ in
Labor, 2007, Silbergelatineabzug/gelatin silver print, 100 × 123,5 cm/39 ⅜ × 48 ⅝ in
Man Ray, 2007, C-Print, 100,5 × 123,5 cm/39½ × 48⅝ in
Niépce, 2007, C-Print, 24 × 30 cm/9 ½ × 11 ¾ in
Labgirl, 2008, Silbergelatineabzug/gelatin silver print, 31,2 × 22 cm/12 ¼ × 8 ⅝ in
Lab Girls – Carte de visite (1–16), 2008, C-Prints, Carte de visite mit Prägung, 4,8 × 7,3 cm hinter Passepartout/carte de visite with imprinting,
 1 ⅞ × 2 ⅞ in behind passe-partout, 31,2 × 22 cm (Rahmen)/12 ¼ × 8 ⅝ (frame)

Courtesy Emmanuel Post, Leipzig/Berlin, © Laura Bielau

▶ THOMAS DEMAND

Hydrokultur, 2010, C-Print, Diasec, 168 × 138 cm/66 ⅛ × 54 ⅜ in
Paket/Parcel, 2011, C-Print, Diasec, 108 × 93 cm/42 ½ × 36 ⅝ in
Tribute, 2011, C-Print, Diasec, 166 × 125 cm/65 ⅜ × 49 ¼ in
Vorhang/Curtain, 2010, C-Print, Diasec, 240,8 × 165 cm/94 ¾ × 65 in

Besitz des Künstlers/owned by the artist, © Thomas Demand/VG Bild-Kunst, Bonn 2011

▶ RINEKE DIJKSTRA

Saskia, Harderwijk, The Netherlands, March 16, 1994, C-Print, 117,5 × 94,5 cm/46 ¼ × 37 ¼ in
Elise, Baarn, The Netherlands, July 26, 2010, C-Print, 90 × 72 cm/35 ⅜ × 28 ⅜ in
Tecla, Amsterdam, The Netherlands, May 16, 1994, C-Print, 117,5 × 94,5 cm/46 ¼ × 37 ¼ in
Tex, Amsterdam, The Netherlands, August 2, 2010, C-Print, 90 × 72 cm/35 ⅜ × 28 ⅜ in
Julie, Den Haag, The Netherlands, February 29, 1994, C-Print, 117 × 94,5 cm/46 × 37 ¼ in
Louis, Baarn, The Netherlands, August 10, 2010, C-Print, 90 × 72 cm/35 ⅜ × 28 ⅜ in

Besitz der Künstlerin/owned by the artist, Courtesy Galerie Max Hetzler, Berlin, Marian Goodman Gallery, Paris/New York, und/and Tate, London, © Rineke Dijkstra

▶ WILLIAM EGGLESTON

Sämtliche Exponate aus/all exhibits from *14 Pictures,* 1974, 14-teilig/14-parts

Ohne Titel/untitled, 1971, Dye-Transfer-Print, 31,5 × 47,1 cm/12 ⅜ × 18 ½ in
Ohne Titel/untitled, 1971, Dye-Transfer-Print, 32,5 × 48 cm/12 ¾ × 18 ⅞ in
Ohne Titel/untitled (Memphis, Tennessee), 1971, Dye-Transfer-Print, 32,5 × 48 cm/12 ¾ × 18 ⅞ in
Ohne Titel/untitled (Memphis, Tennessee), 1971, Dye-Transfer-Print, 32,5 × 48 cm/12 ¾ × 18 ⅞ in
Ohne Titel/untitled, 1972, Dye-Transfer-Print, 31,5 × 47,1 cm/12 ⅜ × 18 ½ in
Ohne Titel/untitled, 1972, Dye-Transfer-Print, 32,5 × 48 cm/12 ¾ × 18 ⅞ in
Ohne Titel/untitled, 1974, Dye-Transfer-Print, 32,5 × 48 cm/12 ¾ × 18 ⅞ in
Ohne Titel/untitled, 1972, Dye-Transfer-Print, 32,5 × 48 cm/12 ¾ × 18 ⅞ in
Ohne Titel/untitled (Memphis, Tennessee) um/about 1972, Dye-Transfer-Print, 32,5 × 48 cm/12 ¾ × 18 ⅞ in
Ohne Titel/untitled (near Senatobia, Mississippi), 1972, Dye-Transfer-Print, 48 × 32,5 cm/18 ⅞ × 12 ¾ in

Niedersächsische Sparkassenstiftung, Hannover/Hanover, © Eggleston Artistic Trust 2011

▶ HANS-PETER FELDMANN

Blumenbilder/Flowerpictures, 2006, Lambda C-Prints, 170 × 120 cm/66 ⅞ × 47 ¼ in

Courtesy Mehdi Chouakri, Berlin, © Hans-Peter Feldmann/VG Bild-Kunst, Bonn 2011

▶ LEE FRIEDLANDER

Philadelphia 1965, Silbergelatineabzug/gelatin silver print, 28,2 × 18,7 cm/11 ⅛ × 7 ⅜ in
Madison, Wisconsin 1966, Silbergelatineabzug/gelatin silver print, 18,9 × 28,1 cm/7 ½ × 11 ⅛ in
New York State 1966, Silbergelatineabzug/gelatin silver print, 18,7 × 28,2 cm/7 ⅜ × 11 ⅛ in
New York City 1966, Silbergelatineabzug/gelatin silver print, 18,8 × 28,2 cm/7 ⅜ × 11 ⅛ in
Colorado 1967, Silbergelatineabzug/gelatin silver print, 18,7 × 28,2 cm/7 ⅜ × 11 ⅛ in
New City, New York 1967, Silbergelatineabzug/gelatin silver print, 18,7 × 28,2 cm/7 ⅜ × 11 ⅛ in
Philadelphia 1967, Silbergelatineabzug/gelatin silver print, 28 × 19 cm/11 ¼ × 7 ½ in
Buffalo, NY 1968, Silbergelatineabzug/gelatin silver print, 18,7 × 28,2 cm/7 ⅜ × 11 ⅛ in
Route 9W, New York 1969, Silbergelatineabzug/gelatin silver print, 18,9 × 28,2 cm/7 ½ × 11 ⅛ in
Canyon de Chelly 1983, Silbergelatineabzug/gelatin silver print, 30,2 × 20,1 cm/11 ⅞ × 7 ⅞ in
Tokyo 1994, Silbergelatineabzug/gelatin silver print, 26,2 × 25,2 cm/10 ¼ × 9 ⅞ in
Tokyo 1994, Silbergelatineabzug/gelatin silver print, 25,6 × 25,8 cm/10 ⅛ × 10 ¼ in
New City 1996, Silbergelatineabzug/gelatin silver print, 25,9 × 25,6 cm/10 ¼ × 10 ⅛ in
Montreal 1997, Silbergelatineabzug/gelatin silver print, 25,9 × 25,8 cm/10 ¼ × 10 ⅛ in
Paris 1997, Silbergelatineabzug/gelatin silver print, 25,5 × 25,6 cm/10 × 10 ⅛ in

Niedersächsische Sparkassenstiftung, Hannover/Hanover, © Lee Friedlander

▸ STEPHEN GILL

51 Arbeiten ohne Titel aus/51 works untitled from *Coming up for Air*, 2008/09, 97-teilig/97-parts, C-Prints, 61 × 41 cm/24 × 16 ⅛ in

Niedersächsische Sparkassenstiftung, Hannover/Hanover, © Stephen Gill

▸ JOHN GOSSAGE

16 Arbeiten ohne Titel aus/16 works untitled from *The Pond,* 1985, 54-teilig/54-parts, Silbergelatineabzüge/gelatin silver prints, 48 je 26,7 × 33,5 cm/
 48 each 10 ½ × 13 ⅛ in, 6 je 11 × 17,8 cm/6 each 4 ⅜ × 7 in

Niedersächsische Sparkassenstiftung, Hannover/Hanover, © John Gossage

▸ PAUL GRAHAM

Sämtliche Exponate aus/all exhibits from *A Shimmer of Possibility*, 12 fotografische Serien/12 series of photographic works

Ohne Titel/untitled (New York/North Dakota), 2005, 15-teilig/15-parts, Pigment Ink Prints, 25,3 × 36,3 cm/10 × 14 ⅜ in, 27,2 × 33,1 cm/10 ¾ × 13 in,
 32,9 × 46,2 cm/13 × 18 ⅛ in, 35,2 × 49,3 cm/13 ⅞ × 19 ⅜ in, 38 × 53,3 cm/15 × 21 in, 38 × 53,3 cm/15 × 21 in, 41,7 × 58,4 cm/16 ⅜ × 23 in,
 41,7 × 58,4 cm/16 ⅜ × 23 in, 43,5 × 61 cm/17 ⅛ × 24 in, 43,5 × 61 cm/17 ⅛ × 24 in, 46,7 × 65,6 cm/18 ⅜ × 25 ⅞ in, 46,8 × 65,6 cm/18 ⅜ × 25 ⅞ in,
 63,4 × 88,8 cm/25 × 35 in, 72,5 × 101,6 cm/28 ½ × 40 in, 76,2 × 106,6 cm/30 × 42 in
Ohne Titel/untitled (Louisiana), 2005/06, 5-teilig/5-parts, Pigment Ink Prints, 43,9 × 62,6 cm/17 ¼ × 24 ⅝ in, 44,2 × 62,6 cm/17 ⅜ × 24 ⅝ in,
 44,5 × 62,6 cm/17 ½ × 24 ⅝ in, 55,5 × 78,2 cm/21 ⅞ × 30 ¾ in, 63,7 × 90,2 cm/25 × 35 ½ in

Niedersächsische Sparkassenstiftung, Hannover/Hanover, Courtesy carlier|gebauer, Berlin, © Paul Graham

▸ ANDREAS GURSKY

Cocoon II, 2008, C-Print/Diasec, 211,5 × 506 × 6,2 cm (Rahmen)/83 ¼ × 199 ¼ × 2 ½ in (Frame)

Courtesy Julia Stoschek Collection, Düsseldorf, © Andreas Gursky/VG Bild-Kunst, Bonn 2011

▸ JITKA HANZLOVÁ

Sämtliche Exponate aus/all exhibits from *Forest,* 2000–2005

Ohne Titel/untitled (Moon Shine), 2000, C-Print, 26,7 × 17,8 cm/10 ½ × 7 in
Ohne Titel/untitled (Summer Meadow), 2001, C-Print, 50,9 × 34,6 cm/20 × 13 ⅝ in
Ohne Titel/untitled (Tightrope Walker), 2002, C-Print, 26,7 × 17,8 cm/10 ½ × 7 in
Ohne Titel/untitled (Grass Path), 2003, C-Print, 50,9 × 34,6 cm/20 × 13 ⅝ in
Ohne Titel/untitled (Raining), 2003, C-Print, 26,7 × 17,8 cm/10 ½ × 7 in
Ohne Titel/untitled (Summer Green Sea), 2003, C-Print, 50,9 × 34,6 cm/20 × 13 ⅝ in
Ohne Titel/untitled (Appearing Light), 2004, C-Print, 26,7 × 17,8 cm/10 ½ × 7 in
Ohne Titel/untitled (Policeman), 2004, C-Print, 26,7 × 17,8 cm/10 ½ × 7 in
Ohne Titel/untitled (Sharp Fingers), 2004, C-Print, 26,7 × 17,8 cm/10 ½ × 7 in
Ohne Titel/untitled (Singing Grass), 2004, C-Print, 26,7 × 17,8 cm/10 ½ × 7 in
Ohne Titel/untitled (Antlers), 2005, C-Print, 50,9 × 34,6 cm/20 × 13 ⅝ in
Ohne Titel/untitled (Dead Tree Dancing), 2005, C-Print, 26,7 × 17,8 cm/10 ½ × 7 in
Ohne Titel/untitled (Green Snake), 2005, C-Print, 26,7 × 17,8 cm/10 ½ × 7 in
Ohne Titel/untitled (Split), 2005, C-Print, 50,9 × 34,6 cm/20 × 13 ⅝ in
Ohne Titel/untitled (Walking), 2005, C-Print, 26,7 × 17,8 cm/10 ½ × 7 in
Ohne Titel/untitled (White Hole—Black Snow), 2005, C-Print, 50,9 × 34,6 cm/20 × 13 ⅝ in

Courtesy Jitka Hanzlová, Galerie Kicken, Berlin, © Jitka Hanzlová

> JOCHEN LEMPERT

Anschütz, 2005, Silbergelatine Baryt/gelatin silver print, 51,6 × 81 cm/20 ¼ × 31 ⅞ in
Gleichenia, 2007/2011, Silbergelatineabzug/gelatin silver print, 17,8 x 22,6 cm/7 × 8 ⅞ in
Etruskischer Sand/Etruscan Sand, 2009, Silbergelatineabzug/gelatin silver print, 103,8 × 75,6 cm/40 ⅞ × 29 ¾ in
Glühwürmchen I–IV/Fireflies I–IV, 2009, Luminogramm auf 35-mm-Film/luminogram on 35 mm film, 39,8 × 58 cm/15 ⅝ × 22 ⅞ in, 38,9 × 58,1 cm/15 ¼ × 22 ⅞ in,
 39 × 58,2 cm/15 ⅜ × 23 in, 38,8 × 58,2 cm/15 ¼ × 23 in
Ohne Titel/untitled (nach/after R. J. Camerarius) I, 2010, Silbergelatineabzug/gelatin silver print, 59,3 × 48,6 cm/23 ⅜ × 19 ⅛ in
Ohne Titel/untitled (nach/after R. J. Camerarius) II, 2010, Silbergelatineabzug/gelatin silver print, 59,1 × 48,8 cm/23 ¼ × 19 ¼ in
Anna Atkins British Algae 2011, 2-teilig/2-parts, 2011, Silbergelatineabzug/gelatin silver print, Fotogramm/photogram, 24 × 30 cm/9 ½ × 11 ¾ in,
 Silbergelatineabzug/gelatin silver print, 24 × 18 cm/9 ½ × 7 in
Subjektive Fotografie/Subjective Photography, 2011, Silbergelatineabzug/gelatin silver print, 23,8 × 17,8 cm/9 ⅜ × 7 in

Courtesy ProjecteSD, Barcelona, © Jochen Lempert/VG Bild-Kunst, Bonn 2011

> BORIS MIKHAILOV

Sämtliche Exponate ohne Titel aus/all exhibits untitled from *German Portraits,* 2008/2011, C-Prints, je ca. 105 × 70 cm/each approx. 41 ⅜ × 27 ½ in

Besitz des Künstlers/owned by the artist, Courtesy Galerie Barbara Weiss, Berlin, © Boris Mikhailov/VG Bild-Kunst, Bonn 2011

> ELISABETH NEUDÖRFL

35 Arbeiten ohne Titel aus/35 works untitled from *Ökoton,* 2011, C-Prints, je ca. 20 × 25 cm/each approx. 7 ⅞ × 9 ⅞ in

Courtesy Barbara Wien Wilma Lukatsch, Berlin, © Elisabeth Neudörfl/VG Bild-Kunst, Bonn 2011

> NICHOLAS NIXON

20 Arbeiten aus/20 works from *Photographs from One Year*, 1981/82, geprintet/printed in 2005/2008, 40-teilig/40-parts

Page Street, Chelsea, Massachusetts 1981, Silbergelatineabzug/gelatin silver print, 20,3 × 25,3 cm/8 × 10 in
26th Avenue, Tampa, Florida 1982, Silbergelatineabzug/gelatin silver print, 20,3 × 25,3 cm/8 × 10 in
Allentown, Pennsylvania 1982, Silbergelatineabzug/gelatin silver print, 20,3 × 25,3 cm/8 × 10 in
Ashland, Kentucky 1982, Silbergelatineabzug/gelatin silver print, 20,3 × 25,3 cm/8 × 10 in
Chestnut Street, Louisville 1982, Silbergelatineabzug/gelatin silver print, 20,3 × 25,3 cm/8 × 10 in
Covington, Kentucky 1982, Silbergelatineabzug/gelatin silver print, 20,3 × 25,3 cm/8 × 10 in
Cypress Street, Oakland, California 1982, Silbergelatineabzug/gelatin silver print, 20,3 × 25,3 cm/8 × 10 in
Edwin Street, Winter Haven, Florida 1982, Silbergelatineabzug/gelatin silver print, 20,3 × 25,3 cm/8 × 10 in
Eloise, Florida 1982, Silbergelatineabzug/gelatin silver print, 20,3 × 25,3 cm/8 × 10 in
Friendly, West Virginia 1982, Silbergelatineabzug/gelatin silver print, 20,3 × 25,3 cm/8 × 10 in
Gum Tree, Kentucky 1982, Silbergelatineabzug/gelatin silver print, 20,3 × 25,3 cm/8 × 10 in
Halo, Kentucky 1982, Silbergelatineabzug/gelatin silver print, 20,3 × 25,3 cm/8 × 10 in
Harlan, Kentucky 1982, Silbergelatineabzug/gelatin silver print, 20,3 × 25,3 cm/8 × 10 in
Myrtle Street, Detroit 1982, Silbergelatineabzug/gelatin silver print, 20,3 × 25,3 cm/8 × 10 in
Neon, Kentucky 1982, Silbergelatineabzug/gelatin silver print, 20,3 × 25,3 cm/8 × 10 in
Pear Street, Lakeland, Florida 1982, Silbergelatineabzug/gelatin silver print, 20,3 × 25,3 cm/8 × 10 in
Putnam Avenue, Cambridge 1982, Silbergelatineabzug/gelatin silver print, 20,3 × 25,3 cm/8 × 10 in
Race Street, Cincinnati 1982, Silbergelatineabzug/gelatin silver print, 20,3 × 25,3 cm/8 × 10 in
Railroad Avenue, Clearwater, Florida 1982, Silbergelatineabzug/gelatin silver print, 20,3 × 25,3 cm/8 × 10 in
Tennessee Street, Lakeland, Florida 1982, Silbergelatineabzug/gelatin silver print, 20,3 × 25,3 cm/8 × 10 in

Niedersächsische Sparkassenstiftung, Hannover/Hanover, © Nicholas Nixon

▸RITA OSTROWSKAJA/OSTROVSKAYA

Sämtliche Exponate aus/all exhibits from *Anwesenheit/Presence,* 1996–2005

Mit meinem Mann/My Husband and I, 1995, Kiew, Silbergelatineabzug, sepiagetönt/gelatin silver print, sepia toned, 27,3 × 27,5 cm/10 ¾ × 10 ⅞ in
Mit/With Ute Eskildsen, 1995, Essen, Silbergelatineabzug, sepiagetönt/gelatin silver print. sepia toned, 28,1 × 28,3 cm/11 × 11 ⅛ in
In der Küche/In the Kitchen, 1996, Kiew, Silbergelatineabzug, sepiagetönt/gelatin silver print, sepia toned, 27 × 25 cm/10 ⅝ × 9 ⅞ in
Mit/With Martin Cunz, 1998, Aarau, Silbergelatineabzug, sepiagetönt/gelatin silver print, sepia toned, 31 × 28,3 cm/12 ¼ × 11 ⅛ in
Auf dem Bett/On my Bed, 1999, Kiew, Silbergelatineabzug, sepiagetönt/gelatin silver print, sepia toned, 29,7 × 29 cm/11 ⅝ × 11 ⅜ in
Mit Katarina Holländer/Katarina and I, 1999, Zürich, Silbergelatineabzug, sepiagetönt/gelatin silver print, sepia toned, 28,2 × 28,1 cm/11 ⅛ × 11 in
Im Grünen/In the Country, 2005, Kassel, Silbergelatineabzug, sepiagetönt/gelatin silver print, sepia toned, 30,5 × 29,5 cm/12 × 11 ⅝ in
Mit meiner Kamera/With my Camera, 2005, Kassel, Silbergelatineabzug, sepiagetönt/gelatin silver print, sepia toned, 31 × 29,2 cm/12 ¼ × 11 ½ in
Vor der Karte Deutschlands/In front of the Map of Germany, 2005, Kassel, Silbergelatineabzug, sepiagetönt/gelatin silver print, sepia toned,
 30 × 29,5 cm/11 ⅞ × 11 ⅝ in
Vor meinem Tisch/In Front of my Table, 2005, Kassel, Silbergelatineabzug, sepiagetönt/gelatin silver print, sepia toned, 32 × 29 cm/12 ⅝ × 11 ⅜ in

Besitz der Künstlerin/owned by the artist, © Rita Ostrowskaja

▸HELGA PARIS

Selbstporträts/Self-portraits, 1981–1989, 12 Silbergelatineabzüge/12 gelatin silver prints, je 20,4 × 13,5 cm/each 8 × 5 ¼ in

Sprengel Museum Hannover/Hanover, © Helga Paris

▸MARTIN PARR

Sämtliche Exponate aus/all exhibits from *Luxury,* 2004–2011

Russia. Moscow. Fashion Week, 2004, Pigment-Print, 101 × 152 cm/39 ¾ × 59 ⅞ in
Russia. Moscow. Fashion Week, 2004, Pigment-Print, 101 × 152 cm/39 ¾ × 59 ⅞ in
South Africa. The Durban Races, 2005, Pigment-Print, 50,5 × 40,5 cm/19 ⅞ × 16 in
Russia. Moscow. The Millionaire Fair at the Crocus Expo International Exhibition Center, 2007, Pigment-Print, 152 × 101 cm/59 ⅞ × 39 ¾ in
Russia. Moscow. The Millionaire Fair at the Crocus Expo International Exhibition Center, 2007, Pigment-Print, 101 × 152 cm/39 ¾ × 59 ⅞ in
United Arab Emirates. Dubai. Polo Match, 2007, Pigment-Print, 76 × 50,5 cm/30 × 19 ⅞ in
United Arab Emirates. Dubai. Harpers Bazaar Party, 2007, Pigment-Print, 50,5 × 40,5 cm/19 ⅞ × 16 in
England. Newcastle. Ladies Day at Gosfroth Races, 2008, Pigment-Print, 50,5 × 76 cm/19 ⅞ × 30 in
India. Delhi. A Hindu Wedding, 2009, Pigment-Print, 50,5 × 76 cm/19 ⅞ × 30 in
India. Delhi. The Jaipur Polo Club, 2010, Pigment-Print, 50,5 × 76 cm/19 ⅞ × 30 in
India. Delhi. The Jaipur Polo Club, 2010, Pigment-Print, 50,5 × 76 cm/19 ⅞ × 30 in
Kenya. Nairobi. The Kenya Derby Horse Race, 2010, Pigment-Print, 50,5 × 76 cm/19 ⅞ × 30 in
Switzerland. St Moritz. St Moritz Polo World Cup on Snow, 2011, Pigment-Print, 50,5 × 76 cm/19 ⅞ × 30 in
Switzerland. St Moritz. St Moritz Polo World Cup on Snow, 2011, Pigment-Print, 50,8 × 40,6 cm/20 × 16 in

Besitz des Künstlers/owned by the artist, © Martin Parr/Magnum Photos

▸THOMAS RUFF

ma.r.s.06, 2010, C-Print, 255 × 185 cm/100 ⅜ × 72 ⅞ in
ma.r.s.12, 2011, C-Print, 255 × 185 cm/100 ⅜ × 72 ⅞ in
ma.r.s.17, 2011, C-Print, 255 × 185 cm/100 ⅜ × 72 ⅞ in

Courtesy Johnen Galerie, Berlin, © Thomas Ruff/NASA/JPL/University of Arizona/VG Bilc-Kunst, Bonn 2011

▸MICHAEL SCHMIDT

Sämtliche Exponate aus/all exhibits from *Ihme-Zentrum 1997/98*, geprintet/printed in 2009

Ihme-Zentrum, 1997, Digitalprint, 160 × 202,7 cm/63 × 79 ¾ in, 162,6 × 204,8 cm (Rahmen)/64 × 80 ⅜ in (frame)
Ihme-Zentrum, 1997/98, Digitalprint, 147,2 × 189,2 cm/58 × 74 ½ in, 162,6 × 204,1 cm (Rahmen)/64 × 80 ⅜ in (frame)
Ihme-Zentrum, 1997/98, Digitalprint, 186,2 × 147,2 cm/73 ¼ × 58 in, 201,4 × 162,6 cm (Rahmen)/80 ⅜ × 64 in (frame)
Ihme-Zentrum, 1997/98, Digitalprint, 138,8 × 108 cm/54 ⅝ × 42 ½ in, 157,8 × 125,8 cm (Rahmen)/62 ⅛ × 49 ½ in (frame)

Courtesy Galerie Nordenhake Berlin/Stockholm, © Michael Schmidt

‣HEIDI SPECKER

Sämtliche Exponate aus/all exhibits from *Termini*, 2010/11

Auto Sex, Digital-Fine-Art-Print, 40 × 26,5 cm/15 ¾ × 10 ½ in
Divano, Digital-Fine-Art-Print, 40 × 30 cm/15 ¾ × 11 ¾ in
E.U.R. Campo Totale, Digital-Fine-Art-Print, 40 × 30 cm/15 ¾ × 11 ¾ in
E.U.R. Campo Totale C, Digital-Fine-Art-Print, 40 × 30 cm/15 ¾ × 11 ¾ in
E.U.R. Museo, Digital-Fine-Art-Print, 40 × 30 cm/15 ¾ × 11 ¾ in
Mostra, Motiv I, Digital-Fine-Art-Print, 40 × 26,5 cm/15 ¾ × 10 ½ in
Mostra, Motiv II, Digital-Fine-Art-Print, 40 × 26,5 cm/15 ¾ × 10 ½ in
Piazza Bologna, Motiv V, Digital-Fine-Art-Print, 40 × 30 cm/15 ¾ × 11 ¾ in
Piazza C.L.N., Motiv V, Digital-Fine-Art-Print, 40 × 30 cm/15 ¾ × 11 ¾ in
Piazza di Spagna 31, Motiv II, Digital-Fine-Art-Print, 210 × 152 cm/82 ⅝ × 59 ⅞ in
Piazza di Spagna 31, Motiv V, Digital-Fine-Art-Print, 210 × 152 cm/82 ⅝ × 59 ⅞ in
Prati, Digital-Fine-Art-Print, 40 × 30 cm/15 ¾ × 11 ¾ in
Sabaudia, Motiv II, Digital-Fine-Art-Print, 40 × 30 cm/15 ¾ × 11 ¾ in
Travertin, Digital-Fine-Art-Print, 40 × 30 cm/15 ¾ × 11 ¾ in
Treno I, Digital-Fine-Art-Print, 40 × 30 cm/15 ¾ × 11 ¾ in

Mit besonderem Dank an/with special thanks to EUR S.p.A.
Courtesy Brancolini Grimaldi, London, © Heidi Specker/VG Bild-Kunst, Bonn 2011

‣THOMAS STRUTH

South Lake Street Apartments I, Chicago, 1990, Silbergelatineabzug/gelatin silver print, 46,4 × 56,9 cm/18 ¼ × 22 ⅜ in
South Lake Street Apartments II, Chicago, 1990, Silbergelatineabzug/gelatin silver print, 45,9 × 57,2 cm/18 × 22 ½ in
South Lake Street Apartments III, Chicago, 1990, Silbergelatineabzug/gelatin silver print, 46,3 × 57,5 cm/18 ¼ × 22 ⅝ in
South Lake Street Apartments IV, Chicago, 1990, Silbergelatineabzug/gelatin silver print, 45,9 × 55,8 cm/18 × 22 in

Pinakothek der Moderne, München/Munich, seit 2003 Dauerleihgabe der Siemens AG/since 2003 on permanent loan by Siemens AG, © Thomas Struth

‣WOLFGANG TILLMANS

Oriental Pearl, 2009, Inkjet-Print, 200 × 138 cm/78 ¾ × 54 ⅜ in
In flight astro (II), 2010, Inkjet-Print, 200 × 138 cm/78 ¾ × 54 ⅜ in
Movin Cool, 2010, Inkjet-Print, 200 × 138 cm/78 ¾ × 54 ⅜ in
Nightfall (b), 2010, Inkjet-Print, 200 × 138 cm/78 ¾ × 54 ⅜ in
TGV, 2010, Inkjet-Print, 200 × 138 cm/78 ¾ × 54 ⅜ in
Times Square LED, 2010, Inkjet-Print, 200 × 138 cm/78 ¾ × 54 ⅜ in
Tukan, 2010, Inkjet-Print, 200 × 138 cm/78 ¾ × 54 ⅜ in
Ushuaia Favela, 2010, Inkjet-Print, 200 × 138 cm/78 ¾ × 54 ⅜ in

Courtesy Galerie Daniel Buchholz, Köln/Cologne und/and Berlin, © Wolfgang Tillmans

‣JEFF WALL

Florist's shop window, Vancouver, 2008, C-Print, 73,5 × 89 cm/29 × 35 in
Men move an engine block, 2008, Silbergelatineabzug/gelatin silver print, 138,5 × 176,5 cm/54 ½ × 69 ½ in
Search of Premises, 2008, C-Print, 192 × 263 cm/75 ⅝ × 103 ½ in
Siphoning fuel, 2008, C-Print, 186 × 235 cm/73 ¼ × 92 ½ in

Courtesy der Künstler/the artist und/and Marian Goodman Gallery, Paris/New York, © Jeff Wall

‣TOBIAS ZIELONY

Sämtliche Exponate aus/all exhibits from *Trona – Armpit of America,* 2008

13 Ball, C-Print, 84 × 56 cm/33 × 22 in
BMX, C-Print, 56 × 84 cm/22 × 33 in
Car Wreck, C-Print, 56 × 84 cm/22 × 33 in
Crystal, C-Print, 84 × 56 cm/33 × 22 in
Desert, C-Print, 56 × 84 cm/22 × 33 in
Diana, C-Print, 56 × 84 cm/22 × 33 in
Dirt Field, C-Print, 56 × 84 cm/22 × 33 in
Kids, C-Print, 84 × 56 cm/33 × 22 in
Me, C-Print, 56 × 84 cm/22 × 33 in
Ramshackle, C-Print, 56 × 84 cm/22 × 33 in
Trona Rd, C-Print, 84 × 56 cm/33 × 22 in
Two Boys, C-Print, 84 × 56 cm/33 × 22 in
Two Cigarettes, C-Print, 84 × 56 cm/33 × 22 in

Courtesy Sammlung Halke, © Tobias Zielony

IMPRESSUM AUSSTELLUNG/IMPRINT EXHIBITION

PHOTOGRAPHY CALLING!
Eine Ausstellung des Sprengel Museum Hannover in Kooperation mit der Niedersächsischen Sparkassenstiftung/An exhibition by the Sprengel Museum Hannover in cooperation with the Niedersächsische Sparkassenstiftung, 9. Oktober 2011–15. Januar 2012/October 9, 2011–January 15, 2012
Gefördert von der Sparkasse Hannover/Sponsored by the Sparkasse Hannover

Niedersächsische Sparkassenstiftung
Präsident/President: Thomas Mang
Stiftungsdirektorin/Director of the Foundation: Sabine Schormann
Bildende Kunst/Visual Arts: Ulrike Schneider
Leitung Kommunikation/Head of Communications: Martina Fragge

Sprengel Museum Hannover
Direktor/Director: Ulrich Krempel
Kuratiert von/Curated by: Inka Schube, Thomas Weski
Sekretariat/Office: Ingrid Mecklenburg
Mitarbeit/Assistance: Gesa Lehrmann, Stefanie Loh, Leo Merkel, Johanna Saxen
Bildung und Kommunikation/Education and Communication: Gisela Deutsch, Gabriele Sand, Gabriela Staade
Presse- und Öffentlichkeitsarbeit/Press and Publicity: Isabelle Schwarz, Alexandra Lücke
Blog Technik/Blog, technology: Andreas Ullrich
Konservatorische Betreuung/Conservators: Ria Heine, Martina Mogge-Auerswald
Fotografie/Photography: Aline Gwose/Michael Herling
Registrar: Eva Köhler, Brigitte Nandingna
Verwaltung/Administration: Carola Hagenah, Michael Kiewning, Olivia Posielsky
Betriebstechnik/Technical department: Hartmut Kaluscha, Marianne Lietz, Vitali Missal, Michael Schmiedel, Hans Zimmer
Ausstellungstechnik/Exhibition installation: Jakup Asci, Yasin Baban, Rainer Juranek, Bronislav Kunke, Johann Mayer, Emanuel Nylhof, David Reichel, Ursula Sowa, Alexander Stuhlberg, Alfred Stuhlberg